CREATING THEIR OWN IMAGE

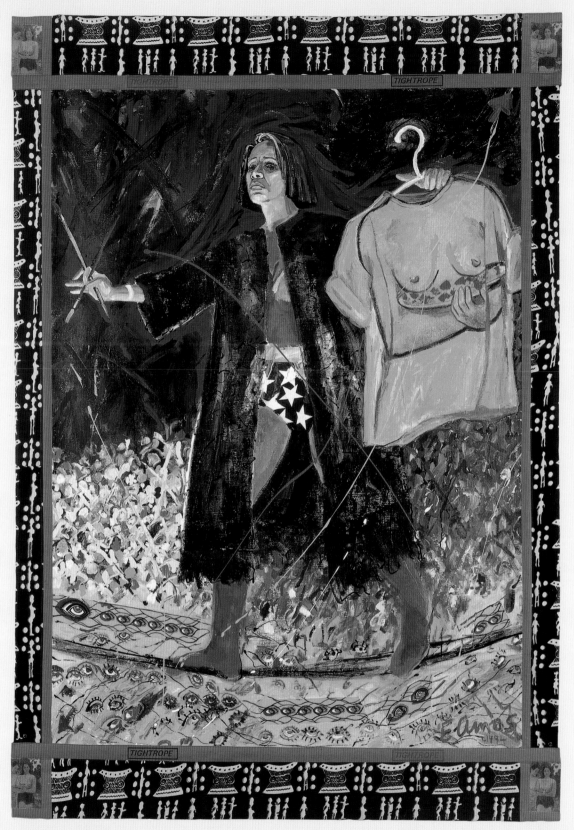

Emma Amos, *Tightrope*, 1994

LISA E. FARRINGTON

CREATING THEIR OWN IMAGE

The History of African-American Women Artists

OXFORD
UNIVERSITY PRESS

2005

OXFORD
UNIVERSITY PRESS

Oxford New York
Auckland Bangkok Buenos Aires Cape Town Chennai
Dar es Salaam Delhi Hong Kong Istanbul Karachi Kolkata
Kuala Lumpur Madrid Melbourne Mexico City Mumbai Nairobi
São Paulo Shanghai Taipei Tokyo Toronto

Published by Oxford University Press, Inc.
198 Madison Avenue, New York, New York 10016

www.oup.com

Oxford is a registered trademark of Oxford University Press

Library of Congress Cataloging-in-Publication Data
Farrington, Lisa E.
Creating their own image : the history of African-American women artists /
Lisa E. Farrington.
 p. cm.
ISBN 0-19-516721-X
1. African American art. 2. African American women artists. I. Title.
N6538.N5F27 2004
704'.042'08996073—dc22 2003066171

9 8 7 6 5 4 3 2 1

Printed in China
on acid-free paper

To my late mother, JOAN DOYLE FARRINGTON

whose joyous spirit and brilliant mind will always inspire my life

Some thirty years ago, when I was first introduced to the subject of African-American women artists, no cohesive historical record of these women existed. Indeed, much of the research on them had yet to be undertaken. After being approached to write such a history, it struck me as unpardonable that, in all the intervening years, a historical chronicle of these women had not been published. To be sure, there were biographies of contemporary artists, studies of the major painters and sculptors, and a few exhibition catalogs that chronicled individuals or particular genres within the larger group. But no aggregate history had materialized to chart the lives and careers of African-American women artists from the age of slavery to the new millennium.

Several roadblocks impeded the publication of this history before now. Until the women's art movement, few scholars existed who were able or motivated to explore the sketchy past and abstruse present of women artists. The first major feminist art histories gave precedence to women of European descent, while by and large neglecting women of color. The numerous histories of African-American art that began to appear in the first half of the twentieth century devoted most of their pages to men. There was also the challenge of finding a publisher courageous and committed enough to invest in a thorough upmarket text on a subject that remains unfamiliar to most potential book-buying audiences. Oxford University Press has, to its credit, felled this last obstacle.

Using contextual historical records, and building on the works of scholars such as Tritobia Benjamin, Leslie King-Hammond, Jontyle Robinson, and Arna and Jacqueline Bontemps, to name only a few, I have pieced together a chronological history, which continues to suffer from historic fissures, particularly in the earliest years, when the institution of slavery obscured the names and achievements of countless women artists. It is my hope that this book will serve to incite others to unearth and to produce work on African-American women artists so that we might all benefit from the knowledge of how these women lived, worked, and produced some of America's finest visual art.

Preface

My deepest appreciation to the many institutions, collectors, artists, photographers, and supporters who helped to make this book possible, with special thanks to:

American University

Emma Amos

The Arnett Family

Artists Rights Society

Judith A. Augustine

Scott Baker

Beeldrecht Amsterdam

Tritobia H. Benjamin

Belin Berisaj

Michael Bieze

Camille Billops

Kay Brown

Phillip A. Bruno

California African-American
 Museum

Ralph Carlson

Elizabeth Catlett

Cavin-Morris Gallery

Barbara Chase-Riboud

Kenneth Combs

Brian Cooper

Renee Cox

Rick Dexter

Raymond Dobard

David Driskell

Sharon Dunn

Lucious Edwards

The Farrington Family

Susan Ferber

Ford Foundation

Fowler Museum of Cultural
 History, UCLA

James Larry Frazier

David Fuller

Edmund Barry Gaither

Phyllis Galembo

Raymond Ganderton

Ben George

J. Paul Getty Museum

Gilley's Gallery

Stacey Hamilton

Juliette Harris

Harry Henderson

Melanie Herzog

Vera Hoar

Howard University

Richard H. and Kathleen Hulan

Mary Lou Hultgren

Benjamin Jaffe

Ada Jarred, APHN

Acknowledgments

Jack Jarzaveck

Marie Johnson-Calloway

Eileen Johnston

Sean Kelly Gallery

Nancy Lane

Tammi Lawson

Library Company of Philadelphia

Juan Logan

Charles Matthews

Grace Matthews

Miriam Matthews

Dindga McCannon

Andrea Mihalovic, VAGA

Peter Norton Family Foundation

Jan Nederveen Pieterse

Adrian Piper

Roberto Del Principe

Madeline Murphy Rabb

Faith Ringgold

Michael Rosenfeld Gallery

Luise Ross

Alison Saar

Betye Saar

Robert Sengstacke

Brent Sikkema Gallery

Lorna Simpson

Harry Smith

Smithsonian Institution

Sylvia Snowden

Tinwood Media

University of Iowa Museum of Art

Pat West

Michael S. and Piper Wyatt

Contents

CREATING THEIR OWN IMAGE

What would the images and monuments of the past look like if they had been conceived by foreign cultures—if someone other than those being portrayed had usurped the privilege of self-characterization? What if the only artistic records of Native Americans had been produced by European colonists? What if the only depictions and hieroglyphic histories of ancient Egyptians had been produced by their long-time adversaries in Nubia? What if the Gauls—sworn enemies of Julius Caesar—had engineered the only visual or written chronicles of the Roman Empire? What if, for hundreds of years, virtually all known depictions of Africans in Western culture had been made by those who loathed them? What if, for most of the history of the world, images of women had been cast solely by men?

These latter two questions can be readily answered, since they refer to an ongoing actuality. Images of Africans in the West have been commandeered by Europeans, and images of women, until very recently, have been regulated by men. One need not resort to conjecture to envision the distortions that would surface in such imagery. Since the eighteenth century, African men have been portrayed in Western high art and popular culture as brutish; African women as lewd; and for much of Western history women in general have been characterized as submissive. One need only look at the written, visual, and historic records of Africans and women in Western culture to confirm just how skewed their portrayals have been. Chronicled in this text is the legacy of struggle and triumph of African-American women artists, who have fallen prey to both racial and gender misrepresentations and who have, since the African slave trade began, strained against a dominant and insular culture.

Chapter 1 begins with an examination of the synthetic notions about women of African descent that have evolved over the past four centuries and branded them as oversexed, overbearing, and simple-minded. This probe is framed by revelations regarding the relatively recent development

Introduction

of pseudoscientific theories of racial inferiority, which began in the eighteenth century, and the millennia of favorable, even deferential, assessments of Africans by Europeans that preceded modern-day racism. The discourse moves from a historic review of racial distortions to a localized discussion of the stereotypes that have specifically been applied to black women: the carnal Jezebel, the asexual Mammy, and the imperious Matriarch. The rationale for this chapter, which is devoted as much to social history as to art history, can be found in the art works that appear on the ensuing pages—works by African-American women which, in form and content, seek to deconstruct the persistent falsehoods that have dogged black female iconography.

The remainder of the text comprises a chronological assessment of African-American women artists, analyzing the impediments they faced in gaining access to the realm of the professional artist, evaluating the art they produced, and examining how both their art and their exploits have reinvented their public and private identities. Chapter 2 highlights the art of enslaved African women of generations past, who found creative outlets in their daily work and alleviated the drudgery of plantation life by lovingly tending a garden or making a colorful quilt that harked back to an African textile tradition they had left behind. Their gardens and quilts may have been the property of slave owners, but the care and aesthetic sensibility that infused these creative endeavors distinguished the makers as artists.

Subsequent generations of free African-American women continued to grapple with oppressive social conditions that thwarted their creativity, as discussed in chapter 3. Widespread poverty and limited professional opportunities required African-American women to spend lifetimes as migrant workers or domestic servants, rather than as painters or sculptors. Yet, before the end of the nineteenth century, the first professional women artists of color had emerged, and their ranks have swelled ever since. By the second half of the nineteenth century, artists and former slaves such as Harriet Powers (a sought-after quilt maker) and Elizabeth Keckley (fashion designer to Mary Todd Lincoln), as well as sculptor Edmonia Lewis (internationally renowned for her neoclassical works in marble) were blazing trails for subsequent generations of African-American women artists. By the turn of the century, women of color such as Meta Fuller, May Howard Jackson, and Laura Wheeler Waring were attending art classes at the Pennsylvania Academy of Fine Arts and traveling abroad to further their training and careers.

The Harlem Renaissance and the "New Negro Movement" are the subjects of chapters 4 and 5. The 1920s and 1930s produced an entirely new crop of artists whose technical skills and creative sophistication were coupled

with a social and political agenda, providing the world with new and improved images of African Americans. This objective continued throughout the twentieth century, intensifying during the politically engaged decades of the 1960s and 1970s, when the feminist and Black Power movements (discussed in chapters 6 and 7) dramatically altered the kinds of images that African-American women created. During this period, women of color defied patriarchal demands that they curtail their professional ambitions. Through masterful visual means, they contested society's insistence on their subservience and vulgarity, and they redefined themselves and their gender. They used their talents to express themselves with honesty and courage. From this empowered vantage point, African-American women artists changed their past as well as their future and assumed the right to define themselves through the persuasive language of art.

This book is presented in two overarching segments. Part I, outlined above, comprises a review of art historical periods beginning with the age of enslavement. Part II (chapters 8 through 12) centers on stylistic developments in recent decades, such as abstraction, conceptualism, and postmodernism. The eclecticism and shared chronology of much art since the mid-twentieth century lends itself to a stylistic discussion rather than a linear one and, as such, has determined the formalist methodology employed in part II. The bifurcation of the text into two distinct segments is also dictated by the virtual anonymity of African-American women artists during the age of enslavement and the difficulty of their becoming professional artists prior to the twentieth century, which has resulted in an incommensurate relationship between available data before and after the age of modernism. While shedding light on much of the early history of African-American women artists, this book is also a call to historians to further probe this veiled past.

Visual art, above all else, is a form of language. As such, it has the palpable power to define and communicate particularized ideas as well as collective cultural codes. Makers of art throughout history have exercised their immanent right to define themselves through art and to fashion a self-definition that reveals them and their respective societies in the best possible light. African-American women artists have exercised the same right, but until recently their voices have been hushed by the bellows of outsiders. If nothing else, this book stands as evidence that their voices are now thunderous and will continue to resonate over time.

PART I

A persistent theme in the art of African-American women has been the configuration of their own image without racial or gender stereotypes. Prompted by an unwelcome inheritance of axiomatic portrayals that falsely defined them as lustful, loathsome, and inferior, many women artists of color have chosen to counteract these perversions by portraying themselves with dignity, honesty, and insight. Others have challenged the status quo by doggedly pursuing artistic careers despite the deeply rooted prejudices that excluded them from the realm of the artist. Inaccurate conceptions of African-American women, shrouded for centuries in an intricate web of sexual and racial fantasies, have proven to be enduring impediments to their progress.

Since the beginning of the slave trade in the 1500s, women of African descent have been typecast in the Western imagination as both sexually attractive and physically repulsive; as promiscuous femme fatales and genderless domestic servants; as excellent caregivers to white children and inadequate mothers to their own children; and as either naïve and childlike primitives or dangerous and cunning shrews. This amalgam of conflicting clichés integrates misperceptions of both race and gender, making an analysis of the African-American woman's image doubly problematic. Whereas African-American men have been unsympathetically categorized as criminal, indolent, dull-witted sexual predators, their female counterparts have endured these same racial stereotypes, as well as others rooted in their gender.

Conventional portrayals of African-American women, in both the fine arts and popular culture, are manifested most often in three contiguous image types: the Jezebel, or sinfully sexualized woman (fig. 1.1); the Mammy, whose character remains remote from any sexual connotations and who works primarily as a contented caregiver (sometimes sympathetically portrayed as the caregiver to her own family) (fig. 1.2); and the Matri-

O N E **The Image**

arch, or "superwoman," who is physically and emotionally powerful and, as the head of her own family, embodies both male and female attributes (fig. 1.3). Each of these conventions presents African-American women as one-dimensional characters rather than as complex human beings and tells us more about the image makers than the women themselves. Stereotypes such as these originated in the 1800s and gained popularity in the United States during the post-Reconstruction era of the 1880s and 1890s. At the time, imagery that placed blacks in subservient roles was embraced by white Americans because in these portrayals African Americans remained the chattel of whites, and through such visual conventions fears concerning the perceived threat of large numbers of recently freed blacks to the social and economic status of whites were allayed.[1]

Prior to the onset of the African slave trade, Western conceptions of blacks were decidedly different. As several historians have chronicled, from classical antiquity to the Renaissance, Africans were highly regarded in Western culture.[2] The ancient Greeks, for example, believed that the inhabitants of Africa, or "Aithiopia" ("land of the sun-darkened"), were of the highest moral character and, according to Homer's *Odyssey*, were the "just and blameless" favorites of the gods. Africans were likewise exalted in classical mythology, which was recorded in the eighth century B.C.E. by Homer and Hesiod. For instance, the Ethiopian princess Andromeda, considered a rare beauty, was rescued from a sea monster by the Greek hero Perseus, who

Figure 1.1
Paul Colin
La Revue Nègre
(The Negro Revue), 1925
oil on plywood, 39 1/2 x 31 1/2"
(100 x 80 cm). Design for
advertising poster for Josephine
Baker in "The Negro Review" at
the Théatre des Champs-Elysées,
Paris

Figure 1.2
Richard Norris Brooke
A Pastoral Visit (detail), 1881
oil on canvas, 47 3/4 x 65 3/4"
(121.28 x 167 cm)

Figure 1.3
Sargent Claude Johnson
Forever Free, 1933
wood with lacquer on cloth,
36 x 11 1/2 x 9 1/2"
(91.44 x 29.21 x 24.13 cm)

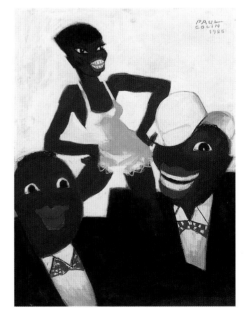

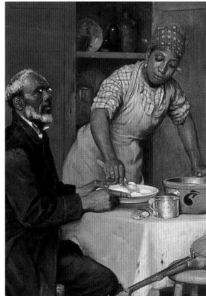

then married her. Evidence of the African blood of Andromeda, a favorite of Athena, can be seen in Greek vase paintings; she and her retinue are represented variously with cropped curly hair, thick lips, broad noses, and dark skin (fig. 1.4).

Hellenic admiration for African military prowess is also well documented in Greek vase paintings by numerous representations of black warriors, and in repeated depictions during the fifth century B.C.E. of the legendary African king Busiris, who once imprisoned Heracles. Interest in African physical beauty is conspicuous in the Janiform kantharos ceramics of the fifth and sixth centuries B.C.E., which juxtapose European and African faces, suggesting a Greek fascination with, and appreciation for, diverse corporeal charms (fig. 1.5). In some instances, legendary Greek characters such as Odysseus and Circe (the Homeric enchantress who turned men into swine) are themselves represented with African features.

Similar imagery appears in the sculptures and mosaics of ancient Rome, which depict not only mythological scenes, but also portraits of the African dignitaries, workers, priests, soldiers, hunters, and musicians who populated the Roman Empire (fig. 1.6). In the Christian era, the image and reputation of Africans continued to fare well. Prior to the seventh century, Western European Christians and eastern Byzantines shared beliefs and mutual respect with Coptic or Ethiopian Christians. For example, the North African healer and Christian military crusader St. Menas, who converted Africans to Christianity, is routinely represented in medieval manuscript illuminations with dark skin and African features.[3]

Subsequent to the early Christian era, between the seventh and eleventh centuries, Muslims conquered North Africa, Persia, much of the Byzantine Empire, southern Italy, and parts of Spain and France (coming within a hundred miles of Paris before being driven back). During these centuries, ties between Europe and Christian Africa were severed and prejudices began to form in the European psyche. Africans began to be cast in a derogatory light as children of the biblical Ham who were cursed by God. Especially targeted were "Moors," or North African Muslims, with whom Europeans had come into violent contact during the Muslim invasions. In Western Europe in particular, black became the color of the enemy, and the idea of "blackness" was associated with sin, evil, and darkness.[4] In the art of this period, Africans are depicted as devils and demons and as biblical executioners or persecutors of Christians. Despite political hostilities, however, depictions of Africans in Sicilian and Byzantine art of the Middle Ages remained impartial, likely due to the higher percentage of actual Africans living in these areas.

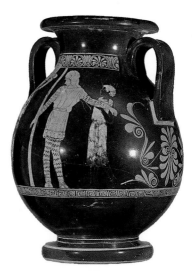

Western European antipathy toward Africans was mitigated after the tenth century when the Spanish, through their explorations and invasions of Africa, and the French and northern Italians, as a result of the Crusades, once again gained firsthand familiarity with African culture. Tangible interactions with Africans, who were the unquestionable creators of a sophisticated culture, tended to promote good will between the races and lessened the accretion of stereotypes. Although animosity toward Muslims continued, it did not extend to all Africans. On the contrary, the legend of Prester (presbyter, or priest) John, which developed in the twelfth century, described a magical and marvelous Ethiopian Christian king who was descended from the Magi and hailed as the forthcoming savior of European Christianity. Based partially on fact (Coptic kings allied themselves with the papal court at Avignon and aided in the defeat of Muslim armies between the thirteenth and sixteenth centuries), the legend of Prester John developed into a full-blown European preoccupation with a mythical African champion.[5]

A similar fixation occurred with the figure of St. Maurice (d. 287), an African officer of the Theban Roman Legion fighting in France, whose image proliferated in architectural reliefs, paintings, and illuminated man-

Figure 1.5
Kantharos
Greek, late Archaic period,
about 510–480 B.C.E.
Place of manufacture: Greece,
Attica, Athens, ceramic red
figure, height 7 9/16" (19.2 cm),
diameter 5 5/8" (14.3 cm)
© 2003 Museum of Fine Arts,
Boston

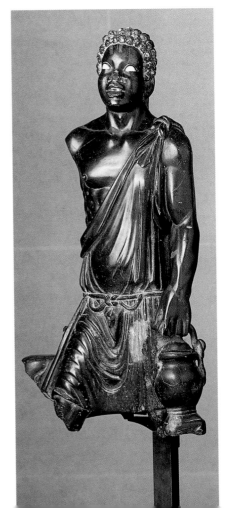

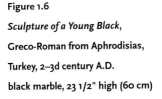

Figure 1.6
Sculpture of a Young Black,
Greco-Roman from Aphrodisias,
Turkey, 2–3d century A.D.
black marble, 23 1/2" high (60 cm)

Figure 1.7
St. Maurice, c. 1240–1250
polychromed sandstone

Figure 1.8

Hieronymus Bosch

Balthazar, the African Magus,
detail from *The Adoration of the
Magi,* central panel, c. 1450–1516

oil on panel, 4' 5 7/8" x 28"

(138.11 x 72 cm)

uscripts of the thirteenth and fourteenth centuries (fig. 1.7). When St. Maurice, a Christian, refused an imperial edict to pay homage to the Roman gods of victory, he and several of his fellow officers were put to death. The martyrs' remains were buried at Aguanum (today, St. Maurice-en-Valais) in France, where an abbey was established in their honor in 515. The martyrdom of St. Maurice was best documented in the fifth century by St. Eucherius, bishop of Lyon; and modern archaeological evidence suggests that much of Eucherius's account is accurate. Until the restrictions of the Reformation in the sixteenth century made the worship of Maurice unpopular, he was the center of a chivalric order, the patron saint of European soldiers, and celebrated among the nobility. Indeed, the tenth-century German emperor Otto I adopted St. Maurice as a Saxon patron.

Prester John and St. Maurice were joined by a number of other black personae who, by the 1400s, had ushered in a so-called African Century in Europe.[6] They include the biblical queen of Sheba (first depicted as African in late twelfth-century German art); Caspar, the Moorish king and one of the three Magi, who appears in Gothic and Renaissance paintings of the Adoration (fig. 1.8); and Fierefiz, the Moorish knight of King Arthur's Round Table, lauded in the thirteenth-century romantic epic *Parzifal*. Fierefiz, who accompanied his half brother Parzifal on the quest for the Holy Grail, was the poem's hero and ultimately deemed of higher moral and military caliber than his European brother. Yet, despite the availability of ample historic literature and artifacts that portrayed Africans as esteemed allies and citizens of Europe, few of their images appear in modern histories of Western art, as the definitive histories of European art were recorded by the canonical historians Joachim Johann Winckelmann in the eighteenth century and Heinrich Wölfflin in the nineteenth century and reflect the biases of their ages.

The group that, for centuries, had shouldered most of the burden of the Eastern Hemisphere's ethnic chauvinism was not African, but rather European, particularly Eastern European or Slavic peoples. Between the fall of Rome in the fifth century and the advent of the Renaissance in the fifteenth century, Europe's only marketable exports were, for

the most part, wood and slaves procured from Slavic nations and sold farther east. The term *Slav*, in fact, denoted Europe's "slave" population, and Muslims and Byzantines referred to Europeans, rather than Africans, as "savages" or "wild men." After the fifteenth century, the term *savage* was transferred first to Native Americans in the New World and then, by the eighteenth century, to Africans.[7]

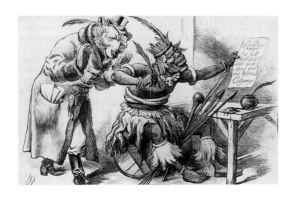

Despite the abundant evidence of Africa's political, religious, and social history, eighteenth- and nineteenth-century European historians, scientists, and other scholars began to refer to Africa as a land without a history. Renaissance admiration for Africa's numerous and elaborate court systems and its far-reaching network of developed cities evaporated by the eighteenth century. Motivated by a sense of racial and national superiority, colonial explorers provided the West with distorted accounts of Africa as an uncharted, near-impenetrable jungle when, in reality, a well-traveled system of trade routes had spanned the continent for centuries. Europe's so-called explorers did not, in fact, traverse uncharted lands, but merely asked for directions from Africans, who served as their guides and translators. Nonetheless, illustrated accounts of the perilous "Dark Continent" were embellished by authors who, in some cases, had never set foot in Africa, and these books often were wildly popular.[8]

The racial and civil vanity that spurred transatlantic exploration and colonization also bolstered the European need to dominate Africa, whose people were portrayed as perverse and satanic pagans in need of subjugation and religious conversion (for those who were not already Christian). In the drawings and photographs that entered eighteenth- and nineteenth-century popular culture, images of African elders, dignitaries, and other authority figures were excluded or replaced with exaggerated depictions of seemingly wanton rituals, barbaric behavior, brutality, and violence—the very activities of Europeans in their successful attempts to conquer the land and people of Africa. The more ruthless the actions of the European "conquerors," the more savagely Africans were portrayed. Meanwhile, colonial Europeans conveniently overlooked the fact that much of the violence attributed to Africans was carried out in defense of their homeland. Compare, for example, two illustrations of the Zulu king Cetshwayo (figs. 1.9, 1.10). An 1879 image, which appeared in the British magazine *Judy*, portrays Cetshwayo as a crude barbarian with coarsely exaggerated features. It contrasts severely with an actual portrait of the king from 1888, which was intended for an anthropological text. The later work reveals a sensitive,

Figure 1.9
Cetshwayo, King of the Zulus,
1879
Illustration from the British
periodical *Judy*

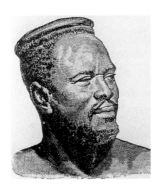

Figure 1.10
Cetshwayo kaMpande, 1888
Portrait of the Zulu king
from George Thomas Bettany's
*The World's Inhabitants; or,
Mankind, Animals, and Plants*

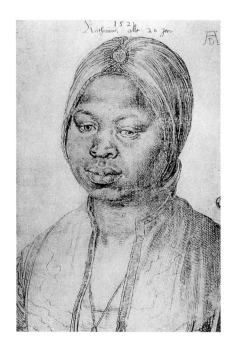

Figure 1.11

Albrecht Duerer (1471–1528)

The Moorish Woman (Catherine,
the Mulatto Woman of the
Portuguese Bradao), 1521

silverpoint drawing

attractive, and intelligent man whose face and demeanor bear no resemblance to the *Judy* caricature.

In the second half of the eighteenth century, European scholars began to engage in the pseudoscience of racial superiority and inferiority in order to prove the subhuman status of Africans and to justify European aggression. Swedish botanist Carolus Linnaeus published an account in 1758 of the "*homo africanus,*" whom he described as phlegmatic, lax, careless, crafty, and slothful with an apelike nose, swollen lips, and a desire to be ruled by authority. The female exemplar was noted to have a distended bosom and breasts that gave milk profusely.[9] (Not coincidentally, certain of these descriptive terms were once applied to the medieval European "wild man.") Mid-eighteenth-century scholar David Hume believed that not only Africans, but "all other species of men" were inferior to whites. He insisted that "there never was a civilized nation of any other complexion than white" and, despite historical evidence to the contrary, that Africans had produced no cultural artifacts nor made any worthy contributions to society.[10]

Figure 1.12

Diego Rodriguez da Silva y
Velazquez (Spanish, 1599–1660)

Juan de Pareja (born about 1610,
died 1670), 1650

oil on canvas, 32 x 27 1/2"
(81.3 x 69.8 cm)

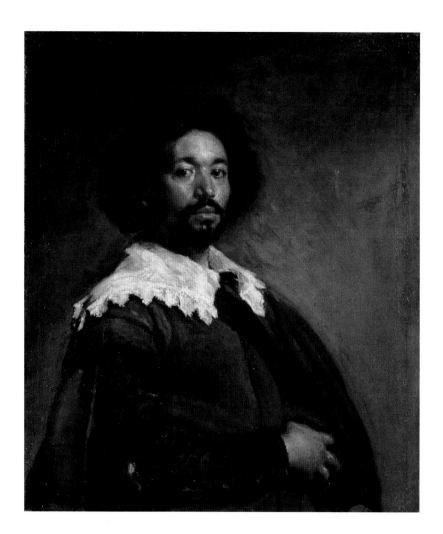

In 1791, anatomist Petrus Camper examined human skulls and concluded, based on the angle and shape of their heads, that Africans were more closely related to animals than were other humans. In 1795, German scholar Johann Friedrich Blumenbach coined the term *Caucasian* and subjectively described Caucasians as "most handsome and becoming," while reserving derogatory terms such as "knotty," "uneven," "puffy," and "bandy-legged" for "Ethiopians." The German philosopher Georg Wilhelm Friedrich Hegel lectured in 1830 that Africans were "wild and untamed in nature," were bereft of "morality and sensitivity," and had "nothing remotely humanized" in their character.[11]

This literature, coupled with Charles Darwin's popular theory of natural selection presented in *Origin of the Species* (1859), fueled racial chauvinism during the colonial and postcolonial eras. These writings stood in stark contrast to earlier descriptions, such as the one written by a Franciscan friar in 1350, which characterized Africans as "men of intelligence with good brains . . . understanding and knowledge."[12] Colonial presumptions also belied the sensitive and dignified depictions of African men and women that appeared in European art of the sixteenth and seventeenth centuries, which were created by masters such as Hieronymus Bosch, Albrecht Durer, Peter Paul Rubens, Rembrandt van Rijn, and Diego Velazquez (figs. 1.8, 1.11, 1.12). The intent of the colonial misrepresentation of Africans was to demonize them, so that any objective understanding of black culture after the 1700s became virtually impossible.

As the Linnaeus definition of *homo africanus*, cited above, indicates, special attention was given to the examination of African women. European scholars and scientists found the bodies of black women particularly captivating and devoted many hours and much ink to cataloging their attributes and exotic Otherness. In published materials, African women were often depicted nude or scantily clad, a fact of African life that Europeans found especially titillating, despite characterizations of the black female as physically and morally repulsive and antithetical to Western ideals of beauty. The French naturalist Georges Louis Leclerc de Buffon wrote in his acclaimed 1802–1805 *Histoire naturelle* that African women (and men) had lascivious sexual appetites; he also suggested that African

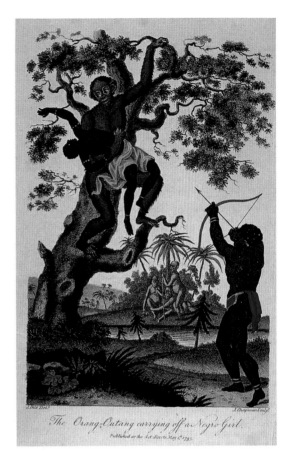

The Orang-Outang carrying off a Negro Girl.
Published as the Act directs May 1st 1795.

Figure 1.13
The Orang-Outang Carrying off a Negro Girl, 1795 illustration

women copulated with apes (fig. 1.13). Julien Joseph Virey's *Histoire naturelle du genre humain*, published in 1824, postulated that the African woman's "voluptuousness is developed to a degree of lascivity unknown in our climate, for their sexual organs are much more developed than those of whites." Virey also found the black woman's body "hideous" and her nose "horribly flattened."[13]

So fascinated were European audiences with the African woman's body that it was publicly displayed at world expositions in Paris, London, and Chicago and in gala performances throughout Europe and the United States during the nineteenth century (figs. 1.14, 1.16). Many of these spectacles were little more than peep shows offering the modest Victorian viewer (under the guise of anthropology) a voyeuristic glimpse of seminude black bodies. The ethnographic pavilions at the celebrated World's Columbian Exposition, held in Chicago in 1893, were organized by two of the nation's foremost anthropologists from the Smithsonian Institution—Otis Mason and Thomas Wilson—and thus were perceived by a wide public (more than 27 million people visited the exposition) as accurate. The pavilions firmly established blacks, both in Africa and America, as the primitive Other. Indeed, contemporaneous cartoons depicted grotesque caricatures of African-American fair visitors wearing African costumes, carrying spears, and eating watermelon as they toured the exposition, suggesting that they were as primitive as their African counterparts.[14]

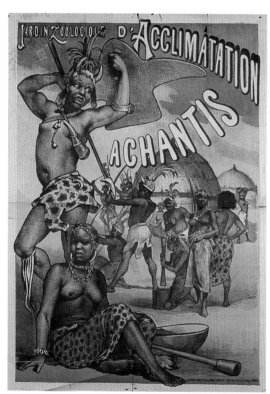

Figure 1.14
Anonymous
Jardin zoologique d'Acclimatation, Achanti, Paris, 1895
color lithograph, 51 1/8 x 37 3/4" (130 x 96 cm). Poster for *Petit Journal, supplément illustré*, 31 May 1903

One of the most notorious displays of the nude African woman's body was that of the "Hottentot Venus" from 1810 until her death in 1815 (fig. 1.15). Also known as Saat-Jee or Saartjie Baartman, the Hottentot Venus was a South African woman, whose body was "exhibited" in Paris and London as an example of the naked savage within the context of quasi-zoological exhibits. Her large buttocks were characteristic of KhoiKhoi or Kwena women, and the Baartman/Kwena body type both captivated anthropologists and seemed to provide physical evidence that black female sexuality was aberrant (fig. 1.16). Following her death from smallpox, Baartman's genitalia were dissected, analyzed, and chronicled in an autopsy and, astonishingly, remained on display in a bell jar at Paris's Musée de l'Homme until the 1970s.[15] The anatomist who performed the autopsy, Georges Léopold Cuvier, focused on the "Hottentot Apron"— a physical modification that enlarged the labia (not

unlike modern breast implantation). The result was considered beautiful in KhoiKhoi culture, but became a mark of sexual perversion in Europe. The Hottentot Apron was mythologized in the medical community as a grossly overdeveloped clitoris, matched only by Baartman's equally amplified buttocks. Scientists believed that the size of Baartman's hips and genitalia were a direct reflection of the size of her sexual appetite and, by extension, that of all African women. Thus "science" firmly implanted the idea of the "black Jezebel," or sexualized black female, into the Western consciousness.[16]

Men of letters were quick to make a connection between the configuration of the Hottentot body and that of the European prostitute. Protruding buttocks, full lips, fleshiness, and other so-called African traits were associated with European women of questionable morals and were believed to be indicators of their sexual abnormality. Prostitutes were thought to be carriers of disease, lesbians (or in some way masculine), or sexual deviants. Sexual myths of this type were designed both to subjugate black women and to curtail the sexual activities of white women. The widespread acceptance of these theories indicated a psychological desire on the part of European men to project their own sexual appetites onto the women of both races. As one psychiatrist noted, Europeans tended "to project onto . . . colonial peoples the obscurities of their own unconscious—obscurities they would rather not penetrate."[17]

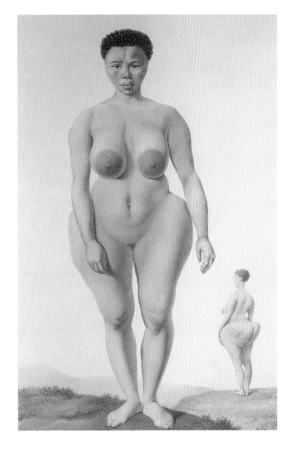

Figure 1.15
Léon de Wailly and
Jean-Charles Werner
Saartjie Baartman or *Venus
Hottentote*, 1815
lithograph extracted from
Geoffroy Saint Hilaire and
Georges Léopold Cuvier's
*Histoire naturelle des
mammifères*

Figure 1.16
Prince Roland Napoleon
Bonaparte (French, 1858–1924)
*Three Unidentified African
Women* in the Jardin Zoologique
d'Acclimatation at the Exposition
Universelle, Paris, c. 1889
from *Boschimans et Hottentots*
(Bushmen and Hottentots)
Collection and © J. Paul Getty
Museum, Los Angeles

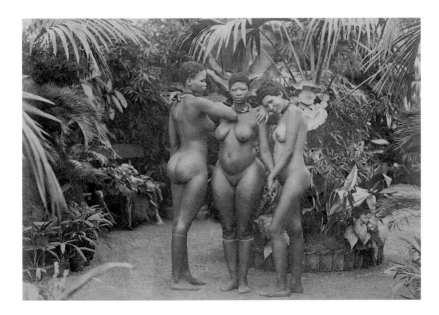

References to Africa as the Dark Continent symbolized the depths of the Victorian subconscious projected onto an entire land. Terms such as "penetration" (of the African jungle) and "rape" (of the African people and their homelands) have become standard vocabulary in discussions of colonialism.[18] The same terminology also found its way into the vocabulary of art history—a lexicon that was formed, for the most part, concurrently with racial theories. The German expressionist artist Wassily Kandinsky, for example, described the act of painting in both colonial and sexual terms, interpreting it as a kind of lecherous assault: "I learned to battle with the canvas, to come to know it as a being resisting my wish . . . and to bend it forcibly to this wish. At first it stands there like a pure chaste virgin . . . and

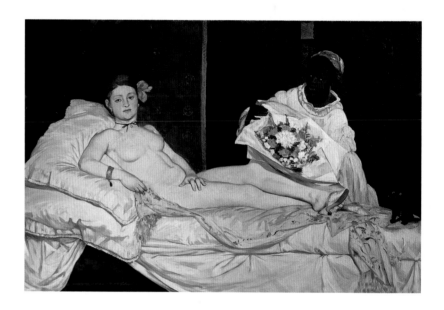

Figure 1.17
Edouard Manet (1832–1893)
Olympia, 1863–1865
oil on canvas, 51 1/4 x 74 3/4"
(130.5 x 190 cm)

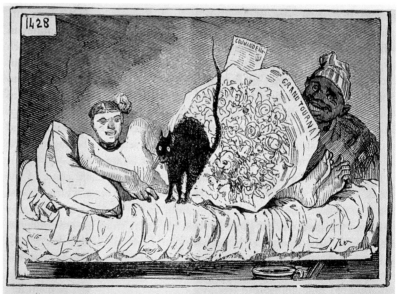

Figure 1.18
Bertall (Charles-Albert d'Arnoux)
Le queue du chat, ou la
charbonnière des Batignolles,
1865
wood engraving

La queue du chat, ou la charbonnière des Batignolles.
Chacun admire cette belle charbonnière, dont l'eau, liquide banal, n'a jamais offensé les pudiques contours. Disons-le hardiment, la charbonnière, le bouquet dans du papier, M. Manet, et son chat, sont les lions de l'exposition de 1865. Un bravo senti pour M. Zacharie Astruc.

then comes the willful brush, which first here, then there, gradually conquers it with all the energy peculiar to it, like a European colonist."[19]

In the fine arts, as in popular culture, images of black women served as metaphors for Africa (wild, untamed, and awaiting domination) and symbolized heightened sexuality. The best-known example of this is in the French artist Edouard Manet's 1863 painting *Olympia*, which features the reclining nude figure of a French prostitute whose pose is indebted to Titian's *Venus of Urbino* (1538) and other conventional prototypes (fig. 1.17). Exhibited at the Académie Française Salon of 1865, the painting's sexual immediacy shocked viewers. Nudity in the academic salon was generally reserved for remote subjects—ones that were distanced from the viewer by time or place, as would be the case with a historical or "oriental" (foreign) nude or allegorical and mythological figures (such as Titian's *Venus*). *Olympia*, on the contrary, was very real and anything but remote. Critics described her as vulgar and repulsive, a "wan and wasted courtesan" unfit to grace a work of high art.[20]

The intensity of the public's response to *Olympia* can be seen in contemporaneous cartoons, which ridiculed the painting and depicted *Olympia* as a grotesque caricature (fig. 1.18). An illuminating element in this illustration is the emphasis placed not on Olympia, but on the black cat, the black maid, and the flowers—surrogates for decadence, race, and sexuality. The rounded buttocks, fleshy lips, and corpulence that were associated with European prostitutes, while absent in Olympia herself, are symbolically present in her companion, the black maid, a professional model named Laura.

The presence of the black woman in *Olympia* underscores the relationship between the black woman's image and that of the sexualized white woman. Spanish artist Pablo Picasso illustrated this relationship with wit and clarity in a 1901 tribute to Manet, also entitled *Olympia*. In this work,

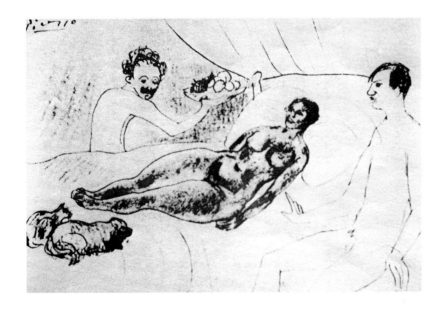

Figure 1.19
Pablo Picasso
Parody of Manet's *Olympia*
(Sebastian Junyer-Vidal and
Picasso), 1901
pen and ink and colored crayon,
6 x 9 1/8" (15.3 x 23 cm)

Picasso replaced Manet's French courtesan with a voluptuous, nude black woman, essentially revealing the African specter hidden inside Manet's harlot (fig. 1.19).[21] The proffered flowers in Manet's *Olympia*, which symbolize the presence of a male suitor as well as fertility, are replaced by Picasso with an even more insistent signifier of fecundity, a plate of fruit carried this time by the client himself—a naked, mustached voyeur. The black cat, which Manet places at the foot of Olympia's bed, is joined in Picasso's version by a dog, traditionally a metaphor for fidelity. In the Spanish master's cleverly articulated sketch, the dog and cat also represent the animalistic impulse in both genders.

Picasso was well acquainted with brothels and prostitutes, as indicated by his 1907 protocubist painting *Les Demoiselles d'Avignon* (fig. 1.20), inspired by a group of Barcelona prostitutes. The artist's alleged rage toward women in general, and prostitutes in particular, whom he disdained as carriers of venereal disease, is expressed in the painting's harsh palette, in the fierce "attack" of the brushwork, and in the African-style masks placed over the faces of two of the figures. *Les Demoiselles*, with its "monstrously distorted" heads, scandalized and disturbed Picasso's confidants who first viewed the painting in the artist's studio. Picasso's use of African masks invokes the primitive and barbaric woman, the symbolist femme fatale of late nineteenth-century painting, the Woman as Destroyer—the African woman.[22]

Powerful icons of the wanton African woman continued to proliferate throughout the twentieth century and were embodied in real-life characters such as entertainer Josephine Baker, the African-American sex goddess and star of the Folies Bergère (fig. 1.1). Exemplars decades later include film and recording celebrity Grace Jones, whose approximation of pop culture carnality and androgyny ideally personified the fabled Jezebel, and hip-hop artists such as Foxy Brown and Li'l Kim, whose near-nude and suggestive poses on album covers and in publicity photos tested the limits of propriety.

The doppelgänger of the Jezebel is the stout, sturdy, and sterile Mammy, who exists as much to sexualize her white counterpart as to provide a foil for the latter's milky skin and slender form (fig. 1.17). The Mammy, or black maid, is at variance with the Jezebel theme in that she is obese, rather than voluptuous, and she serves the white mistress rather than the master. Her obesity prevents her from being sexually attractive, allowing her to be welcomed into the home of her mistress as a domestic worker and surrogate mother to the family's children. Her duties include midwifery, wet-nursing, cooking, cleaning, sewing, and serving. Indeed, generations of African-American domestic workers proudly performed these real-life tasks in the

Figure 1.20
Pablo Picasso (1881–1973)
Les Demoiselles d'Avignon, 1907
oil on canvas, 96 x 92"
(243.8 x 233.7 cm)

homes of whites to earn livings for themselves and their own families. In the Mammy stereotype, however, she had no family or life of her own and functioned solely to serve her adopted white family.

The Mammy genre was part of a larger group of stereotypes that included the Black Brute, the Happy Darkie, and sundry Sambos and pickaninnies. The rise of depictions of blacks as whores, servants, villains, idlers, idiots, and clowns was accompanied by virulent racism, which found both legal and illegal expression in post-Reconstruction and Jim Crow America. The Mammy, whose jolly contentment served as "proof" that slaves were happy, became a ubiquitous and nonthreatening image to turn-of-the-century whites. Proof positive of the Mammy's impact was demonstrated when the first Academy Award ever bestowed on an African American was given to Hattie McDaniel in 1940 for her role as "Mammy" in the film *Gone with the Wind*. Its long-term iconic value is further seen in the Aunt Jemima image used on pancake boxes and in company advertisements for more than a century. Aunt Jemima's depiction as a smiling, full-faced maid wearing a kerchief epitomized white America's ideal of the black woman, so much so that the product image remained relatively unchanged from its debut at the 1893 World's Columbian Exposition until 1989, when Aunt Jemima's kerchief was removed and her drab clothing was replaced with updated business attire.

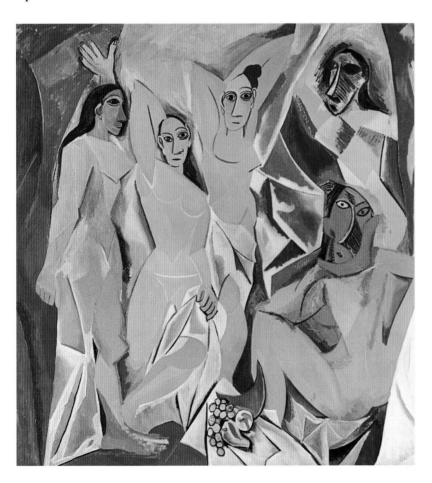

The black earth mother, nurturer, and happy workhorse, which Mammy personified, was the antithesis of the white mistress, whose own gender stereotype required her to be pale, frail, passive, and pious.[23] Neither image was accurate, but each served to strengthen and perpetuate the other and to confirm already entrenched beliefs in the differences between the races. These disparities were bolstered by the myth of the black Matriarch, who possessed the strength and stamina of the Mammy, but lacked something of her gentle demeanor and benevolent good humor. The Matriarch, in her more cantankerous incarnation as the proverbial "black bitch," also lacked the Mammy's boundless desire to serve whites. At best, she was portrayed as a self-sufficient, solitary pillar of strength and consummate family protector who embodied both father and mother, as exemplified in African-American artist Sargent Johnson's *Forever Free* (1933) (fig. 1.3).

The Matriarch can be seen as the Mammy from the point of view of her black family rather than her white one. She is often portrayed as a single parent or as head of her household, who bears the burden of providing for her children and extended family—an ex-Jezebel who is now paying for her earlier indiscretions. The Matriarch possesses certain masculine attributes, such as large size (she is often as obese as the Mammy), extended work hours outside of the home, and a domineering personality. At her worst, she is ill-tempered and sharp-tongued, and much of her irascibility is directed toward her spouse or other male members of her household.

The Matriarch was often blamed for the ills of the African-American family by twentieth-century American social scientists studying the supposed pathologies of black families. In 1902, Joseph A. Tillinghast wrote that post-Reconstruction blacks were barbaric and retrogressive precisely because they had been released from the "civilizing restraints" of slavery. Unsuccessful attempts on the part of African Americans to assimilate into white society after Emancipation were believed to promote self-hatred and to cause no end of pathological disorders. Mother-led black families, rather than racist attempts to thwart assimilation, were blamed for this phenomenon. Leading sociologists such as Robert E. Park and Gunnar Myrdal diagnosed a "Negro problem."[24] The black man was described by Park in 1918 as incapable of decisive action and as "the lady of the races," and in 1944, Myrdal postulated a similar parallel between women and blacks, whom he saw as "laboring under the yoke of unassimilability," and with whom "white men generally prefer [to take] a paternalistic and protective position"—a situation that Myrdal likened to feudalism.[25] The limited political and financial opportunities available to African-American men during and after post-Reconstruction earned them the reputation of being "like women." On the other hand, the same financial difficulties that

forced African-American women to take jobs as maids, cooks, and seam-stresses to help support their families gave them (at least in the eyes of social scientists) a financial independence that was inappropriate for women. Consequently, African-American women were said to be "like men." Their presumed sexual promiscuity added to their manliness. Scholars concluded that, because the African-American woman had more sexual freedom and financial power than was deemed appropriate, she (rather than any circumstance of social injustice) debased and humiliated her male analogue. Feeling thus degraded, African-American men were said to have devolved into "filthy, careless and indecent" human beings who were, according to sociologist Howard Odum, "as destitute of morals as any of the lower animals."[26]

Hypotheses that blamed African-American women for the so-called pathologies of black men reached an apex in the 1960s with the Moynihan Report. Written under government sponsorship by U.S. Senator Daniel Patrick Moynihan and sociologist Nathan Glazer, the well-publicized and well-meaning report alleged, in part, that the assertiveness, independence, and intelligence of African-American women tended to undermine the social well-being of black men. The report postulated (among several theories) a causal relationship between the scholarly and professional achievements of women and the poor educational performance and criminal behavior of men, reiterating earlier findings that African-American women were to blame for the perceived "Negro problem."[27]

The philosophical basis of these many studies was manifested in the myth of black matriarchy, which characterized African-American women as superwomen, personified in such stereotypes as the character Sapphire from the popular radio and television show *Amos 'n' Andy*. Based on nine-teenth-century "blackface minstrel" characters (white actors who wore dark makeup and ridiculed blacks), *Amos 'n' Andy* first aired in 1929 and quickly became the most popular radio show in the country. White actors were replaced with black ones when the show made the transition to television in 1951. The TV show featured Amos, Andy, and their friend Kingfish as updated versions of the Sambo or Happy Darkie. Kingfish's shrewish wife, Sapphire, was the epitome of the overbearing, tyrannical, and emasculating Matriarch. Using cruel wit, she found endless ways to belittle her husband and his friends, whom she found shiftless, unprincipled, and irresponsible.[28] Despite protests that the television show was an overtly racist attempt to reinforce black stereotypes (sadly with the aid of African-American actors), *Amos 'n' Andy* won an Emmy Award in 1952 and continued to air in syndication until the mid-1960s. Its overwhelming success fixed the black Matriarch in American perceptions.

By 1970, the myth of black matriarchy had been exposed by revisionist scholars, who argued that, far from being an empowered group, African-American women had always worked at the lowest-paying jobs and faced unemployment levels significantly higher than those of whites or black men. Data showed that "African-American women were at the bottom of the sex-race hierarchy in terms of all socio-economic indices" and were virtually incapable of either controlling or dominating their men to the extent that the Moynihan Report suggested. Toni Cade Bambara's 1970 anthology, *The Black Woman*, included insightful essays that successfully deconstructed the paradigm of a relationship between female strength and male impotency. Robert Staples's essay "The Myth of Black Matriarchy," which appeared in *Black Scholar* in 1970, argued that African-American families were not, by and large, matriarchal. In *Black Macho and the Myth of the Superwoman*, Michele Wallace established how the male-biased politics of the mid–twentieth century devalued African-American women and undermined their right to self-determination. Wallace also explored the ways in which African-American women fell victim to their own mythology, seeing themselves as "women of inordinate strength" who, fearing the stigma of the Matriarch, resolutely put the needs of their husbands and sons before their own.[29]

Despite revisionist scholarship, the impact of which was felt mostly in academic circles, the image of the matriarchal black superwoman persisted with great tenacity in popular culture, creating what scholar Patricia Morton termed "The Invisible, Shrinking Woman."[30] At the very moment when the Civil Rights and Black Power movements were demanding equality for African Americans, women of color were being undermined. In writings that appeared in the 1960s, African-American women were advised to concern themselves solely with the status of their men and to curtail efforts to improve their own social and economic status. It was believed that an enhanced social situation for African-American men would automatically benefit women.[31]

Mirroring wider society, African-American men, too, trivialized the needs of women of color and denied them equal status within the black community. Striking examples of this trend could be found in the practices of several major black organizations of the 1960s and 1970s, including the Black Panther party, the Nation of Islam, and CORE (the Congress of Racial Equality). The Black Panther party monitored and restricted the behavior of women, excluding them from most leadership roles and encouraging their maltreatment. Floyd McKissick, one of the more militant leaders of CORE, decisively categorized the Black Power movement as a man's movement when, in 1966, he stated: "[This] shall be remembered

as the year that we lift our imposed status as Negroes and become black *men.*" Elijah Muhammad, then leader of the Nation of Islam, also made no secret of the fact that women were meant to play a subordinate role in the home and in the community. He openly referred to women as "property" and described them as being in need of supervision because they were prone to evil.[32]

Succumbing to the myth of black matriarchy, African-American men subscribed to hypotheses that identified women of color as their downfall, labeling them "evil, hard to get [a]long with, domineering, suspicious, and narrow-minded."[33] Eldridge Cleaver, in his 1968 *Soul on Ice*, indicated that there was "a war going on between the black man and woman, which makes her the silent ally . . . of the white man." Cleaver's words echoed a widespread belief that women of color did not support their men and thus aided and abetted the "white male oppressor" in his attempts to subjugate the African-American male population.[34] For the time being, the fact that African-American women were as much victims of racial oppression as were their men was forgotten.

With so many powerful forces working against them, African-American women have been faced with the near-impossible task of recasting their own image into one that better reflects their emotional and intellectual depth and diversity. Of the many harmful manifestations of racist and sexist propaganda, visual imagery is perhaps the most indelible. The drawings, paintings, photographs, and films that depict African-American women as Mammies, Jezebels, and Matriarchs have left a lasting impression on Western culture. These representations have been configured not by the women in question, but by others whose insights into the true nature of black womanhood have left us with a distorted picture. Fittingly, many African-American women have chosen to use the same weapon—the visual arts—to inhibit this trend.

Guided by my heritage of a love
of beauty and a respect for
strength—in search of my
mother's garden, I found my
own. And perhaps in Africa over
two hundred years ago, there
was just such a mother; perhaps
she painted vivid and daring
decorations in oranges and
yellows and greens on the walls
of her hut. . . . perhaps she wove
the most stunning mats.
—Alice Walker,
In Search of Our Mothers'
Gardens, 1983

When the first African women arrived in the New World, their ability to express themselves through art was severely hampered by their social status as slaves. The adverse conditions of their lives precluded them from becoming artists in a traditional sense, but they were able to redirect their creative energies into the decorative arts. African-American women were adroit artisans and specialized in textile design, weaving, dyeing, quilting, basketry, and landscaping—tasks that became, for them, avenues of self-definition, self-expression, and psychological respite from the hardships of daily life. In rare cases, talented women of color were able to barter their skills for manumission and to embark on lucrative business careers as free entrepreneurs. Those less fortunate worked exclusively for their owners but, in scarce moments when their time was their own, they were able to create works of art for personal gratification. Whether cultivated in a cramped plantation sewing room, a candle-lit slave cabin, or in the few academies where free blacks could study needlework, the aesthetic impulses of women of color were preserved.[1]

Due to the "craft" designation of most early African-American art, the importance of this work has been underestimated. Western culture assigns to crafts the appellation "low" art, while "high" or "fine" art, such as painting and sculpture, intended for viewing and contemplation rather than for practical use, is more eminently valued in the West. Enslaved women, who hailed from societies that understood art as simultaneously useful, beautiful, and symbolic, were unfamiliar with the Western ethos. As a matter of course, African fabrics incorporated emblematic patterns and elements of language; architectural reliefs displayed elaborate narrative carvings; furniture, headrests, and other household items were embellished with consequential decorative motifs; and wooden sculptures were carved as much for their appearance as for their ceremonial applications. Yet, despite the integration of life and art in traditional African creative arts, Western culture

T W O **Creativity and the Era of Slavery**

engages these objects on its own terms—isolated from context in museum displays or admired as mere decoration, so that the objects essentially become high art.[2]

As a result of ingrained attitudes that assert the formal and conceptual orientation of high art rather than its usefulness, much of the creative output of early African Americans has not received comprehensive study. According to historian Floyd Coleman:

> The high-low arts dichotomy with its attendant function-nonfunction associations has not given impetus to extensive crafts art scholarship. Menial labor [such as the labor of slaves] does not produce the stuff that demands intellectual and aesthetic analysis. . . . Yet, it is from craft arts . . . that the fundamental humanistic values are expressed in plastic form. This is especially true for African-American craft art.[3]

Unlike male-produced art forms such as carving, engraving, and building (which correlate to the high arts of sculpture, painting, and architecture), art made by African-American women has been twice deferred due to biases against both the art of women and the decorative arts.

Fabric art, in particular, has suffered from its status as a craft and as "women's work"—a Western tag that contrasts with a long-standing African tradition of male weavers. Furthermore, despite the skillful handling of two-dimensional design elements such as line, color, shape, texture, and pattern that we find in textile design, this medium is rarely discussed in conjunction with other two-dimensional art forms, such as painting and drawing. Even when scholars have seriously discussed African-American fabric design, they have tended to emphasize its so-called ethnic traits (bright colors, large patterns, and improvisational elements) rather than attributes of quality, level of skill, technique, and other formal concerns of the medium.[4] While culture and gender do indeed inform the art-making process, the creative decisions and abilities of the individual artists deserve commensurate analysis.

By the nineteenth century, women of color had made substantial inroads into textile design, which they experienced as a significant conduit for their creative expertise. On plantations and in factories throughout the country, African-American women spun and wove raw cotton into cloth, helping to support one of the antebellum South's largest commercial industries. Enslaved women toiled for many hours in plantation buildings called cloth houses, attending to their quilt-making duties, producing lace, weaving textiles, and sewing garments; and they frequently worked well into the evening, after long and arduous days of laboring in the fields. One

Figure 2.1

Louiza Francis Combs

Woven wool blanket, Kentucky

c. 1890

79 1/2 x 61" (202 x 155 cm)

Figure 2.2

Photograph of Louiza Francis

Combs c. 1900

narrative, dictated by the ex-slave Fannie Moore, describes how her mother had to "work in the field all day and piece and quilt all night."[5] Other records indicate that enslaved seamstresses were required to work in painfully cramped quarters, often with no heat in winter. Yet, despite the difficulty of their circumstances and the system of labor that compelled their activities, women of color found that needlework could serve both the requirements of their white masters and their own artistic ends. They somehow found time to weave their own cloth and piece their own quilts—an exercise that developed into one of the most widely practiced of all the African-American crafts.

The history of quilt making is an illustrious and international one. It dates as far back as Old Kingdom Egypt, ancient China, India, Mali, and late medieval Europe, where appliqué techniques (sewing precut figures onto a fabric ground) were employed. The same appliqué method was used throughout postcolonial Africa and in the United States, where an admixture of African and European quilt-making practices culminated in a rich and complex art form. African-American women excelled in all manner of quilting methods, including piecing, appliqué, embroidery, and "broderie perse," or cutout chintz, and they drew from a variety of cultural sources. For example, while adopting the means for quilt fabrication from Euro-American traditions, women of color made quilt tops using their own African-derived designs.

A favored method of quilting was strip piecing (joining strips or ribbon-thin "strings" of cloth together to make larger fabrics). This technique eliminated the need for large bolts of cloth and allowed for the sewing together of scrap material—often the only fabric available to enslaved quilters. Strip quilting has thrived for centuries in coastal South Carolina, Georgia, Alabama, Mississippi, Tennessee, Maryland, and Pennsylvania and has roots throughout Western culture. Strip piecing, like appliqué, was also practiced in Europe, particularly in Great Britain beginning in the seventeenth century. In their usage of both appliqué and strip systems, African-American quilters have dipped into multiple wellsprings, giving an unparalleled look to their designs.[6]

African-American textiles were cited by nineteenth-century observers for their variegated colors and patterns, incongruous motifs, irregular perimeters, and assimilation of disparate types of cloth. One surviving example of such unconventional fabrics, dating to the 1890s, is a wool blanket designed by **Louiza Francis Combs** (1853–1943) of Hazard, Kentucky

(figs. 2.1, 2.2). Combs, who was born in Guinea, came to the United States in the mid-1860s and made and dyed woven fabrics and quilts from the wool of sheep raised by her family. Her hand-woven blanket features a red striped pattern, patchwork, and two broad asymmetrical panels. The discontinuity of the two sides, while appearing arbitrary, was likely not. Idiosyncratic design elements of this type were employed consciously and deliberately in many nineteenth-century African-American textiles and are rooted in African—specifically Mande—religious precepts.[7]

The Mande, a group of West Africans who made up some 25 percent of the American slave population, believed that evil spirits traveled in straight paths and could not access the living if the latter were protected by broken lines or fragmented shapes. Scholar Judith Chase documented the endurance of this belief in the United States and observed of slave-made fabrics that "there sometimes appeared to be no attempt to match pattern. . . . Considering the obvious dexterity of the weaver, this may be an Africanism. Black slaves oftentimes refused to plow in a straight furrow or follow a straight line in a pattern without occasionally deviating to foil the malevolent spirits."[8]

While the Combs blanket epitomizes the concept of deliberately broken or interrupted lines, an album quilt made by **Josie Covington** (1876–?) of Triune, Tennessee, is an ideal exemplar of unmatched patterns (fig. 2.3). Considerably more complex than the Combs blanket, the Covington quilt

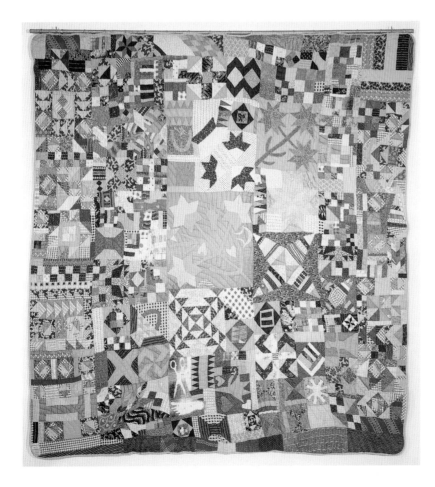

Figure 2.3
Josie Covington
Album quilt, c. 1895
81 x 80" (205.7 x 203.2 cm)

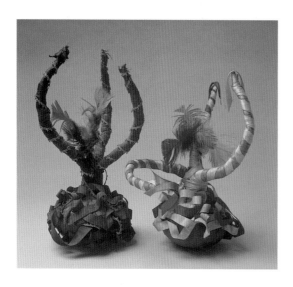

Figure 2.4
Pakèts Kongo
13 1/8" high (33.5 cm)
UCLA Fowler Museum
of Cultural History, FMCH
X93.9.1C.D

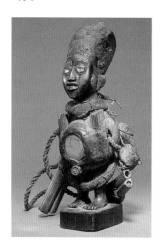

Figure 2.5
Kongo *nkondi/nkisi*, or power
figure, undated, wood, mirror,
glass, cane, fiber, bone,
10" high (25.5 cm)
UCLA Fowler Museum of
Cultural History, FMCH X65.8501
Gift of the Wellcome Trust

exhibits comparable random design elements, including undulating border patches and multifaceted shapes and textures. Careful examination of the Covington quilt reveals a studied use of pandemic quilt blocks, meticulous edge sewing, and a controlled chaos that has been likened by one historian to the works of abstract expressionist Jackson Pollock.[9]

Just as certain African-American quilt designs have their roots in Africa, so too does the occurrence of veiled symbols. Encrypted fabric patterns exist in Epke or Leopard society cloth made by the Ejagham women of the Cameroon; Nigerian textiles incorporate a 400-year-old encoded script called *nsibidi*; and Yoruba women, also of Nigeria, make *adire* cloth, which is dyed with sacred symbols inspired by Yemoja, goddess of fertility. Similarly, *adinkra*, a cotton fabric, is stamped with enshrouded signs by the Asante men of Ghana; and the Bamana women of Mali dye-impress emblematic characters called *bogolanfini* onto protective textiles. African-American equivalents include the nine-patch quilt (a three-row, nine-square motif), which frequently incorporates a hand shape or protective talisman known as a "mojo" (fig. 2.3).

The protective hand symbol derives from the Fon religion of Vodun, which is indigenous to northwest Africa. Known in the Americas as Vodou, Fon theology has been practiced by Africans in Hispaniola (present-day Haiti and the Dominican Republic) since the sixteenth century and in the United States since the eighteenth century. Reference to the hand as a conjuring symbol occurs in the Creole phrase *travailler avec deux mains*, or "to work with two hands." This statement describes the act of casting spells, or mojos, which is practiced by persons wishing to affect human behavior and circumstances. (Such persons should not be confused with bona fide Vodou priests, who dedicate themselves solely to the spiritual health of their communities.) To the uninitiated observer, the Vodou significance of the hand shape in a mojo quilt is inscrutable.[10]

African-American quilts depict other latent designs, such as "voodoo dolls," which are variations on the theme of a Vodou amulet known as a *pakèts kongo*. Small protective pouches, *pakèts* are filled with *minkisi*, empowering elements such as seeds, bone, and soil. They are made of satin, beads, and feathers and are often configured with stemlike torsos and "arms" that cause them to resemble small dolls (fig. 2.4). Both dolls and *pakèts* can be traced to Kongo *nkondi*, or power figures, and have safeguard-

ing and healing powers (fig. 2.5). In the early history of the African diaspora, dolls and *pakèt*s were antedated by carved wooden figures called *bocio* (modified *nkondi*), which were noted as early as 1797 among the few possessions of the enslaved (fig. 2.6). The colonial chronicler of Hispaniola, Moreau de St.-Mery, described these figures as fetishistic "body guards" that held supernatural powers and controlled the wills of others.[11]

Over the centuries *bocios* were replaced by cloth-covered dolls, or *popés*, as they are called in the Vodou community (from the French word for dolls) (figs. 2.7, 2.8). In Haiti, New Orleans, New York, Miami, and other locations where Vodou is still practiced, dolls of this type are believed to embody the spirits, to protect their owners, and to bring good fortune. Dolls are integral to Vodou altar decoration, are placed as guardians in and around the home, and are used to entertain children. Doll making as a vocation represents yet another creative outlet and cultural continuum for African Americans. Therefore, it is hardly unusual to find doll imagery present in African-American quilts (note the doll figure, placed on its side with outstretched arms in the lower right quadrant of the Covington quilt, which also features a mojo hand at its center [fig. 2.3]). Nor is it surprising that doll making in Vodou society, like textile making in Africa, is not considered "women's work" but is practiced frequently by men.[12]

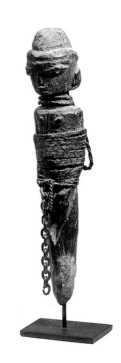

Figure 2.6

Fon male *bocio* figure, Benin, undated, twine, wood, metal, 10.8" high (27.5 cm)

UCLA Fowler Museum of Cultural History, FMCH X92.129.

Gift of Mrs. Shirley Black

Figure 2.7

Pierrot Barra

Doll/snake, 1993, plastic, fabric, synthetic hair, metallic ribbon, ribbon, length 20.86" (53 cm)

UCLA Fowler Museum of Cultural History.

FMCH X94.76.14

Figure 2.8

Altar for Ezili, 1993

created by mambo Madame Celanie Constant Nerva of Jacmel, Haiti

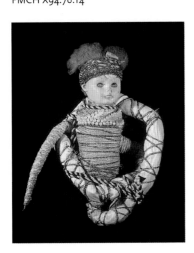

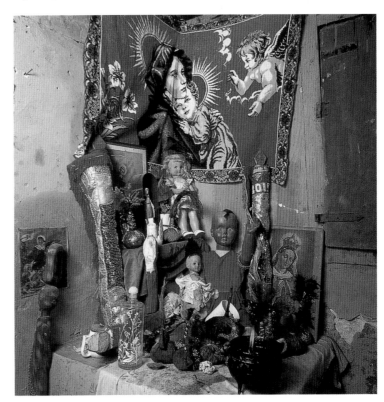

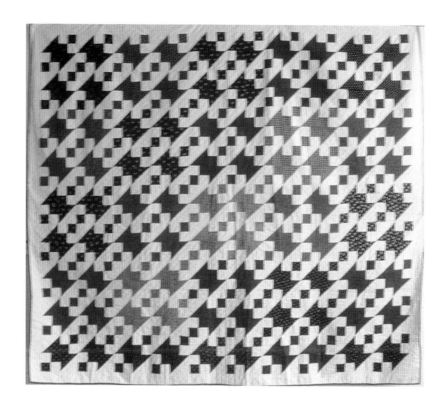

Figure 2.9

Jacob's Ladder quilt, c. 1890s

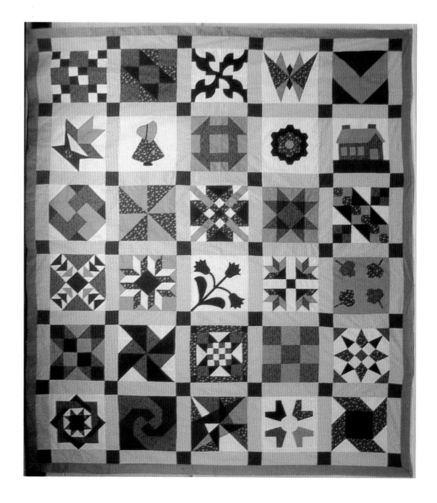

Figure 2.10

Daughters of Dorcas and Sons
of Washington, D.C.
Sampler quilt, 1987–1988

One of the most significant exponents of the African-American symbolic textile tradition is the Underground Railroad quilt which, according to some accounts, served as an encoded signpost for runaway slaves.[13] The Underground Railroad, in operation from the early nineteenth century until the Civil War, was an extensive system of secret locations where escaped slaves could hide, rest, and replenish their supplies on their way to freedom. Underground Railroad "stations" were situated at five- to twenty-five-mile intervals between the southern United States and Canada. Professedly, these locations were secretly identified by way of emblematic quilts that were hung on lines or fences outside of Underground Railroad safehouses (usually homes or barns). Some scholars have surmised from oral accounts that the Jacob's Ladder quilt motif (also known as the Underground Railroad pattern) was frequently used to designate to runaways that they had reached a safe haven (fig. 2.9).

The Jacob's Ladder design (a diagonal, geometric pattern) was only one of a series of coded emblems that provided escaped slaves with vital information. The Underground Railroad quilt code actually consisted of ten principal patterns, each of which represented a different phase in the escape process. Like ancient hieroglyphs, the code comprised reductive forms that could be read as clearly as any written language, if one only knew the meaning of each symbol. For more than a century, the code was presumably passed down from one generation of African Americans to another, and it represents an astounding example of the endurance of African oral culture in the United States. The quilt code was recently committed to print by historians Jacqueline Tobin and Raymond Dobard, based upon an oral account obtained from Ozella McDaniel, an elderly Charleston quilt maker, who learned the code from her grandmother. Though suppositions about the existence of an Underground Railroad quilt code have been hotly debated by scholars who question the validity and accuracy of such an oral history, others have argued that written histories are also susceptible to inaccuracies, and that it is unreasonable to expect that slaves (whose lives were on the line) or their immediate descendants (who often could not write) would have been willing or able to commit such a highly secret code to paper. In either case, there is no question that the code has entered popular memory and thus deserves study.[14]

McDaniel's ten-part code includes as its first two symbols the monkey wrench and the wagon wheel (fig. 2.10). These two visual codes instructed potential runaways to pack their wagons with the tools and supplies they would need for their journey north. The crest of the bear's paw advised runaways to follow bear tracks through the mountains to Canada (fig. 2.3). According to recent research conducted by the National Park Service, the

sign of the crossroads (four contiguous diamond shapes within a square) directed absconding slaves to travel to Cleveland, a major Underground Railroad depot. The log cabin emblem consists of stacked rectangular strips, placed at right angles to simulate a log pile or log cabin wall. The design often incorporated black or indigo fabric centers—a probable reference to the black slave. The use of dark center squares differentiates the Underground Railroad version of the log cabin quilt from others that have red centers (symbolizing the hearth), which were not a part of the Underground Railroad code. Some log cabin quilts had yellow centers, indicating a "light or beacon in the wilderness" (in other words, a safe-house).

A rare example of an early nineteenth-century log cabin quilt made by a family of fugitive slaves who settled in Canada has been preserved in the collection of the Buxton National Historic Site and Museum in Ontario (fig. 2.11). Dating to the early nineteenth century, the log cabin motif has been the subject of conflicting oral accounts. Some suggest that it was a visual directive to escaped slaves to establish homes safely away from slave-holding states. Other reports indicate that it either referred to an actual safe-house outside of Cleveland, or to encoded ground drawings of log cabins that marked the path north. The likelihood of the latter theory is supported by a long-standing tradition of African ground drawings that can be found in certain applications of Ejagham *nsibidi* and in sacred Vodou pic-

Figure 2.11

Log Cabin quilt made by descendants of fugitive slaves, c. 1840s

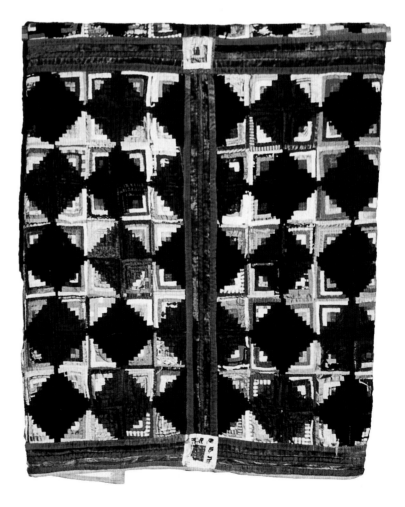

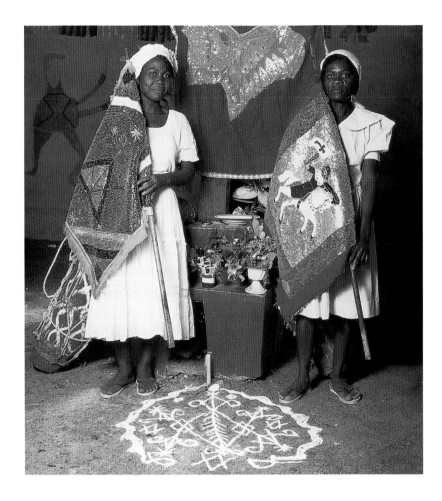

Figure 2.12

*Rose Anne and Andre Rose
Mercilien* (with drapo for Ogoun
Feraille and St. James), 1995

tographs known as *vèvès* (fig. 2.12), both of which have surfaced in nine-
teenth-century African-American quilts.[15]

The shoofly quilt symbol, a square with a triangle radiating from each
corner, is believed to be a Masonic code referring to the Prince Hall Order,
a black fraternal society that aided runaways along the Underground Rail-
road trail.[16] The quilt code continues with a bow tie pattern, which
instructed escaped persons to dress decorously, so as not to give away their
status as impoverished slaves (figs. 2.3, 2.10). The flying geese design (abut-
ting triangles that suggest winged flight) directed Railroad travelers to
migrate northward, like the birds of the same name (fig. 2.3), and the
drunkard's path emblem was an admonishment to fugitives to traverse in a
zigzag pattern, so as to elude bounty hunters (fig. 2.10). Finally, the star pat-
tern referenced the North Star as a beacon that led to safety in the northern
United States or Canada (figs. 2.3, 2.10). It is believed that a sampler quilt
incorporating all of the codes was used as a teaching tool, so that potential
runaways could memorize the symbols prior to their journey (fig. 2.10).

Precedents for the Underground Railroad quilt ciphers can be found in the encoded patterns of the Sierra Leone Poro Society and in the quilted horse armor of the Hausa of Nigeria, both of which resemble the bow tie motif; in Epke Society cloth (almost indistinguishable from the flying geese design); and in Egbo Secret Society five-pointed stars, thus establishing a further link between African-American and African textiles.[17]

While Underground Railroad quilt tops were produced using the piecing method, appliqué techniques were equally popular in the production of quilts, particularly from 1775 to 1875. Generally less decorative than Euro-American prototypes, African-American appliquéd quilts emphasized narrative content over ornamentation. They recorded political, historical, social, and religious events and ideas and, as such, were akin to many types of African textiles. For example, appliquéd Fon fabrics documented the activities of the royal family and decorated palace walls and royal umbrellas, banners, and costumes. Likewise, Ibibio funerary hangings, Kongo flags, and Fante standards from Nigeria and Ghana exhibited symbolic appliquéd figures and designs comparable to those found in the Americas.

The Vodou flag, or *drapo*, is one example of a modified African banner adapted by displaced Africans in Louisiana and Hispaniola. Influenced by European military insignia and British Masonic symbols (such as crossed compasses), Vodou banners were originally made of unadorned colored

Figure 2.13
Vodou Drapo of Dambalah Woedo, 31.5 x 32.3" (80 x 82 cm)
UCLA Fowler Museum of Cultural History, FMCH X94.2.2B

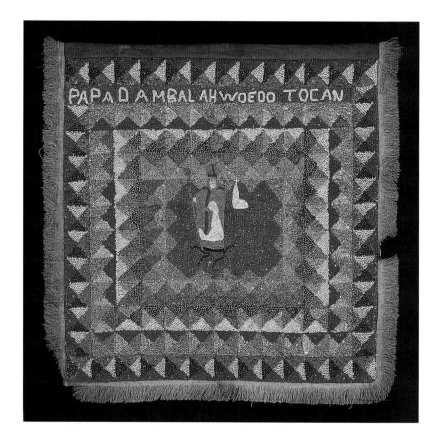

fabric, but have lately evolved into painstakingly handmade objets d'arts composed of satin, velvet, rayon, sequins, and bugle beads (fig. 2.12). The *drapos* depict figurative and diagrammatic *vèvès* (schematic drawings) of the *lwas*, or Vodou spirits, and are waved at the beginning of the Vodou ceremony to invite the *lwas* to join the celebration. Images are beaded or appliquéd onto the *drapo* and feature a combination of African and Christian icons—the latter of which were adopted by enslaved Vodou practitioners in order to camouflage forbidden African religious services. The cross sign, for example, while resembling a Christian crucifix, is actually a representation of the Vodun or Fon god Lisa, as well as the Vodou *lwa* Papa Gédé (also known as Baron Samedi and Baron La Croix). The serpent icon signifies the Fon god Dan, the Vodou *lwa* Dambalah, and appears in Vodou banners as St. Patrick driving the snakes from Ireland (fig. 2.13). Another image, the mounted knight, represents both St. James (St. Jacques), vanquisher of the Moors, and Ogoun, Vodou god of war (fig. 2.12).

Vodou renderings of the Virgin Mary with dark skin and a slashed or bloodied cheek symbolize Ezili Dantò, warrior spirit of mothers and protector of women (fig. 2.14). Her image derives from European black Madonnas, specifically Our Lady of Częstochowa, an icon housed since 1382 in the Jasna Gorà monastery in southern Poland (fig. 2.15). According to Polish legend, the cheek of the icon was slashed by Hussite warriors in

Figure 2.14
Libation Bottle for Ezili Dantò,
glass, fabric, sequins, cork,
faux pearls, metallic cord,
thread, 20 5/8" high (52.5 cm)
UCLA Fowler Museum
of Cultural History,
FMCH X94.76.19

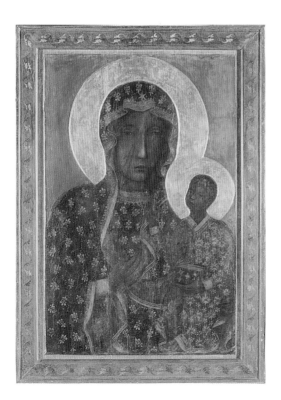

Figure 2.15
*Our Lady of Częstochowa
(Black Madonna)*
Byzantine icon, c. 1312,
paint on limewood

1430 and again by invading Swedes in 1655. Christened the "Queen of Peace" and "Queen of Poland" by King John Casimir in 1656, Our Lady of Częstochowa was carried into battle by Polish troops and is said to have bled from her defacements and caused the death of an enemy soldier.[18] Her patronage was especially relished by Polish soldiers who likely imported the icon to Haiti around 1800, during the Haitian revolution when an estimated 1,500 Polish troops defected from Napoleon's army to fight on the side of the Haitians.[19] Soon afterward, the Polish Madonna's Vodou counterpart, Ezili, became an especially popular *lwa*, and her *vèvè* (a heart shape) began to appear on banners, in doll form, in paintings, and on Vodou libation bottles (fig. 2.14).

Flag portrayals of the *lwas* are often accompanied by chevron, diamond, or lunette patterns that were borrowed from Napoleonic military standards (figs. 2.12, 2.13).[20] Similar geometric motifs appear in African-American and Euro-American quilts, as well as in Kongo Bakuba textiles. Vodou flags conflate a medley of influences and are, for this reason, quintessential exponents of African art in the diaspora. *Drapos* can be highly individualized creations and their makers, often Vodou *mambos* (priestesses), are masters of their craft. The concentrated effort required to complete a *drapo* is considered an offering of time and attention to the *lwas*, as well as an exercise in creativity that synthesizes life, art, and the spirit.

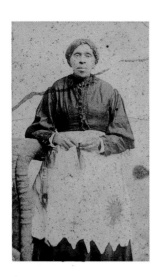

Figure 2.16

Photograph of Harriet Powers

(American, 1837–1911),

about 1900

2 3/16 x 1 1/4" (5.5 x 3.2 cm)

© 2003 Museum of Fine Arts, Boston

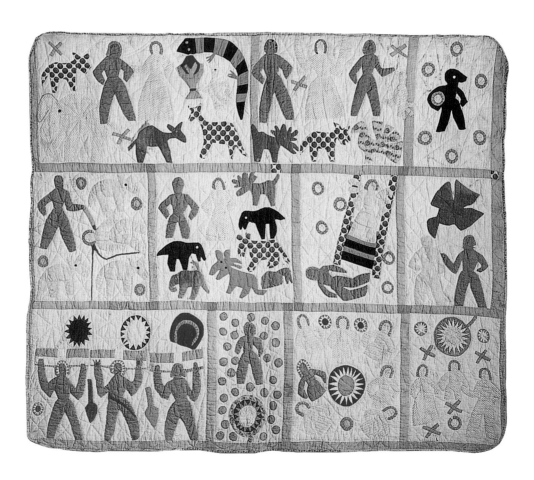

The appliqué textile method exploited in African and Vodou banners, with all its attendant symbolism, found its most celebrated advocate in quilt-maker **Harriet Powers** (1837–1911) (fig. 2.16). While the great majority of African-American quilters working prior to the twentieth century have remained anonymous, Powers is an important exception. Her quilts bear historic significance and provide us with unique insights into African-American quilting practices. Born a slave and native of Athens, Georgia, Powers is best known for her narrative, multiple-scene quilts, two of which are extant. Powers, who began quilting after Emancipation, first gained notoriety when a local schoolteacher, Oneita Virginia Smith, admired one of her quilts at the 1886 Athens Cotton Fair and purchased the quilt five years later.[21]

The theme of Powers's quilt is biblical and features eleven cotton segments of varying sizes, which form a lively asymmetrical composition (fig. 2.17). The quilt illustrates Adam and Eve in Eden (panels 1 and 2), Satan amid the stars (3), Cain slaying Abel and traveling to the land of Nod (4 and 5), Jacob descending the ladder (6), Christ's baptism and crucifixion (7 and 8), Judas receiving the thirty pieces of silver (9), the Last Supper (10), and the Nativity (11). Powers embellishes each scene with crescent, star, and sunburst motifs that reference astrological phenomena and Masonic emblems. These enhancements reappear in a subsequent Powers quilt (1895–1898) which was commissioned by the wives of Atlanta University professors (fig. 2.18).

The inclusion of Jacob's ladder in the earlier quilt and the profusion of Masonic forms in both textiles suggest two things—that Powers had knowledge of the Underground Railroad quilt code and that she may have been a member of a Masonic order that participated in Underground Railroad activity. Recent research indicates that both Powers and her husband, Armstead, very likely belonged to Masonic orders in Athens or Clarke County, Georgia. In the only existing photograph of Powers (fig. 2.16), she wears a ceremonial apron decorated with African-style serrated edges and with the same Masonic symbols (a moon or "dark sun," a cross, and a star or "bright sun") that one finds appliquéd to her quilts. The star emblem on Powers's apron has been identified as the symbol of the Eastern Star Lodge of women Masons.[22]

Powers's second quilt was exhibited at the Tennessee Centennial Exposition in Nashville and at the Cotton States and International expositions in Atlanta at the end of the 1890s. It is composed of fifteen calico squares of equal dimensions, and enlivened by alternating dark and light backgrounds. The biblical vignettes in the quilt depict Job praying, with crosses and a coffin (panel 1), Moses and the serpent (3), Adam and Eve tempted by

Figure 2.17

Harriet Powers

(American, 1837–1911)

Bible Quilt, c. 1885–1886

73 3/4 x 88 1/2"

(187.3 x 224.8 cm)

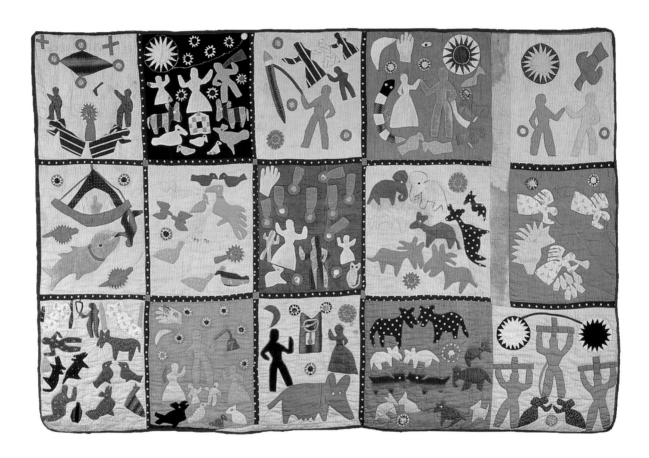

Figure 2.18
Harriet Powers
(American, 1837–1911)
Pictorial Quilt, United States
(Athens, Georgia), 1895–1898
pieced, appliquéd, and printed
cotton embroidered with plain
and metallic yarns, 68 7/8 x 105"
(175 x 266.7 cm)
© 2003 Museum of Fine Arts,
Boston

the serpent (4), John baptizing Christ (5), Jonah and the whale (6), God creating two of each animal (7, 9, and 14), a seven-headed beast and the angels of wrath blowing trumpets (10), and the Crucifixion, replete with eclipse (15). Other scenes represent local historical events, such as a representation of a hog that reportedly ran 500 miles from Georgia to Virginia (13).[23] This episode is accompanied by a parable of the godlessness of the wealthy. Other events pictured include the eclipse, or "Dark Day," of 19 May 1780, during which seven stars appeared in the noonday sky (2), the falling stars, or Leonid meteor storm, of 13 November 1833 (8), the "Cold Thursday" of 10 February 1895 (11), and the "Red Light Nights," or meteor showers, of August 1846 (12).

Powers's quilts are infused with her own distinctive brand of religious enthusiasm, which affords natural wonders the same importance as biblical histories. Wonders of nature, such as meteor showers, were viewed by nineteenth-century African Americans as apocalyptic events, and these incidents became a permanent part of the cultural memory, visually recorded by Powers. She clearly understood the value of her works as cultural documents, as demonstrated by the fact that she was reluctant for many years to part with her first Bible quilt. Only after financial stresses necessitated its sale did Powers relinquish the quilt to Smith, and even after its sale, she made several trips to Smith's home to "visit the darling off-spring of her brain."[24]

The complexity and formal arrangement of Powers's quilts also demonstrate an understanding of African and European aesthetics. Using a basic block construction common to quilts worldwide, Powers also employed running stitches and appliqués, common to both English and Fon designs. Powers's quilts also function as historical records in a manner similar to Yoruba, Fon, Ewe, and Fante textiles, which illustrated the major events of a king's reign, meteorological rarities, and important occurrences in the lives of ordinary citizens who commissioned commemorative textiles. Powers's treatment of ambiguous ground planes, streamlined forms, and certain figural motifs prefigure the "jazz" cutouts of French modernist Henri Matisse (fig. 2.19) and at the same time point directly to Fon and Kongo imagery. For example, the whale depicted in panel 6 of Powers's second quilt, which portrays the story of Jonah, displays a collar similar to those found in depictions of Benin rulers, such as Houegbadja (1645–1685) and Behanzin (active 1889–1896), both of whom are represented in royal textile narratives as fish adorned with regal collars. The configuration of standing birds in Powers's quilts duplicates the bird symbol for the Fon king Kpengla (1774–1789), and Powers's horned animals also have analogues in Fon designs.[25]

Figure 2.19
Henri Matisse (1869–1954)
Icarus, from *Jazz* series
(each double sheet
16 5/8 x 25 5/8"
[42.2 x 65.1 cm])

The numerous affinities between West African textiles and Powers's quilts have prompted scholars to conclude that she likely had firsthand knowledge of Benin fabrics. Despite the 1808 congressional ban on international slave trading, Africans from Dahomey (the Republic of Benin) were still being smuggled into Georgia during Powers's youth. She might easily have learned from them the art of the Fon template—a cloth or paper cutout used to duplicate figures for appliquéd textiles. Enslaved Fon could readily have reproduced the templates from memory, since their shapes were rigidly copied and passed down from one generation to the next without alteration.[26] Powers's fusion of disparate elements—personal, aesthetic, and cultural—distinguishes her as a uniquely creative fabric artist, whose works draw from the African and the European genealogies of her African-American heritage.

In addition to quilt making and textile design, enslaved women worked as couturiers and seamstresses, playing an essential role in the American fashion industry (fig. 2.20). Many enslaved women designed and produced all manner of attire (from elaborate ball gowns to simple garments) for the clientele of slave owners, who were able to operate profitable design houses as a result. Free African-American women also engaged in dressmaking, an occupation which they embraced in large numbers. In fact, by 1860, 15 percent of all free women of color participated in the dressmaking profession.

Figure 2.20
Blue and Gray Striped Dress
made by anonymous slaves in the nineteenth century
rendering by Joseph L. Boyd for the WPA, c. 1937
watercolor and graphite on paper, 16 15/16 x 12"
(43.1 x 30.5 cm)

A number of these talented, business-minded women founded their own clothing design and manufacturing companies, thriving especially in fashionable cities such as Richmond, New Orleans, and Louisville.[27]

Slave-born **Lucy McWorter** (1771–1870) obtained her freedom in 1817 and manufactured woven and knitted fabrics and garments in Kentucky and Illinois. McWorter amassed enough of a fortune to buy (with the assistance of her entrepreneur husband, Frank) freedom for some sixteen of her family members. At the end of the nineteenth century, **Fanny Criss** (c.1866–1947) founded a dress-designing business in Richmond, Virginia, that catered to wealthy whites. South Carolina native **Mamie Garvin** (active nineteenth–twentieth centuries) created "designer" dresses based on illustrations she saw in *Vogue* and *Harper's Bazaar*. While visiting Boston during the summer of 1913, Garvin collaborated with two other women, turning their apartment into a makeshift factory where they produced inexpensive copies of the latest styles for local customers.[28]

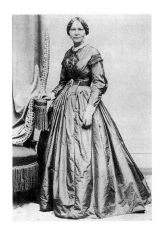

Figure 2.21

Photograph of Elizabeth Keckley, c. 1860s

The best-known African-American woman clothier was **Elizabeth Hobbs Keckley** (1818–1907) (fig. 2.21). Keckley was born in Virginia to enslaved parents and sold as a young girl to a North Carolina slave owner, by whom she bore a son. After giving birth, Keckley was repurchased by her original owners, the Burwell family, and taken to St. Louis by one of their daughters, Anne Burwell Garland. Keckley had acquired expertise as a seamstress and a quilt maker from her mother; she excelled in appliqué, embroidery, and piecing techniques. Once in St. Louis, she put her skills to profitable use as a "slave entrepreneur," meaning that she managed her own business but was obliged to give the lion's share of her profits to her owner. Keckley's business flourished. Her acumen as a designer and businesswoman was so highly regarded that several of her St. Louis clients arranged to lend her $1,200 so that she might purchase freedom for herself and her son. Keckley did so in November 1855 and within five years had paid off her loan. She moved her business to Baltimore and then to Washington, D.C., where she acquired an aristocratic coterie of clients, including Mrs. Jefferson (Varina Howell) Davis and First Lady Mary Todd Lincoln. Keckley's sumptuous creation of velvet and lace accented with contrasting piping was designed for Mrs. Lincoln and is held in the collection of the Smithsonian Institution. It attests to Keckley's remarkable talents and design expertise (fig. 2.22).[29]

Figure 2.22

Elizabeth Keckley

Gown designed for First Lady

Mary Todd Lincoln, c. 1863

Mrs. Lincoln was drawn to Keckley for her gentleness, intelligence, and even-tempered personality as much as for her fashion expertise. Keckley soon became the First Lady's personal dress designer, confidante, and traveling companion. After President Lincoln's assassination in 1865, Keckley helped Mrs. Lincoln alleviate some of her financial difficulties by arranging an auction in New York of the First Lady's White House wardrobe. The two remained close friends for several years, until the publication in 1868 of Keckley's memoirs, *Behind the Scenes; or, Thirty Years a Slave and Four Years in the White House*, which exposed Lincoln family indiscretions and confidences, including Mrs. Lincoln's sometimes harsh personal opinions of Washington dignitaries and society personalities. *Behind the Scenes* damaged Keckley's reputation and ultimately led to the decline of her thriving fashion business. Despite these trials, however, Keckley lived a long, if less prosperous, life. She held the position of director of domestic art at Wilberforce University in Ohio and won accolades from the *New York Times* for samples of her students' needlework exhibited at the 1893 World's Columbian Exposition.[30]

While the great majority of pioneer African-American women artists were compelled to work within one fabric tradition or another, others found an outlet in the related field of basket weaving. Portable, functional, and requiring minimal material resources, baskets were ideal objects for creative self-expression. Unlike quilting, African-American basket-making techniques emanated almost exclusively from Africa, where similar methods were utilized throughout the Guinea Coast. The earliest African-American baskets were made in South Carolina between 1690 and 1730 and were used as agricultural tools to winnow rice, store foodstuffs, and carry supplies. Basket types varied from rice "fanners" (two feet in diameter at the base with shallow sloped edges) to storage baskets with high walls that came in a variety of sizes. The quintessential type of African-American basket is the coiled sweetgrass basket (fig. 2.23).[31]

Coiled baskets are native to Louisiana, Alabama, Tennessee, and Mississippi, but the areas best known for coil basketry are the South Carolina and Georgia Sea Islands, where African cultural retentions are strongest. Africans made up some 70 percent of the population of the Sea Islands by 1790, and the illegal slave trade continued to bring African artisans to the area until 1854. Consequently, Sea Island, or Gullah (a creolization of "Angola"—the birthplace of one- to

Figure 2.23

Sweetgrass Coiled Basket

South Carolina, mid-nineteenth century

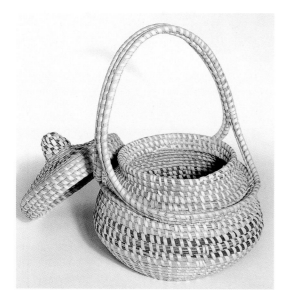

two-thirds of the Sea Island Africans), baskets are hardly distinguishable from Senegambian baskets made in West Africa. Both integrate distinctive geometric or striped patterning, contrasting light and dark colors, and coil construction. Sea Island artisans used local marsh fibers, or sweetgrass, for the bodies of the baskets, split palmetto leaves for binding, and pine needles to create decorative bands. A more rigid rush fiber, bound with palmetto butt or white oak, was used for sturdier baskets such as fanners, which had to last through many seasons of field use. Using only local materials and natural fibers, Gullah weavers made some of the most unique objects of their type in the United States.[32]

In addition to baskets and textiles, African-American women engaged in unique forms of "outdoor art," including the decoration of gardens. Art historians have long acknowledged the importance of gardens as vehicles for cultural and personal articulation, ranging from the hanging gardens of Babylonia and the elaborate gardens of ancient Egypt, Greece, and Rome to the classically inspired gardens of the Palace of Versailles and the Japanese-inspired gardens of French impressionist Claude Monet. Yet, despite the history and cultural importance of landscape design, African-American garden traditions are virtually unknown. Few descriptions of slave gardens exist, since antebellum travelers rarely took note of them. Due to the ephemeral nature of these gardens, most of what is known about their appearance has been gleaned from historical literature and from the oral accounts of ex-slaves recorded by the Works Progress Administration of the federal government in the 1930s and 1940s.[33]

Modern reconstructions of slave gardens point to their varying sizes, which ranged from a "scrap" of ground to as much as a half acre. Also evident are unregulated, curving perimeters and an integration of cooking and work areas, privies, animal pens, and tracts for vegetables, flowers, and shrubs (fig. 2.24). Slave gardens likely appeared inelegant to white

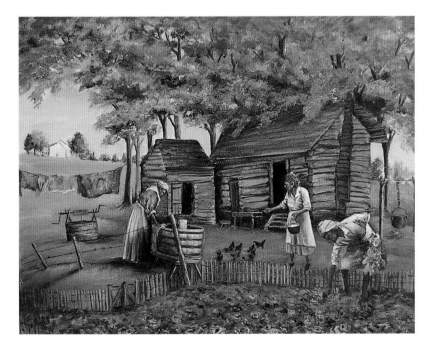

Figure 2.24
Belin Berisaj
Field: Slave Yard, 2003
oil on canvas, 26 1/2 x 32 1/2"
(67.31 x 82.55 cm)

observers, due to their informal arrangement, deemphasis on flowers, and inclusion of objects such as bottles, dolls, bricks, and fieldstones. These items were salvaged from plantation refuse and were often the only decorative materials available to enslaved persons. The limited access slaves had to flower seeds and decorative shrubs and the need for vegetables and livestock to supplement the diet and to sell or barter resulted in a landscape design that was particular to the enslaved gardener. Despite their untutored appearance, however, slave gardens were thoughtfully decorated and sometimes edged with glass jars that substituted for costly fencing, which slaves could not afford. This tradition continues today in southern African-American gardens, where passersby find all nature of containers, from snuff jars to soda bottles, lining garden walkways and perimeters.[34]

Not surprisingly, slave gardens shared characteristics with African ones. Both incorporated swept dirt areas rather than grass. Swept gardens have long been a standard feature of the southern United States, despite the fact that perennial rain causes dirt surfaces to become muddy and difficult to navigate. Since the climate of the South is not especially conducive to swept yards, scholars have surmised that this practice was transplanted from certain locales in West Africa, where the weather is drier and the arid season longer (particularly Angola and inland Nigeria). Swept yards are also found in damper African climes, such as that of Ghana, suggesting that there exists a preference in African culture for minimalist gardens that feature only a few ornamental trees and shrubs. Gardens of this type were (and still are) familiar sights in the Sea Islands and in Alabama.[35]

A related form of landscape design is the African-American burial site, which for centuries has been "the realm of art as well as the resting place for the departed."[36] The memoirs of an antebellum observer, Mrs. Telfair Hodgson, date African-American funerary precincts to the early nineteenth century. Recent archaeological discoveries, such as the African burial ground in New York City, date these interment locales to the eighteenth century and earlier, and link them to African customs. Prototypes can be traced to Nigeria, Ghana, Gabon, and the Kongo where, according to the nineteenth-century accounts of European travelers, African graves were adorned with crockery, bottles, old cooking pots, and numerous other items such as gourds, clothing, and wooden chests. In America, Africans embellished their cemeteries with similar articles. Ceramic cups, pitchers, saucers, bowls, and flower pots were deliberately broken and placed upon sepulchral mounds to connote the breaking of the life cycle. These items might also be pierced with holes, allowing the spirit to pass back into the material world and to commune with a living family member who touched the punctured vessels. Conversely, inverted bottles were embedded in the

dirt covering the grave in order to forestall contact by enclosing or containing the spirit. Other sundry adornments included clocks (indicative of the time of death or the ending of life's "time"), spoons, medicine bottles, toys, dolls, knives, cans, and even false teeth (fig. 2.25).[37]

African-American funereal decoration, despite its random appearance, results from the deliberate and inspired selection and arrangement of devotional objects. This sacred and creative practice is predicated on the idea that deceased spirits walk the earth and affect (for good or ill) the destinies of the living. This notion necessitated the meticulous care and tending of funerary districts. The articles used to adorn them were frequently the actual belongings of the dead, who wished to have their earthly possessions close at hand so that they could attend to their very human needs to play, eat, or groom themselves after death. If contented, they were thought to remain in the realm of the dead and refrain from disturbing the living. The mindful arrangement of proprietary objects upon the grave mound honored the memories of the departed and encouraged their entry into the next world.[38]

The metaphysical import of African-American funerary landscapes was especially profound during the colonial era when death represented an escape from the nightmare of slavery and a passageway back to Africa. Indeed, certain enslaved Africans (specifically, practitioners of Vodou) referred to the spirit world as "Ginen," after their lost home of Guinea, considered both the birth and the resting place of their forebears. Ginen, a proverbial Valhalla or garden of Eden irretrievably lost during the slave

Figure 2.25
Grave of Hackless Jenkins (1878–1928), Sea Islands, Ga., decorated with clocks, glassware, and other objects

trade, was believed to be a watery realm that separated life from death, just as the Atlantic Ocean separated enslaved populations from their emancipated existence in Africa. An allusion to Ginen is apparent in the preference for white objects as grave decorations (particularly porcelain, enamel, stone, plaster, and blanched seashells), which acknowledge the Kongo-inspired belief that dead spirits, known as *bakulu*, become ghostly white after relocating to their subaquatic domain. Grave ornaments such as cups, bowls, vases, and pots were intentionally chosen because of their ability to hold water. Mirrors, too, were a common burial decoration because they had reflective surfaces similar to those of lakes, rivers, and seas. A number of burial mounds were decorated with shells, symbolizing the sea and forming a barrier between the earthly world of the living and the watery refuge of the dead.[39]

As recently as the 1990s, African-American graves have been discovered in South Carolina, Georgia, and other southern states that confirm the long-standing nature of this mortuary tradition. Its practice was sustained primarily by women. The comments of several Georgia women, interviewed in 1926 and in 1940, attest to their efforts as custodians of the dead and to their cognizance of the gravity of their responsibilities: "I don't guess you['ll] be bothered much by the spirits if you give [th]em a good funeral and put the things [t]hat belong to [th]em on top of the grave," explained Sarah Washington of Eulonia. Jane Lewis of Darien echoed these same sentiments, emphasizing the practical needs of the spirits and their physical proximity to the living: "We take what victuals [are] left and put it in a dish by the chimley [*sic*] and that's for the spirit to have a last good meal. We cover up the dish and there's many a time [when] I['ve] hear[d] the spirit lift [it]." Finally, Rosa Sallins of Harris Neck described some of the merits of placing shattered materials on the grave mound: "You break the dishes so that the chain will be broke[n]. You see . . . if you don't break the things, then . . . others in the family will die too. They will follow right along."[40]

Like gardens, the appearance of African-American cemeteries is informal. Rather than orderly rows of headstones, objects are strewn in an apparently haphazard manner across the earthen mounds. Graveyard configurations of this type have caused many an onlooker to mistake these sacred places for junk heaps or scatterings of, in the words of one anthropologist, "late period garbage."[41] Looks, in the case of these hallowed sites, are undeniably deceiving. Novelist William Faulkner, who was raised in Mississippi, understood the significance of these funerary landscapes better than many an anthropologist when he wrote, "The grave, save for its rawness, resembled any other marked off without order about the barren plot by shards of pottery and broken bottles and old brick and other objects

insignificant to sight but actually of a profound meaning and fatal to touch, which no white man could have read."[42] The danger to outsiders of disturbing mortuary art, as described by Faulkner, is consistent with similar taboos in West Africa, and the persistence of the African-American necropolis into the twentieth century is further testament to the tenacity of African culture in the diaspora.

The early forays of antebellum African-American women into the realm of art engendered in them a sense of self-determination and self-worth in a world that had all but vanquished their ability to control their own destinies. Their skills and talents likewise provided their daughters with avenues into the marketplace and with the will and ability to succeed as artists. Furthermore, their endeavors formed a link between the decorative arts practices of the past and the fine arts pursuits of the future.

By the mid-nineteenth century, as slavery ended, African-American women artists faced a whole new set of impediments. These included escalating bigotry, economic hardship, and the reconciliation of their racial status with their new roles as "free" American women who suffered the same gender typecasting and aspired to many of the same feminine ideals as their Euro-American sisters. No longer of worth to slave owners, the art produced by women of color after slavery was often devalued and, as a result, much of it was irretrievably lost. As art historian Tritobia Benjamin observed, each object that survived "represents hundreds of pieces that have been lost. Art that is not valued by the mainstream culture is not saved. Art that is not recognized is not safeguarded."[1] Fortunately, contemporary scholars have made great strides in rebuilding this obscured legacy, and two women who have come to light as a result are **Sarah Mapps Douglass** (1806–1882) and **Annie E. Anderson Walker** (1855–1929).

Douglass has the distinction of being known as the earliest documented African-American woman painter. She was active both before and after Emancipation as an abolitionist, artist, and teacher who founded a school for African-American children in Philadelphia in the mid-1820s. She followed in the footsteps of her grandfather Cyrus Bustill who, in the 1700s, had established one of the first black schools in the city. By 1850, Douglass's own institution was deemed the most successful of its kind in the area, with higher enrollment than any other private school in Philadelphia's black community. In 1853, Douglass was appointed to the administration of the Institute for Colored Youth, a philanthropic organization founded by the Quakers, and she held this position until she was nearly seventy years old.[2]

In addition to being a successful educator, Douglass was also a gifted painter. Her command of the medium can be seen in an 1836–1837 watercolor of a rose, which she painted in the "album" of a student, Elizabeth

Figure 3.1
Sarah Mapps Douglass
The Rose, 1836–1837
watercolor, 3 3/4 x 2 3/4"
(9.52 x 7 cm)

T H R E E **The Nineteenth-Century Professional Vanguard**

Smith (fig. 3.1). Albums, or scrapbooks, were customarily maintained by pupils as a verbal and visual personal record of their educational observations and insights.[3] In Smith's album, Douglass inscribed beneath her painted rose, "Lady, while you are young and beautiful, 'Forget not' the slave, so shall 'Heart's Ease' ever attend you."[4] While revealing Douglass's outlook as a teacher of life lessons, her words also constitute a clever horticultural pun on the "forget-me-not," or flower of faithfulness and friendship, and on the "heart's ease," or pansy, both of which are depicted in the Douglass study. The painting itself is a masterful blend of meticulous observation, fluid brushwork, a highly developed sense of color, and an eye for well-balanced composition.

An 1843 pencil drawing of an urn and flowers, also etched in a student notebook, further reveals Douglass's interest in precise rendering and symmetry, as well as in academic still lifes (fig. 3.2). The well-ordered composition is finely detailed, particularly the flora, and it attests to Douglass's fascination with and comprehensive knowledge of horticulture. This interest is reconfirmed in another student album, that of Mary Anne Dickerson, which contains a sketch of fuchsia, paired with a lengthy and informative essay about the plant.[5] As gifts, these sketches are convincing evidence of Douglass's generosity of spirit and dedication to improving the cultural lives of young African-American women.

An entrepreneur as well as an artist and teacher, Douglass advertised her skills in local newspapers as early as the 1840s. She shared advertising space with her brother Robert, who created and sold textile designs in his art shop on Arch Street, where the Douglass family lived. The Douglass family had more than its share of creative talent. Apart from her brother's work, Douglass's mother was a milliner with her own workshop in the Arch Street building. Douglass herself had a creative repertoire beyond botanical sketches, including patchwork quilt designs which she offered for sale. Her aesthetic output, however, appears to have been circumscribed by her teaching—one of the few professions open to nineteenth-century women.

Figure 3.2
Sarah Mapps Douglass
Vase of Flowers, 1843
pencil, 4 x 2 3/4" (10.1 x 7 cm)

A native of Brooklyn, New York, portraitist Annie E. Anderson Walker was also an educator. She taught in Florida and Alabama in the 1870s and, after marrying Selma lawyer Thomas Walker, relocated to Washington, D.C. In 1890, Walker began to study drawing and painting under private tutelage, and she soon submitted her portfolio for admission to the Corcoran Gallery, which offered art instruction to gifted pupils. When she appeared at the Corcoran to take her first classes, her enrollment was rescinded because school administrators had not realized that she was African American. To Walker's consternation, she was informed by an admissions officer that "the trustees have directed me not to admit colored people. If we had known you were colored, the committee would not have examined your work."[6] Abolitionist Frederick Douglass, with whom Walker was acquainted, intervened on her behalf and wrote an impassioned letter to the Corcoran Gallery requesting that they "reconsider this exclusion and admit Mrs. Walker . . . and thus remove a hardship, and redress a grievous wrong imposed upon a person guilty of no crime, and . . . in every way qualified to compete with others in the refining and ennobling study of art."[7] Despite his position as one of the most influential African Americans of his day, he could not sway the Corcoran administration. Instead, Walker enrolled without incident at Cooper Union in New York City, where she completed her degree in 1895.

Walker's next move was to Paris, where scores of American artists ventured to enhance their reputations, immerse themselves in the great French art collections, and receive "continental" art instruction. There, Walker studied at the famed Académie Julien, a private academy where Americans abroad routinely enrolled (since foreign students were not admitted to the more prestigious Académie des Beaux Arts unless they presented the "proper credentials" and "passed a stiff examination").[8] At Julien's, Walker was able to hone her skills and receive weekly criticism from established academic masters who made the rounds to the school's various *ateliers*. Soon after enrolling at Julien's, Walker achieved the honor of being chosen to exhibit her work in the 1896 Paris Salon, the annual juried show of the French Academy. She showed a pastel drawing entitled *La Parisienne* (fig. 3.3), which reveals her facility with modeling and her ability to communicate through color and line the essence of her sitter.[9]

La Parisienne depicts a woman in near-profile, clad in somber late-Victorian attire against a muted grey background. Despite Walker's use of a subdued palette, she has rendered the delicate textures of fur, feather, velvet, and hair with authenticity, using light rather than color. Walker's facile manipulation of light in *La Parisienne* is reminiscent of American impressionist John Henry Twachtman, and her attention to naturalistic details

brings to mind the work of American realist Thomas Eakins, both of whom gave lectures and instruction at Cooper Union during Walker's education there.[10] Perched above the snug, high collar of the dark violet dress that she wears, the enigmatic face of *La Parisienne* compels our attention. In selecting the work for exhibition, the Paris Salon jury might well have been captivated by the dark, delicate arch of the sitter's brow, raised almost imperceptibly, and her keenly intelligent expression. Bereft of the conventional feminine prettiness ordinarily associated with academic portrayals of the "gentler sex," *La Parisienne* is all the more compelling for its directness and for its presentation of an image of unconventional womanhood.

Walker spent a second year abroad during her Grand Tour visiting Switzerland, England, and Italy. At the end of 1896, she returned home to Washington, D.C., to her duties as a teacher and wife. For a brief time, Walker continued to study and execute works similar to *La Parisienne* but, as was the case with Douglass, her professional career as an artist was never realized. Two years after her return from Europe, Walker suffered a nervous breakdown and never again engaged in artistic pursuits, remaining a homebound invalid until her death in 1929.[11]

While the careers of Douglass and Walker may have been forestalled, several African-American women did achieve professional artistic status during this period. One such artist was **Mary Edmonia Lewis** (c. 1843–c. 1911), who was introduced to the fine arts while studying at Oberlin College in Ohio, the first interracial and coeducational college in the United States. Founded in 1833 by Protestant evangelists who believed fervently in human rights, within two decades one-third of its students were African American. Lewis enrolled at Oberlin in 1859, the same year that abolitionist John Brown launched his raid on the federal arsenal at Harpers Ferry. In fact, two of Lewis's classmates (Lewis Sheridan Leary and John A. Copeland) were members of Brown's doomed rebel force. When Brown—a white farmer who worked on the Underground Railroad and waged a bloody self-styled war against slavery—was caught and brought to trial for murder, his arrest created a national sensation and stirred up tremendous support for emancipation. Members of the Oberlin faculty formally protested his hanging, which was nonetheless carried

Figure 3.3
Annie E. A Walker
La Parisienne, 1896
pastel on paper, 25 1/2 x 19 3/4"
(64.8 x 50 cm)

Figure 3.4

Edmonia Lewis

Urania, 1862

pencil on paper, 14 1/4 x 12"

(16.2 x 30.5 cm)

out in December 1859. Brown's exploits so impressed Lewis that some of her first drawings included likenesses of the dead hero.[12]

The daughter of a woman of Chippewa (Ojibwa) descent and a free Afro-Caribbean father, whom she described as a "gentleman's servant," Lewis was orphaned as a toddler and raised, until the age of twelve, by her mother's family, who purportedly gave her the Chippewa name "Wildfire." (Historians have surmised, however, that the name was likely created by Lewis later in life to intrigue her enthusiasts.) While living with the Chippewa, Lewis learned traditional crafts, such as basket weaving and the embroidering of moccasins to be sold at market. At age fifteen, she left the Chippewa to study at Oberlin, financed by her stepbrother Samuel ("Sunrise"), a gold prospector who supported Lewis throughout her career.[13] At Oberlin, Lewis's curriculum and activities were supervised by a college trustee, the Reverend John Keep. Lewis received a well-rounded education, studying English composition, rhetoric, botany, algebra, theology, Greek, French, Latin, and zoology. Her interest in fine arts was sparked in early September 1862, during an elective drawing course. In class, Lewis created her first rendering of a neoclassical sculpture, a genre that would ultimately become her signature style (fig. 3.4).

Before her artistic interests had a chance to blossom, Lewis's life was turned upside down by an episode that was indicative of the racial volatility of the period. Two of her white roommates, after suffering severe stomach cramps upon their return from a sleigh ride, accused Lewis of poisoning them. Lewis's ensuing trial for attempted murder became a local cause célèbre. Based on a perfunctory physical exam, the roommates' conditions were diagnosed as cantharides, or "Spanish Fly," poisoning. The girls declared that Lewis must have secretly served them the aphrodisiac in some spiced wine they had shared before the outing. Their accusations resulted in Lewis's dismissal from school and her arrest. Reverend and Mrs. Keep came to her aid, securing Oberlin graduate John Mercer Langston (later, dean of the Howard University Law School and the first African-American congressman) as her counsel.[14] For their efforts, the Keeps found themselves at odds with the town's less-tolerant element, who were "impatient to see Edmonia punished" and who promised, "If Oberlin authorities could not handle their colored folk, others would."[15]

Local reactionaries soon made good their threats, abducting the eighteen-year-old Lewis prior to her trial, brutally beating her, and leaving her for dead. No one was ever arrested for the kidnapping and, after a period of recovery, Lewis was brought to trial. During the proceedings, Langston argued decisively that there was neither the prerequisite medical nor circumstantial evidence to convict his client, and in the end, Lewis was found innocent. Despite her acquittal, the young woman was regarded with suspicion by students and faculty. She became the campus scapegoat and was twice accused of stealing art supplies during subsequent semesters. Though exonerated each time, she was ultimately prevented from graduating when the head of the Oberlin Ladies' Department, Marianne Dascomb, refused to allow Lewis to enroll for her last semester.[16]

Dismissed from Oberlin, Lewis moved to Boston in 1863. She arrived armed with a letter of introduction from William Lloyd Garrison, the influential abolitionist and publisher, whom Lewis likely met through Reverend Keep. In Boston, Lewis decided to test her creative talents by apprenticing with neoclassical sculptor Edward-Augustus Brackett, whose bust of John Brown had impressed Lewis. Brackett provided the aspiring artist with sculpting tools and invaluable training. Lewis quickly became adept in the neoclassical genre practiced by Brackett, a style marked by stoic severity of expression and classical Greek forms. Within a year of arriving in Boston, she opened her own studio.[17]

One of Lewis's early works was a bust of Colonel Robert Gould Shaw, leader of the ill-fated black Massachusetts 54th Infantry (fig. 3.5). Shaw died in battle in 1863 along with nearly half of his troops shortly after Lewis witnessed him and his men marching south from Boston. Lewis's bust of Shaw, conceived in the wake of his heroic death, sold nearly one hundred copies and brought her to the attention of the sculptor Harriet Hosmer, who encouraged her to travel to Italy to further her art education. With profits earned from the sale of replicas of the Shaw bust, as well as from medallions of John Brown, Lewis traveled to France and Italy in August 1865. She especially enjoyed the latter country's rich history and culture, preferring its cosmopolitan milieu where, in her words, she "was not constantly reminded of [her] color." For Lewis, Italy stood in sharp contrast to the United States, which she believed "had no room for a colored sculptor."[18]

Figure 3.5
Edmonia Lewis
Colonel Robert Gould Shaw,
1866–1867
marble after original plaster cast
of 1864, approx. life-sized

Figure 3.6

Edmonia Lewis

Forever Free (Morning of Liberty), 1867–1868

marble, 41 1/4" high (104.8 cm)

Lewis became a lifelong expatriate and settled in Italy permanently.[19]

While living in Florence in the mid-1860s, Lewis took Hosmer's advice and expanded her knowledge of the neoclassical style. There she became acquainted with two esteemed American neoclassical sculptors, Hiram Powers and Thomas Ball. She also familiarized herself with the city's antiquities before relocating to Rome to take advantage of potential American art buyers who visited the city on the Grand Tour. In Rome, Lewis shared a residence with a group of expatriate American artists, described by writer Henry James as the "marmorean [marble] flock . . . a sisterhood of . . . American lady sculptors."[20] In Rome, Lewis was warmly greeted by Hosmer, the leading member of the "flock," and with her aid obtained studio space in the home of a cross-dressing American actress, Charlotte S. Cushman. Cushman, an astute businesswoman who helped to support the professional endeavors of her female friends, took Lewis under her wing during her first years in Rome, marketing the young artist as a self-taught naïf and exotic. Soon, Americans abroad were flocking to Cushman's atelier to get a glimpse of the "marvelous untaught maiden."[21]

During her first years in Rome, Lewis produced one of her best-known works, *Forever Free* (1867–1868), which celebrates the Emancipation (fig. 3.6). The work's subject reveals the extent to which Lewis remained connected to the political struggles of African Americans. Her self-proclaimed desire in creating the piece was to help her "father's people."[22] To that end, Lewis sculpted two African-American figures—one a standing man and the other a kneeling female. With their recently broken chains, the pair conveys both classical heroism and nonclassical subjectivity, intensified by their dramatic poses, upturned faces, and joyous expressions.

Unlike the female figure, who is bereft of any definitive ethnic features, the male is endowed with a crop of thick curly hair, marking him as a person of African descent. This was rare in neoclassical sculpture, which tended to favor Roman models in terms of their physical characteristics. Lewis's hero stands in *contrapposto* with one knee bent and one hand raised—an homage to classical orator sculptures and a departure from conventional images of supplicant slaves. Compare, for example, Lewis's

Forever Free with Thomas Ball's *Emancipation* (1876), in which a black slave kneels before the standing figure of Abraham Lincoln, as if receiving benediction (fig. 3.7). Ball's depiction of the submissive "ideal slave," while praised by white observers, was seen by African Americans as a hackneyed representation of subservience and a reminder of the president's own racial ambivalence. In fact, at the unveiling of Ball's sculpture in Washington, D.C., Frederick Douglass reminded a mostly white audience that, despite Lincoln's stance on abolition, he had initially favored the return of runaways to their owners and, prior to secession, had given little if any special consideration to African Americans, treating them, in Douglass's words, as "step-children . . . children by force of circumstances and necessity."[23]

Unlike the slave in Ball's *Emancipation*, Lewis's male figure appears to have broken his own chains, and his raised fist, upright posture, and forthright demeanor indicate his strength and independence. The female figure, derived from an abolitionist medallion designed by British ceramicist Josiah Wedgewood, kneels, clearly suggesting her subordinate status. To Lewis's credit, she has rendered the woman fully clothed, unlike most characterizations of slave women, which emphasized their sexual availability through nudity or seminudity. Also worthy of note is the neoclassical idealism and Victorian piety with which Lewis has infused the figure—traits seldom associated with images of black women. Finally, Lewis's decision to even include a female figure in the composition indicates the importance to the artist of enfranchisement for women, still excluded from the civil rights that had been recently acquired by African-American men.[24]

Exhibited in Boston soon after its completion, *Forever Free* was lauded by critics for its innovative coupling of neoclassical austerity and Romantic intensity: "Who threw so much emotion into those figures? What well-known sculptor arranged with such artistic grace those speaking forms? Will anyone believe it was the small hands of a small girl that wrought the marble and kindled the life within it? A girl of dusky hue, mixed Indian and African."[25] These comments, made by Elizabeth Peabody, editor of the *Christian Register*, indicate the extent to which Lewis's allure was enhanced by her unusual background, which the artist exploited, drawing patrons, curiosity seekers, and critical interest. Lewis quickly established herself as a fascinating and

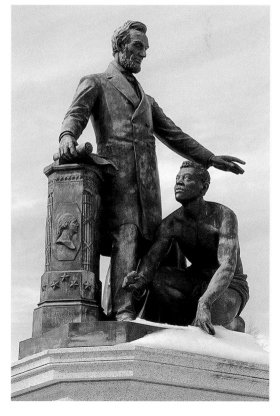

Figure 3.7
Thomas Ball
Emancipation Monument
(Freedmen's Memorial
Monument to Abraham
Lincoln), 1876
bronze, approx. 108 1/4" high
(275 cm)

Figure 3.8

Edmonia Lewis

Awake, 1871–1872

marble, 26 1/2" high (64.8 cm)

enigmatic artist of astounding abilities—astounding particularly to those who could not imagine a black genius. Well aware of the complex reasons for her popularity, Lewis deliberately played the naïf for the benefit of her more ingenuous admirers.[26]

Americans abroad clamored to meet Lewis and visit her Rome studio. Doubtful that a woman of African descent was capable of creating monumental stone sculptures, they required proof of her abilities and demanded to see Lewis at work, wielding mallet and chisel with her own hands. Ironically, most neoclassical sculptors did not engage in direct stone carving. Sculptors such as Ball and Powers preferred to contract professional stone carvers to translate their clay models into marble. But, in order to quell rumors that she was a hoax, Lewis welcomed visitors to watch her carve directly into marble.[27] According to one critic, Lewis came to be known as "one of the few sculptors whom no one charge[d] with having assistance in her work. Everyone admits that, whether good or bad, her sculptures are her own."[28]

Lewis excelled at multiple-figure compositions. Among the most favored of her works of the early 1870s were two sculptural "conceits" of lounging infants entitled *Asleep* and *Awake* (1871–1872) (fig. 3.8). Both are examples of a nineteenth-century vogue for images of children and cupids, especially popular among American audiences. Exhibited in both Italy and the United States, *Asleep* won a gold medal at the International Exhibition of the Naples Academy of Arts and Sciences, and a copy of it was later featured in the 1876 Philadelphia Centennial. In order to sell these and several other works, Lewis made an arduous trip to California in 1873. In an interview with the *San Francisco Chronicle*, she explained: "Here they are more liberal and as I want to dispose of some of my works, I thought it best to come West."[29]

Reviews of Lewis's sculptures exhibited at the San Francisco Art Association reveal the polarized reactions to her works. A critique in the *San Francisco Chronicle* demonstrates the reviewer's ambivalence toward the sculptor:

All the pieces give evidence of considerable artistic taste. . . . still there is so much labored finish to them that very little expression is left. The chisel has been used with too much mechanical nicety, and even if the conceptions were originally beautiful, the over careful manner in which they have been carved out would prevent them

from ever taking a high rank in art. Miss Lewis is a skillful manipulator of marble and the polish she gives it is very fine, but compared with the works of Powers and other eminent sculptors, her efforts make a poor show. It cannot be denied, however, that she has acquired a certain excellence in the art.[30]

While acknowledging Lewis's "excellence" as a sculptor, the critic laments the lack of expression in her works and compares them negatively to those of Powers, though a comparison reveals that both artists adhere equally to the rigorous impassivity of the neoclassical style (fig. 3.9).

The *San Jose Patriot* directly contradicts the *Chronicle* assessment, acclaiming the demonstrative quality of Lewis's work:

> The two pieces, "Asleep" and "Awake," are very beautiful, perfect creations, and establish Miss Lewis's claim to high rank as an artist. . . . The features are . . . extremely natural . . . and we were struck with the wonderfully expressive features of the little girl in "Awake" on half opening her eyes and beholding her dear little brother still asleep.[31]

The critical response may have been mixed, but the popular reaction to Lewis's work was clear. Virtually all of the sculptures she brought to California were sold. In addition to *The Marriage of Hiawatha* and *Love in a Trap*, purchased by collectors in San Francisco, *Asleep*, *Awake*, and a bust of Abraham Lincoln were acquired by the San Jose Library with the aid of a wealthy donor, Mrs. Sarah L. Knox. After being displayed, the sculptures languished in "dust-covered oblivion in the library basement" for nearly a century until 1968, when they were "discovered" by scholar Philip M. Montesano and once again became the subject of popular and scholarly acclaim.[32]

After returning to Italy, Lewis completed several versions of a life-sized sculpture of Hagar, the Egyptian slave of Genesis fame who served in the household of Abraham, most memorably as his mistress and mother of his first son, Ishmael (fig. 3.10). *Hagar* combines Lewis's technical skills and gift for composition with a personal, ethnic, and humanitarian theme that was a significant departure from most neoclassical subject matter. Hagar, who was first sex-

Figure 3.9
Hiram Powers
The Greek Slave, 1843
marble, 65 1/2" high (168 cm)

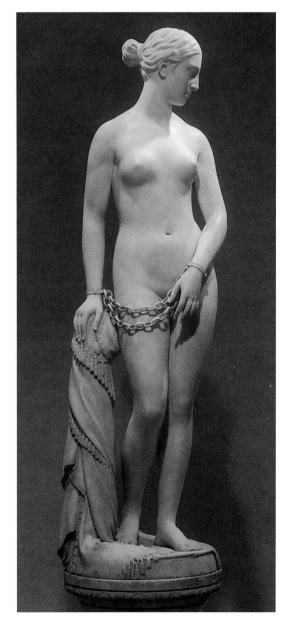

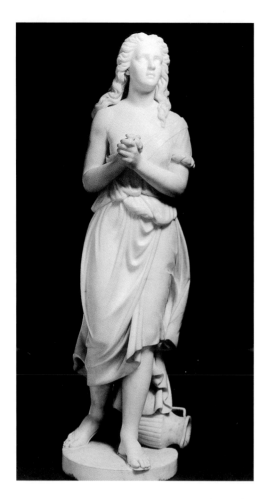

ually exploited by her master and then spurned by his wife, symbolizes countless enslaved African women with whom Lewis surely identified. Hagar's status as an outcast closely parallels the artist's, particularly if Hagar's flight into the desert after conceiving Ishmael and her subsequent rescue at the hands of an angel are seen as metaphors for Lewis's expulsion from Oberlin and delivery from the "desert" of American racial turmoil into the "promised land" of Rome.[33]

Lewis depicts a beatific Hagar gazing heavenward at the moment when she hears the angel intone the legendary question, "Hagar, . . . whence camest thou? and whither wilt thou go?"[34] While Hagar's facial expression is devoid of emotion, her clasped hands and upturned face infuse the sculpture with feeling comparable to that seen in *Forever Free.* Contemporary critics were quick to acknowledge the divergence of Lewis's interpretation from the academic norm. In 1876, Henry Tuckerman noted that *Hagar* embodied a "distinctive . . . style which may take high rank as the 'American School.'" For Tuckerman, the so-called American School differentiated itself from European neoclassicism by an abated rigidity and a lack of pretentiousness. Tuckerman, who believed Lewis to be "unquestionably the most interesting representation of our country in Europe," urged other artists to follow her aesthetic example.[35]

Another distinctive feature of Lewis's *Hagar* is the artist's representation of her subject with a fully rounded face and limbs (similar to the female figure in *Forever Free*). Deviating from representations of Hagar as emaciated and suffering from her ordeal in the desert, the stoutness of Lewis's figure seems to mirror the artist's own countenance—an indication of the autobiographical nature of the work and of the fact that the artist may well have used herself as a model. Further supporting a self-referential reading of *Hagar* is the fact that Lewis had recently become a practicing Catholic and is believed to have expressed, through *Hagar*, her "feelings of hope" with regard to her renewed religious outlook.[36]

In order to complete *Hagar* in marble, Lewis borrowed large sums of money. Hoping to ward off her creditors, she arranged a return trip to the United States—this time to Chicago, where she rented an exhibition hall for presentation of the sculpture to the public, and ran an ad in the *Chicago Tribune*:

Her advertising copy capitalized on her uncommon status as a woman of color, a sculptor, and an expatriate—an irresistible combination for post–Civil War curiosity seekers. *Hagar* was sold for $6,000—a substantial sum for the time—and Lewis was able to return to Italy, where she enjoyed at least a temporary respite from her financial woes.

In 1872, Lewis completed a sculpture that established her reputation as an international master on a par with her most renowned contemporaries. *Old Arrow Maker* was so well received that at least three versions were commissioned by buyers who were anxious to acquire copies (fig. 3.11). Originally titled "The Wooing of Hiawatha," this intricate composition features two main figures—one crouching and one seated—and the limp body of a fawn. Inspired by a Chippewa legend and by Henry Wadsworth Longfellow's popular *Song of Hiawatha*, the sculpture represents Minnehaha, her father, and the red deer that Hiawatha presented to Minnehaha. Longfellow's poem, in fact, was the literary source for a number of Lewis's works, including *Minnehaha* (1867), *Hiawatha* (1868), and *Marriage of Hiawatha* (1871). In 1869, Longfellow himself visited Lewis's studio and sat for a portrait.[38]

The figures that comprise *Old Arrow Maker* occupy a tightly orchestrated space defined by a circular base. The seemingly effortless handling of this complex arrangement attests to Lewis's sculptural maturity. Her skilled manipulation of the stone is evident in the many areas of negative space, the overlapping of multiple forms, and the veracious treatment of the textured surfaces, including hair, leather, skin, fabric, tools, flora, and fauna. A relatively small work just under two feet in height, *Old Arrow Maker* is jewel-like in its articulation of intricate details, especially of authentic Chippewa clothing, moccasins, and jewelry. Adding to the verity of the work is Lewis's visualization of the elder's coiffure, which was inspired by the indigenous Americans with whom the artist had spent her childhood.

Forever Free, *Hagar*, and *Old Arrow Maker* reflect Lewis's long-standing concern for the struggles of both African and Native Americans. Lewis completed

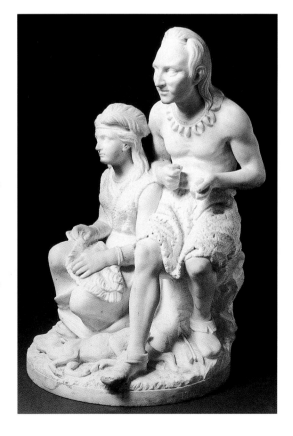

Figure 3.11

Edmonia Lewis

Old Arrow Maker

(The Old Indian Arrow Maker and His Daughter), 1872

carved marble,

21 1/2 x 13 5/8 x 13 3/8"

(54.5 x 34.5 x 34 cm)

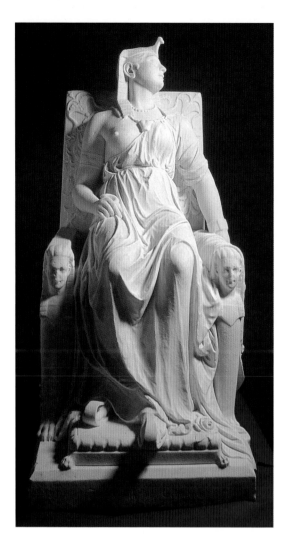

at least sixty works of political, social, and historical (as well as biblical and mythological) significance. Of her many compositions, the famed *Death of Cleopatra* (1876) is perhaps her finest masterpiece and was an immediate sensation (figs. 3.12, 3.13). "Oriental" in theme, fashionable after Napoleon's Egyptian military campaigns, *The Death of Cleopatra* was exhibited in 1876 at the Women's Pavilion of the Philadelphia Centennial, where "larger crowds [gathered] around it than any other work in the vast collection," and again in 1878 at the Chicago Interstate Exposition.[39]

Lewis's *Cleopatra* manifests an elegant dignity, which is stylistically indebted to Italian neoclassical sculptor Antonio Canova. But unlike his idealized figures, *Cleopatra* is defined by scrupulous realism. Lewis studied ancient Roman coins that bore Cleopatra's portrait in order to accurately capture the face of the great queen. She also made the controversial decision to portray Cleopatra in the throes of death, with flaccid limbs and parted lips, exhaling her final breath—a decision that both riveted and repulsed audiences. Cleopatra is seated upon an elaborately carved throne with one breast bared. A poisonous asp, the instrument of the monarch's suicide, curls around her lifeless right hand. Her left arm lies languidly against the throne, and her head, which in death has fallen against the back of the chair, is turned

Figure 3.12

Edmonia Lewis

The Death of Cleopatra, 1876

marble, 63 x 31 1/4 x 46"

(160 x 79.37 x 116.84 cm)

away from the viewer to reveal a smooth, full cheek and rigid, powerful throat. The ponderous "dead" weight of the figure is emphasized by the use of "wet" drapery, which both reveals and conceals Cleopatra's bulk.[40]

Lewis's pragmatic depiction of death garnered a great deal of praise and some criticism. The words of nineteenth-century artist Walter J. Clark best articulate the contemporary response:

> This is not a beautiful work, but it is a very original and striking one . . . as its ideals [are] so radically different from those adopted by [William W.] Story. . . . The effects of death are represented with such skill as to be absolutely repellent. Apart from all questions of taste, however, the striking qualities of the work are undeniable and it could only have been produced by a sculptor of very genuine endowments.[41]

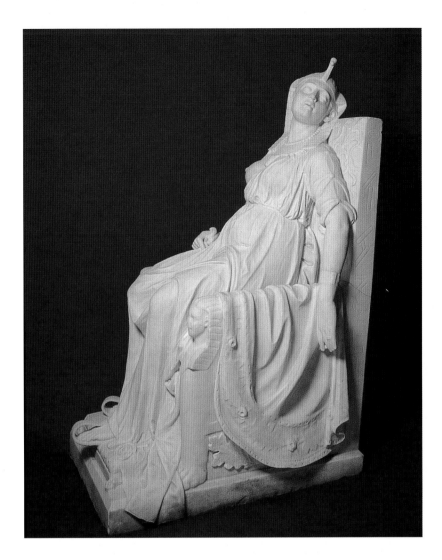

Figure 3.13
Edmonia Lewis
The Death of Cleopatra
(3/4 view), 1876
marble, 63 x 31 1/4 x 46"
(160 x 79.37 x 116.84 cm)

Figure 3.14
William Wetmore Story
Cleopatra, 1869
marble, 55 1/2 x 33 1/4 x 51 1/2"
(141 x 84.5 x 131 cm)

Story's *Cleopatra*, also exhibited at the centennial exposition, appears to be lost in thought rather than mortally wounded (fig. 3.14). The brow of Story's queen is furrowed and her gently inclined head rests against her palm. She supports her own weight, and thus her pose, while suggestive perhaps of mental fatigue, fails to convey any convincing physical debilitation or sense of impending death. By contrast, Lewis deftly wed the dissonant attributes of death and grandeur, conveyed through the queen's rigid spine pressed flush against the back of the throne and the raised, almost haughty tilt of her chin.[42]

The Death of Cleopatra was Lewis's last monumental sculpture, and the centennial exhibition at which it made its debut marked the end of the neoclassical age in Amer-

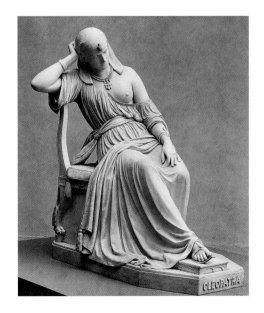

ica. Lost after the centennial, the statue stood forgotten in Chicago's suburban Forest Park for nearly a century. *Cleopatra* had been purchased by a gambler and racetrack owner named John Condon, who used it as a funerary monument for the grave of one of his race horses. At Condon's behest, the sculpture remained undisturbed until sixty years after his death, despite a number of building projects that were conducted on the site. In 1972, the sculpture was removed to make room for a post office and was stored in an outdoor machine yard. By this time, the provenance of the piece had been completely obscured. The work stood unattended and covered in grime until a passing fireman, impressed by its austere beauty, endeavored to have the sculpture cleaned and restored. The task was eventually taken up in 1987 by the Forest Park Historical Society. Only then did historians realize that *Cleopatra* had been created by Edmonia Lewis, whose name and home, "E. Lewis Roma," was inscribed on the base.[43]

Other than some infrequent references, the facts of Lewis's last years remain, for the most part, unknown. As abolitionist circles dwindled and the vogue for neoclassicism waned, so did Lewis's patron base and popularity. A fascinating and enigmatic artist whose unique personality served her well, Lewis enjoyed social and financial advantages that allowed her entrée into international art circles far exceeding those of most aspiring African-American women artists. Few could afford the private tutoring that sustained Lewis, and many found themselves barred from art schools and academies, which seldom admitted blacks. Others discovered that, even if accepted at an academy, they were forbidden to study the nude figure, an exercise essential to the success of an academic artist. Public opinion against exposing women to the nude was so entrenched that in 1886, when Thomas Eakins allowed a female student to sketch from a live nude model, he was forced to resign from his teaching position at the Pennsylvania Academy.[44]

Another impediment faced by Lewis's successors was the intensification of racism after Reconstruction. Lewis, it must be remembered, achieved popularity in the 1860s and 1870s, when sentiment toward African Americans was somewhat sympathetic, particularly in the North. During this period, while northern armies occupied and controlled the southern states, the civil rights of African Americans were established and briefly preserved. The ensuing backlash resulted in a reversal of these gains (through Jim Crow laws and legalized segregation), which would affect the social progress of African Americans until well into the twentieth century. Several determined women artists did manage to carve out careers despite the political climate that existed after Reconstruction. Notable among them were the sculptors Meta Vaux Warrick Fuller and May Howard Jackson.

Meta Warrick Fuller (1877–1968) was the middle-class child of a successful Philadelphia barber, William H. Warrick, and his wife, Emma (who was an equally accomplished wig maker and hair stylist). Fuller's talents as an artist, evident from childhood, were nurtured by her older sister Blanche, who studied art, and by visits with her father to the Pennsylvania Academy. In the early 1890s, Fuller became one of a select few African-American students chosen to participate in an innovative public school program that offered gifted youngsters instruction in art. Once a week, Fuller received training in the rudiments of art and design at the J. Liberty Tadd Art School.[45]

Fuller's youthful skill was rewarded with the exhibition of a small wooden sculpture at the World's Columbian Exposition in 1893. When Fuller graduated from high school, she was awarded a three-year scholarship to attend the Pennsylvania Museum and School for the Industrial Arts (known today as the Philadelphia College of Art). In exchange for her scholarship, Fuller had to create and donate a work of art to the school, which she fulfilled with an ambitious thirty-seven-figure bas-relief entitled *Procession of the Arts and Crafts*. The Romanesque-style sculpture garnered Fuller an additional year of postgraduate scholarship study. Her college career culminated in 1898 with an honorable mention at her senior exhibition for clay modeling and an award for a metal sculpture entitled *Crucifixion of Christ in Anguish*.[46] The *Crucifixion*, which typified Fuller's early style, struck viewers as especially morbid in its gruesome details, to which the artist responded, "If the Savior did not suffer, wherein lay the sacrifice?"[47]

In 1899, Fuller followed in Lewis's and Walker's wakes, traveling abroad first to England and then to Paris, where she studied sculpture at the Académie Colarossi (the Académie Julien's competition) and at the prestigious École des Beaux Arts. In order to appease her mother, who was concerned about sending a young girl abroad unchaperoned, Fuller had invited her friend, sculptor May Howard Jackson, to accompany her. Jackson, however, declined the invitation, patriotically stating that she "did not think it necessary to go to Europe to further her education."[48] Fuller remained in Paris until October 1902, under the watchful eye of an expatriate family friend, the acclaimed African-American artist Henry Tanner.

Tanner proved invaluable to Fuller on more than one occasion. Upon Fuller's arrival in Paris, Tanner came to her rescue when she was denied a room at the American Girls' Club where she had made reservations. The Girls' Club did not allow tenants of color and had assumed Fuller was white when they took her reservation. Tanner enlisted the aid of the club's director and the two found alternate accommodations for Fuller. Both gentle-

men took a liking to the young artist and made a point of acquainting her with the Paris art world. In fact, the club's director went so far as to arrange an introduction between Fuller and another established American sculptor, Augustus Saint-Gaudens, who visited Fuller's studio and encouraged her to study drawing as a way to enhance her understanding of three-dimensional art. While in Paris, Fuller honed her skills through studies of the live model, availed herself of the city's great museum collections, and attended lectures at the École des Beaux Arts. During the summer of 1901, a fellow student at the Académie Colarossi introduced Fuller to the French sculptor Auguste Rodin. Hoping to be permitted to study with the master, Fuller presented him with her portfolio and a small clay model, which was likely a study for a later work entitled *Man Eating Out His Heart* (fig. 3.15).[49]

Not unlike the angst-ridden works of Rodin, the crouched and compressed figure of *Man Eating Out His Heart*, with its mottled and rotting flesh, is a literal translation of a state of mind. Fuller's anti-heroic psychological interpretation is in keeping with the contemporaneous symbolist movement. Symbolism was the vehicle of such artists as Gustave Moreau, Odilon Redon, Paul Gauguin, and the Nabis painters who were, in turn, inspired by the macabre and introspective writings of Edgar Allan Poe, Paul Verlaine, Charles Baudelaire, and Stéphane Mallarmé, as well as by the recently published studies of dreams and the unconscious by Sigmund Freud. Rodin was very much impressed by Fuller's style and, although he was not accepting students at the time, he offered Fuller high praise, exclaiming, "My child, you are a sculptor—you have a sense of form!" He also agreed to visit her studio and to critique her work whenever he was in Paris.[50]

The abiding influence on Fuller of symbolist subject matter and Rodinesque modeling can be seen in her continued exploration of emotive themes, expressive forms, and irregular surface textures, which she learned to execute with "greater force" under Rodin's guidance. Fuller showed her work in both solo and group exhibitions in Paris, most notably in a one-person show held at Samuel Bing's L'Art Nouveau gallery, which represented avant-garde artists such as Henri de Toulouse-Lautrec, Mary Cassatt, and Aubrey Beardsley. In 1903, two of Fuller's sculptures, *The Wretched* and *The Impertinent Thief*, were selected for inclusion in the annual Paris Salon. Fuller's Paris years produced these and subsequent similar compositions, such as *Man Car-*

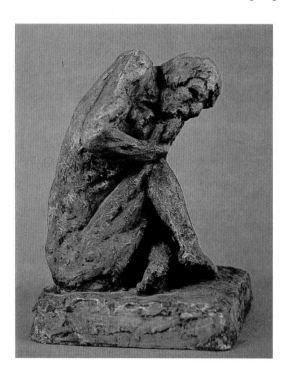

Figure 3.15
Meta Warrick Fuller
*Man Eating Out His Heart
(The Secret Sorrow)*, c. 1905–1906
painted plaster, 7 x 3 x 2"
(17.8 x 7.6 x 5 cm)

rying a Dead Comrade, *Dark Hero*, and *Head of John the Baptist* (fig. 3.16).
Her works of this period alternated between the cerebral elegance and
attenuated lines of the latter work, and the lurid intensity and truncated
masses of *Man Eating Out His Heart*. Fuller's sculptures manifested,
according to critics, exceptional "power and originality," and the "delicate
sculptor of horrors," as Fuller had become known, earned both financial
and critical success before her return to Philadelphia in 1902.[51]

Soon after arriving home, Fuller re-enrolled in the Pennsylvania
Museum School to study ceramics. Within a year, she had received the
school's first prize award for pottery and opened a studio on South Camac
Street in Philadelphia. Fuller was further honored with a showing of her
work in 1906 at the Pennsylvania Academy, where she had enrolled as a stu-
dent of portrait sculptor Charles Grafly.[52] Critics noted with admiration
the impact upon Fuller of her mentor, Rodin, and they were equally
beguiled by the fact that Fuller was a woman of color. Ever fascinated by
the implicit evidence of miscegenation in American culture, Fuller's con-
temporaries paid as much lip service to describing her racial heritage as
"a young colored woman with a strain of white blood" as they did to char-
acterizing her work as "extremely individual, showing a morbid, strong
imagination and the influence of Rodin."[53]

Fuller's career was bolstered by a prestigious federal commission in 1907
to design a multiple figure "tableau" for the Jamestown (Virginia) Ter-
centennial Exposition. The work, for which Fuller received a gold medal,
celebrated the achievements of African Americans since their arrival in
Jamestown in 1619 and made Fuller the first African-American woman to
be awarded a government commission in the fine arts. Fuller's success con-
tinued when, the following year, she was again chosen to exhibit at the
Pennsylvania Academy (where she would continue to show until the late
1920s). In 1909, Fuller married a Liberian neuropathologist and psychia-
trist, Solomon Fuller, and moved to Massachusetts. Fuller was determined
that her professional aspirations not be hampered by her new role as a doc-
tor's wife. She continued to sculpt, first in a small attic studio and later in a
more spacious setting that she designed and built on the shore of a lake near
her home. Once in enlarged quarters, Fuller was able to teach as well as
sculpt and show her works. At the same time, she became active in a variety
of Massachusetts social, artistic, and political organizations, including the
Boston Art Club, the Women's Club, the Civil League, and the Wellesley
Society of Artists.[54]

Over a period of years, Fuller left behind the symbolist subject matter of
her Paris phase and became increasingly influenced by the politically
minded community to which she belonged. Her first major foray into polit-

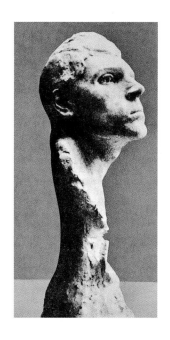

Figure 3.16
Meta Warrick Fuller
John the Baptist, 1899
plaster, destroyed

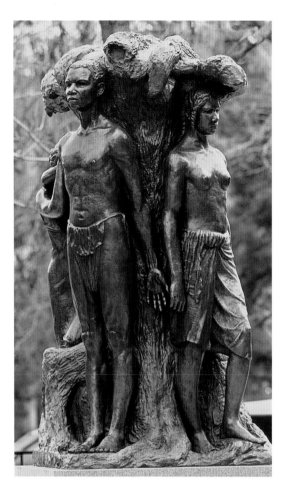

Figure 3.17

Meta Warrick Fuller

Emancipation Proclamation,

plaster produced in 1913; cast

in bronze in 2000, 85 x 42 x 41"

(216 x 106.7 x 104.1 cm)

ical art came as the result of a commission she received from activist-intellectual W. E. B. Du Bois, whom she had befriended in 1900 while he was organizing the African-American pavilion at the Paris Exposition and participating in the first Pan-African Conference in London. Du Bois encouraged Fuller and other artists of color to devote their artistic energies to the black subject, and he invited Fuller to create a sculpture for the New York celebration of the fiftieth anniversary of the Emancipation Proclamation, a commission that resulted in Fuller's best-known work of the same name, completed in 1913 (fig. 3.17).[55]

Du Bois was not the only influence on Fuller's decision to exchange symbolism for Pan-Africanism. She was likewise influenced by her own intellectual and politically aware family. Fuller's brother-in-law was an educator and an active politician; two of her uncles were journalists; and one of them was also a bibliophile and scholar of black history. Moreover, her husband issued from a politically active African family—his parents were Liberian government officials. Shortly after her marriage, Fuller sculpted a plaque to commemorate Ethiopia's recently deceased emperor, *Menelik II* (1913), which, according to historian Judith Wilson, affirms the artist's awareness that Liberia and Ethiopia shared status as the only two African nations at the time that were free of colonial rule. By 1915, Fuller had become active in women's politics, contributing a medallion that was sold in support of the Framingham Equal Suffrage League.[56]

Fuller chose for the Du Bois sculpture a formal approach that fused remnants of the symbolist she had once been with her new interest in social realist heroism. The unlikely combination was described as "masculine"— a qualification that was less a denunciation of the sculpture than a critique of the woman who had dared to model it. Fuller's *Emancipation* depicts several partially clad life-sized figures in various states of emotional distress, grouped around a writhing tree form. One of the female figures covers her face with her arms, her anguished sobs nearly audible; a second woman looks calmly ahead while taking a determined step forward; and a third, male figure stands rigidly erect, his lean musculature and tense sinews communicating both power and dignity. Unlike Lewis's *Forever Free*, Fuller's narrative work features "no discarded whips or chains, no grateful freed-

men kneeling," and it marks a decisive turning point in Fuller's development, which was brought on, in part, by misfortune.[57]

In 1910, a Philadelphia warehouse containing a cache of Fuller's sculptures dating back to 1894 caught fire, and many of her early works were destroyed. As a result, most of Fuller's extant art derives from her social realist phase, leaving only rare examples of her earlier style. Devastated by the loss, Fuller for a time turned her attentions to motherhood, bearing three sons between 1910 and 1916.[58] Her domestic duties notwithstanding, Fuller continued to produce sculpture throughout the 1910s and 1920s. However, her works completed after 1910 displayed less frequently and with less intensity the highly textured surfaces, reductive forms, and understated elegance for which she had garnered attention in Europe. Fuller's later works became visual protests against social injustice and tended to emphasize social content over form.

Fuller's 1919 sculpture, *Mary Turner (A Silent Protest against Mob Violence)*, is one example. It condemns the 1916 murder in Georgia of an African-American woman who had protested the lynching of her husband (fig. 3.18). For her impertinence, Turner was hanged by her feet and brutally butchered by a fierce lynch mob that, appallingly, cut open her abdomen and extracted and then trampled her unborn child. The incident, which was reported in the *New York Times* and in the black press, galvanized the African-American community and brought national attention to the racial violence that had continued unabated since post-Reconstruction.[59]

The feelings of horror and disgust generated by Mary Turner's killing were vented in a silent protest march of more than 10,000 African Americans down New York's Fifth Avenue, which was mobilized by African-American organizations such as the Universal Negro Improvement Association (UNIA) founded by Pan-Africanist Marcus Garvey. After reading a description of the event in Du Bois's NAACP journal, *Crisis*, Fuller produced her monolithic sculpture.[60] Through the use of closed form, a bowed head, and a face obscured by shadow, Fuller rendered the figure of Turner fittingly mute—a metaphor for the silent UNIA march and for the silencing of her people by means of mass murder and brutality. At its base, the body of Turner seems to be decomposing into a contorted mass of grasping hands, clenched fists, and disembodied faces that resemble death masks—symbolizing the lynched, tarred-and-feathered, and beaten dead who preceded Turner to the grave. In this powerful work, there remains yet an echo of the textured surfaces of Rodin, and one is especially reminded of Rodin's 1897 *Monument to Balzac*, which offers a similar treatment of the figure.

Another work by Fuller that is indebted to Rodin is the Pan-Africanist homage *Ethiopia Awakening* (c. 1921) (fig. 3.19). It depicts a lithe Egyptian

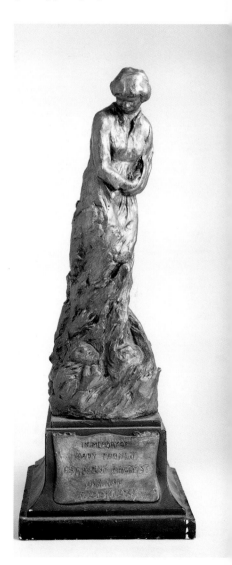

Figure 3.18
Meta Warrick Fuller
Mary Turner (A Silent Protest against Mob Violence), 1919
painted plaster, 15 x 5 1/4 x 4 1/2"
(38.1 x 13.3 x 11.4 cm)

Figure 3.19

Meta Warrick Fuller

Ethiopia Awakening, c. 1921

bronze, 67 x 16 x 20"

(170.2 x 40.6 x 51 cm)

woman who, in the words of the artist, is "awakening, gradually unwinding the bandages of [the] past and looking out on life again, expectant, but unafraid."[61] It has been surmised by art historian Tritobia Benjamin that *Ethiopia Awakening* was created at the behest of NAACP leader James Weldon Johnson for New York City's 1921 "Making of America" festival. Fuller chose the specter of an Egyptian mummy to symbolize the end of a period of living death for people of color who, now a half century removed from slavery, were beginning to assert themselves as enfranchised citizens and as rulers of their own destinies. Fuller's interest in this particular Ethiopian theme may well have been influenced by the publication in 1911 of West African anti-imperialist Joseph Casely Hayford's book *Ethiopia Unbound*, which called for a renewal of awareness of African cultural heritage and for black leadership in Africa. The book's very title suggests the unbinding of a shroud similar to that illustrated in Fuller's sculpture.[62]

A comparison of *Ethiopia Awakening* with an analogous work entitled *Africa* (1904) by American sculptor Daniel Chester French reveals several rather startling differences and foregrounds Fuller's work as a deconstruction of entrenched stereotypes (fig. 3.20). An allegorical interpretation of the "Dark Continent," French's *Africa* epitomizes this racial chauvinism. A large-scale design originally installed outside the U.S. Customs House in New York City, French's work is a prodigious, near-nude female figure whose nudity symbolizes both the primitive and the sexual stereotypes associated with Africa. She slumps listlessly in her throne, the arms of which are formed by high-relief carvings of a lion and a sphinx, representing northern and southern Africa. Her head falls forward as if in sleep and her powerful body is lethargic. In distinct contrast to his *Africa*, French's allegories of the other continents, which were completed as part of the same government commission, depict the remainder of the world figures fully clothed and seated upright in their respective thrones. *Asia* sits rigidly with downcast eyes and peaceful countenance, representing the ancient timelessness of the continent's cultures and religions; *Europe* is a self-possessed queen who stares boldly ahead; and *America*, while seated, appears to step aggressively forward as her head pivots energetically to the left. The antithesis of *Africa*, she is "lively and alert" and "advancing to meet the challenge of the future."[63]

The disparity between French's phlegmatic *Africa* and the dignity and vigor of the other continents was not lost on African-American observers. Black scholar Freeman Murray (a family acquaintance of Fuller's) acerbically referred to French's *Africa* as "Ethiopia Asleep" in his 1916 book on blacks in sculpture. His comment may well have inspired Fuller to reinterpret Africa in a sculpture of her own and to title it *Ethiopia Awakening*.[64] Fuller's *Ethiopia* stands upright with her hand on her breast as if pledging some silent allegiance, and she is modestly covered in an Egyptian-style crown and mummy wrappings, precluding any sexual subtext. By the same token, she is neither "lively" nor "alert." She inhales only the faintest breath, awakening at a measured pace after her prolonged sleep. Despite this apparent inertia, the rendering represents a first step toward the daring reclamation of the black image that would be undertaken by the artists of the Harlem Renaissance within a few short years.

Fuller continued to flourish as an artist and to exhibit throughout her lifetime, receiving numerous honorary degrees, awards, and public commissions into her eighties. One of her most meaningful contributions to African-American art was the inspiration she provided for the next generation of artists, coming into their own during the 1920s. In particular, Fuller met and befriended the young Lois Mailou Jones, also from New England, whose own art and stellar career would echo Fuller's.[65]

May Howard Jackson (1877–1931) was born the same year as Fuller and in the same city, Philadelphia. The early lives of these two women

Figure 3.20
Daniel Chester French
Africa, 1904, from
The Continents (1903–1907),
exterior of the U.S
Customs House, marble,
124" high (315 cm)

echoed each other repeatedly. Jackson, like Fuller, was from a relatively privileged family that embraced the fine arts. She, too, studied at the Pennsylvania Museum School and the Pennsylvania Academy. Jackson won a scholarship to the latter institution in 1895, preceding Fuller and becoming the first African-American woman to attend the academy, where she received neoclassical training and studied with impressionist-influenced painter William Merrit Chase. She was also afforded the opportunity to study the nude model, permitted by the academy some years after Eakins's departure.[66]

Upon completing her academic training, Jackson married a mathematics teacher and high school principal, William T. S. Jackson. The couple moved to Washington, D.C., where he had been appointed head of the math department at the M Street High School. By 1916, Jackson was situated in her own art studio and was exhibiting at the Corcoran Gallery, which had begun to accept African Americans since its rejection of Annie Walker some twenty-five years earlier. Between 1912 and 1916, Jackson also showed her works at the National Academy of Design and at the Veerhoff Gallery (both in New York), receiving praise from critics who described her work as "well-constructed and skillfully modeled."[67] One of Jackson's most oft-discussed works is the self-referential *Mulatto Mother and Child* (fig. 3.21), which was described in a *Washington Star* review as "a very remarkable and dramatic work, touching upon the mysteries of heredity in a way which is exceedingly striking.... Her work has always shown promise, but these pieces now on exhibit indicate exceptional gifts, for they are not merely well-modeled but individual and significant."[68]

Mulatto Mother and Child is a plaster bust of a young woman and her infant enveloped in the mother's flowing tresses. It integrates the bathos of Lewis's "conceits," *Asleep* and *Awake* (fig. 3.8), with a sober sincerity that is to some degree vitiated by the picturesque quality of the work. *Mulatto Mother and Child* depicts biracial identity, an issue integral to Jackson's own life as someone of very fair complexion who was often mistaken for white. Art historian Leslie King-Hammond recently praised Jackson's "efforts to address ... without compromise and without sentimentality, the issues of race and class, especially as they affected mulattos."[69] As such, Jackson provided her viewing public with some of the first

Figure 3.21

May Howard Jackson

Mulatto Mother and Child, n.d.

plaster, 24 x 17 x 13"

(61 x 43.2 x 33 cm)

consistent examples in American art of blacks as dynamic and heterogeneous individuals.[70]

Jackson's decision to devote the major portion of her art to African-American subjects caused some to pigeon-hole her as an "ethnic" artist whose "frank and deliberate racialism" overshadowed more important aesthetic concerns.[71] Jackson limited her works, for the most part, to objective portraits of children, friends, family members, and African-American literati such as Du Bois, Jean Toomer, Kelly Miller, and Paul Laurence Dunbar (figs. 3.22, 3.23). Despite the fact that portrait painting and sculpture had for centuries been deemed worthy specialties for an artist, the academy-driven era that supported portraiture had ended by 1900 (replaced by private art dealership and the more avant-garde styles of early modernism), and Fuller's reputation suffered as a result. From a purely technical point of view, Fuller executed her portraits with psychological insight and empathy, revealing through subtlety and nuance each sitter's personality.[72] The Dunbar portrait (1919), commissioned by Dunbar High School in Washington, D.C., is an especially distinguished example of Jackson's gift for precise and poignant portraiture.

Figure 3.22
May Howard Jackson
Clark Bailey (Head of a Negro Child), c.1916
terra cotta, 21 x 12 5/8 x 8"
(53.3 x 32 x 20.3 cm)

Jackson's career, unlike that of Fuller, was less than satisfying and, at best, a qualified success. Her work and professional achievements were routinely overlooked, even by African-American scholars, whose disdain may have stemmed from Jackson's rejection of the requisite Grand Tour. Her decision was deemed a career faux pas in 1936 by influential art and literary critic Alain Locke. In his 1943 *Modern Negro Art*, James Porter described Jackson's work as "prosaic" and lacking in originality. Present-day scholars, however, have found that Jackson's isolation from the European art scene allowed her to develop a "distinctly personal style" that even Locke ultimately admitted was a refreshing departure from the "academic cosmopolitanism" for which Fuller was known.[73]

Detractors aside, Jackson had a number of staunch supporters, including journalist Mary Gibson Brewer who, in an article published in 1928 in the *Afro-American Newspaper*, rebuked James Weldon Johnson for excluding Jackson from an article on black artists he had written for *Harper's* magazine.[74] Fuller, too, appealed on Jackson's behalf to art historian and author Freeman Murray, requesting that he focus more attention on Jackson in his own research and writing: "Why don't you say something about May Howard Jackson? I can't think that you are among those who dislike her

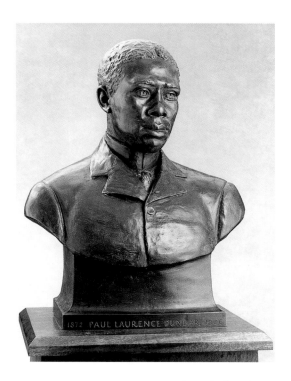

and even if you were, I believe I know you well enough to be sure that you would not allow any ill feeling to influence your regard for her ability."[75] Alluded to in this passage is a factor that contributed to Jackson's career difficulties—an irascible personality, for which she was evidently well known.

Adding to Jackson's difficulties were the idiosyncratic social exchanges she endured as a woman of color who could "pass" for white. One such instance involved the Washington Society of Fine Arts, to which Jackson had applied for membership. Her application was at first accepted and then rejected when the society learned that she was of African descent. A similar incident occurred when the National Academy of Design, which had exhibited one of Jackson's sculptures (a bust of black intellectual Kelly Miller), sent someone to Jackson's home to ask whether or not she was of "Negro blood" and then declined to include her work in subsequent exhibitions.[76] In reaction to repeated incidents such as these, Jackson wrote, "I felt no satisfaction! Only a deep sense of injustice, something that has followed me and my efforts all my life."[77] Du Bois described her as

> at once bitter and fierce with energy, cynical of praise and above all at odds with life and people.... With her sensitive soul, she needed encouragement and contacts and delicate appreciation. Instead of this, she ran into the shadows of the Color Line.... In the case of May Howard Jackson the contradictions and idiotic ramifications of the Color Line tore her soul asunder.... She met rebuffs in her attempts to study and in her attempts at exhibition ... in her chosen ideal of portraying the American mulatto type.[78]

Despite her experiences and outlook, Jackson met some professional success. She joined the faculty of Howard University, serving as an art instructor from 1922 to 1924. There she taught and influenced the young James Porter, who would go on to write one of the first comprehensive histories of African-American art. In 1928, three years prior to her death, Jackson was honored with a sculpture award from the Harmon Foundation. Founded by real estate investor William Elmer Harmon, the foundation offered monetary awards to encourage African-American excellence in a variety of professions, including the fine arts. Under the direction of Mary Beattie Brady, between 1928 and 1935 the foundation sponsored annual

juried art exhibitions and exposed widespread American audiences to African-American art.[79] Despite Harmon's support, appreciation of Jackson's contributions to American art would not come about during her lifetime, and the public's lukewarm response to her work was a bitter pill for her to swallow. Locke accurately predicted that "when a school of Negro sculpture fully emerges, Mrs. Jackson's work will be seen in a new perspective as noteworthy [and] pioneering."[80]

Despite the troubled careers of Jackson and her nineteenth-century cohorts, their contributions as professional vanguards are enormous. In particular, Jackson's, Fuller's, and Lewis's decisions to challenge prevailing stereotypes and redefine the image of the Other by means of their own work paved the way for ensuing generations of African-American artists to do the same. Wilson believes that "in broaching the subject of African heritage for the first time in the history of Afro-U.S. art, Edmonia Lewis, then Meta Fuller, anticipated the entire subsequent history of black artists' conscious struggle with questions of cultural heritage and racial identity in the United States."[81] Wilson also notes that the lives and art historical fates of these women, as well as those of their sister-painters, reveal

> problems that haunt black women artists to this day. . . . Their lives and work are seldom analyzed in detail, their politics have largely been ignored, and their activities are seldom viewed as having influenced other artists or played a crucial role in art historical developments. . . . [They] have been denied their rightful inheritance. Deprived of full knowledge of the female art historical continuum of which they are a part, they remain "Hagar's daughters," crying in the wilderness of cultural anomie.[82]

After years of virtual scholarly oblivion, the continuum of African-American women artists has moved decisively into the light of late twentieth-century revisionist history.

Also designated as the Roaring Twenties, the Jazz Age, and the New Negro movement, the Harlem Renaissance was characterized by racial pride, political activism, and heightened cultural awareness. The movers and shakers of the Harlem Renaissance, such as Du Bois, Locke, and Garvey, set forth as their most compelling agendas the deconstruction of negative stereotypes that had, by the 1920s, become resolutely associated with blacks, and the amelioration of their disadvantaged social condition—both of which could be achieved, it was hoped, through social criticism, civic and economic engagement, and artistic propaganda. These ambitions were felt urgently at the end of World War I, when African-American soldiers returning from battle found that they were as yet disenfranchised citizens, unwelcome and even despised on their own soil, despite their evident patriotism. Incidents of lynchings, beatings, and other violent assaults against African-American soldiers, and citizens in general, escalated to such an extent that the months immediately following the war became known as the "Red Summer."[1]

The enmity felt by white Americans toward their darker countrymen was epitomized in a now infamous film, *Birth of a Nation*, the brainchild of noted director D. W. Griffith (fig. 4.1). First released in 1915, this widely influential film glorified the Ku Klux Klan and promoted racial hatred, while portraying African Americans as culturally and intellectually bereft and as violent criminals who threatened the political and social equilibrium of the nation—precisely the kinds of misrepresentations that Harlem Renaissance leaders hoped to dispel. The film's unprecedented popularity with white audiences attested to the entrenched racism that marred American thinking. Furthermore, between 1909 and 1921, the well-publicized racial antipathies of Presidents Theodore Roosevelt, William Howard Taft, and Woodrow Wilson (the latter publicly endorsed *Birth of a Nation*) encouraged the oppression of people of color.[2]

FOUR · The Harlem Renaissance and the New Negro

Even before 1920, black leaders had begun to advocate a variety of formulas for combating the physical persecution and social and economic oppression of African Americans that had been set in motion during post-Reconstruction. Booker T. Washington, educator and founder of Tuskegee Institute in Alabama, proposed a moderate program of racial segregation (in part, to reduce violent interactions between the races) and called for improved technical education as an avenue toward black financial independence. Du Bois championed more aggressive political activism, integration, and immediate equality for African Americans, while Garvey emphasized a strengthening of Pan-African ties among people of color on both sides of the Atlantic as a means of fostering black self-esteem and financial autonomy.[3]

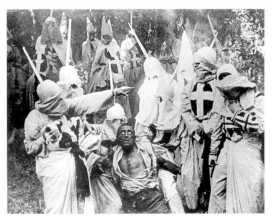

Figure 4.1

Scene from *Birth of a Nation*, 1915

To advance his position, Garvey formed the Universal Negro Improvement Association (UNIA), which thrived in Harlem and elsewhere from 1916 to 1925. The organization boasted more than 3,000 delegates and ownership of a steamship company (the Black Star shipping line), which combined commercial trade with passenger transportation to the African continent. Other self-improvement organizations included the National Association for the Advancement of Colored People (NAACP) and the Urban League. The NAACP, founded in 1909 and led by Du Bois and William Monroe Trotter, sought to ensure equal treatment of African Americans through federal legislation, while the Urban League, founded in 1911, dedicated its energies to improving economic and social opportunities for blacks.[4]

The UNIA, NAACP, and Urban League were all headquartered in New York City, the epicenter of the Harlem Renaissance, where political activism and an unprecedented eruption of black creativity merged. Unparalleled professional opportunities were available to New York's African-American artists, performers, writers, actors, and musicians. Even as racial oppression continued unabated, black art shaped the cultural climate. Throughout the 1920s, plays and musicals focusing on black subjects were staged at Manhattan theaters. Among the most popular of these were Eugene O'Neill's *Emperor Jones* and *All God's Chillun Got Wings* and Noble Sissle and Eubie Blake's *Shuffle Along* and *Chocolate Dandies*, which featured performers such as Josephine Baker and Paul Robeson. Other Harlem luminaries included writers Countee Cullen, Jean Toomer, Zora Neale Hurston, Langston Hughes, Claude McKay, and James Weldon Johnson, whose poetry and fiction centered on black subjects and found audiences both in

the United States and abroad. Visual artists, too, were integral to the renaissance and committed to responding to Du Bois's call to "set the black man before the world as . . . a strong subject for artistic treatment."[5]

The upsurge in creativity and social action that marked the Harlem Renaissance was felt across the country and around the world, particularly in cities like Atlanta, Chicago, Kansas City, and San Francisco, where communities of African Americans responded eagerly to the new cultural phenomena. European cities such as Paris, Copenhagen, and Berlin boasted international communities of black artists and entertainers and a growing fascination with all things African. Nevertheless, the bona fide nexus of the renaissance remained in a small section of uptown Manhattan known as Harlem which, over a period of less than a decade between 1920 and 1930, transformed from a well-to-do white residential neighborhood into a veritable mecca for African Americans of all economic and social strata. How was it possible for so many people of color to arrive in Harlem at virtually the same moment? The answer lies in an intriguing composite of local population shifts and a marvel of regional demographics known as the Great Migration.

When Harlem was annexed to New York City in 1873, northern Manhattan was populated by the descendants of European pioneers, and most African Americans lived in Lower Manhattan. Displaced by Irish and Italian immigrants over the next several decades, the population of color moved northward to Harlem, settling for brief periods in Greenwich Village and midtown Manhattan. As the result of a speculative building boom in Harlem at the turn of the twentieth century, landlords became desperate to rent their vacant apartments and began soliciting African-American tenants. The latter included not only native New Yorkers, but an ever-increasing population of people of color, who were part of the relocation of hundreds of thousands of African Americans from the rural South to the urban North, beginning in 1914 and continuing until World War II. The advance guard of the Great Migration came north to escape the constraints of Jim Crow legislation and increasing racial violence, and consisted mainly of unmarried young people with limited skills. A significant percentage of these new Harlemites, however, were educated professionals, politicians, businesspeople, skilled workers, and, more important, artists. By the end of the 1920s, the number of African Americans in Harlem had grown to more than 90,000, while nearly 120,000 whites who were unwilling to reside in an integrated community moved out.[6]

The more talented and urbane of these recent émigrés were christened the "New Negroes." The term, coined early in the century by Booker T. Washington, referred to African Americans who were intellectually, politi-

cally, and creatively dedicated to engaging and validating the best of their ethnic heritage. The New Negro was someone separate and distinct from the post-Reconstruction "Old Negro," who was "worried over, harassed or patronized" like a child but never seen as a mature, independent, or sophisticated human being, as was his new-age counterpart. The arrival of the New Negro signaled the death of "dusty spectacles of past controversy" exemplified by stereotypes such as Mammy, Uncle Tom, and Sambo. The demise of the Old Negro, for Alain Locke, was akin to a "shedding of the chrysalis of the Negro problem," which would lead to a "spiritual emancipation" for African Americans.[7]

Locke was one of the major arbiters of the Harlem Renaissance, particularly of its art. He received his Ph.D. from Harvard University, was the first African-American Rhodes scholar, consulted for the Harmon Foundation (one of the leading patrons of the renaissance), and headed the philosophy department at Howard University from 1912 to 1953. Locke crystallized his thoughts on New Negro art in a pivotal essay entitled "The Legacy of the Ancestral Arts," which appeared in the March 1925 issue of the literary journal *Survey Graphic* (fig. 4.2).[8] The entire issue was devoted to Harlem as the "mecca of the New Negro" and became the manifesto of the Harlem Renaissance. Locke's essay urged African-American artists to look to their black ancestors for creative inspiration. No longer considered coarse and uninspired, the influence of African aesthetics on European art could be seen in the works of Matisse, Picasso, Derain, and the German Expressionists. In Locke's words, "if African art is capable of producing the ferment in modern art that it has, surely this is not too much to expect of its influence upon the culturally awakened Negro artist of the present generation."[9] Locke hoped that African-American artists would begin to integrate African art forms and leitmotifs into their own work. He also counseled artists of color to dedicate themselves to dignified and engaging portrayals of blacks, so as to "reveal the beauty that prejudice and caricature has overlaid."[10] He even went so far as to reproach artists such as Henry Tanner, Meta Warrick Fuller, and May Howard Jackson for dedicating only a portion of their art to black subjects and for imitating European styles.[11]

A faction of progressive whites, who had turned a cold and irate shoulder to the decadent forces within Western culture that had been responsible for World War I, shared Locke's belief in the restorative potential of African

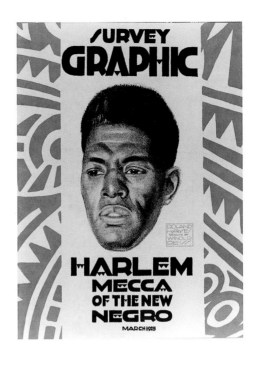

Figure 4.2

Winold Reiss

Drawing of Roland Hayes

culture. This "coterie of white intellectuals and radicals" were convinced that, in a broader sense, African culture might do more than invigorate Western art: it might provide an antidote to widespread corruption in Western society. Scholar Jan Pieterse explains that "at this particular juncture, the white elite went 'slumming'" in black Manhattan and many other cities, in a desperate search for solace.[12] The fondness that whites evinced for black culture, while at the same time continuing to oppress blacks, reflected an ambivalence that Pieterse argues was characteristic of the epoch:

> It was part of Europe's emancipation from Victorian puritanism by means of a . . . revaluation of the clichés about savagery: the clichés remained but . . . they were now evaluated as positive. It was a return of the repressed: with [Western] judgements about non-Western peoples returning like boomerangs to their source.[13]

In other words, the attraction that certain whites felt for the African ethos represented a recognition of their own "primitive" and "savage" natures (embodied in the violence of colonial oppression and world war) projected unconsciously onto another group.

One phenomenon especially highlights the desire that whites had to explore their inner *primitif*: the meteoric rise to fame of Josephine Baker, an African-American dancer from St. Louis, Missouri (figs. 1.1, 4.3). In the 1920s, New York theatergoers and Parisian nightclub devotees by the thousands clamored to watch Baker perform in *Chocolate Dandies*, *La Revue Nègre*, and the Folies Bergère. In the French performances, Baker was topless and wore little more than her infamous "banana skirt." Acutely aware of her role as the personification of white fantasies about the primordial nature of blacks—particularly the myth of black female sexuality—Baker's performance included being "carried upside down, like a wounded gazelle, on the back of a robust Martiniquan dancer" to the delight of a frenzied white audience.[14]

Another escape for whites from "Victorian puritanism" was jazz. Widespread American audiences embraced the Kongo-inspired cadences of Duke Ellington's new "jungle music," which they heard on live radio performances broadcast from Harlem's famed Cotton Club. Ellington was dubbed "The African Stravinsky," and his music, in the words of one British critic, embodied a "Shakespearean universality" that had the power to "erase the color line."[15] Harlem band leader Fletcher Henderson performed his brand of jazz for the benefit of all-white audiences at the Roseland ballroom in midtown. His sound, later known as "big band swing," was appropriated by the white band leader Benny Goodman (who hired Henderson

as his arranger) and aired nationwide on the weekly NBC radio show *Let's Dance*. Blues and jazz greats such as Louis Armstrong, Bessie Smith, and Thomas "Fats" Waller dazzled music lovers at rousing Harlem night spots like the whites-only Cotton Club and Connie's Inn and at the integrated Small's Paradise and Savoy ballroom, where black and white "swingers" could dance the popular steps of the day—the Lindy Hop, the Charleston, the Shimmy, and the Shim Sham—side by side.[16]

The gala atmosphere of Harlem's night life was immortalized in such popular songs as "Stompin' at the Savoy" and "This Joint Is Jumpin'," and its

Figure 4.3

Josephine Baker in the Ziegfeld Follies, 1927

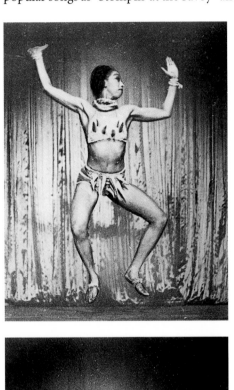

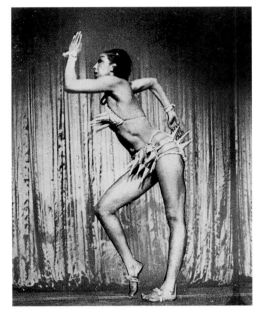

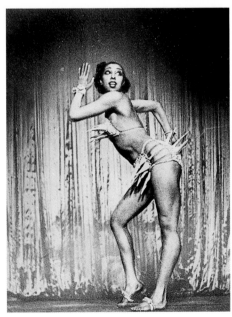

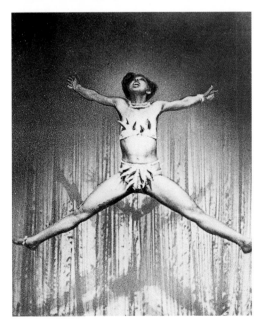

habitués were etched for posterity in the sculptures and paintings of several Harlem Renaissance visual artists, including **Laura Wheeler Waring** (1887–1948). Waring's *Jazz Dancer I* conceives the quintessential Jazz Age couple within an electrifying Harlem dance hall atmosphere (fig. 4.4).[17] In Waring's depiction, a monocled black gentleman, elegantly attired in top hat and tails, high-steps across the dance floor with his satin-clad partner. Their frenetic movements are echoed by the artist's indulgent use of slashing white lines to indicate the vibrating floorboards and by the profound centrifugal force of her composition. Waring's portrayal also epitomizes the look of the New Negro—attractive, cosmopolitan, and fashionable—a potent foil for the widespread depictions of people of color as "grotesque, garishly dressed beings, with black skins, protruding red lips, and bulging eyeballs."[18]

Waring's paintings, often portraits of her friends, family, and Harlem literati, are paradigmatic of the images of upscale blacks that marked the Harlem Renaissance.[19] Her portrait of writer, educator, and suffragette Alice Dunbar Nelson reveals, through a superb color sense and impressionistic brushwork, Waring's affinity with the late nineteenth-century French painter Edgar Degas (fig. 4.5). Waring, who attended the Pennsylvania Academy (1918–1924) and the Académie de la Grande Chaumière in Paris (1914–1917, 1924–1925), won a Harmon Foundation gold medal in 1927 for her moving and realistic portrayal of Anna Washington Derry (fig. 4.6), as well as subsequent medals in 1928, 1930, and 1931. Waring's observant and objective eye and her expressive handling of paint reveal the influence of both realism and impressionism. Her ability to capture the nuances of the African-American psyche on canvas, through the use of discursive brushwork and carefully selected, often sumptuous colors (figs. 4.7, 4.8) convinced the officials of the Harmon Foundation to commission her to execute a series of portraits of esteemed African Americans, including Du Bois, James Weldon Johnson, and famed contralto Marian Anderson.

Waring experimented with a range of themes, from portraiture and genre scenes to landscapes and still life paintings (fig. 4.9). An admired and respected professional, she exhibited at such prestigious institutions as the Philadelphia Museum of Art, the Corcoran Gallery, the Art Institute of Chicago, and the Galerie du Luxembourg in Paris. Through the years of the Harlem Renaissance and

Figure 4.4
Laura Wheeler Waring
Jazz Dancer I (Study), c. 1939
watercolor and gouache on
paper, 10 x 8" (25.4 x 20.3 cm)

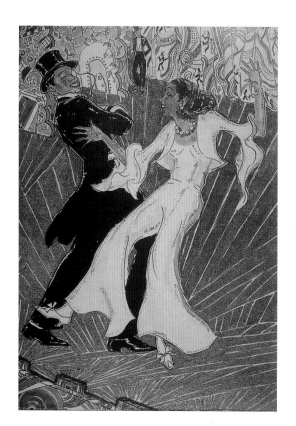

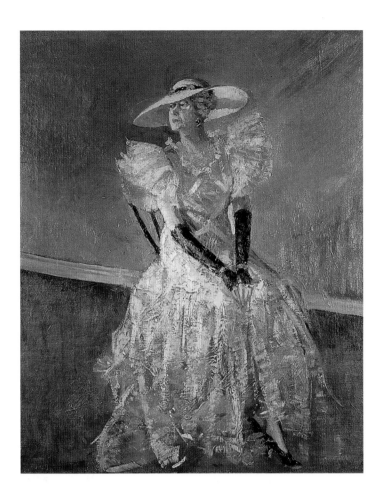

Figure 4.5
Laura Wheeler Waring
Alice Dunbar Nelson, 1928
oil on canvas, 25 x 21"
(63.5 x 53.34 cm)

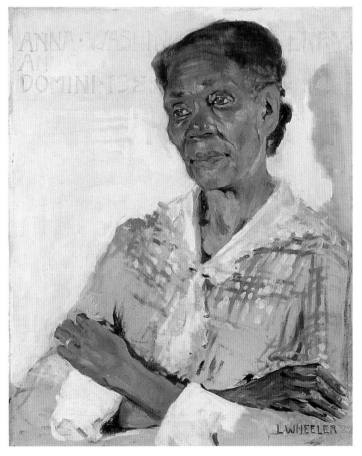

Figure 4.6
Laura Wheeler Waring
Anna Washington Derry, 1927
oil on canvas, 20 x 16"
(50.8 x 40.5 cm)

Figure 4.7
Laura Wheeler Waring
Girl in Red Dress, c. 1935
oil on board, 18 x 14"
(45.7 x 35.5 cm)

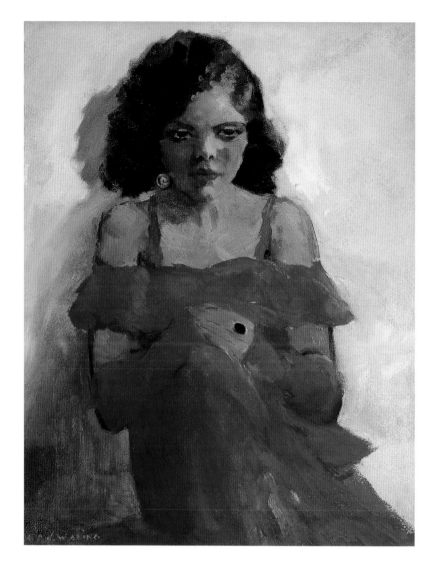

Figure 4.8 *(below left)*
Laura Wheeler Waring
Susan Davis Lowery, 1937
oil on canvas, 42 x 36"
(106.68 x 91.44 cm)

Figure 4.9 *(below right)*
Laura Wheeler Waring
Rose of Sharon, n.d.
oil on canvas, 19 1/4 x 15 1/4"
(48.9 x 38.7 cm)

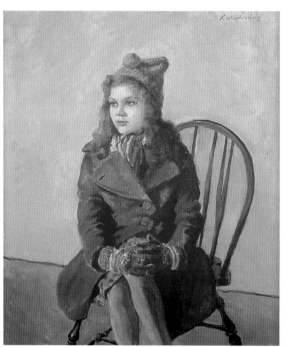

after, Waring taught art and music at Cheyney Training School for Teachers in Philadelphia. Her work has been described as romantic without being overly "pretty"—an attractive style to the major art patrons of the day such as the Harmon Foundation.[20]

As one of the only institutions in the country that systematically promoted African-American art, the Harmon Foundation wielded tremendous influence over the artists it supported, particularly with regard to the style and content of their art. Under the considerable influence of Locke, the foundation was inclined to endorse art that incorporated black subject matter or African-inspired motifs.[21] By the early 1930s, the works of Harmon artists were being described in distinctly racial terms, and the officers of the foundation openly encouraged the depiction of supposed black traits such as "physical strength, a sense of rhythm, optimism and humor, simplicity and aplomb," as delineated in a 1935 foundation report.[22] Such avowals, stereotypical as they may be, motivated African-American artists to create imagery that espoused the foundation's vision of blackness.

Albert Alexander Smith is a case in point. His *Dancing Time* (1930), depicting an assembly of black revelers, encapsulates the archetypes that the foundation favored (fig. 4.10). Smith was a Harmon leading light, exhibiting multiple works in each Harmon exhibit. *Dancing Time*, while not representative of the breadth of Smith's oeuvre, does illustrate a motif that many collectors looked for in black art. Critics of the foundation, such as artist Romare Bearden and art historian James Porter, found the popular preference for racialist imagery problematic because it ghettoized African-American art and encouraged aesthetic mediocrity by catering to the preferences of the art-going public rather than encouraging artistic excellence and individuality.[23]

African-American artists had to walk a fine line between portraying the African aesthetics that were supported by Locke and his circle, the clichéd black "primitivism" that white patrons expected, and imagery that expressed their own individuality. Examples of such patrons included the aficionado of French modernism Albert C. Barnes and the wealthy widow Charlotte Osgood Mason, who believed that art produced by African Americans should be representative of an experience unlike the Euro-American experience—a visual incarnation of jazz, so to speak. In a somewhat heavy-handed attempt to shape one artist's work, Barnes offered financial support to Harlem Renaissance artist Aaron Douglas with the stipulation that he consider adopting a brighter and more multichromatic (hence more "ethnic") palette in lieu of the

Figure 4.10
Albert Alexander Smith
Dancing Time, 1930
oil on canvas, 22 1/2 x 26 1/2"
(57.1 x 67.3 cm)

subdued cubist palette that had become a hallmark of his technique. Mason's willingness to pay the travel and living expenses of Harlem Renaissance intellectuals and artists such as Alain Locke, Zora Neale Hurston, Langston Hughes, and Aaron Douglas was intended, in part, to perpetuate Mason's own agenda: the preservation of a certain naïveté or primitivism, which she felt was unique to African-American creativity. Indeed, Mason's influence upon the work of those whom she financed was so taxing that Hurston, Hughes, and Douglas each ultimately declined her assistance in order to preserve their artistic integrity.[24]

The sponsorship of African-American artists by affluent benefactors such as Barnes and Mason was amplified by institutional patrons, including the New York Public Library, the New York State Fair, the Julius Rosenwald Foundation (which awarded fellowships to artists of color beginning in 1917), and commercial galleries, such as Edith Halpert's Downtown Gallery. Black patronage came from the "Negro chapters" of the YMCA (which served as venues for showings of African-American art) and from historically black colleges and universities, such as Howard University in Washington, D.C., Hampton University in Virginia, and Fisk University in Nashville, which collected and exhibited African-American art.[25]

Well-to-do blacks also played a role. Perhaps the best known of these were historian Arthur Alfonso Schomburg and cosmetics heiress A'lelia Walker. Born in 1874 of German and West Indian parents, Schomburg came to New York from Puerto Rico in the early 1890s. Over the next several decades, until his death in 1938, he amassed a collection of black art and ephemera that would, in years to come, form the core archive of Harlem's Schomburg Center for Research in Black Culture, today a branch of the New York Public Library. A'lelia Walker was the daughter of business tycoon Madame C. J. "Sarah" Walker, whose patented hair growth and straightening system made her America's first self-made woman millionaire. A'lelia not only collected African-American art but, at one point, commissioned Aaron Douglas to redesign her townhouse manor on 136th Street, known as the "Dark Tower," in order to accommodate a cultural salon the likes of which Harlem had never seen. French princesses, Russian dukes, English Rothschilds, and New York nobility shared cocktails and conversation with aspiring black artists in this remarkable environment where social roles were inverted. African Americans were the reigning elite, served champagne and caviar, while white guests were sequestered in separate, less sumptuous quarters and fed chitterlings and bathtub gin. Walker's salon was a premiere venue for black artists and literati.[26]

As a result of this diversity of patronage and artistic philosophies, the look of Harlem Renaissance art was even more eclectic than its patron base.

African-American artists were compelled to respond to an array of both social and aesthetic stimuli. An artist who navigated this grey area between personal freedom and public obligation with an aplomb few others could muster was **Lois Mailou Jones** (1905–1998). She began her vocational pursuits shortly before the Harlem Renaissance, in 1919, as a freshman at the High School of Practical Arts in Boston. Encouraged by a chance meeting with the older artist Meta Warrick Fuller and by her lawyer father, Jones pursued a professional career as a designer. Her talents were prolific. She mounted her first one-woman show in 1923 at seventeen, and ventured into costume design while still a high school student. Working as an assistant to dress designer and Rhode Island School of Design (RISD) professor Grace Ripley, Jones discovered African costumes and masks and quickly incorporated their unique qualities into her own art.[27]

Jones spent afternoons and Saturdays taking drawing classes at the Boston Museum of Fine Arts, where she sharpened her skills as a designer. After high school, she continued at the Boston Museum School on a four-year college scholarship, where she majored in design and frequently won art prizes. Intensely dedicated to her artistic education, Jones spent her last year of college taking additional design courses at the Boston Normal School (today, the Massachusetts College of Art) from which she received a design certificate in 1927, simultaneously graduating with honors from the Boston Museum School.[28] By the time Jones received her B.F.A., she had become a skilled designer and draftsman.

Jones received a scholarship for graduate study at the Boston Designers Art School. There she majored in textile design, and she began selling her designs to prominent New York fabric houses, including F. A. Foster and Schumacher Company (fig. 4.11). Jones's prize-winning patterns did not satisfy her professional ambitions, however. She realized that textile designers were considered practitioners of the low arts and were not likely to enter the historical roster of great masters. Fame was something Jones craved, as her own words attest: "Only the name of the design . . . was known, never the artist. . . . That bothered me because I was doing all this work but not getting any recognition. And I realized I would have to think seriously about changing my profession if I were to be known by name."[29] Jones would make good her promise to become "known by name" within a very few years when she shifted her focus from design to painting.

Soon after completing graduate study, Jones sought employment in the form of a teaching assistantship at her alma mater, the Boston Museum School. Despite her exemplary academic record and professional successes, her application was turned down. Jones was instead advised to travel south "to help her people"—advice which disconcerted her because it implied

that the only appropriate place for her to pursue a teaching career was in the black South, rather than in her New England home. Jones did, however, go south where, in 1928, she met Charlotte Hawkins Brown, director of a private black high school and junior college in Sedalia, North Carolina: the Palmer Memorial Institute. Jones persuaded Brown to hire her to chair a new art department, which Jones fashioned after the Boston Museum School. During her first year at Palmer, Jones invited James V. Herring, chair of the art department at Howard, to come to Sedalia as a guest lecturer. Impressed with Jones's administration of the art department, Herring invited her to join the recently formed Howard University fine arts department, which she did in 1930.[30]

During this period, Jones traveled regularly to New York City and became acquainted with the leaders of the New Negro movement, among them Langston Hughes, Countee Cullen, Aaron Douglas, and her Howard University colleague Alain Locke. Under the influence of Locke and the Harmon Foundation (from which she received an honorable mention for a

Figure 4.11
Lois Mailou Jones
Textile Design for Cretonne, 1928
offset, 28 x 21" (71.1 x 53.3 cm)

1930 portrait of one of her Palmer Institute students), Jones focused consistently on African and African-American subject matter, alternating these interests with her more personal interest in landscape, abstract design, and the human figure (fig. 4.12). In an interview shortly before her death in 1998, Jones confirmed that much of the art she produced for the Harmon exhibits was designed especially to appeal to the foundation's conceptual program:

> Having gone to the Boston Museum School and had the exposure of the Boston Museum . . . where I would go and look at the works of [John Singer] Sargent and Winslow Homer and aspire, more or less, in that direction, I wasn't thinking, at that time, of any particular racial boundary—you know, limit. So that it really was sort of wide open. But . . . the Harmon exhibits did sort of change you into working in the direction of black art because, to interest the people in Harlem, for example, the black subject would be popular.[31]

In works such as *Les Fétiches* (1938), Jones struck a delicate balance between the requirements of the foundation and those of her own creative spirit (fig. 4.13). The work reveals the artist's knowledge of cubist monochromy and flattened form and indicates Jones's familiarity with African sculpture, which she studied firsthand in Paris. Depicted in *Les Fétiches* are Dan, Yaure, and Baule masks and talismans from the Ivory Coast and a striped *kifwebe* headdress from the Kongo. These boldly rendered images, within the vernacular of cubism, represent a marriage of African and European artistic traditions, and of personal and public aesthetic requirements.

Les Fétiches was completed while Jones was in Paris on sabbatical leave, and she remained there for a year under the financial auspices of the General Education Board. In Paris, she spent her time painting *en plein air* (outdoors, in the impressionist manner) along the banks of the Seine and studying at the Académie Julien. She also met French symbolist painter Émile Bernard, who provided her with invaluable criticism as well as storage space in his studio for her easel and canvases. Bernard's kindness was an example of the goodwill tendered by many French artists to their African-American comrades. Jones felt "shackle-free" in Paris; its liberating environment allowed her to identify herself as a painter, rather than as a

Figure 4.12

Lois Mailou Jones

Jenny, 1943

oil on canvas,

35 3/4 x 28 1/4"

(88.3 x 77.7 cm)

Figure 4.13
Lois Mailou Jones
Les Fétiches, 1938
oil on canvas, 25 1/2 x 21"
(64.8 x 53.3 cm)

"Negro," and it permitted her the freedom to absorb both French modernism and African art. Jones's Paris works from this and later visits alternated between academic portraits and figures and lively impressionist street scenes and still lifes (fig. 4.14). She progressed so rapidly as a painter that by the end of her sabbatical, she had completed more than forty works and exhibited at the Salon de Printemps, the Galerie Charpentier, and the Société des Artistes Français. Jones's time in Paris marked a turning point in her career, giving her the space to become a painter "of strength and accomplishment."[32]

In Paris, Jones benefited from a French parallel to the Harlem Renaissance known as *Négritude*. This literary and visual arts phenomenon, like the New Negro movement, exalted African culture and espoused a belief in an exceptional "Negro personality." Specifically, *Négritude* artists proclaimed the existence of a "mythic" African soul that was sensitive, sensual,

and spiritual. Simultaneously, *Négritude* thinkers, like other Pan-Africanists, declaimed the global oppression of African people. The *Négritude* movement was propelled by a group of black intellectuals from French West Africa and the Antilles who lived in Paris, including writers Birago Diop, René Maran, Aimé Césaire, Léon Dumas, and Léopold Senghor and painter Gerard Sekoto. A coincident group in Haiti, known as the *Indigenists* (with which Jones also became acquainted) included writers Jean Price Mars and Petion Savain, who was also a visual artist. *Négritude* writing (mostly poetry) and painting was expressionistic—colorful and deliberate in its articulation and purpose (rather than surrealistic as is sometimes suggested)—and it focused on the moral supremacy and dignity of African people, all elements that were evident in Jones's work.[33]

After her first year abroad, Jones was honored with a solo exhibition of her Paris street scenes, figures, and portraits at the Robert C. Vose Gallery in Boston. The exhibition was well received by critics, who described Jones as "the leading Negro artist" of the day and declared her paintings to be "imbued with the qualities the Impressionists sought to achieve through painting with broad strokes [and] summary patches of color, which catch the effect of sunlight upon surfaces."[34] In the wake of her Paris and Boston successes, Jones capitalized on her emerging reputation by submitting works to major museum shows. She avoided the pitfalls of her predecessors by arranging for white friends to present works on her behalf. The ploy made it possible for Jones to enter paintings in competitions at the Corcoran Gallery and the Pennsylvania Academy, among other institutions, where she might otherwise have been turned away. When, on one occasion, a first prize honor from the Pennsylvania Academy was revoked upon discovery of her ethnic identity, Jones remained impervious to the insult. "I never let it affect me," she maintained. "I lived above it [because] I knew I was good."[35]

Figure 4.14
Lois Mailou Jones
Jardin du Luxembourg, c. 1948
oil on canvas, 23 3/4 x 28 3/4"
(60.3 x 73 cm)

Throughout the 1930s, Jones engaged in the kind of collaborative efforts between literary and visual arts that marked the Harlem Renaissance. Such cooperative undertakings could be seen on the covers and in the pages of political journals, such as *Crisis, Opportunity,* the *Messenger,* and *Survey Graphic,* and in books authored by the literary giants of the day and illustrated by renowned Harlem Renaissance artists. Jones worked as an illustrator for the Associated Publishers of Washington, D.C., a firm that was founded by African-American historiographer Carter G. Woodson and dedicated to the publication of black literature, including the *Journal of Negro History* and the *Negro History Bulletin.* Jones's career with Associated began in 1936 and lasted some thirty years. She illustrated covers of the *Bulletin,* books of poetry, and African history texts.[36] Bold reductive forms, clearly articulated outlines, strong diagonals, and solid vertical thrusts are the hallmarks of her illustrations.

As both a painter and an illustrator, Jones was heralded in France, Haiti, and the United States for her dedication to black themes and to an ever-evolving individual aesthetic. In 1952, *Lois Mailou Jones: Peintures, 1937–1951* was published in France—one of the earliest monographs on an African-American artist. In 1955, she was awarded the Diplôme Décoration de l'Ordre National by President Magloire of Haiti, which was the home of her husband, Louis V. Pierre-Noël (whom she had married in 1953), and where she taught at the Port-au-Prince Centre d'Art and Foyer des Arts Plastique. Later in her career, Jones continued to exhibit in dozens of group and solo shows at home and in the annual Paris salons, the thematic influence of the Harlem Renaissance remaining evident in her work. A painting completed after a trip to Africa when Jones was in her sixties, *Ubi Girl* reveals her interest in West African themes as well as her unremitting sense of design (fig. 4.15). At the end of her life, Jones's career was chronicled in the biographical monograph *The Life and Art of Lois Mailou Jones* (1994), and her painting *Les Fétiches* graced the cover of the historic Smithsonian Institution catalog on African-American art, *Free within Ourselves* (1992).[37] Despite her successes and her perennial loyalty to the "Lockean" subject, by the end of her life Jones admitted that she had "tired of being considered only as a black painter. I'm an American painter who happens to be black."[38] Her comments echo the attitudes of a great many African-American artists who feel that their creativity need not be grounded in an exclusively racial experience.

Artists such as Waring, from her base in Philadelphia, and Jones from Washington, D.C., did their respective parts to spread the word (and the imagery) of the New Negro movement. Others, such as sculptor **Beulah Ecton Woodard** (1895–1955), carried the torch as far afield as California.

Geographically but not spiritually removed from Harlem, these artists, to use Woodard's words, were determined to "promote a better understanding of the African with his rich historical background" in the true Harlem Renaissance tradition.[39] Born on an Ohio farm, Woodard was the daughter of a Civil War veteran and his wife, Mr. and Mrs. William P. Ecton. Her parents relocated, and she grew up in Los Angeles, inheriting a love of the arts from her grandfather, who was a sculptor, and from her grandmother, a former slave and expert weaver who made her own dyes and designs. Inspired by their example, Woodard studied architectural drawing at L.A.'s Polytechnic High School, and she later took instruction in sculpture at the Los Angeles School of Art, Otis Institute, and the University of Southern California.[40]

While studying sculpture, Woodard simultaneously cultivated an interest in African culture, sparked by a childhood acquaintance with an African national. Woodard's *African Woman* (fig. 4.16), modeled in glazed terra cotta, was consciously designed to extol African beauty. *African Woman* abounds with physical virtues—from the subtle inclination of her head to the silhouette of her full, heart-shaped mouth, and from the turn of her shapely nose to the delicate expanse of arched brow above her heavily lidded eyes. In the tradition of nineteenth-century French ethnographic sculpture, Woodard painstakingly replicated the style of braided coiffure, headdress, and earrings worn by women of the Ekoi of Nigeria and the Luba, Hemba, and Mangbetu of central Africa. Her goal in doing so was as much educational as aesthetic. As she explained, "In the so-called 'primitive' African, there is much of which Negroes today should be proud. I am recording types . . . [that] are at once interesting, picturesque, dramatic, and colorful."[41]

While still an aspiring artist, Woodard, who worked out of a small studio in her home, drew the attention of James R. Smith, publisher of the *California News.* Smith decided to exhibit Woodard's work in the newspaper's offices and also to make advertising space available to her, which she used to sell her sculptures to *California News* readers. The exposure provided for Woodard prompted librarian Miriam Matthews to organize a show of Woodard's art at the Los Angeles Public Library's Vernon branch. Woodard subsequently received several commissions from the Urban League and, after a number of minor exhibitions, was invited to mount a one-person show at the Los Angeles County Museum, the first African American ever to be given access to this celebrated venue. The eight-week exhibition comprised a series of clay and papier-mâché masks, which were decorated with elaborate beading and feathers and based upon the artist's

Figure 4.16
Beulah Ecton Woodard
African Woman, c. 1938
glazed terra-cotta,
11 1/4 x 10 3/4 x 5"
(28.5 x 27.3 x 12.7 cm)

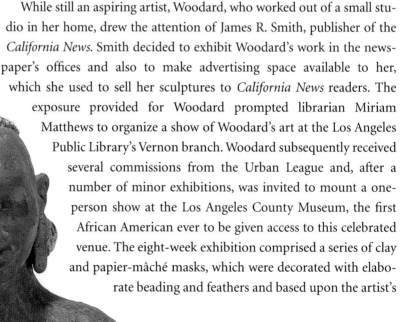

anthropological research. The masks were remarkable enough to attract the notice of several Los Angeles newspapers, and word of the exhibition was carried by the Associated Press to print media throughout the country. As a result, thousands of visitors flocked to see Woodard's *Mangebeton Queen, Fulah Kunda,* and *Masai Warrior.*[42]

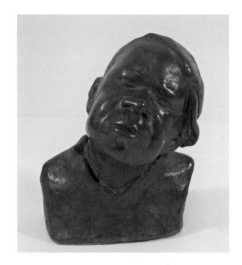

According to historian Lizzetta LeFalle-Collins, the nineteen masks displayed at the museum represented one of the artist's most meaningful achievements. Replete with realistic details, these sculptures were designed, in the artist's estimation, "to educate African Americans to take pride in their African heritage."[43] Woodard's masks also tapped into the enthusiasm that whites on both coasts evinced for black culture. According to LeFalle-Collins, "these objects held mystery for well-heeled patrons" and provided entrée for Los Angelenos into the realm of the Other.[44] The exhibition's notoriety was a boon to Woodard's career. She was invited to lecture on the academic circuit and received a number of commissions from prominent California politicians, philanthropists, and collectors. Woodard's subsequent creative phase comprised straightforward character studies of African Americans, carved or modeled in wood, bronze, clay, and stone (figs. 4.17, 4.18). Sculptures such as *Bad Boy* (1936) and *Maudelle* (dancer and model Maudelle Bass, c. 1937) point to Woodard's preference for realism—a preference that was praised by one Hollywood critic as a welcome reprieve from the contemporaneous trend toward abstract sculpture: "Not for her [Woodard] the *fol-de-rols* [*sic*] of abstraction, to create which one needs only ingenuity. What counts with her is something more worthwhile—to wit, emotion."[45]

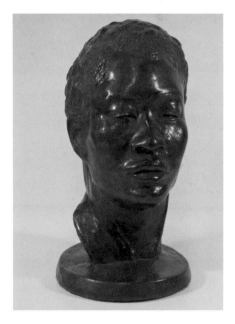

Committed to the tenets of the New Negro movement and to supporting artists of color, in 1937 Woodard founded the Los Angeles Negro Art Association. She continued to exhibit and to receive commissions throughout the 1940s, but, by this time, the economic and social expansiveness that had facilitated the Harlem Renaissance was coming to a close.[46] By the mid-1930s, escalating social discontent and economic adversity, brought on by the stock market crash and the Great Depression, had reduced Harlem to an impoverished slum. Government patronage of the arts took over from private support, and this new federal patronage manifested itself for the next decade in President Franklin Delano Roosevelt's unprecedented New Deal.

In an effort to alleviate the joblessness and poverty that beset Americans nationwide, President Franklin Roosevelt inaugurated an ambitious program of social and economic reform known as the New Deal. A major component of the program was the Works Progress Administration (WPA), which provided sorely needed jobs and financial support to record numbers of unemployed and impoverished citizens, not the least of whom were African Americans. In fact, African Americans, who made up approximately 10 percent of the national population, comprised between 15 and 20 percent of the WPA work force. The WPA employed a massive labor force mainly composed of construction workers and road and park maintenance crews. Also retained were professionals such as doctors, teachers, writers, musicians, actors, and visual artists. The WPA's Federal Art Project fostered artists' productivity throughout the difficult years of the Great Depression by funding social realist imagery that lionized the New Deal, American history, the working class, political activism, and "practical" arts such as graphic design. During the decade of its existence, the agency spent $85 million in support of the arts and refocused sponsorship away from privatized dependency upon wealthy patrons toward the less capricious public sphere. It also introduced incalculable numbers of Americans to the fine arts for the first time and permanently mainstreamed fine arts into American culture.[1]

The Federal Art Project, conceived by artist and lawyer George Biddle, began in 1933 as the Public Works of Art Project (PWAP) of the Civil Works Administration (CWA). The PWAP operated under the direction of Edward Bruce with more than $1 million allocated, and nearly 4,000 artists employed at weekly salaries of about $40. Due to concerns that the program would prove too costly and create "a permanent class of relief recipients," the CWA was dismantled after its first year. Persistent unemployment and pressure from both government officials and the public resulted in the con-

F I V E **The New Negro and the New Deal**

figuration of a new relief program in 1935, with initial funding from Congress of almost $5 billion.[2]

Using these resources, President Roosevelt created the WPA—a substantially more comprehensive version of the CWA. Its support of the arts extended to the Federal Music Project (FMP), the Federal Theatre Project (FTP), the Federal Writers Project (FWP), and, as a replacement for the PWAP, the Federal Art Project (FAP). Under the directorship of Holger Cahill, the FAP employed painters, sculptors, graphic designers, and art teachers. It funded community art centers in Cleveland (the Karamu House Artist Association), in Detroit (Heritage House), on Chicago's Southside (the Southside Community Art Center), and in New York (the Harlem Art Workshop and the Harlem Community Art Center). Between 1935 and 1943, the WPA supplied some 10,000 artists with weekly salaries, training, and supplies. Under the program's auspices, hundreds of thousands of easel paintings, prints, photographs, posters, sculptures, and murals were produced. African-American artists especially benefited from WPA employment during the depression, the effects of which had all but decimated the black community. Compared to the 30 percent unemployment of white Americans in 1933, nearly 50 percent of the African-American population was out of work. Despite the fact that, in its initial phase, the art project paid black artists a lower wage than it did whites (a practice that was subsequently outlawed), the WPA quite literally rescued hundreds of African-American artists from destitution.

In the course of their employment, WPA artist-recruits were given rare opportunities to work alongside master professionals in training programs and as artists' assistants. Artists of color were able to meet and to study with painters, sculptors, and photographers such as Dorothea Lange, Grant Wood, Stuart Davis, Jackson Pollock, George Bellows, Thomas Hart Benton, John Steuart Curry, Isamu Noguchi, Arshile Gorky, Diego Rivera, and José Clemente Orozco. Many artists remembered their years of creative collaboration in the WPA as "the most meaningful and happiest times" of their lives, and they recalled the WPA era as one which provided them with a "sense of purpose" and an opportunity for "close comradeship" with fellow artists.[3]

In Harlem, one such cooperative WPA initiative entailed the configuration of a sequence of murals at Harlem Hospital, under the direction of African-American painter Charles Alston. Alston oversaw the work of nearly two dozen artists of color, including Gwendolyn Knight, Elba Lightfoot, Selma Day, Georgette Seabrooke-Powell, Beauford Delaney, Louis Vaughn, and others. The collective nature of the Harlem mural enterprise, its WPA mission to bring art to the public, its subject matter of black

history and folklore, and the iconic realism of the styles employed mirrored a global shift toward readily comprehensible and socially conscious art, which dovetailed with Harlem Renaissance aesthetics. Similar objectives were central to the efforts of the constructivist graphic designers of postrevolutionary Russia, the German Neue Sachlichkeit painters, and the Mexican muralists, in particular *los tres grandes* (the three greats), José Clemente Orozco, Diego Rivera, and David Alfaro Siqueiros. Indeed, both Rivera and Orozco frequented Harlem in support of African-American artists, and their works were cited by FAP founder Biddle as paradigms for the WPA.[4]

Markedly atypical in the production of the Harlem murals was the presence of a number of women artists on the creative team. Their participation was due in part to the expansive nature of the WPA which, in 1935, issued a mandate against sexual and racial discrimination in the workplace. As a result, 30–40 percent of newly hired artists were women. As Benjamin notes, "From the upper echelons to the bottom ranks, women played major roles. . . . [They] donned overalls, climbed ladders, and worked in public spaces in large numbers, side by side with their male colleagues."[5]

One artist to benefit from the WPA's antidiscrimination edict was painter and printmaker **Georgette Seabrooke-Powell** (1916–). A native of Charleston, South Carolina, Seabrooke-Powell's family migrated to New York in 1920. As a young woman, she became affiliated with the Harmon Foundation and worked on mural projects at both Harlem Hospital and Queens General Hospital. Seabrooke-Powell's 1936 mural, *Recreation in Harlem*, venerated the everyday citizen in a manner that approximated the socialist art of Russia and Mexico (fig. 5.1). This monumental oil painting, nearly twenty feet in length, is a montage of working-class Harlemites engaged in a variety of activities. In a series of vignettes, Seabrooke-Powell depicted a choral youth group performing in a small amphitheater, two

Figure 5.1

Georgette Seabrooke-Powell

Recreation in Harlem, **1936**

oil, 5' x 19' 5" (152.4 x 579.12 cm)

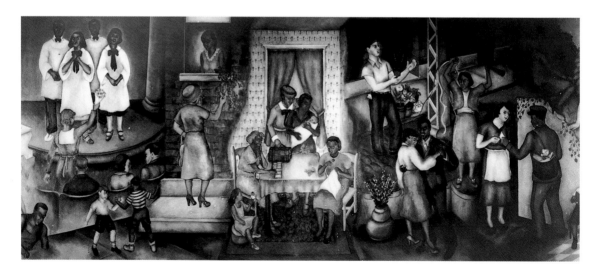

women conversing through an open apartment window, and a domestic scene including four women, an infant, and a child. Additional tableaux featured a couple dancing, a reveler, a postman delivering mail, and two children wrestling. At the time of the completion of the Harlem Hospital project, Seabrooke-Powell was an art student at Cooper Union, where she had just won the school's painting prize for a depiction of a lively church service. She later studied theater design at Fordham University, the foreshadowing of which can be seen in the stagelike construction of *Recreation in Harlem*.[6]

Especially striking in the mural is the marked presence of Harlem's female citizens. Of the approximately two dozen figures in Seabrooke-Powell's rendering, well over half of them are women. Each is an active, integral participant in the artist's interpretation of Harlem life, and male family members are conspicuously absent. Her inscrutable woman reveler, who stands atop a small platform with raised arms, holding a narrow horn and streamers, is curiously reminiscent of a Harlem street-corner philosopher—an archetype more readily associated with men than with women. These protofeminist figures offer glimpses of women who, while empowered, have neither the physical (stout) appearance of the mythical Matriarch nor superhuman autonomy. On the contrary, Seabrooke-Powell's women are slender, attractive, and obviously part of an interdependent community.

What proved controversial at the time was not Seabrooke-Powell's representation of women, but the fact that her original design depicted an all-black community. Hospital officials insisted that she integrate white figures into her schema, stating that they did not want their institution to become known as a "colored hospital." While compelled to follow this directive, the artist titled her work *Recreation in Harlem*, so that its intended subject matter would not be obscured. Furthermore, of the eight white characters eventually incorporated into the design, five of them face away from the viewer and three are racially ambiguous, thus diminishing their presence within the otherwise African-American enclave. By adhering to the letter, but not the spirit, of the hospital's requirements, Seabrooke-Powell was able to remain true to her initial vision. Her affinity with art deco design is evident in her *Woman in Profile*, which represents a distinct departure from the style of the Harlem mural (fig. 5.2). The emphatic silhouettes in this 1930 linocut link Seabrooke-Powell's imagery to the illustrations of Lois

Figure 5.2

Georgette Seabrooke-Powell

Woman in Profile, 1930

linocut, 6 3/8 x 5 5/8"

(16.2 x 14.3 cm)

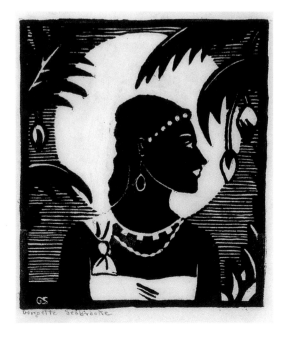

Jones. Indeed, like Jones, she worked as an illustrator and, in 1932, designed a cover for *Opportunity* magazine.[7]

The sculptor-activist **Augusta Savage** (1892–1962)—arguably the most influential African-American artist of the 1930s—took full advantage of the support provided by the WPA. Born Augusta Fells in Green Cove, Florida, Savage was the seventh of fourteen children of Cornelia Fells and her husband, Edward Fells, a rigidly conservative minister who believed corporal punishment would cure his daughter's interest in making "graven images." His ardent and sometimes violent disapproval of her artistic pursuits nearly extinguished Savage's childhood dreams of becoming a sculptor. She temporarily escaped his wrath by entering into marriage at age fifteen. Unfortunately, soon after the birth of Savage's first child, her husband died, and the teenaged widow was obliged to return to her family in West Palm Beach. Savage opportunely found support for her artistic endeavors in the local school system, where her high school principal, impressed with her talents, invited her to teach modeling to her classmates. In 1919, Savage exhibited her first sculptures (clay birds) at the West Palm Beach County Fair, where she not only sold several pieces, but also won a blue ribbon and a $25 prize for excellence.[8]

In 1921, after a short-lived second marriage and a brief enrollment at Tallahassee State Normal School (now Florida A&M University), Savage moved to New York. She was twenty-nine years old when she arrived in the city and had less than $5 in her pocket. More precious than money was a letter of introduction from the superintendent of the West Palm Beach Fair, George Graham Currie, to Solon Borglum, founder of the School of American Sculpture and member of the American Academy of Fine Arts. When Borglum realized that Savage could not afford the cost of tuition at his institution, he introduced her to Kate L. Reynolds, head of Cooper Union, a scholarship-based school that required no tuition. The portfolio that Savage presented to Reynolds was so superior that the artist was admitted to Cooper immediately, ahead of 142 others on the waiting list.[9]

Supporting herself as a housekeeper, Savage began her student career. The aspiring artist advanced through the Cooper curriculum so rapidly that, within weeks of her arrival, she was enrolled in upper-level classes. She was also awarded a scholarship to help pay her living expenses. A commission from the Schomburg Center to produce a portrait bust of Du Bois added to her resources. This prestigious commission brought Savage under Du Bois's considerable influence and stimulated Savage's interest in art politics. After graduating from Cooper in 1923, Savage was awarded a scholarship to attend the Fontainebleau School of Fine Arts in France. Unfortunately, when two other scholarship recipients from Alabama (with whom

Figure 5.3

Augusta Savage

Gamin, 1930

bronze, 16 1/2 x 8 1/3 x 7"

(42 x 21.2 x 17.8 cm)

the artist would have shared summer accommodations) refused to travel with a "colored girl," Savage's award was rescinded. The affront garnered a great deal of publicity for the artist and resulted in an outpouring of protests, including direct intervention on her behalf by Du Bois. Appeals were made to the French government to reinstate Savage's scholarship, but the awards committee could not be persuaded and Savage was unable to travel to France. The missed opportunity to study abroad devastated the artist. It would take her six years to accumulate the necessary funds to make the voyage.[10]

During this period, family obligations weighed heavily upon Savage. Much of what she earned, primarily working as a laundress, was sent to Florida to help support her family. Although she relocated them to her small Harlem apartment to better (and more economically) care for them, their dependency upon her made travel to Europe logistically impossible. In 1925, for example, Savage declined a working scholarship to study in Italy, which had been offered to her by Countess Irene Di Robilant of the Italian-American Society. The award paid for travel and study only—not for living expenses, which Savage could not afford. Exacerbating matters, her extended family moved in with her after her brother's untimely death in a tragic drowning accident, sapping any surplus savings that Savage might have accrued for a continental journey.[11]

As an alternative to European study, Savage chose to train with Herman MacNeil, then president of the National Sculpture Society and a dissenting member of the Fontainebleau awards committee. MacNeil invited Savage to study privately with him at his studio in College Point, New York, which she did during the summer of 1923. Over the next several years, Savage became immersed in the milieu of Harlem. When commissioned to sculpt a portrait of Marcus Garvey, she met her third husband, UNIA secretary general Robert L. Poston. The influences of Garvey's Pan-Africanist circle and of Du Bois would soon dovetail with Savage's own aims as a sculptor, at which point she would become as committed to social activism as she was to art.[12]

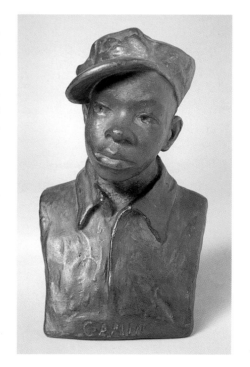

Savage launched her career by exhibiting at the Harmon Foundation. One of her first submissions in 1928, *Head of a Negro*, won the foundation's Otto Kahn Prize, but it was her sculpture *Gamin* (fig. 5.3) that earned Savage a Rosenwald fellowship and allowed her, at long last, to travel to Europe. *Gamin* is a portrait of the artist's nephew Ellis Ford, and it exemplifies a subject that was very popular in American art: the street urchin. *Gamin* portrays Ellis as an attractive, street-wise boy whose skewed cap, slightly inclined head, and

Figure 5.4
Augusta Savage
James Weldon Johnson, 1939
painted plaster, 17 x 9 x 9 1/2"
(43.2 x 22.9 x 24.1 cm)

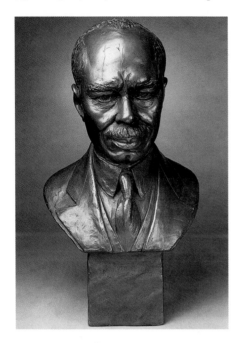

melancholy wide-set eyes offer observers an enticing glimpse of Harlem reality. His ample lips and delicately rounded nose celebrate African-American physiognomy and "reveal the beauty that prejudice and caricature has overlaid," in precisely the manner that Locke had intended. *Gamin* is also an example of the "new realism" that was so popular at the time.[13]

In addition to the Rosenwald moneys, *Gamin* won a second award from the Carnegie Foundation. With the support of these funds and further contributions from MacNeil and other supportive friends, Savage sailed for Europe in 1929. Settling in Paris and making occasional excursions to Belgium and Germany, she studied traditional sculpting styles and methods at the Académie de la Grande Chaumière. Savage flourished in Paris. During her first year there, she participated in exhibitions at the Société des Artistes Français de Beaux Arts, the Grande-Palais, and both the Salons d'Automne and de Printemps, where her sculptures won honorable mentions. In 1931, her works were again featured in the Paris Salon, as well as in the French Colonial Exposition. Savage remained linked to the New York art scene by shipping sculptures home for inclusion in the Harmon exhibitions, which allowed her to establish her reputation on two continents. Savage's interlude in Europe came to an end after two years and, at the age of forty, she returned to the United States.[14]

Savage's homecoming in 1932 was triumphant. She was the first African American to be elected to the National Association of Women Painters, and she was invited to exhibit in the tenth annual Salons of America spring exhibition. The formidable Argent Galleries agreed to act as her agent, and numer-

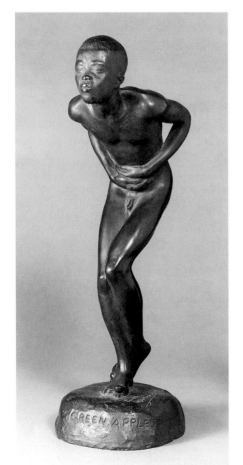

Figure 5.5
Augusta Savage
Green Apples, 1928
bronze, 15 1/4" high (38.7 cm)

ous other exhibitors throughout the Northeast displayed her portrait busts of children, friends, and renowned African Americans for an appreciative public (fig. 5.4). The exquisitely polished, lithe, and lyrical style that Savage had fine-tuned in Paris, evident in her bronze sculptures *Green Apples* (1928) and *La Citadelle/Freedom* (1930), was highly prized by collectors and set the price of her works as high as $300 (figs. 5.5, 5.6). At this point in her professional career, Savage became involved in art-world politics, administration, and teaching. She helped to supervise the Uptown Art Laboratory and, in 1932, established her own Studio of Arts and Crafts on West 143d Street in Harlem. Operating under the financial auspices of the Urban League, "the Studio," as Savage's academy was known, offered a variety of art classes to Harlemites and set a standard for the artist's future ventures. In 1933, with renewed aid from the Carnegie Foundation and in collaboration with colleagues such as Seabrooke-Powell, Charles Alston, and Harmon director Mary Beattie Brady, she established the Harlem Art Workshop, expanding upon the pedagogical offerings of the Studio.[15]

Housed initially in the Schomburg Center on 135th Street, the Harlem Art Workshop was affiliated with the State University of New York's adult education division and offered one of the largest free art instruction programs in New York City. By 1935, it boasted nearly seventy students (fig. 5.7). Savage organized an ambitious student art exhibition around the theme of Harlem life, which was installed at the 138th Street branch of the YMCA, also in 1935. Within a year of its establishment, the Harlem Art Workshop had obtained WPA sponsorship and moved to an old red-brick stable at 306 West 141st Street—a site procured by Alston and sculptor Henry W. Bannarn. Alston, who took up residence there, began to invite fellow artists and friends to socialize, study, and converse with him and his colleagues at "306." Almost immediately, the address became a social and intellectual hub, to rival A'lelia Walker's Dark Tower.[16]

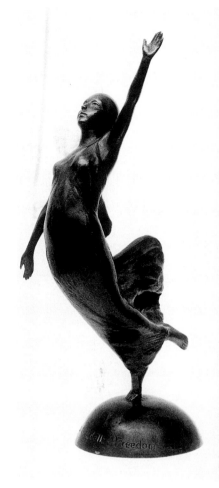

Figure 5.6
Augusta Savage
La Citadelle/Freedom, 1930
bronze, 14 1/2" high (36.8 cm)

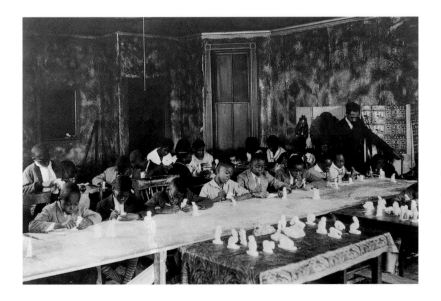

Figure 5.7
At the Harlem Art Workshop,
James Wells oversees a group
of children, c. 1935

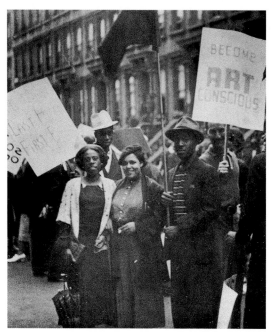

Figure 5.8

Members of the Harlem Artists
Guild picketing WPA cutbacks
Right foreground, Norman
Lewis; *center foreground*,
Gwendolyn Bennett; *behind
Bennett in the white hat*,
Frederick Perry; *right side behind
Lewis*, Artists Union organizer;
others unidentified

Figure 5.9

Instructors of the Harlem
Community Art Center, 1930s
Front row (left to right): Zell
Ingram, Pemberton West,
Augusta Savage, Robert Pious,
Sarah West, and Gwendolyn
Bennett; *back row (left to right):*
Elton Fax, Rex Gorleigh, Fred
Perry, William Artis, Francisco
Lord, Louise Jefferson, and
Norman Lewis

Cross-disciplinary exchanges between artists, writers, musicians, critics, and journalists were central to the gatherings at 306. The address attracted the likes of dancer Katherine Dunham, historian Charles Seifert, sculptor Selma Burke, writer Ralph Ellison, and dozens more. The white intellectual aristocracy, too, frequented the popular salon, including German writers Ernst Toller, Stefan Zweig, and Ludwig Renn. Topics of discussion ranged from New Deal politics to union participation, and from Mussolini's invasion of Ethiopia to the importance of socially conscious art. One of the issues at the forefront of 306 discussions was the limited number of African Americans employed in supervisory capacities by the WPA, and it was at 306 that resolutions to this dilemma were discussed and formulated.[17]

In response to racial inequities within the WPA, and coincident with the Harlem riot of 1935 (which was sparked by endemic job discrimination, among several causes), Savage cofounded the Harlem Artists Guild with Alston and Arthur Schomburg (fig. 5.8). The guild was a political organization dedicated to the needs and concerns of African-American artists, and it provided an alternative to the Artists' Union, which was made up of mostly white artists and only tangentially concerned with the particular needs of artists of color. Serving as president of the guild, Savage helped to secure employment and increased wages for a number of her peers.[18]

In 1936, as a result of her work in the Harlem Artists Guild, Savage was appointed an assistant supervisor for the WPA's FAP. To lobby for increasing the numbers of African Americans employed by the agency, she went

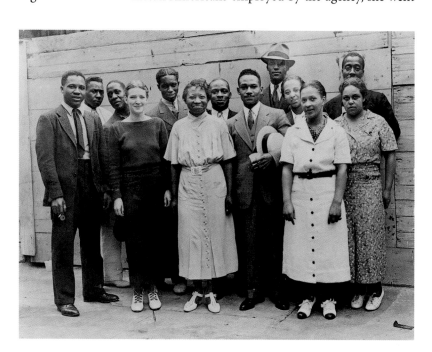

about the business of "badgering politicians, conducting press conferences, and organizing black artists to have their voices heard."[19] As a result of her "vigor and advocacy" she was named, in 1937, the first director of the Harlem Community Art Center, an outgrowth of the Harlem Art Workshop, which she had founded in late 1936 (fig. 5.9). The center continued to provide the black community with an "unprecedented and rare opportunity to study fine arts," and trained more than 1,500 students in drawing, painting, sculpture, printmaking, and photography.[20]

Under Savage's directorship, the center "was heralded throughout the nation" as a model for WPA art centers. First Lady Eleanor Roosevelt attended the center's opening day ceremonies on 20 December 1936. The resulting public attention attracted such renowned visitors as Albert Einstein and Paul Robeson. Included in the center's student population were Jacob Lawrence, Ernest Crichlow, Norman Lewis, and William Artis, all of whom went on to become renowned artists. The eventual successes of students such as these meant a great deal to Savage, who believed that her primary legacy was to "inspire . . . youngsters to develop the talent [she knew] they possess[ed]."[21]

In 1937, Savage was offered a professional commission by the Board of Design of the New York World's Fair. She was one of four women hired by the fair committee, and one of only two African Americans (the other was William Grant Still). Asked to create a sculpture based on the theme "The American Negro's Contribution to Music," Savage produced the sculpture *Lift Every Voice and Sing* (fig. 5.10). It would be her most successful public commission, and her last. The monumental, sixteen-foot-high work featured a harp with strings that were formed by the cylindrical bodies of a black choir. In the foreground, a kneeling man held a plaque upon which the notes of "Lift Every Voice and Sing" were inscribed, paying homage to the "black national anthem." Savage received a silver medal for *Lift Every Voice and Sing* and, when the fair opened in 1939, the sculpture was displayed in a place of honor: in the courtyard of the Contemporary Arts Pavilion. The piece, which received considerable attention from the press, was so popular with the fair-going public that small cast-iron copies of it were made and sold as souvenirs. Savage's dealer, Argent Galleries, capitalized on her growing fame by mounting her second one-person exhibition that year.[22]

At the close of the fair, Savage did not have the funds to store or permanently cast her work which, for the sake of expediency, had been cast in plaster and painted to simulate bronze. Sadly, *Lift Every Voice and Sing* was destroyed when the fair was dismantled. To make matters worse, Savage discovered that, by taking a leave of absence from the Harlem Community

Art Center, she had lost her position as its director. Her provisional replacement, artist and author Gwendolyn Bennett, was retained as the permanent head of the program since it was determined by the WPA that Savage had become gainfully employed and was, therefore, no longer in need of government relief. Savage managed to secure temporary status with the FAP as a consultant at a salary of $1,800 a year but, in the end, she chose to resign from the WPA.

The year 1939 marked the last major showing of Savage's work. The loss of the Harlem Community Art Center directorship effectively stalled the momentum of her career. Assuming that she had been able to maintain her

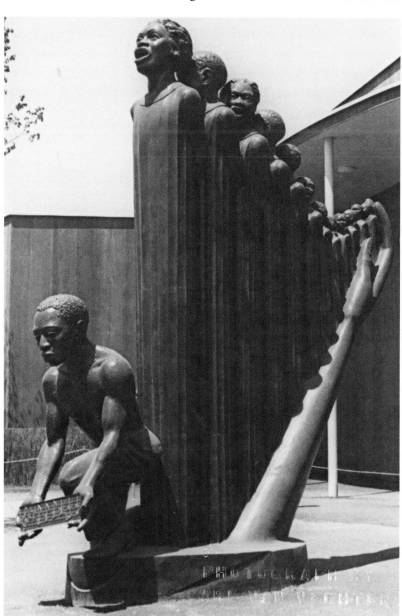

Figure 5.10

Augusta Savage

Lift Every Voice and Sing

(The Harp), 1939, destroyed,

painted plaster, 16' high (4.9 m)

status with the WPA, her job would have been terminated at any rate when the Federal Art Project itself was dismantled three years later. Turning elsewhere for her livelihood, Savage became director and president of Harlem's Salon of Contemporary Negro Art, a black-owned and -operated organization that exhibited African-American art. Its opening exhibition featured more than thirty artists, including Fuller, Jones, Seabrooke-Powell, and Selma Hortense Burke, who would receive national acclaim for a 1945 relief portrait of President Roosevelt (fig. 5.13).[23]

The prospects that the WPA presented to women and minority artists throughout the 1930s faded as quickly as they had appeared. Professional opportunities dissipated as World War II approached and as national sentiments regarding the socialist movers and shakers of the WPA began to reverse themselves. Savage rarely exhibited or even produced art after the early 1940s. Lacking the financial resources and patron base needed to sustain her career, she slipped into professional obscurity. She lived out much of her life in the Catskill mountains of New York, where she sold the occasional portrait bust and taught arts and crafts at local summer camps. Her waning years were spent writing children's books and murder mysteries, none of which were ever published.[24]

Selma Hortense Burke (1900–1995) was a Savage acolyte, drawn to the New York art community in the 1930s from Philadelphia. She developed an early interest in African culture—spurred by her father, who had traveled the globe as an ocean liner chef. He passed on to his daughter a thirst for knowledge about global communities, an interest that was enhanced by two of Burke's uncles, who were A.M.E. Zionist missionaries working in Africa. They sent home to Burke and her family African sculptures and masks that had been "confiscated" from newly converted Christians. The presence of these objects in Burke's childhood home made a profound impact on her intellectual and aesthetic gestation. "I have known African art all of my life," she stated in 1970. "At a time when this sculpture was misunderstood and laughed at, my family had the attitude that these were beautiful objects."[25]

At her mother's insistence, Burke initially entered the nursing profession rather than pursue an artistic career. Her appreciation for art and her desire to become an artist was not, however, diminished. On the contrary, nursing provided for Burke the financial security she needed to venture into the art profession. After attending Women's Medical College in Philadelphia in the late 1920s, Burke became the private nurse of philanthropist Sarah Logan Wister Starr, a broad-minded and generous woman who had rescued the Women's Medical College from bankruptcy in the 1920s—and the association benefited Burke in several ways. She was able to remain relatively untouched by the financial stresses of the depression and,

evidently acting as both a companion and a nurse to Starr, she was also given entrée into Philadelphia society and its cultural milieu. Burke became well versed in the arts during these years and accumulated substantial savings, which provided her with a much-needed monetary buffer over the next decade.[26]

In 1935, Burke, determined to become a sculptor, moved to New York to study art. She found work as an artist's model at Sarah Lawrence College, where she met and later married Claude McKay, the celebrated Harlem Renaissance author. McKay had spent more than a decade as an expatriate in Europe and North Africa, where he was proclaimed the "inventor" of *Négritude* by Léopold Senghor. He was also active in the Pan-African arena as well as in the WPA Federal Writers Project. Through him, Burke was introduced to a vast and influential social circle, which included James Weldon Johnson, playwright Eugene O'Neill, actress Ethel Waters, and writers Sinclair Lewis, Max Eastman, and Langston Hughes. During this period, Burke joined the Harlem Artists Guild and honed her skills as a sculptor at the Harlem Community Art Center, where she was invited to teach under

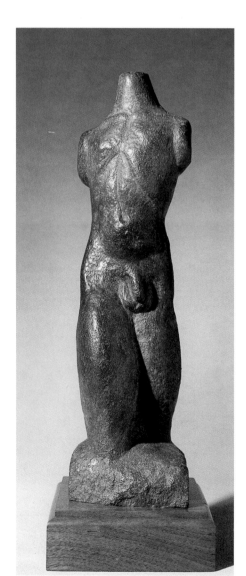

Savage's supervision. As a testament to her rapid artistic maturation, Burke was awarded a full scholarship to Columbia University and received the Rosenwald and Boehler Foundation awards in 1935 and 1936, respectively.[27]

Burke's sculptures of the 1930s, mostly academic figures and portrait busts, were enlivened by bold, often sensuous forms. Her *Torso*, for example, radiates an earthy vitality and displays palpable textured surfaces (fig. 5.11). Its attenuated form sprouts reedlike from a column of protuberant thighs, imparting a sense of organic growth. Timeless and elegant, *Torso* coalesces linear refinement and swelling masses into an invocation of universal humanity. Conversely, her *Temptation* (c. 1938) is more quiescent (fig. 5.12). Its efficacy derives from the bas-relief incisions on its surface and from its integrated forms, which preserve the essence of the original block of stone from which it was carved. "It is very inspiring to release a figure from a piece of stone or wood," Burke once declared. "Very often, I look at [the] stone or wood for a year or longer. . . . I will have completed the piece mentally before attacking the material."[28]

Burke traveled to Europe in 1938 and spent a year in France, Germany, and Austria, studying ceramics and modeling with several noted artists, including French sculptor Aristide Maillol. When she returned to New York in 1939, she

founded a modest art school in Greenwich Village and continued her studies at Columbia, earning her M.F.A. in 1941. That same year, she mounted her first commercial exhibit at New York's McMillan Galleries. Before leaving Columbia, she befriended classmate Margo Einstein, the daughter of Albert Einstein, both of whom had a special regard for African-American art and artists (as evinced by Einstein's visit to the Harlem Community Art Center) and provided invaluable support and encouragement to Burke during this stage of her career.[29]

In 1943, Burke won a national competition to sculpt a relief portrait of President Roosevelt, for which the commander in chief sat on two occasions (fig. 5.13). Burke's design has been cited as the model for John R. Sinnock's famed profile of Roosevelt on the dime, which replicates Burke's composition with barely perceptible alterations. The most evident distinctions are the jutting chin and steeply sloping forehead and nose in Burke's composition, which she believed gave the president "that wonderful look of going forward." She spent two years completing the likeness, her most celebrated sculpture, and in March 1945, before it was displayed in the Recorder of Deeds Building, Eleanor Roosevelt visited Burke's studio to approve the final design. The First Lady consented to endorse the sculpture, but not without comment. She was uncomfortable with Burke's decision to portray the president as younger than his sixty-plus years. To this the artist replied,

Figure 5.12 *(below left)*
Selma Burke
Temptation, c. 1938?
limestone, 14 x 10 1/4 x 4 3/4"
(35.5 x 26 x 12 cm)

Figure 5.13 *(below right)*
Selma Burke
Franklin Delano Roosevelt, 1945
bronze plaque, 3' 6" x 2' 6"
(106.7 x 76.2 cm)

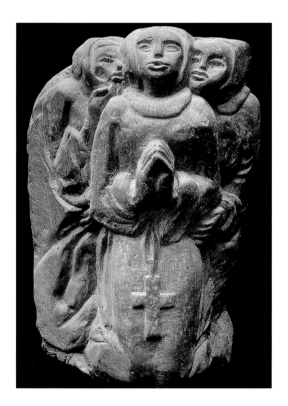

"I have not done it for today, but for tomorrow and tomorrow. Five hundred years from now America and all the world will want to look at our president, not as he was for the few months before he died, but as we saw him for most of the time he was with us—strong, so full of life."[30]

In 1949, after the death of Claude McKay, Burke married the prominent architect Herman Kobbe and initiated an active existence as a member of the art community of New Hope, Pennsylvania, and surrounding Bucks County. She joined the Chamber of Commerce (which, since 1979, has sponsored the annual Selma Burke/Bucks County Sculpture Show) and the county Council on the Arts. Burke also served as a member of the Pennsylvania Council on the Arts and as a consultant to the A. W. Mellon Foundation. Late in life, she established an art facility in Pittsburgh, patterned after Savage's Harlem Community Art Center. Indeed, Savage provided a stellar role model for Burke and, decidedly, her support and encouragement were invaluable to the younger sculptor. Not only had Savage welcomed Burke at the art center, but she also included Burke in the inaugural exhibition of the Salon of Contemporary Negro Art. (Savage's plans to promote Burke and other African-American artists by means of the salon proved short-lived, however, as the gallery went bust after only a few months and Savage's own career declined.)

Figure 5.14
Nancy Elizabeth Prophet
sculpting, undated

The career of sculptor **Nancy Elizabeth Prophet** (1890–1960) offers an uncanny parallel to that of Savage (fig. 5.14). Although not directly affiliated with the WPA, Prophet benefited from her associations with WPA artists and, like Savage, thrived for a time in the liberal environment of the 1930s. Cycles of affluence were interrupted by fiscal distresses and, more than once, Prophet was forced to work as a maid in order to support herself. Indicative of the vicissitudes she endured, when asked on a Harmon Foundation application to list her academic record, Prophet named her alma mater as "The College of Serious Thought . . . situated in the campus of Poverty and Ambition."[31]

Prophet grew up in Rhode Island and attended RISD, graduating in 1918. She was the only African-American student at the time, and likely one of very few who ever paid their tuition by working part time as a domestic servant. Although Prophet excelled in RISD's curriculum of painting and drawing, three-dimensional media would become her forte. Attracted by the New York art scene, she moved there after graduation and forged a consequential alliance with artist Gertrude Vanderbilt Whitney (1875–1942), a member

of New York's cultural elite and founder of the Whitney Museum of American Art. She and Prophet were fellow artists and, after becoming close friends, shared a studio and exhibited together at the Newport Art Association. Whitney financed Prophet's first trip, in 1922, to Europe, where the latter remained for ten years. Like other African-American artists, Prophet found the climate of Paris more conducive to artistic accomplishment than that of the United States, where racial prejudice tainted virtually every aspect of an African-American artist's life, as Prophet had experienced. Shortly after completing her degree at RISD, for example, Prophet was invited to participate in a postgraduate exhibition. The invitation, however, was contingent upon her absence from the show's opening reception, intended for white guests only. Prophet withdrew her submission and moved to Europe.[32]

In Paris, Prophet began a rigorous program of study at the École des Beaux Arts. Within two years of her arrival in France, she was already exhibiting works in the illustrious salons, where she showed consistently over the next decade. Her sculptures were also featured at the Société des Artistes Français de Beaux Arts (1929) and earned lofty kudos from the

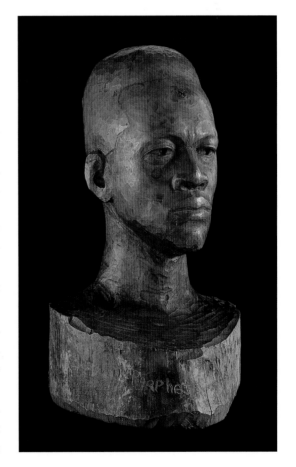

French critics, who described them as "vigorous and energetic" and "conceived in a . . . supple, assured style."[33] The rugged surfaces and forceful modeling of *Negro Head*, for example, exemplify the dynamism and confidence of Prophet's chisel (fig. 5.15). Carved in wood, the sculpture discloses at every turn the forceful gouges made by the artist's hand, and the piercing gaze, flaring nostrils, and ample lips foreground the beauty and nobility of the black male. Sculptural skills aside, Prophet was also a beguiling personality, described by Countee Cullen in 1930 as someone with "unequaled éclat . . . at peace with herself, content with the direction of her life and her art."[34]

Toward the end of her stay in France, Prophet began to cultivate her U.S. reputation. She sent two works to the 1930 Harmon exhibition, one of which was *Negro Head*. The sculpture was as well received in New York as it had been in Paris and won for the artist a $250 prize. Prophet also made the acquaintance of Du Bois, Cullen, collectors Edouard and Julia Champion, and fellow sculptor Savage, who it seems was influenced in her own work by Prophet's

elegant and introspective portrayals of men and women.[35] Prophet's effect is evident in a comparison of her 1930–1931 *Congolaise* (fig. 5.16)—a gaunt and somber portrait of a Masai nobleman—with the streamlined refinement of Savage's work.

Prophet's *Congolaise*, *Silence*, and *Discontent* typify her style (figs. 5.16, 5.17, 5.18). In these brooding representations, Prophet exploits her undeniable instinct for modeling and envelops her subjects in a psychological cloche, as it were, producing an effect that critics have described variously as "stark," "non-sentimental," "cool," and "remote."[36] Prophet's sculptures (for the most part, allegorical busts) maintain an emotional distance from the viewer, frustrating any efforts to access their hermetic personae. Com-

Figure 5.16

Nancy Elizabeth Prophet

Congolaise, 1931

wood, 17 1/8 x 6 3/4 x 8 1/16"

(43.5 x 17.15 x 20.48 cm)

Whitney Museum of American Art, New York. Purchase 32.83. Photograph by Geoffrey Clements, New York

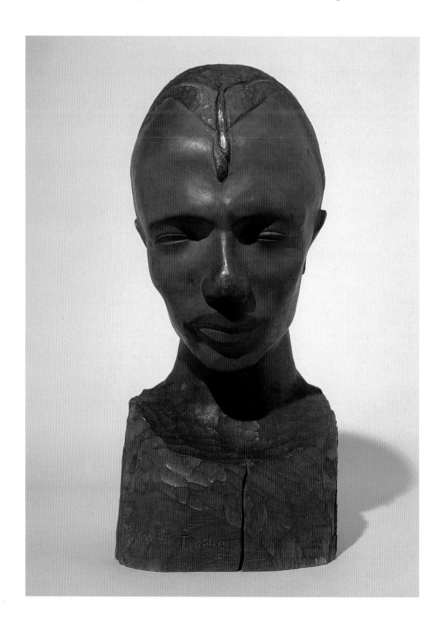

pressed tension around the mouth and a cheerless, almost vacant, elucidation of the eyes achieve this effect. The resulting sculptures fuse conceptual and material realities and reveal aspects of Prophet's own introspective nature. In the artist's judgment, her works personify "the unifying quality of body, mind, and soul."[37]

Silence, particularly, is grounded in an autobiographical framework. Despite the fact that its features do not resemble those of the artist, Prophet confessed that *Silence* was the outcome of "months of solitary living in her little Paris apartment, hearing the voice of no one for days on end." Of *Discontent* she said, "[It was] the result of a long emotional experience, of restlessness, of gnawing hunger for the way to attainment."[38] *Discontent* was purchased by collectors Ellen D. Sharpe and Eleanor Green (wife of a Rhode Island senator) for the considerable sum of $1,000 and donated to the RISD Museum of Art, where it resides today. The work, described by Cullen as "a face Dantesque [*sic*] in its tragedy, so powerful . . . that it might stand for the very spirit of revolt and rebellion," won the prestigious Richard S. Greenough Prize in 1932.[39]

While in France, Prophet received an invitation from John Hope, president of Atlanta University, to teach sculpture at Spelman College, and she decided to accept it and return home. With her reputation firmly established abroad, she was better able to cultivate American patrons and to

Figure 5.17 *(below left)*
Nancy Elizabeth Prophet
Silence, before 1930
marble, 12" high (30.5 cm)

Figure 5.18 *(below right)*
Nancy Elizabeth Prophet
Discontent, before 1930
polychromed wood,
14" high (35.6 cm)

command critical attention in the United States. Prophet exhibited at diverse East Coast galleries, including Salons of America, the American-Anderson Galleries, and the Vose Galleries in Boston (where Lois Jones also showed). In addition, Prophet received exhibition honors from the Boston Society of Independent Artists and the Newport Art Association.[40]

Prophet joined the fine arts faculty at Spelman in 1934. She expanded the art curriculum of drawing, painting, printmaking, and composition already established at Atlanta University by Hope and artist Hale Woodruff to include her own expertise in sculpture and art history. Incorporated into her academically rigorous history course, which spanned art and architecture from Paleolithic times to the modern era, was instruction in criticism, aesthetics, and the various methodologies of visual analysis. A dedicated intellectual who believed in strict student discipline, Prophet frequently invited students to her home: "We read, talk, and try to lift our minds from the common rut of complaint and gossip. These evenings of really serious effort, I take out of the classroom order, and try to make them free and pleasant. My students look forth with great enthusiasm to these evenings."[41]

As the decade progressed, so did Prophet's career. She participated in major U.S. exhibitions, including the Whitney Museum Sculpture Biennials in 1935 and 1937. She also became one of the first African-American artists to enter the Whitney collection when the museum purchased *Congolaise*. In 1940, Prophet's work was shown at the Philadelphia Museum of Art in its Sculpture International exhibition. Now at her professional apex, Prophet counted Du Bois, Gertrude Whitney, Mrs. William Randolph (Millicent) Hearst, and Mrs. Vincent (Helen) Astor among her circle of celebrated patrons. By the early 1940s, however, the dwindling of private fortunes and changing attitudes toward minority artists detrimentally affected Prophet's career. In 1944, Prophet returned to Providence, finding the social restrictions of the segregated South too taxing. After several failed attempts to rekindle her reputation in the Northeast, including one last exhibition at the Providence Public Library, Prophet came full circle and was forced once again to accept work as a housekeeper. The reduced state of her finances resulted in the loss of many of her works, which were either destroyed or left to deteriorate out-of-doors because Prophet lacked the funds to house and preserve them. Mirroring Savage's decline, Prophet's final years were also "marked by poverty and obscurity."[42]

Just prior to her death from a heart attack in 1960, Prophet concluded that her racial heritage was at the root of all her woes. She began to deny her African blood. "I have no use for the colored" and "I am not a Negro," she avowed, claiming instead her father's Narragansett ancestry as her sole heritage. Although Prophet had been included in James Porter's 1943 history

American Negro Art, and although she had participated freely in the African-American art scene up to that time, she later asked to be excluded from an updated history written by Cedric Dover in 1960 on the grounds that she was not black. Prophet's only creative outlet during the 1950s had been occasional work making commercial portrait busts for a ceramics factory. She was so penniless at the time of her death that a former employer had to pay for her funeral.[43]

During this phase of American history, few women artists enjoyed prolonged, continuous professional successes. Most careers could not withstand the economic, political, and social fluxes of the interwar years. The stories of Savage and Prophet are representative of the experiences of many women artists, even taking into account the succor of the WPA.[44] As the arrested progress of these two careers indicates, the opportunities afforded to women and minorities during the depression were fleeting. In the words of art historians Norma Broude and Mary Garrard:

> The narrow window of opportunity for women artists that had briefly opened during the economic hard times of the 1930s quickly snapped shut again in the forties with the emergence of . . . the Abstract Expressionist movement and its macho mystique—to which women artists were automatically excluded access.[45]

Abstract expressionism had replaced the social realism of the depression, and the sundry artists, including women and African Americans, whose capabilities had been celebrated during the 1930s fell out of official favor and lost their tenuous footing in the art world.

Despite the evident benefits of the WPA, sweeping changes in the political climate of the United States at midcentury precipitated the demise of this bold program. When conservative elements took control of Congress in 1940, New Deal art programs came under attack as "wasteful, propagandistic, and filled with Communists." The WPA's Federal Art Project was especially targeted because it had received the sponsorship of the American Artists' Congress—a Communist party affiliate that worked to prevent art censorship and to minimize WPA advocacy of military agendas. Congress branded the WPA a "bed of Communist activity," and by 1943 it had lost popular support. Those associated with the program automatically became suspect as "un-American," an accusation that anticipated the indictments of the McCarthy era.[1]

With the commencement of the Cold War between the United States and the Soviet Union, the two nations began to contend for imperial control of the globe and to view one another with increasing hostility. Americans were persuaded by President Harry S. Truman's administration to take a dim view of Russia's Communist regime. By the early 1950s, growing anti-Communist sentiment culminated in the formation of the House Un-American Activities Committee (HUAC). Spearheaded by Senator Joseph R. McCarthy, the HUAC targeted for investigation political progressives who, it was believed, were or had been affiliated with the Communist party and with the WPA. The reformist practices of both entities, while generally sanctioned during the 1930s, were now viewed with outright suspicion.[2]

Often without substantiation, the HUAC publicly accused "red" radicals of alleged Communist agitation, which the committee perceived as a threat to democracy and to capitalism. The HUAC succeeded in destroying or impeding the careers of many high-profile Americans, whose censorship garnered the most public attention. A number of African Americans were

S I X **Civil Rights and Black Power**

included in this group, such as prizefighter Canada Lee and actors Paul Robeson, Ruby Dee, and Ossie Davis. The HUAC also maintained "blacklists," or rosters of citizens of all races who were suspected of harboring Communist sympathies. Many Americans lived in fear that their names might appear on these rosters, which could, and often did, cost them their careers, their jobs, and even their friends. As a result of the HUAC's activities, an atmosphere of acute suspicion and paranoia prevailed in the United States for nearly a decade.

African-American artists, whether or not they had actually been associated with the Communist party or the WPA, were viewed with particular skepticism. So, too, was the social realism that dominated much of their artwork—despite the fact that the style had enjoyed more than a decade of approbation. The proletariat themes of WPA murals and prints became synonymous with Communist concepts of collective labor and social parity, and were subsequently scorned by the new, politically conservative art establishment. The philosophical and methodological converse of social realist art was abstract expressionism, which in the 1940s and 1950s was lauded for its implicit denunciation of partisan agendas. One of the most influential ambassadors of abstract expressionism was the art critic Clement Greenberg who, in a 1939 essay, touted nonfigurative or nonobjective art as the quintessentially avant-garde and inexorable outcome of twentieth-century visual aesthetics.

Greenberg set abstraction in opposition to realism, which he regarded as hackneyed fare for the "masses." According to Greenberg, abstract art represented the achievements, rights, and freedoms of the individual rather than the group. Imagery that was "reproducible" (such as WPA photographs, prints, and posters) was designated by Greenberg as "kitsch" or banal—a form of cultural commodity, rather than a unique and recondite work of art. His argument, set forth in an epoch-making article entitled "Avant-Garde and Kitsch," countered the opposing polemic charted in 1936 by Marxist critic Walter Benjamin in his essay "The Work of Art in an Age of Mechanical Reproducibility." Benjamin believed that art making was a "materialist" process, fueled by social and historical revolution and disjuncture. He was spellbound by the modern potential for art—once nurtured only in the rarefied atmosphere of museums and in the homes of wealthy collectors—to doff its highbrow aura and to make itself accessible to the "lowly masses." Greenberg, on the other hand, disassociated art from the concept of revolution and saw it as "historicist," that is, the product of continuous growth and tractable evolution.[3] Greenberg's prognostications mirrored a shift in mainstream artistic philosophy away from art for the working class and toward art for the social and intellectual elite.

Artists of color, who in the past had routinely been consigned to the fringe of the art world, found themselves even further displaced, owing to their erstwhile identification with populist imagery, which had been favored by the "Communist" WPA. African-American artists were denied access to art dealers and galleries, particularly if they continued to produce figurative art rather than embrace abstraction, and their occupational prospects dwindled significantly. Many found the climate in the United States untenable and opted to relocate to either Europe or Mexico. A number of expatriates favored Mexico because of its lively communal art scene and because socially disposed art was still in favor there. In the estimations of historian Harry Henderson and artist-historian Romare Bearden, "No one knows exactly how many of these [expatriate] artists there are, but their absence represents a cultural loss to the United States."[4] Conceivably, the most significant such loss was the sculptor, painter, and printmaker **Elizabeth Catlett** (b. 1915).

Born in Washington, D.C., Catlett's precocity as an artist was evident early in life. She professed to have inherited her creative aptitude from her father, an accomplished musician and woodcarver, who died just a few months before her birth. With staunch support and encouragement from her mother and from one of her high school teachers, Haley Douglass (a descendant of abolitionist Frederick Douglass), Catlett decided to become a visual artist. She also demonstrated her active interest in politics. While still in high school, she participated in an antilynching rally in front of the Supreme Court building, during which she and other demonstrators wore nooses around their necks to draw congressional support for anti-lynching legislation. After Catlett enrolled in Howard University in 1931, her commitment to human rights intensified. She became an active member of the National Student League (an antifascist and pacifist group) and came into contact with several key players of the Harlem Renaissance who, as Howard faculty members, were instrumental in her aesthetic and ideological development. Catlett studied African art with department chair James Herring; printmaking with James Lesesne Wells, who had taught at the Harlem Art Workshop; design with Lois Jones; and painting with James Porter. Catlett's tenure at Howard was also concurrent with that of Alain Locke. Although Catlett had no direct contact with Locke during these years, she was nonetheless aware of his aesthetic doctrine and had read his critical essay, "The Legacy of the Ancestral Arts." Through these influential teachers, Catlett assimilated the "New Negro" aspiration for art that would enhance the image and enrich the lives of people of color.[5]

While a university student, Catlett secured, with the assistance of Porter and Wells, an assignment to complete a mural on the subject of Harlem,

under the auspices of the PWAP. Catlett chose as a visual catalyst the drawings of Mexican artist Miguel Covarrubias, whose published collection of works, *Caricatures of Harlem* (1929), she had studied at Howard. She found Covarrubias's synthesis of the figurative and the abstract inspiring, and this early initiation into the art of contemporary Mexico would fuel a lifelong admiration for the country. Upon her graduation in 1935, Catlett began a teaching career in the Durham, North Carolina, public school system. While there, she fought to raise the salaries of African-American teachers, who were paid only half as much as their white colleagues. Soon, Catlett became discontented with the inadequate income and heavy demands of public school teaching, which left her little time for her own creative work. Realizing that teaching at the college level was less time consuming than elementary and high school teaching, Catlett resolved to upgrade her professional qualifications. She abandoned Durham and enrolled in the State University of Iowa, where she earned a master of fine arts degree, necessary for university teaching.[6]

At Iowa, Catlett perfected her skills as a sculptor, working principally in wood, plaster, and terra cotta. She also studied painting with the distinguished regionalist and WPA artist Grant Wood, famed for his stylized renderings of the Iowa countryside and for his sardonic characterization of a rural American couple in the 1930 painting *American Gothic*. Wood was empathic to Catlett's position as one of very few women or African-American students at Iowa, and he made a special effort to guide and advise her. As an instructor, he encouraged Catlett to strive for technical precision and refinement in her work and to derive her subject matter from her own experiences. Wood further acted as Catlett's defender when she learned in her second year at Iowa that she might not be able to receive an M.F.A., but would only receive an M.A. Catlett was informed by the art department chair that she was not eligible for a fine arts degree, ostensibly because she had not completed the required number of printmaking courses at Iowa (although she had taken several such courses at Howard). There was apparently some resistance to granting Iowa's first M.F.A. to Catlett. Fortunately, Wood intervened on her behalf and convinced the art chair to grant the fine arts degree. As a result, Catlett became one of the first two persons ever (the other was her own sculpture instructor, Harry Stinson) to receive a master of fine arts degree from that institution.[7]

In 1940, after securing her teaching credentials, Catlett joined the faculty at Dillard University in New Orleans, a historically black college founded with the aid of WPA funds. There, in addition to heading the art department, Catlett taught courses in art history, drawing, painting, and printmaking. While she found teaching at Dillard intellectually and

creatively satisfying, she could not say the same for her day-to-day existence as a woman of color in the Deep South. A parochial university administration railed against Catlett's attempts to organize nude-drawing classes, and she and her students were refused admission to the Delgado Museum (today, the New Orleans Museum of Art) because it was located in a segregated park that allowed white visitors only. (Catlett was eventually able to arrange a visit by agreeing to escort her students to the museum on a day when it was closed to the public.) Other troubling incidents included the wrongful arrest of several Dillard students for allegedly tampering with public segregation signage. Although Catlett successfully campaigned for the students' release, she incurred the ire of the Dillard Board of Trustees for her efforts. The final insult came when the university board mandated that Dillard faculty teach throughout the summer months without additional pay. After barely two years of residency in Louisiana, Catlett resigned.[8]

As her career at Dillard came to a close, Catlett began participating in Atlanta University's annual exhibitions as both an artist and a juror. The "Atlanta Annuals" were initiated in 1942 by Hale Woodruff to carry on the tradition of the Harmon exhibitions, which were discontinued in 1935. For nearly thirty years, the annuals provided a national forum for African-American art and carried with them a cachet that the Harmon exhibits lacked, due to the discriminating entry selections of preeminent jurors such as Catlett. Her reputation grew when her work was included in the 1940 Chicago American Negro Exposition, where she won first prize for her limestone sculpture *Negro Mother and Child* (fig. 6.1). Catlett's award-winning sculpture, which had been her master's thesis, was inspired by the tempered realism of Lithuanian-American sculptor William Zorach. Catlett's tribute—a monumental rendering of a seated, seminude black woman embracing her child—echoes the Egyptian-inspired frontality and symmetry of Zorach's work and is enhanced by a deepened depiction of the maternal bond. *Negro Mother and Child* was so well received that Alain Locke, who chaired the exposition committee, featured the work in his 1940 book, *The Negro in Art*, as did James Porter three years later when he published *Modern Negro Art*. The forthright reductive forms, visual potency, and evident ethnicity of Catlett's figures were intensely compelling to both Locke and Porter, as well as to the Chicago viewing public.[9]

Also during her Dillard period, Catlett spent the summer of 1941 in Chicago with friend and fellow artist **Margaret Taylor Burroughs** (1917–) studying sculpture at the Art Institute and lithography at the WPA-sponsored Southside Community Art Center, which Burroughs had founded. Like the Harlem Community Art Center, its Chicago counterpart was a

meeting place for African-American artists during what became known as Chicago's "Harlem" Renaissance. Included in the Southside group were leading lights such as dancer Katherine Dunham, sculptor Richmond Barthé, and painter Archibald Motley, as well as younger artists Eldzier Cortor and Charles White, the latter of whom Catlett married later that year. White was renowned in his own right and went on to become a core faculty member at the Otis Art Institute in California and at Howard University. During his brief marriage to Catlett, the two shared both an interest in creating epic-style imagery of the African-American proletariat and similar political concerns that were nurtured in the collectivist environment of the Southside Center.[10]

A number of artists at the center were Communist party members who sustained a vested interest in collective art activity. Burroughs, who went on to direct the DuSable Museum of African-American History in Chicago, and her artist-husband, Bernard Goss, shared aesthetic objectives. Goss once remarked, "I wish my art to speak not only for my people but for all humanity.... My subject matter is social commentary, and seeks to improve the condition of life for all people."[11] As a group, Southside members endorsed art with radical political implications—art that would act as a "weapon" for social change. Their anticapitalist and anti-elitist WPA politics left a lasting impression on Catlett. Although she opted not to join the Communist party herself, its promise of racial and social equality mirrored Catlett's own commitment to African-American enfranchisement and informed her art for the remainder of her life.[12]

In the spring of 1942, Catlett relocated with White to New York to further their artistic careers. Catlett studied privately with Russian-born sculptor Ossip Zadkine, who had been active in Paris but emigrated to New York to escape Nazi persecution. Zadkine familiarized Catlett with cubist abstraction, and her work began to demonstrate a fusion of cubism and African figural austerity. Catlett continued to perfect her printmaking skills, studying lithography at New York's Art Students League. She also continued to commingle art making, art education, and art politics. Between 1944 and 1946, she taught ceramics at New York's Jefferson School and at the progressive George Washington Carver School, both of which were administered by socialist polemicists who sought to provide educational opportunities to the population of Harlem. The Carver School, where

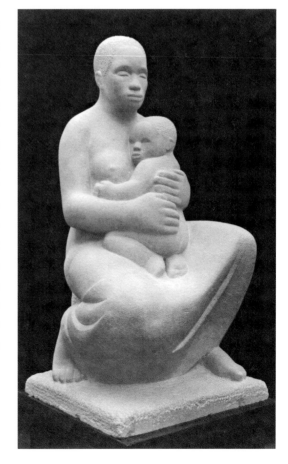

Catlett expended the greater part of her energies, was supervised by Gwendolyn Bennett, one-time president of the Harlem Artists Guild and the director of the Harlem Community Art Center who succeeded Augusta Savage. Bennett was joined in her sponsorship of the Carver School by the Reverend Adam Clayton Powell and by city council member Benjamin Davis, an affiliate of the National Central Committee of the Communist party. Catlett's contributions to the school included designing posters to advertise its academic and professional offerings, fundraising, and teaching an assortment of classes, from sculpture to dressmaking.[13]

In 1945 and 1946, Catlett was awarded a Rosenwald fellowship to produce a series of works on the subject of black women. In order to devote her time to the creative process, Catlett discontinued her work at Carver in the second year and used the Rosenwald funds to study in Mexico. Although she had considered going to Europe, she shared Locke's belief that European creativity had become sterile, and she was particularly drawn to the socialist art for which the Mexican muralists were recognized. In addition, the modest fellowship of $2,000 would not sustain an extended visit to Europe. Fortuitously for Catlett, the public art movement in Mexico, which had been triggered by the 1910 Mexican Revolution and its call for social reforms, was still teeming when she arrived.[14]

In Mexico, Catlett enrolled in the Escuela de Pintura y Escultura, known by its nickname, "the Esmeralda." There she studied with leading sculptors Francisco Zúñiga and José L. Ruiz. Catlett also made Diego Rivera's acquaintance and was fortunate enough to be invited to visit the home of another of *los tres grandes*, David Siqueiros. Catlett was immersed in the Mexican School agenda, which fused elements of indigenous Central American and Spanish artistic traditions to create "visual representations of a national identity," or *mexicanidad*. Artists reacted against the bourgeois notion of art exclusively for the *haute monde*, alternatively offering "art for the people" in the form of monumental public works and widely disseminated prints and graphics that addressed the concerns of the Mexican working class, much as the WPA had done. Specifically, Catlett allied herself with the Taller de Gráfica Popular (TGP), a Mexican School alliance and print workshop founded in 1937, which provided graphic design to antifascist, popular, and labor coalitions. Catlett was one of the first women (along with Chicago photographer Mariana Yampolsky) to join the TGP, and she remained an affiliate for more than two decades.[15]

Catlett became enamored of Mexico, where she felt less hampered by racial bigotry: "I feel like a person in Mexico. When I am in the States, I feel very conscious of what my race is."[16] Catlett also fell in love with a fellow

TGP member, Francisco "Pancho" Mora and, in 1946, briefly returned to the United States to divorce White. Soon thereafter, she settled permanently in Mexico and married Mora, with whom she had three sons; the two remained together as spouses and creative colleagues for more than a half century.

Under the sway of the Mexican aesthetic and in the supportive atmosphere of the TGP, Catlett completed her Rosenwald fund assignment: a series of fifteen linocuts entitled *The Negro Woman* (later renamed *The Black Woman Speaks*).[17] The first image in the series, *I Am the Negro Woman*, depicts a close-up view of the face of a young woman, as if seen through the zoom lens of a camera, whose penetrating gaze is focused decisively on a distant, unseen objective (fig. 6.2). The image is evocative of Michelangelo's *David* who, upon seeing his enemy Goliath, prepares mentally to fell him and to take his own rightful place as the king of a great nation (fig. 6.3). The visual similarity between the two icons indicates an allegorical likeness, in that Catlett's woman, too, faces an enemy—human injustice and suffering—which she, the female incarnation of David, is determined to vanquish with equal resolve.

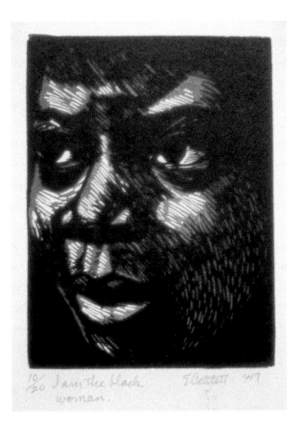

A recitation of the titles in the series (which reads like an autobiographical narrative), suggests Catlett's growing commitment to the subject of the black woman: *I Am the Negro Woman, I Have Always Worked Hard in America, In the Fields, In Other Folks' Homes, I Have Given the World My Songs, In Sojourner Truth I Fought for the Rights of Women as Well as Negroes, In Harriet Tubman I Helped Hundreds to Freedom, In Phillis Wheatley I Proved Intellectual Equality in the Midst of Slavery, My Role Has Been Important in the Struggle to Organize the Unorganized, I Have Studied in Ever Increasing Numbers, My Reward Has Been Bars between Me and the Rest of the Land, I Have Special Reservations, Special Houses, And a Special Fear for My Loved Ones*, and *My Right Is a Future of Equality with Other Americans*. The series, as these titles indicate, is dedicated to the archetypal peasant woman as well as to several explicit historic heroines, such as nineteenth-century women's rights advocate Sojourner Truth, neoclassical poet and slave Phillis Wheatley, and Underground Railroad conductor Harriet Tubman (fig. 6.4).

Figure 6.3
Michelangelo (1475–1564)
David (detail, frontal view
of head), 1501–1504
marble, full height of sculpture
approx. 14' (4.26 m)

As a series, *The Negro Woman* is indicative of Catlett's portrayal of and identification with the sociopolitical underdog, principally women and

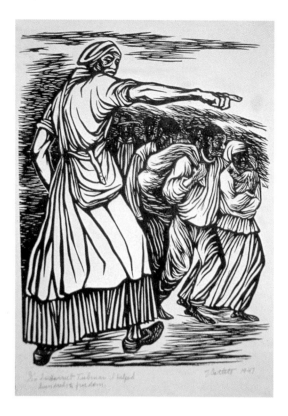

people of color. Indeed, in the 1950s, the artist found herself in the role of the underdog and at the mercy of the HUAC because of her various associations with socialist and Communist groups. Her tribulations also stemmed from political and aesthetic transformations that were taking place in Mexico by the mid-1950s. Coincident with the onset of abstract expressionism in the United States, the Mexican predilection for social realist art of the type produced by the WPA and the TGP began to wane. Younger Mexican artists allied themselves with what they saw as the loftier aims of "art for art's sake" rather than "art for the people." Social realism and the "anachronistic nationalism" of the Mexican School were now considered obsolete.

Los tres grandes—Rivera, Siqueiros, and Orozco—were supplanted by a new hero, painter Rufino Tamayo, who had lived in New York during the Harlem Renaissance and who was well versed in the international art scene. The ideological nemesis of the Mexican School, Tamayo alleged that *los tres grandes* were misguided in their readiness to give social content precedence over aesthetic objectives. As an alternative to murals and prints, Tamayo revived easel painting as the preeminent medium for Mexican art. His seamless amalgamation of influences from cubism, Mexican folk art, and pre-Hispanic sources, which preserved some of the *mexicanidad* construct, endeared him to an entire generation of young artists who stressed form and individual genius over social content and confederate activity. Abstraction soon predominated in Mexico just as it did in the United States and, by 1960, the genre had usurped the place once held by social realism.[18]

Due to its commitment to left-wing politics, the TGP was designated a "Communist front organization" by the HUAC. As such, TGP members (excluding Catlett, who was an American citizen) were barred from entry into the United States. Catlett was ordered in 1955 to submit a written declaration of her political affiliations and to name others (for the purpose of the HUAC blacklist) whom she knew to be affiliated with the Communist party. Catlett refused to comply with the mandate and was, in due course, imprisoned as a "foreign agitator" by Mexican authorities in collusion with the HUAC. In protest, Catlett made the radical decision to renounce her American citizenship upon her release from prison. In 1962, she became a

citizen of Mexico, at which time the U.S. government promptly declared her an "undesirable alien" and for the next ten years prohibited her from returning home.[19]

Just as the matrix of, first, the WPA years and then the McCarthy era had influenced Catlett's life, the age of civil rights to which McCarthyism gave way in the late 1950s and early 1960s had an equally profound impact on both the artist and her art. Indeed, any considered appreciation of African-American art during these years requires an appreciation of the intensity of the Civil Rights movement. During an interval of nearly two decades, African Americans embarked on a systematic campaign to end social oppression. Central to the struggle was the Southern Christian Leadership Conference (SCLC), founded in 1957 and led by, among others, Dr. Martin Luther King, Jr. The numerous large-scale protests and demonstrations that were staged by the SCLC brought racial injustice to the forefront of the American consciousness. Also leading the charge against minority oppression was the NAACP's Legal Defense Fund. Masterminded by the indomitable Thurgood Marshall, who would later become a Supreme Court justice, time and again the NAACP's legal team effectively challenged the double standards in the U.S. judicial system. In the historic 1954 case, *Brown v. Board of Education of Topeka*, the Supreme Court ruled that public school segregation was unconstitutional. In 1956, following the arrest of Rosa Parks for refusing to give up her seat to a white passenger on an Alabama bus, segregation in public transportation was also declared unlawful. In 1957, the first significant civil rights legislation since 1875 was passed, protecting voter rights. Massive voter registration campaigns ensued, resulting in an appreciable strengthening of the African-American political voice.

The prodigious civil rights victories made by African Americans in the 1950s were answered by whites with fierce antagonism. In 1957, African-American students in Little Rock, Arkansas, while attempting to register at a newly integrated high school, were met by state troopers and irate white citizens, who hurled insults and blocked their entry into the school building. Not until President Dwight D. Eisenhower dispatched federal troops to the scene were the students permitted to attend classes. Reports of murders and lynchings, which had subsided almost completely by 1952, once again escalated. One of the most heinous racial crimes of the era took place in Mississippi in 1955. The incident involved fourteen-year-old Emmet Till who, after being accused of whistling at a young white woman named Carol Bryant, was abducted, viciously beaten, and shot to death by Bryant's husband and brother-in-law. Despite admitting that they had kidnapped Till

(and later detailing the murder in an article for *Look* magazine), the two were acquitted by an all-white jury. The Till murder sent shock waves through the African-American community and marked the beginning of years of unrelenting civil unrest.

The struggle for civil rights reached a fever pitch between 1961 and 1964, when the Congress of Racial Equality (CORE) organized a series of well-publicized, interracial Freedom Rides designed to integrate bus routes in the South. Participants were fire-bombed, battered, and arrested, and Freedom Rider James Chaney along with two of his white companions, Michael Schwerner and Andrew Goodman, were murdered by the Ku Klux Klan. African Americans were fast becoming disenchanted with nonviolent protests, which they felt were ineffectual in the face of such overwhelming violence. An ever-increasing militancy infected the Civil Rights movement, accompanied by a resurgence of African pride and an assertion of ethnic difference that belied earlier calls for integration. African-derived clothing and hairstyles became fashionable, and the slogan "black is beautiful," first popularized by Garvey in the 1920s, was resurrected. By the mid-1960s, the Civil Rights movement had yielded to the more radical Black Power movement, and nonviolent, integrationist leadership, epitomized by Martin Luther King, was replaced by militant black nationalism, personified by Malcolm X.

Expatriate status notwithstanding, Catlett was staunchly committed to the Black Power movement and to its visual arts equivalent, the Black Arts movement. In the early 1960s, soon after being named the first woman to head the department of sculpture at the Universidad Nacional Autónoma in Mexico City, Catlett became the movement's primary spokesperson, and her imagery became its icons. In 1961, shortly before becoming a Mexican citizen, Catlett made her last trip to the United States for many years, to deliver a keynote address at the Third Annual Meeting of the National Conference of Negro Artists. Her widely influential oration, "The Negro People and American Art at Mid-Century," reaffirmed her allegiance to African Americans and to their art. She urged artists of color to spurn the inherently racist and exclusionary network of American museums and galleries and to organize their own "all-black" exhibitions. She also reiterated a Lockean and Du Boisian directive to create art that would "express . . . racial identity, communicate with the black community, and participate in struggles for social, political, and economic equality."[20] According to art historian Harry Henderson and artist-scholar Romare Bearden:

> Catlett's speech marked a significant turning point for many black artists. . . . It resulted in the formation of groups, such as Spiral in

New York, and all-black exhibitions swept across the country. Instead of accepting a shut-out by galleries and museums, these all-black exhibitions brilliantly demonstrated the talent of black artists in all parts of the country, awakening millions of Americans to their existence for the first time.[21]

Spiral, one of the first organized responses to Catlett's call, was a black artists' collective—the first to be formed in New York since the Harlem Renaissance. Its name, which was chosen by artist Hale Woodruff, referred to the spiral of Archimedes, a third-century B.C.E. Greek mathematician who conceived of this abstract vortex as one that remained in perpetual motion. One of several catalysts for Spiral's founding was the 1963 March on Washington, during which Martin Luther King, Jr., and a quarter of a million demonstrators voiced their indignation at the persistence of racial oppression in the United States. The first Spiral meeting took place in Bearden's Greenwich Village studio, and the group set as its goal an intellectual interchange designed to help establish the African-American artist's place in the struggle for racial equality.[22]

In addition to Bearden and Woodruff, Spiral members included Norman Lewis, Charles Alston, Ernest Crichlow, Reginald Gammon, Felraith Hines, Alvin Hollingsworth, Richard Mayhew, Merton Simpson, James Yeargans, and a sole woman artist, **Emma Amos** (b. 1938). In May 1965, two years after Spiral's founding, the group mounted its first and only exhibition in a rented gallery space at 147 Christopher Street. Works in the show were limited to a black-and-white palette in deference to the civil rights crusade, and the exhibit was aptly titled "Black and White." Bearden suggested that each artist submit a collage, for the sake of media consistency, but other members would not agree to this proviso. Amos was represented by a black-and-white etching (now lost) entitled *Without Feather Boa*—a nude portrait bust of the artist staring indifferently at the viewer from behind a pair of dark sunglasses.[23] The work's title and its matter-of-fact nudity allude to the sitter as a "soldier" of the movement and, in the artist's words, "as a woman without beauty but with confrontational power."[24]

Although the exhibition was well attended and successful, Spiral was plagued by internal philosophical conflicts. A number of Spiral members wanted to express their social engagement without losing their individual artistic identities, while others advocated a centralized formal philosophy, following the example of the impressionists. Some felt strongly that the group should be interracial, while other artists disagreed. Members wrangled over everything from aesthetic standards to the dangers of "ghettoization" that might result from all-black shows. Unresolved, these

differences resulted in the dissolution of Spiral soon after the close of the exhibition.[25]

The struggle between divergent camps of artists who strove, on the one hand, for integration into the mainstream art world and, on the other, for proactive separatism, represented in microcosm what was transpiring in the Black Arts movement. Playwright Larry Neal defined the evolving movement as "the aesthetic and spiritual sister of the Black Power concept . . . relate[ed] broadly to the Afro-American's desire for self-determination and nationhood. . . . One is concerned with the relationship between art and politics; the other with the art of politics."[26] For Neal, the Black Arts movement was, unequivocally, the aesthetic embodiment of black nationalism. It encouraged autonomy and self-definition for artists and challenged Greenberg's reification of art for art's sake. Artists of the movement espoused a revolutionary "black aesthetic" that

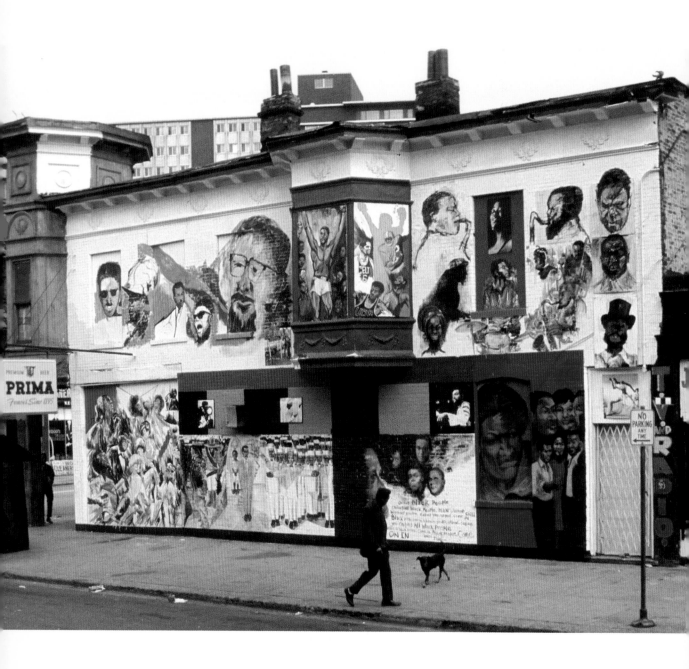

would "be honest in content [and] speak . . . to a black, not a white audience"—and that would lead African-American artists "out of the polluted mainstream of Americanism."[27]

The Black Arts movement was formalized in a number of ways, including the founding of African-American art museums in New York, Washington, D.C., and Boston; the organization of Pan-African conferences, like the Festival of Negro Arts, first held in Dakar, Senegal, in 1966; and strategic protests such as those organized by the Black Emergency Cultural Coalition (BECC) between 1969 and 1971, which drew attention to exclusionary museum practices. Within a short span of years, the art world was persuaded to sit up and take notice of African-American art for the first time since the Harlem Renaissance. New York's Metropolitan Museum mounted the controversial "Harlem on My Mind" exhibition in 1969, featuring the photographs of long-forgotten Harlem Renaissance photographer James Van Der Zee. The Whitney Museum scheduled more than a half dozen shows of African-American art between 1970 and 1975. Black-owned galleries were established, including Acts of Art, Kenkeleba, and Just Above Midtown (JAM), as well as Cinque Gallery (founded by former Spiral members), and the Weusi-Nyumba Ya Sanaa (Swahili for "people's house of art"), later renamed the Weusi Academy of Art.[28]

African-American artists also committed themselves to bringing art to working-class black communities and sought unconventional venues for exhibiting their work. The Organization of Black American Culture (OBAC, pronounced "Obasi") revived the WPA mural tradition with the creation of *The Wall of Respect*, painted on an abandoned building on the Southside of Chicago in 1967 (figs. 6.5, 6.6). The participating artists were Barbara Jones-Hogu, Carolyn Lawrence, Jeff Donaldson, Wadsworth Jarrell (all of whom later became members of the art alliance AfriCOBRA), Sylvia Abernathy, Myrna Weaver, and others. The mural, which honored the achievements of African Americans, comprised portraits of more than a dozen luminaries, including boxer Muhammad Ali, professional basketball player Wilt Chamberlain, jazz artists Sarah Vaughan, Thelonius Monk, Max Roach, John Coltrane, Nina Simone, and Charlie "Bird" Parker, civil rights activists Marcus Garvey, Stokely Carmichael, Malcolm X, W. E. B. Du Bois, and H. Rap Brown, and writers Amiri Baraka and James Baldwin.[29]

Whereas artists hoping to exhibit their works at conventional venues, such as museums, private gal-

Figure 6.6

Barbara Jones-Hogu on scaffolding painting *The Wall of Respect*, 1967 (destroyed 1971), 43rd and Langley streets, Chicago, Ill. Photograph © 1989 Robert A. Sengstacke

leries, and corporate or public sites, were required to secure some form of official sanction, the OBAC artists who designed *The Wall of Respect* turned to the citizens of the Southside for informal approval and input—making the project a genuinely cooperative endeavor. Neighbors who lived near the site of the mural at 43rd and Langley streets spent their days watching the artists' progress and providing them with food, drinks, and criticism as they worked. Even the local gang, the Blackstone Rangers, whose "turf-identifying graffiti" already adorned the walls of the neighborhood, gave their tacit approval by safeguarding the mural from vandals.[30]

In addition to portraits of African-American dignitaries, *The Wall of Respect* portrayed hooded Ku Klux Klan figures and scenes of racial tension and conflagration. The mural, in the words of historian Michael D. Harris, "engaged issues of black cultural accomplishment, radical protest against oppression, and contemporary heroism." It also exemplified Catlett's credo, expressed in her 1961 address to the National Conference of Negro Artists:

> Let us take our painting and prints and sculpture, not only to . . . the art galleries and patrons of the arts who have money to buy them; let us exhibit where Negro people meet—in the churches, in the schools . . . , in the clubs and trade unions. . . . And if we are to reach the mass of Negro people with our art, we must learn from them; then let us seek inspiration in the Negro people—a principal and never ending source.[31]

The OBAC mural did precisely this and, in an authentically collectivist spirit, its creators chose to leave the painting unsigned. *The Wall* was intended as a gift to the community and accordingly, as Harris explains, "individualism was subordinated to group effort and communal benefit." The enterprise was so successful that it sparked hundreds of similar projects in urban neighborhoods across the country. The most noteworthy exemplars of these include the 1969 *Wall of Truth* located on a facing building at 43rd and Langley, the Detroit *Wall of Dignity* (1968), and the Atlanta *Wall of Respect* (c. 1974). These subsequent murals glorified classical African civilizations and past and present heroes and heroines of African descent.[32]

In 1968, OBAC evolved first into the artists' group COBRA (Coalition of Black Revolutionary Artists) and, later, into AfriCOBRA (African Commune of Bad Relevant Artists). In its incarnation as AfriCOBRA, this consortium of dedicated artists epitomized the nature of the Black Arts movement. Visually, their art emphasized stylistic accessibility (words and recognizable figures), which would facilitate a conceptual connection with

the neophyte members of their audience. Other identifiers of the "look of black art" were syncopation (a measured sequence of dominant and latent elements), improvisation, and a dazzling color palette. Likewise, a thematic leitmotif was fostered that would illustrate the African-American struggle for social, economic, and political equality. In the words of AfriCOBRA guru Jeff Donaldson, "black art" demanded "high energy color, bold, uncompromising design, and non-Western patterns and symbols." The style became wildly popular during the late 1960s and 1970s and had far-reaching effects, influencing mural collectives throughout the United States and Europe for more than a decade.[33]

Artist **Betty Blayton** (b. 1937) supervised an extraordinary mural project in Harlem in 1971, which integrated art created by children (fig. 6.7). The untitled work was commissioned by the Reader's Digest Foundation and executed on a playground wall at Lenox Avenue and 140th Street. The creative team included, in addition to Blayton, project supervisor Sulvin Goldbourne and the teenage members of the Children's Art Carnival. Founded in 1969 as an outreach program of the Museum of Modern Art, the Art Carnival developed into an autonomous nonprofit agency which, in the spirit of the Harlem Community Art Center, has provided arts education and programs to New York City youth for nearly thirty years, with Blayton at its helm.[34]

Figure 6.7
Betty Blayton
Untitled, 1971, with the
assistance of Sulvin Goldbourne
and the Children's Art Carnival

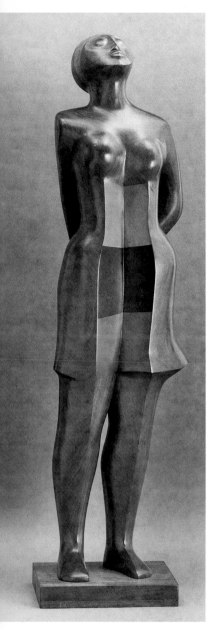

Figure 6.8

Elizabeth Catlett

Political Prisoner, 1971

polychromed cedar,

71 1/4 x 36 x 15"

(181 x 91.4 x 38.1 cm)

© Elizabeth Catlett/Licensed

by VAGA, New York

Blayton, who studied at the Brooklyn Museum School, the Art Students League, and Syracuse University, realized the initial design for the mural on paper. She based her composition on several abstract paintings by children of the Art Carnival and fused their individual designs into a single monumental expression. In her interpretation of the children's artwork, Blayton remained faithful to the original conceptions, except to make color adjustments so that the various paintings would "flow . . . one to the other."[35] Blayton's rendering was transferred to the wall by the young artists who had inspired it. The endeavor became the first of many that the Art Carnival would undertake in city parks, and it stands as a lasting testament to the community spirit of the Black Arts movement.

The movement reached an apogee in 1970, when the Conference on the Functional Aspects of Black Arts, better known as CONFABA, was held in Evanston, Illinois. Organized by Jeff Donaldson and a handful of his African-American art history students at Northwestern University, the conference drew attention to the need for art historians to play a proactive role in "the serious business of preserving, protecting, and projecting the visual art legacy of black people in the United States."[36] Approximately fifty scholars and artists from across the country participated in the conference and formed task forces to address problems of education, research, resources, dissemination, and aesthetics.

CONFABA organizers invited Catlett, as an "advisor and elder of distinction," to attend the conference. Despite CONFABA's best efforts and heedless of the decade that had passed since Catlett was proclaimed an "undesirable alien," the U.S. embassy denied her a visa to attend the conference. Instead Catlett had to address the CONFABA forum by telephone, expressing her indignation at the government's unremitting censorship of social progressives like herself: "How will some consul, some ambassador, some bureaucrat, some president be able to erase the color of my blood, erase my . . . years of life as a black citizen of the United States, where I went to segregated schools, . . . traveled in the back of the bus . . . , sat in stations, in theaters, in restaurants, in the sections that said *Negroes Only!?*"[37] In her CONFABA remarks, Catlett ardently proclaimed her status as a "black revolutionary artist" and reiterated the importance of cooperative efforts among African-American artists to support "the liberation of our beautiful people."[38]

Throughout the 1960s, Catlett remained aligned with the principles of the Black Arts movement, as her unerring commitment to figurative imagery, lucid narrative, and prints indicates. Her art remained both conceptually and empirically accessible to the rank-and-file citizens to whom she was devoted. Through ongoing graphic series as well as monolithic

sculptures such as *Political Prisoner* (1971), Catlett venerated the icons and heroes of black liberation such as Angela Davis and Malcolm X (figs. 6.8, 6.9). *Political Prisoner* pays tribute to the jailed members of the Black Panther party (a corps of young extremists who endorsed armed self-defense against police brutality). The work depicts a universal woman-martyr standing noble and defiant despite her bound hands. Catlett has split the torso of her champion, baring viscera of red, black, and green—the colors of the Black Power movement—suggesting that the spirit of the movement resides in the very core of this symbol of black female militancy. (Catlett's riposte to the movement's mantra, "black is beautiful," is represented in a 1968 lithograph that bears the same title in Spanish, *Negro es bello*, and recurrently features the title's words as well as multiple images of the face from *I Am the Negro Woman*, seen also at the top of *Malcolm X Speaks for Us* [figs. 6.2, 6.9].[39])

Catlett was at last permitted to revisit the United States in 1971, after officials from the Studio Museum in Harlem (which was mounting a major Catlett retrospective) lobbied the State Department to grant Catlett a visa. The exhibit and the publicity surrounding the procurement of her visa

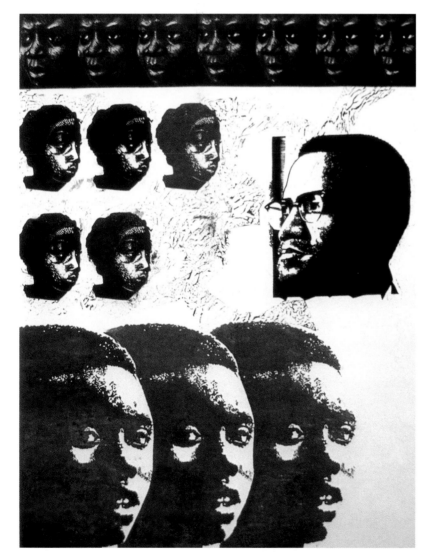

Figure 6.9
Elizabeth Catlett
Malcolm X Speaks for Us, 1969
color linocut, serigraph, and
monoprint, 37 1/2 x 27 1/2"
(95.25 x 69.85 cm)
Collection of the artist,
Cuernavaca, Mexico
© Elizabeth Catlett/Licensed
by VAGA, New York. Photograph
courtesy of Melanie Herzog

catapulted Catlett into the national spotlight and earned her the title "foremother of the Black Arts movement."[40] Soon enough, however, she would come to share this designation with another 1960s revolutionary, **Faith Ringgold** (b. 1930). A Harlem native fifteen years Catlett's junior, Ringgold experienced the Civil Rights and Black Power eras firsthand, as she did the later women's movement—an affinity that stemmed from years of experience with gender bias.

One of Ringgold's earliest and most critical encounters with sexual oppression occurred in 1948, when she enrolled in the City University of New York (CUNY) to study art. She was informed at the time that women were not permitted to major in the fine arts—allegedly a male profession—and she was forced to major in education instead. Over the next decade, Ringgold earned undergraduate and graduate degrees at City College, and she launched a twenty-year teaching career in the public school system. Ringgold's creative stimulus sprang from the ingenuity of the children whom she taught and from painter and CUNY professor Robert Gwathmey who, since the outset of his own career in the late 1930s, had centered much of his work around racial and political motifs. He also instilled in Ringgold a fundamental belief in her own aesthetic instincts, by defending her ingenuous painting style against the criticisms of the older, more experienced students. His nurturing teaching practices gave Ringgold the confidence to act on her own artistic impulses without fear of criticism. As Ringgold conceded years later, "He gave me that and I never let it go."[41]

In the summer of 1961, Ringgold embarked on a Grand Tour of Europe, with her mother and her two daughters in tow. (By this time, she had married and divorced jazz musician Earl Wallace, whose drug abuse ended their marriage in 1956.) The family spent the summer visiting modern art collections in Paris, Nice, and Rome, where Ringgold hoped to discern the *je ne sais quoi* of the great European masters. While abroad, she learned from French and Italian newspapers of the Freedom Riders in the American South who had been assaulted and murdered by white extremists, and soon after arriving in Rome, she received word that her brother Andrew had died of a drug overdose. These contemporaneous events in the artist's life galvanized Ringgold and intensified her longing for self-expression. She began to devote her energies, until now allotted to teaching, to developing her skills as an artist. Her goal was to become successful enough to abandon teaching as her principal source of income.[42]

The racial tensions and disparities that were the fabric of African-American existence became the subject of Ringgold's first fully developed painting series, *American People*, completed over a four-year period

Figure 6.10

Faith Ringgold

Between Friends, from

American People series, 1963

oil on canvas, 40 x 24"

(101.6 x 61 cm)

between 1963 and 1967. The *American People* series comprised images of social satire and isolation and depictions of African Americans as insulated and uneasy characters subsisting in a hostile environment. The nearly two dozen tableaux in the sequence are graphic distillations of Ringgold's encounters with racial integration which, while progressing in 1960s America, was still fraught with conflict. According to curator Mary Schmidt Campbell, Ringgold's *American People* series confronted "the social pretensions and hypocrisies of black and white Americans, and the bogus camaraderie of integration."[43] Campbell's interpretation can clearly be seen in Ringgold's 1963 painting, *Between Friends* (fig. 6.10).

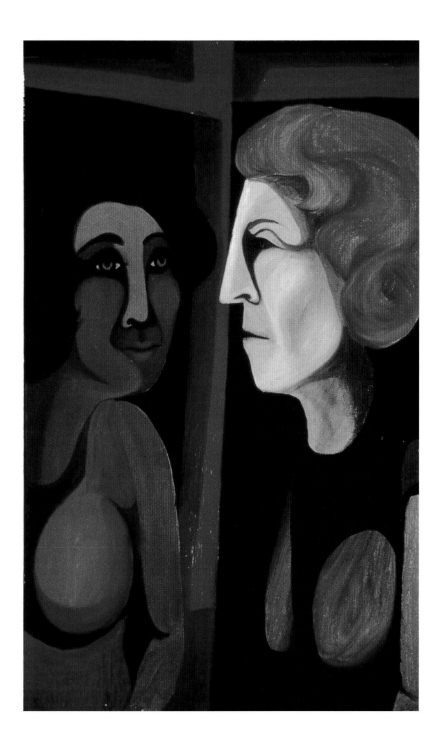

Between Friends depicts two women—one African American, the other Anglo-American—coming face to face in a tightly compressed entryway. The red door jamb effectively segregates the two women, even as it facilitates their meeting. Age and demeanor further set them apart. The white woman is older and presents an implacable profile. Her younger companion faces her and wears a vague smile, as if she is hopeful that a friendship might be forged. Such an alliance seems unlikely, however, given the fact that the two women are posed as stiffly as mannequins, alluding to the taut formality, psychological tensions, and class disparities of the time. The work's totemic design and its original title—*The Wall between Friends*—are signposts of the social impediments that made genuine friendship between blacks and whites nearly impossible.[44]

Ringgold's interests in visually conveying the complexities of African-American life were developing simultaneously in Spiral, which came into being as Ringgold was beginning the *American People* series. Recognizing her kinship with Spiral, Ringgold contacted its secretary, Romare Bearden, in an attempt to join the group. Her hopes for membership were dashed, however, when after reviewing slides of Ringgold's work, Bearden wrote a letter to her in which he unfavorably assessed her idiosyncratic painting style. He complained that Ringgold's deployment of a shallow and condensed picture space prevented her figures from "breathing."[45] Though deflated by the rejection, Ringgold heeded Gwathmey's earlier advice and persisted in her own distinctive semi-abstract style, which merged figural distortion, compressed space, flat planes of color, and geometric design elements with sociopolitical symbolism. In years to come, her art would be celebrated for the very characteristics that had prevented her acceptance in Spiral.

In 1966, Ringgold became affiliated with New York's Spectrum Gallery, a cooperative space managed by poet and critic Robert Newman. In contrast to Spiral, Spectrum included an all-white membership of, for the most part, abstract painters and sculptors. Ringgold's presence was welcomed as a way to integrate the gallery and to diversify the group's art offerings. Likewise, Ringgold benefited from Spectrum's policy of affording its artists time and space for solo exhibitions. Two such shows were mounted for Ringgold over the next several years, the first in December 1967. In preparation for this inaugural showcase, Ringgold redoubled her work on the *American People* series, completing the cycle with three large-scale paintings, which were planned as the centerpieces of the show. They were *Die, U.S. Postage Stamp Commemorating the Advent of Black Power*, and *The Flag Is Bleeding*.

Rendered in a hard-edged, pop art style, *Die* represents Ringgold's response to the rash of race riots and violent confrontations with police that beset the country (fig. 6.11). Chaos reigns in Ringgold's brutal spectacle, and blood is everywhere—spattered on faces, staining clothing, dripping from weapons, pooling beneath fallen bodies, and discoloring the gridlike background, which serves as the only stabilizing element in this grisly panorama. Arms flail, guns explode, and silent screams of horror pervade the narrative. Poet and playwright Amiri Baraka assessed the painting's shock value at the time as "a violent confrontation between slave and slave master in the modern American streets [which] . . . terrorized gallery directors and house *nogrews*, too. They didn't want to be associated with such violence. They certainly didn't want to be the objects of it."[46] His summary of the reaction—one of apprehension and distaste—of many prospective buyers and "house nogrews" (Baraka's term for regressive "Negroes," "house slaves," or "Uncle Toms") to Ringgold's frank and accusatory subject matter explains why *Die* was shunned by dealers, collectors, and museums alike as politically inflammatory.

Curator Lowery Sims put her finger on the pulse of the 1960s art scene and on the problems of political art: "In an intensely political world, art was to have no politics. As a result, politically engaged art was seen to be . . . out of sync with the current values of the art world, and in an insidious way,

Figure 6.11

Faith Ringgold

Die, from *American People*

series, 1967

oil on canvas, 72 x 144"

(183 x 365.7 cm)

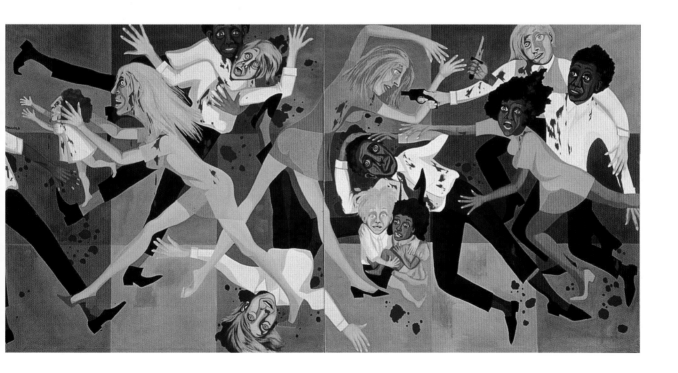

invalid."[47] Ringgold may have been "out of sync" with the mainstream art arena, but she was entirely in tandem with the Black Arts movement and with African-American iconoclasts, such as James Baldwin, whose writings instigated the *American People* series. Baldwin published his pioneering book *The Fire Next Time* shortly before Ringgold began the series, and she was captivated by its authenticity: "I feverishly read, especially everything that James Baldwin had written on relationships between blacks and whites in America. Baldwin understood, I felt, the disparity between black and white people as well as anyone."[48] *Die* is an incarnation of Baldwin's promise of a racial apocalypse made in his essay "My Dungeon Shook":

> If we . . . do not falter in our duty now, we may be able . . . to end the racial nightmare, and achieve our country, and change the history of the world. If we do not now dare everything, the fulfillment of that prophecy, re-created from the Bible in song by a slave, is upon us: *God gave Noah the rainbow sign, No more water, the fire next time.*[49]

In *Die*, it appears that God's wrath has indeed been visited upon us and, as in Noah's time, virtually no one escapes the cataclysm.

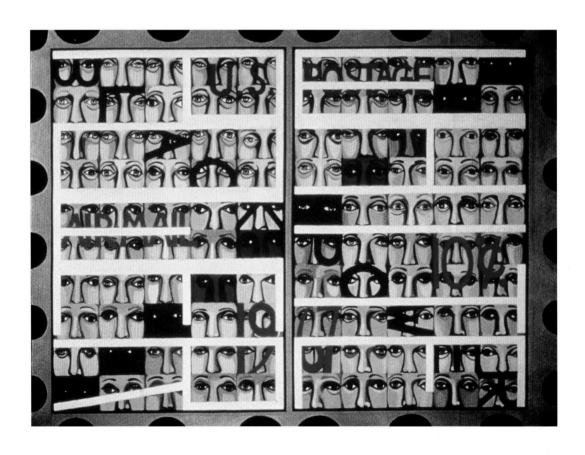

Die owes its compositional cogency in part to Picasso's 1937 *Guernica*, which hung at that time in the Museum of Modern Art and was frequently visited by Ringgold. *Die* and *Guernica* share several design devices, such as compound diagonal elements, figural reduction, and aspects of caricature. Also coincident are the scenarios of human carnage, particularly the slaughter of innocent women and children. The Spanish painter's disorienting synthesis of multiple perspectives, however, is abandoned by Ringgold for an unyielding wall of grisaille tiles, which traps the combatants against the picture plane. Ringgold also rejects Picasso's neutral cubist palette for a luminous and variegated one, which she found more suitable to the emotional intensity of her subject.

The second of Ringgold's large-scale pictures, *U.S. Postage Stamp Commemorating the Advent of Black Power* portrays one hundred faces, ten of which are African American, roughly approximating the ratio of blacks to whites in the United States (fig. 6.12). The words and numbers—"U.S. Postage," "Airmail," "10¢," and "1967"—are inscribed over the faces in red. Painted diagonally in slightly larger, black letters are the words "Black Power" which, together with the ten brown faces, form an X and imply that blacks and their alleged power have been "X-ed" out—negated. Closer scrutiny of the painting reveals the disguised words "White Power," which are inscribed sideways and, at first, are indiscernible. Not only are these letters larger than those that spell out "Black Power," but they completely permeate the composition, cutting through all of its components. The hierarchical interplay between the two phrases "Black Power" and "White Power" impugns the very authority of the Black Power movement and suggests that, despite appearances, Black Power is delimited by a rigid and unalterable class system in which whites rule.[50]

The diagrammatic vitality of *U.S. Postage Stamp* is optimized by the means, if not the meaning, of pop art. Ringgold's canvas is a meditation on the abbreviated forms and mechanistic print qualities of pop art icons, such as Andy Warhol's 1962 *Marilyn Diptych*. Pop art of the 1960s was a tongue-in-cheek affirmation of Walter Benjamin's "mechanically reproducible art." Artists of the genre borrowed from such sources as commercial printing, grid patterning, magazine images, and comic books, and elevated popular imagery to fine-arts ranking in the process. Ringgold capitalized on pop techniques and reconfigured them to suit her own emotive, symbolic, and political ends. Sims defines Ringgold's conflation of pop art form and revisionist substance as a kind of "psychic freedom" within which the artist "produced some of the most powerful icons in the 1960s."[51]

Last in the series, *The Flag Is Bleeding* is an arresting image of the American flag superimposed over three figures: a blonde woman flanked by two

Figure 6.12

Faith Ringgold

U.S. Postage Stamp Commemorating the Advent of Black Power, from *American People* series, 1967

oil on canvas, 72 x 96"

(183 x 243.8 cm)

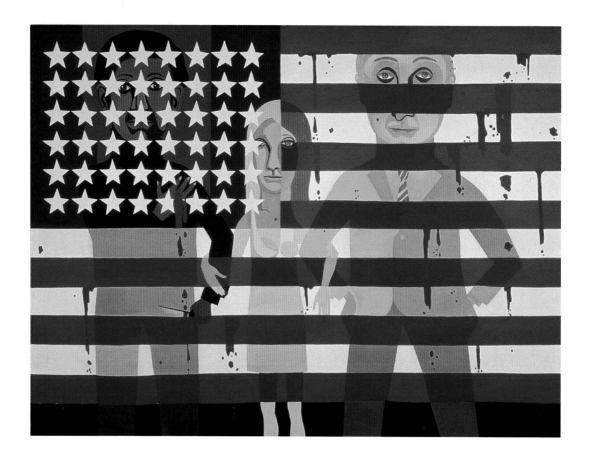

men, one white and one black (fig. 6.13). Blood seeps from the red stripes of the flag and stains the figures. The men are linked by the arms of the woman, whose role is one of arbiter rather than participant in the "bloody" interaction between the men. The darker man is partly concealed by the stars of the flag and bleeds from a wound near his heart. With one hand he holds a knife; with the other he stems the flow of blood from his heart and simultaneously pledges allegiance. The white male figure is taller, broader, and more visible than his companions, connoting the social and political dominance of white males in American society. He stands with his hands on his hips and his legs spread apart, like a cowboy who packs a gun on each hip, thus confirming his potential (and that of the country he dominates) for violence.[52]

Ringgold's interest in the flag as an icon was stimulated by the flag paintings of pop artist Jasper Johns, though she felt that his images were "incomplete" because they remained politically neutral and made no reference to the "hell" of racial violence that had erupted in America. Instead, like many Americans, she preferred to exploit the American flag to critique

social injustice. The burning and defacing of the flag was an oft-employed, if then illegal, form of political expression recognized by an entire generation of Americans who revolted against everything from racism and sexism to war and sobriety.[53] In 1970, Ringgold joined nearly 200 artists who were intent on conveying their civil discontent through the use of the national standard. Their effort, an exhibition titled "The People's Flag Show," was installed at the Judson Memorial Church in Greenwich Village. The artists who participated adapted the icon of the flag to express their displeasure with the U.S. offensive in Vietnam and with the oppression of women and minorities at home. Images such as Kate Millet's flag emerging from a toilet and Alex LaCross's flag-covered penis provided metaphors for the deteriorating state of American politics and the menace of U.S. military chauvinism.

Conceived "as a challenge to the repressive laws governing flag desecration," the show was organized and curated by Ringgold (who contributed two flag pictures, including *The Flag Is Bleeding*) and fellow artists Jean Toche and Jon Hendricks. All three were members of the Art Workers' Coalition (AWC), a group founded in 1969 to protest class discrimination in museum policies and practices.[54] Later nicknamed "The Judson Three," Ringgold, Toche, and Hendricks were arrested and jailed on charges of flag desecration on the closing day of the show. Their plight became an international cause célèbre, and donations to pay for their legal defense poured in from around the world. Art world titans, such as critic Lucy Lippard, Museum of Modern Art director John Hightower, and Allen Schoerner of the New York State Council on the Arts, testified for the defense, but to no avail. The Judson Three were convicted on 14 May 1971, and each was sentenced to a fine or one month in prison. Ringgold paid the fine.[55]

Committed to social reform, Ringgold established along with artist Tom Lloyd the United Black Artists' Committee (UBAC), which expanded the AWC's class concerns to include issues of racial discrimination. The group launched an attack on the Museum of Modern Art to protest the limited representation of minority artists in its collections and programs. The UBAC demanded that a separate wing be established for artists of color, that a curator be appointed to supervise the acquisition of works by minority artists, and that a series of exhibitions of art by African Americans be implemented without delay. The group's action, which consisted of an extensive letter-writing and publicity campaign, as well as on-site demonstrations, was an unqualified success. Within a year, the museum had conceded its "oversight" with reference to artists of color and agreed to revamp the museum's procurement guidelines and to schedule exhibitions of the works of Bearden and sculptor Richard Hunt.[56]

Figure 6.13
Faith Ringgold
The Flag Is Bleeding, from
American People series, 1967,
oil on canvas, 72 x 96"
(183 x 243.8 cm)

The UBAC victory was bittersweet for Ringgold, who chafed against the facts that both of the museum's black exhibitions would showcase men and that Bearden, who had earlier dismissed her talents, would benefit from her arduous politicking. After years of dedication to the Black Arts movement, Ringgold concluded that it did not effectively serve her needs and that Black Power was categorically male. She then made the controversial decision to ally herself with the nascent feminist art movement. In her words:

> [Men] use you and you don't grow. . . . It took all that dedication . . . all those demonstrations . . . all that running around . . . [to] meetings with those trustees . . . for that [the Bearden and Hunt exhibitions] to happen. . . . Nineteen-seventy was [the year of] my coming out as a feminist and in doing that I alienated a lot of people. . . . Things were opening up . . . but not for me. I had stepped on a few toes, I guess, and they were the wrong toes. . . . You know, if you do the yelling, somebody else gets the rewards.[57]

Ringgold was hopeful that the feminist art movement would be more supportive of her professional objectives. For the time being, however, she chose to concentrate once again on making visual, rather than activist, statements. For the next several years, she explored landscape painting, mural art, and graphic design, while continuing to delve into political subject matter.[58]

While the impact, success, and longevity of the careers of both Ringgold and Catlett tend to dominate this period, they were by no means alone in their achievements. Others, such as Marie Johnson Calloway, Samella Lewis, Yvonne Parks Catchings, and Kay Brown were also productive during these reactive years. Throughout her life, California artist and professor **Marie Johnson Calloway** (b. 1920) exhibited her "sculpted paintings"—polychromed wood renderings of everyday African Americans whose heroism emanated from their "quiet, useful lives" (fig. 6.14).[59] Johnson grew up in the then-segregated city of Baltimore and worked as a public school teacher for a decade before completing a degree in art education at Morgan State College in 1952. In 1954, she settled in California, where she became active in the Civil Rights movement, and earned master's and doctoral degrees at San Jose and San Francisco State universities. Johnson's unconventional aesthetics, which foreshadowed the assemblage art of the 1970s,

Figure 6.14

Marie Johnson Calloway

Silver Circle, 1972

construction, 36"

diameter x 6" deep

while not overtly political, persistently portrayed the venerable black urban personalities who touched the artist's life and who epitomized the nobility of African-American culture.[60]

Samella Lewis (b. 1924) was not only a successful visual artist but also fused theory with practice by teaching and writing about art. She completed a doctoral degree in art history and cultural anthropology at Ohio State University in 1951 and in 1953 established the department of art at Florida A&M University, where she remained as a teacher and administrator until 1958. Subsequently, she taught at the State University of New York and Scripps College in California. Her cognitive and managerial capabilities were inexhaustible and extended far beyond the teaching realm. A gifted curator, she founded, with artist and actor Bernie Casey, the Contemporary Crafts Gallery in Los Angeles in 1970. Principally an exhibition space for artists of color, Contemporary Crafts also facilitated the production of inexpensive prints for working-class consumption. Lewis anticipated the 1970 CONFABA call for the historical documentation of African-American art and, in 1966 cataloged the history of black art in the United States in a film, *The Black Artists*. Lewis followed this film with a series of documentaries on individual artists, and ultimately translated her films into print with the 1978 publication of a comprehensive art survey entitled *Art: African-American*, which quickly became a university standard. Lewis was also, for many years, editor in chief of the scholarly journal the *International Review of African-American Art*.[61]

Given the breadth of Lewis's intellectual accomplishments, her concomitant success as a visual artist is awe-inspiring. Like the works of Ringgold and Catlett, hers are pictorial manifestations of the age of civil rights and black liberation. For example, Lewis's 1969 linocut *Field* coalesces the peasant worker motif of Catlett's imagery with a ponderous sculptural solidity unique to Lewis (fig. 6.15). A raised "black power" fist is the focal point of Lewis's design, which seems to have been gouged into the linoleum surface. Lewis's boldly incised markings circumscribe a field worker, who gestures in agony and rebellion under the burning heat of the sun. The matte blackness of the sky is adroitly offset by sweeping lines of varying thicknesses, bearing witness to Lewis's dexterity with the medium. Lewis, whose talents extended also to painting and sculpture, capped her career in 1986 by founding the Museum of African-American Art in Los Angeles, serving as its chief curator for many

Figure 6.15
Samella Lewis
Field, 1969
linocut, 22 x 18" (56 x 45.7 cm)
Samella Lewis Collection of the Hampton University Museum.
© Samella Lewis/Licensed by VAGA, New York

years. Now retired, Lewis continues to paint, exploring composite styles of expressionism and figurative abstraction.

The art of **Yvonne Parks Catchings** (b. 1935) is less known for its response to the politics of civil rights and black power than some of her peers, though she was at least momentarily swayed by the 1960s phenomenon. After completing an A.B. at Atlanta's Spelman College in 1955 and a master's degree in art education at Columbia (1958), Catchings went to Michigan to pursue a second master's degree in museum studies (1970) and a Ph.D. in art education (1981). Catchings, who is best known for delicate

and dreamlike genre, floral, and city scenes, completed a key work in 1968 entitled *Detroit Riot*, which radically diverged from her usual fare (fig. 6.16). An assemblage, *Detroit Riot* was constructed in direct response to one of the worst incidents of racial violence to occur in the 1960s.[62]

One of the most devastating moments of police brutality, racial violence, and civil unrest, the Detroit riot of July 1967 was triggered by a police raid on a black nightclub. Over the next two days, 43 locals were killed and nearly 10,000 were injured or imprisoned. Catchings's *Detroit Riot* is more than a work of art; it is an archaeological vestige of its namesake. The assemblage is quite literally composed of "the flotsam and remnants" that were left behind after the riot subsided.[63] Through the application of lurid red pigments and crude collaged materials, such as charred wood, broken glass, and bits of metal,

Figure 6.16

Yvonne Parks Catchings

Detroit Riot, 1967–1968

oil and mixed-media assemblage

on canvas, 36 x 24"

(91.4 x 61 cm)

Catchings's construction captures the ferocity of the episode and the resultant carnage. *Detroit Riot*, which is essentially a nonfigurative composition, mimics an explosion seen at close range and interprets the Detroit conflagration from the inside out.

Similarly disposed is the neodada work of artist **Kay Brown** (b. 1932), whose 1969 *The Black Soldier* is a large-scale collage which incorporates torn bits of newsprint and photographic imagery, arranged in a seemingly haphazard manner (fig.6.17). The words "death," "Vietnam," and "the black soldier" are interspersed with photos of Uncle Sam, Black Panthers, GIs, and victims of violence. Brown's message is one of protest against the war in Vietnam, speaking in particular to the disproportionate numbers of African-American men who fought and died in combat.

Indisputably, a considerable amount of the art produced by African-American women in the 1950s and 1960s responded directly to contemporary events and ideas. As new priorities unfolded, however, new imagery superseded old. On the immediate horizon was the feminist art movement, which to some, such as Ringgold, seemed the logical next step in their artistic and personal gestation. Ringgold and Brown became leading feminist activists, founding in 1971 the support group Where We At: Black Women Artists. Acutely aware of the patriarchal orientation of the Black Arts movement, women artists of color began to realize that self-support and self-promotion were crucial to attaining their goals. Their amended approaches to art and gender politics would soon pioneer new avenues for women artists of all races.

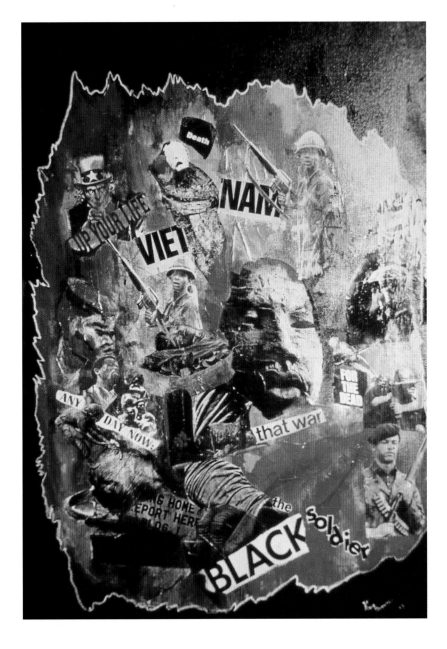

Figure 6.17
Kay Brown
The Black Soldier, 1969
collage, 50 x 37"
(127 x 94 cm)

The women's movement developed in the late 1960s at the same time as the Black Power movement, and it had an equally momentous effect on the art of African-American women. Two events helped to lay the groundwork for the women's movement. The first was the publication in 1963 of *The Feminine Mystique*. This groundbreaking volume critiquing society's repression of and discrimination against women and charting their changing roles was written by NOW (National Organization for Women) founder Betty Friedan.[1] The second was the passing in 1964 of the Civil Rights Act, which banned sex discrimination. By the early 1970s, when the Supreme Court legalized abortion, perceptions of women, their prerogatives, and their status in society had radically changed. In response to this new outlook, women artists began to transform conventional perceptions of themselves into ones that better reflected their newly configured identities. Coming together in a vast array of formal and informal coalitions, a new generation of women artists formed the core of the feminist art movement.

Critic Lucy Lippard defined the feminist art campaign as "neither a style nor a movement [but rather] a value system, a revolutionary strategy, a way of life."[2] Brainstorming a strategy to rectify the absence of women artists from history was foremost on the movement's agenda. Feminist art historians engaged in new research and strove to enrich art historical scholarship regarding women. They also countered claims that female artists were less talented than their male counterparts and thus less deserving of admittance into the annals of art history. Possibly the most celebrated essay on the subject was art historian Linda Nochlin's "Why Have There Been No Great Women Artists," published in *ARTnews* magazine in 1971. Nochlin's thesis adroitly analyzed the fundamental gender chauvinism of Western society and the long history of impediments—lack of access to art schools, the demands of child rearing, social taboos and restrictions—that had pre-

SEVEN **Black Feminist Art**

vented women from becoming "great artists." Nochlin also underscored the dearth of published research on the exceptional women who had, regardless, managed to forge productive careers. Her exposé called attention to the careers of thirteenth-century sculptor Sabina von Steinbach; sixteenth-century painters Marietta Robusti and Artemisia Gentilleschi; rococo artists Élisabeth Vigée-Lebrun and Angelica Kauffman; exponents of the nineteenth-century realist tradition Rosa Bonheur, Berthe Morisot, and Mary Cassatt; and twentieth-century artist Helen Frankenthaler, among others.[3]

Another concern for feminist artists and historians was the way in which women had been portrayed throughout the history of Western art—as either completely open to male voyeurism, or as malevolent and dangerous. Persistent examples of the former can be found in paintings and sculptures from the classic marble goddesses of ancient Greece and the quiescent maids and Venuses of the Renaissance, to the exotic recherché nudes of Gauguin and Picasso. The femme fatale—the alter ego of the coy, reclining nude—while conceived as lively and vigorous, was rarely portrayed as heroic, unlike the archetypal male subjects: the equestrian figure, the warrior, the orator, and other such champions. In the femme fatale figures of fin-de-siècle Europe, for instance, the unleashed malice and sexuality of the Sphinx, Eve, Pandora, and Salomé menaced and engulfed their male victims.[4] The clichés associated with the representation of women in art reinforced the expectations of women in society. "Good" women were required to be passive and submissive, while "bad" women were those who dared to actively flout convention—such as the thousands who were becoming practicing feminists. Forward-thinking women artists understood that a revision of these stereotypes was necessary to achieve social equity.

Women Artists in Revolution (WAR) was one of the first organizations to successfully raise the level of awareness and the representation of women within the art establishment. Its members had come from the ranks of the Art Workers' Coalition, the militant artist group that had evolved in the late 1960s. However, the AWC was monopolized by a white male membership that did little to further the causes of minorities or women. Disaffected by the nepotism within the AWC, black members, including Ringgold, opted to form the UBAC, and female members split off to found WAR. Other women's alliances followed in 1970. The Ad Hoc Women Artists Committee in New York publicized the marginal inclusion of women in the Whitney Museum annual exhibitions and permanent collections. Within a year, the Ad Hoc delegates had persuaded the Whitney to increase the percentage of women in its annuals from 5 percent to 22

percent and to add women of color—specifically Betye Saar and Barbara Chase-Riboud—to their 1971 annual.[5]

The feminist art movement emerged on the West Coast as well. The Los Angeles Council of Women Artists (LACWA) was established in 1970 to expose biases at the Los Angeles County Museum of Art, which could boast in its entire history only one solo exhibition dedicated to a woman, and barely 1 percent female representation in its permanent collection. Judy Chicago and Miriam Schapiro established the Feminist Art Program at the California Institute for the Arts (Cal Arts). The artists' cooperative Womanspace was founded in Los Angeles in 1973, and subsequently initiated an art journal of the same name. This publication was followed by an array of feminist periodicals, including *Women in Art Quarterly*, the *Feminist Art Journal, Women Artists Newsletter* (later, *Women Artists News*), *WomanArt, Chrysalis,* and *Heresies.*[6] These feminist periodicals addressed issues of gender with daring and determination, but the women's movement as a whole was essentially white and middle class and seemed only tangentially concerned with improving the lives of minority women. Many women of color felt that white feminists had coopted the women's movement as *their* movement, as if only they had the right to determine the ways in which issues of race were addressed, or if these issues would be addressed at all.[7] African-American women, therefore, were hard-pressed to embrace a crusade that seemed unaware of, or unconcerned with, their dual dilemma of race and gender discrimination.

Charges of racism were aimed at the women's movement by vocal women of color. Feminist critic bell hooks stated candidly that African-American women were dissuaded from participating in the movement "because . . . the racism of white women" disregarded their needs. Betye Saar, who was an affiliate of Womanspace, noticed the conspicuous lack of support that African-American women artists received from their Euro-American colleagues: "It was as if we were invisible again. The white women did not support [us]."[8] And artist Emma Amos declined to join a consortium of Greenwich Village feminists because, as she explains, "From what I heard of feminist discussions . . . the experiences of black women of *any* class were left out."[9] Author Audre Lorde observed, "As white women ignore their built in privilege of whiteness and define *woman* in terms of their own experience alone, then women of color become 'other,' the outsider whose experience and tradition is too 'alien' to comprehend."[10]

Needless to say, many African-American women spurned feminism and maintained ties with black liberation groups instead. Unfortunately, because of the endemic patriarchal orientation of the black liberation movement, which discounted its women supporters, those who chose black

power over feminism were compelled to accept, and to comply with, their own marginalization.[11] Women artists of color were caught in a quandary. Should they remain faithful to the Black Arts movement, which they found meaningful but which often overlooked issues of importance to them? Or should they shift allegiances to the feminist art movement, which they recognized as fundamentally exclusive, classist, and largely at odds with racial equity? The challenge of this dilemma was fittingly articulated by Ringgold, who asked, "When there is a group for blacks and a group for women, where do I go?"[12]

The solution seemed to lay in a hybrid arrangement that placed commensurate emphasis, in both art and politics, on gender and ethnicity. Selected artists assayed the viability of partnering black and feminist aesthetics. In the tradition of the Black Arts movement, **Sharon Dunn** (b. 1946), for example, carried out a mural initiative at Yarmouth and Columbus avenues in South Boston in 1970 entitled *Maternity* which, like the urban wall paintings produced by AfriCOBRA, was radiantly hued, figurative, and enlivened with rhythmic shapes and patterns (fig. 7.1). Unlike its prototypes, however, Dunn's design was dedicated solely to black women, explicitly the mothers in the black community where the artist lived. A frieze of larger-than-life-sized women, pregnant or partnered with their children, anchors the composition. Above this panel is a second

Figure 7.1

Sharon Dunn

Maternity, 1970

procession of transparent bodies whose breasts and uteri are revealed as if by X ray, underscoring women's roles in procreation. A third register, at the top, portrays in Dunn's words, "the spirit of the ancestors watching," and is a reference to the all-seeing eye in Egyptian iconography. Dunn's identification with her subject was likely heightened by the fact that she was a young mother herself at the time of its completion.[13]

A coterie of African-American women artists concluded that unconditional allegiance to the Black Arts movement guaranteed professional oblivion. They hoped that by working within the women's movement, despite its drawbacks, they might stand a better chance of garnering creative support and attention from art patrons, curators, scholars, and dealers. Moreover, they made up their minds to provide their own support bases, if and when they found themselves relegated to the sidelines of the feminist art movement. Groups such as WSABAL (Women, Students and Artists for Black Art Liberation) and Where We At: Black Women Artists (WWA) were formed to afford women of color a voice in the art world that spoke to their unique concerns.[14] Not surprisingly, Catlett, whose works such as *I Am the Negro Woman* and *Political Prisoner* (figs. 6.2, 6.8) had long paid tribute to women, moved with relative ease into the politics of feminist art. Catlett pledged more than art and lip service to women's liberation. In 1963, she became one of ninety global delegates to the Congress of Women in the Americas. Shortly thereafter, she helped to found the National Union of Mexican Women, a coalition of women's organizations with the goal of "serving the needs of Mexican working class and peasant women."[15] Catlett was also on the group's executive board until her retirement from teaching in 1975. Her devotion to black women in life and art inspired others who proudly assumed the title "feminist artist." Furthermore, Catlett's no-nonsense response to gender abuse and exploitation, evident in her allegation "I think the male is aggressive and has a male supremacist idea in his head, at least in the United States and Mexico," resonated with the more radical feminists and linked her directly with their cause.[16]

Unfortunately, those militant women artists who were inspired by Catlett's example paid a price for their choice to back feminism. In 1967, when the vastly popular and federally sanctioned Moynihan Report officially impugned black women for the social afflictions of the African-American family, those who subscribed to feminism were subject to accusations of sedition. "You seek to divide us," Ringgold was told by women who, like herself, were living within a society that enlisted "their collusion with a [culture] that thrived on race, class, and gender oppression."[17] Many African-American women saw no need to campaign for empowerment.

They believed themselves to be already "liberated" because, unlike so many of the white middle-class proponents of the women's movement, their presence in the work force was strongly felt, although their jobs earned them far lower wages and inferior working conditions.[18]

This tug-of-war between the politics of black liberation and the politics of feminism was keenly felt by Ringgold, who by 1970 had reshaped her aesthetic outlook to focus more definitively on feminist subject matter. Her 1973 *Women's Liberation Talking Mask* offers a textbook example (fig. 7.2). This mixed-media assemblage brings to light Ringgold's enthusiasm for African sources (in the use of raffia fibers, gourds, beading, strip cloth, and a mask) and highlights her awareness of the relevance of African design to the Black Arts movement. On the other hand, the narrative premise of the piece is explicated by its title and discloses Ringgold's support of women's rights. Emphasis is placed on the figure's rigid, conical breasts, which evoke African matriarch and goddess talismans. The figure's nose has been displaced by an arrow that points toward the open mouth of the mask—a figurative charge to women to make their voices heard. *Women's Liberation Talking Mask*

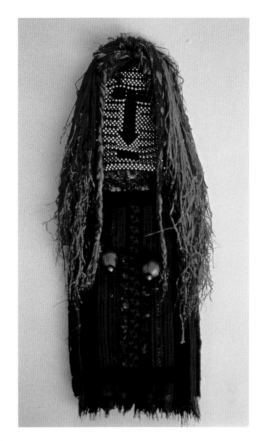

indicates, too, Ringgold's willingness to experiment with the fiber and "craft" media that had become associated with feminist art. Such explorations included soft sculptures, dolls, and quilted and brocaded paintings, which were frequently used in ambitious performances that expressed the artist's sociopolitical outlook.

Already an experienced activist, Ringgold was an ideal candidate to help spearhead the gender crusade. She participated in the Ad Hoc Women Artists Committee and cofounded several support groups for black women artists. Ringgold's art of this period has been described as "Afrofemcentric" owing to its consolidation of her earlier preoccupation with black liberation and her mounting interest in women's causes. According to art historian Freida High W. Tesfagiorgis, who coined the term, Afrofemcentric art embraces principles of harmony—a harmony of ideas and images, of predictable and alternative materials, and of race and gender substance.[19] Ringgold's Afrofemcentric period began about two years prior to the completion of *Women's Liberation Talking Mask*. The "political poster" *Woman Freedom Now* (1971), one of a series of advocacy placards that grew out of the artist's work in the Black Arts movement, is a prototypical example of her multidimensional aesthetic (fig. 7.3).

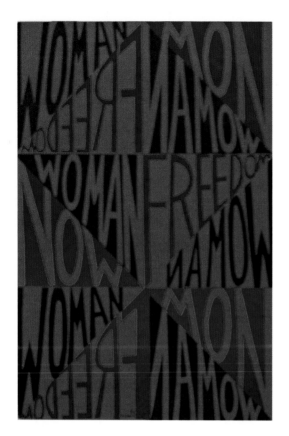

Figure 7.3
Faith Ringgold
Woman Freedom Now,
from *Political Posters,* 1971
collage, 30 x 20"
(76.2 x 50.8 cm)

Woman Freedom Now adopts the form of a Bakuba chevron derived from Kongo textile designs. The diamond-shaped configuration is effected by the joining of a series of red, black, and green triangles, within which are the words "woman," "freedom," and "now," etched forward, backward, and in reverse, as if viewed in a mirror. The poster's color scheme signifies the artist's solidarity with the Black Power movement, while its text salutes the women's movement. The composition is at once an interpretation of op art (a contemporaneous style of painting that employed optical effects through the use of recurring patterns) and a straightforward billboard to be read for literal content. Writer and activist Amiri Baraka christened *Woman Freedom Now* a "modern classic" because it was one of the very first works of graphic design to endorse feminism within the context of black liberation.[20]

Poster art represented Ringgold's first response to the Black Arts movement's demand for "art for the people." The public mural signified her second. Undoubtedly inspired by AfriCOBRA's efforts to bring art to the urban ghetto, Ringgold joined the public art campaign. With help from a Creative Arts Public Service (CAPS) grant, she conceived and executed a mural for a segment of the population that was even more disenfranchised than the residents of America's inner cities: women in prison. As the site for her mural, Ringgold chose the Women's House of Detention on Riker's Island in New York City and appropriately titled the painting *For the Women's House* (fig. 7.4).

Ringgold's reasons for choosing a prison locale were twofold: "To broaden women's images of themselves by showing women in roles that have not been traditionally theirs . . . and to show women's universality by painting a work which crosses the lines of age, race, and class."[21] *For the Women's House* achieves precisely these goals. It depicts, within the Bakuba grid, eight vignettes of women of various ages and races engaged in activities that were considered atypical at the time. After interviewing a number of the Riker's Island inmates, Ringgold chose to base her mural on their frank and ingenuous desires to see represented such ideas as "justice, freedom, a 'groovy' mural on peace, a long road leading out of here, the rehabilitation of all prisoners, [and] all races of people holding hands."[22] The prisoners' comments communicated to Ringgold their need to adorn

their living space with an affirmative vision of life after prison, and she set out to create it.

For the Women's House is a large oil painting composed of two panels, each eight by four feet. Depicted in the upper quadrant is a fiftyish white woman driving a bus, which partially displays the route number "2A" and the destination "Sojourner Truth Square." Together these designators form a prosaic play on words ("To a Sojourner Truth Square") and refer to the "long road out of here" that the inmates envisioned. Below the bus driver is an African-American doctor wearing a lab coat and teaching a class on drug rehabilitation at the fictitious "Rosa Parks Hospital." Ringgold identified the next panel as a "a controversial wedding scene" wherein a bride is being given away by her mother, rather than her father; and in which the presiding minister is a woman.[23] Not only are the traditional male roles of minister and father usurped by women, but the groom is conspicuously absent. The wedding ceremony is thus transformed from an event marking a

Figure 7.4

Faith Ringgold

For the Women's House, 1971

oil on canvas, 96 x 96"

(244 x 244 cm)

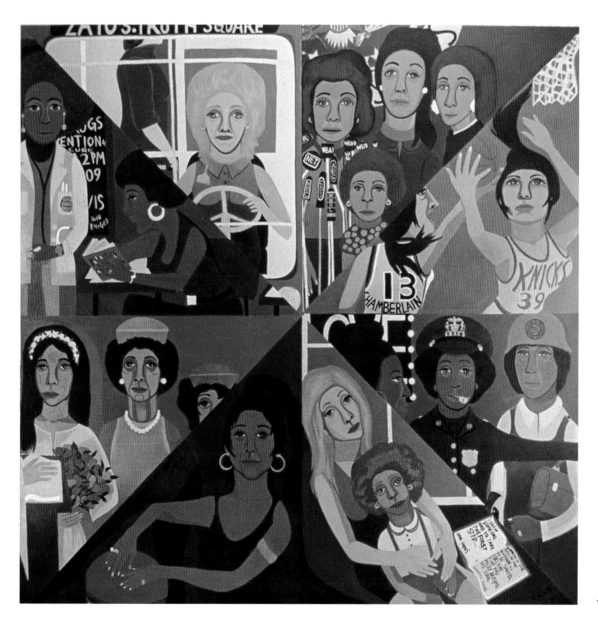

woman's union with a male partner into an initiation of sorts that ushers the woman from childhood to adulthood.

An Asian woman wearing a leotard and playing a drum completes the left side of the painting. This scene suggests both dance and music as possible career options for women. At the top right-hand side of the mural, an African-American woman has just been elected president. (At the time, Ringgold held out the hope that U.S. representative Shirley Chisholm would be elected president.)[24] This image is followed by one of professional women basketball players, one wearing a New York Knicks jersey, the other the jersey of the famed 1960s NBA champion Wilt Chamberlain. Ringgold replaces the male icon with a female one of equal athletic prowess. The basketball tableau is followed by one portraying a policewoman and a construction worker. A final scene depicts a white single mother embracing a child of apparent mixed race and expresses Ringgold's disapproval of the term "illegitimate child," which she thought unfairly stigmatized innocent children.[25]

In 1972, beginning with a group of paintings aptly entitled the *Feminist* series, Ringgold's work began to synchronize high art and crafts. Coincident with the "pattern and decoration movement" (a branch of the feminist art movement that espoused the use of fabric as an art medium), she joined a long list of artists who used fiber media. Motivated by textile-bordered Tibetan *tanka* paintings, which the artist had observed on a visit to the Rijksmuseum in Amsterdam, Ringgold "unstretched" her own canvases and achieved bilateral goals in the process. By removing the frames and wooden stretchers from her paintings and edging them instead with quilted and brocaded soft borders, Ringgold was able to minimize the expense and logistical difficulties of transporting and storing her works (which were now literally foldable, like clothing). She was also able to indulge a lifelong interest in sewing which she had inherited from her mother, a local dress designer, who assisted the artist in framing her first *tankas*.

The *Feminist* series was Ringgold's initial experiment with a painting method that would become her signature style. Like the Tibetan *tankas*, Ringgold's new paintings were vertical in format and comparatively intimate in size (each approximately three by two feet). They comprised abstract forest landscapes configured with brush strokes that pulsated with color. They also incorporated written texts that were inscribed vertically and calligraphically in the manner of Chinese landscape painting. Ringgold drew the textual elements from a recently published anthology of writings entitled *Black Women in White America*, which brought together diaries, slave narratives, speeches, and letters of women such as Sojourner Truth, Harriet Tubman, and Shirley Chisholm.[26]

Of My Two Handicaps, number 10 in the series, for example, reads, "Of my two handicaps, being female put more obstacles in my path than being black," a quote from Shirley Chisholm, the first African-American woman to be elected to Congress and the first to run for president, in 1972, the year the *Feminist* series was painted (fig. 7.5).[27] Charted in number 5 of the series is Sojourner Truth's reaction to the Fifteenth Amendment, which guaranteed the right to vote to black men, while excluding white women and women of color: "And if colored men get their rights and not colored women theirs, you see the colored men will be masters over the women and it will be just as bad as it was before."[28] Ringgold was as exasperated as Truth with the handicaps imposed upon women, and she was as certain as Chisholm that gender prejudice outstripped racial intolerance in America. Her painted words, adopted from her feminist predecessors, doubled for the artist's own voice. Ringgold decided to let her paintings speak for her.[29]

Ringgold maintained a lifelong commitment to the enfranchisement of women and, later in her career, took on the masters of Western art such as Monet, Manet, Van Gogh, Picasso, and Matisse in a tongue-in-cheek series entitled *The French Collection*. The series, which reiterates a number of modern masterpieces, is made up of "story quilts," acrylic paintings that are quilted, cloth bordered, and accompanied by original storybook narratives, written directly onto the canvas. *The French Collection* pokes fun at male artists and exposes the machismo inherent in many of Western culture's titular masterworks. Her *Picnic at Giverny* parodies Manet's *Déjeuner sur l'herbe* with a nude likeness of Picasso posing for a fictional black woman painter, Willia Marie Simone (fig. 7.6). Picasso assumes the role of the passive female nude, exposed to a group of Ringgold's clothed women friends, all of whom lounge alongside a lake that resembles Monet's Giverny waterlily pond. Among the dozen picnickers are art historians Moira Roth, Ellie Flomenhaft, Lowery Sims, and Thalia Gouma-Peterson, art dealer Bernice Steinbaum, and the artist's daughter, writer Michele Wallace. Thus, *Picnic at Giverny* is as much a group portrait as it is a satire. Just as it perverts the role of the male artist, it

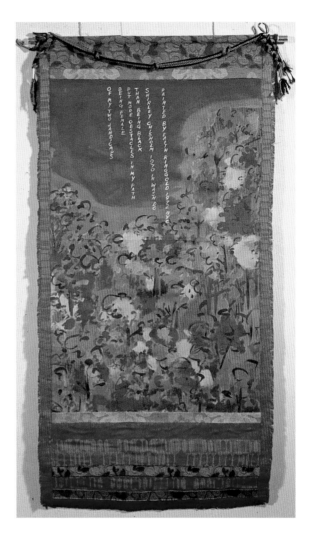

Figure 7.5
Faith Ringgold
Of My Two Handicaps,
from *Feminist* series #10, 1972
acrylic on canvas *tanka*, 51 x 26"
(130 x 66 cm)

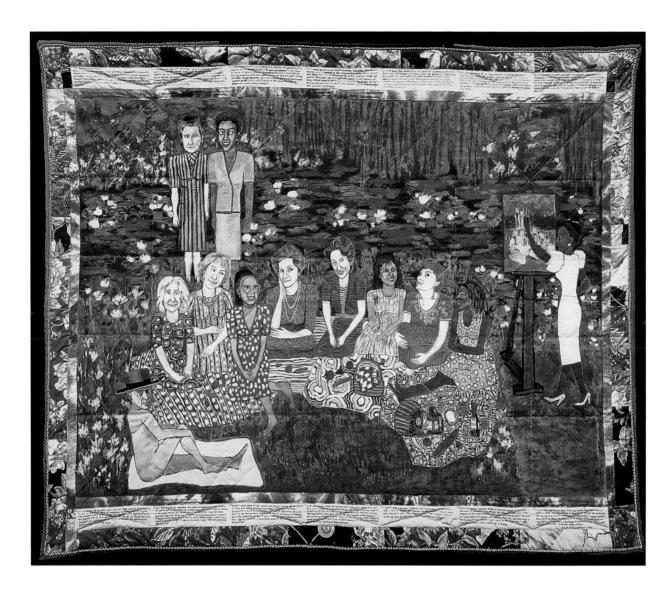

Figure 7.6
Faith Ringgold
The French Collection Part I: #3,
Picnic at Giverny, 1991
acrylic on canvas with pieced
fabric border, 73 1/2 x 90 1/2"
(186.7 x 230 cm)

also celebrates those women with whom Ringgold shared a commitment to expanding the incumbency of women in the arts.

In 1991, another of Ringgold's story quilts, *Tar Beach*, was published as a children's book. It articulates the story of an eight-year-old Harlem girl who dreams of flying and garnered for the artist a far-reaching audience of both children and their parents. The book won more than a dozen literary awards, including the Caldecott Honor Book Award and the Coretta Scott King Award for illustration, and became the first in a series of highly successful children's books which the artist wrote and illustrated. Ringgold encouraged a new generation of artists while teaching performance at the University of California, San Diego, and she educated a wider public about the often unacknowledged achievements of black artists with the establishment of the Anyone Can Fly Foundation.

Painter **Emma Amos** (b. 1938), who is portrayed in Ringgold's *Picnic at Giverny* (seated in a blue and green striped dress), also devotes much of her subject matter to the issues faced by women of color. A native of Atlanta, Amos arrived in New York in 1961 to enroll in the NYU master's program, where she reacquainted herself with NYU professor and Spiral cofounder Hale Woodruff, who had been a friend of the Amos family when he taught at Atlanta University. Through Woodruff, Amos gained entrée into Spiral. Although she was flattered to be a member of the all-male confederacy, even as a young student Amos was aware of the conspicuous absence of any other women artists: "I thought it was fishy that the group had not asked Vivian Browne, Betty Blayton, Faith Ringgold, Norma Morgan, or any other woman of their acquaintance to join. I was probably less threatening to their egos, as I was not yet of much consequence."[30]

Amos was taken aback by the cold reception she received as she showed her work to New York galleries and attempted to find employment. When she applied for teaching positions at the Art Students League and Cooper Union and was told each time, "We're not hiring right now," Amos came to realize that blacks from the South were thought to be "unlearned" plantation exiles who neither "went anywhere or knew anything." She also began to recognize that the New York art scene was "a man's scene, black or white." Not surprisingly, her participation in Spiral was often limited to that of an observer of the group's discussions and activities. Furthermore, Amos felt isolated from other African-American women artists who, for the most part, were unknown to her. Amos recalls that, within the context of Spiral meetings and discussions, even an internationally known artist like Catlett was referred to as "the wife of Charles White."[31]

Not surprisingly, as Amos matured, her art began to reflect her past experiences with patriarchy. *Tightrope* (1994), an objective as well as

psychological self-portrait, visualizes the artist's travails in a fusion of painting, textile design, and printing processes (fig. 7.7). Amos paints herself in red boots, black smock, and a Wonder Woman costume, precariously negotiating a tightrope above a clamoring crowd. In one hand, she holds aloft her paint brushes—the symbols of her trade. In the other, she grasps a T-shirt bearing the likeness of "Mrs. Gauguin's breasts"—a reference to *Two Tahitian Women with Mangoes* by Paul Gauguin in which the nineteenth-century French artist affirmed the "fruity" succulence of his meek, exotic, teenaged bride by painting a bowl of ripened fruit just below her bare breasts.[32]

Amos quotes Gauguin to remind viewers of the objectification of black females that predominates in Western art. Ironically, Amos was first drawn to Gauguin's paintings because he was one of the few modern masters known for his depictions of "beautiful brown women."[33] Learning later of the French artist's notorious misogyny, Amos reconsidered Gauguin and "imagined that he must have abused Te Ha Amana, the thirteen-year-old second 'Mrs. Gauguin,' whom he bought from her father to be his model, housekeeper, concubine, and intermediary to the island's [Tahiti] people. I suppose he gave her syphilis too"—the disease which hastened Gauguin's demise.[34] In her painterly reassessment of Gauguin, Amos includes the dark, young Mrs. Gauguin in an updated conversation about ethnic and gender imperialism.

To underscore her argument, Amos further imprints each of the four corners of *Tightrope* with a crest of Mrs. Gauguin. The presumption is that, when necessary, Amos can don the T-shirt herself in lieu of a painter's smock in order to maintain the delicate balance between her title roles as woman, artist, and black person. Below the artist's feet in *Tightrope* is a netting of disembodied eyes that seem to monitor her every move. Amos gazes back with consternation, but her footing remains steady. Art historian Jontyle Robinson aptly characterizes *Tightrope* as an effort to recontextualize the notion of Otherness "in a culture that despises, devalues, marginalizes, and attempts to erase us [women of color] or have us balance ourselves on tightropes."[35]

A related painting, *Worksuit* (1994), invokes the nude self-portrait of Lucien Freud, the Berlin-born British painter and grandson of Sigmund Freud (fig. 7.8). Amos has "clothed" herself in Freud's naked, white, male body—essentially transforming herself into "the penultimate icon of power, the virile white male."[36] Again, a paintbrush is prominently featured, this time held with its bristles pointing toward the artist's own form, as if she had just painted the white skin over her own. The artist stares gravely downward at her subject—a reclining, pink-skinned female nude—and

Figure 7.7
Emma Amos
Tightrope, 1994
acrylic on linen canvas, African fabric collage, laser-transfer photographs, 82 x 58"
(208.3 x 147.3 cm)

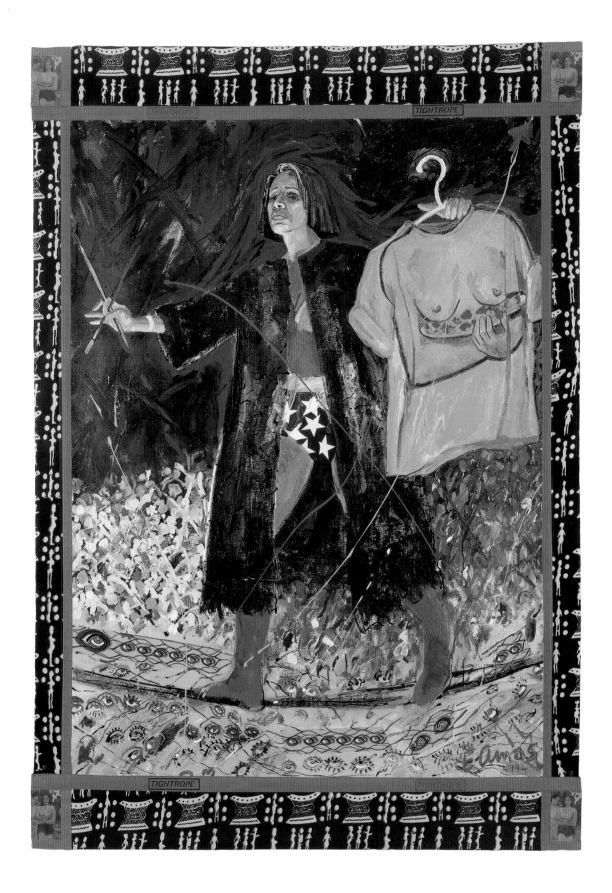

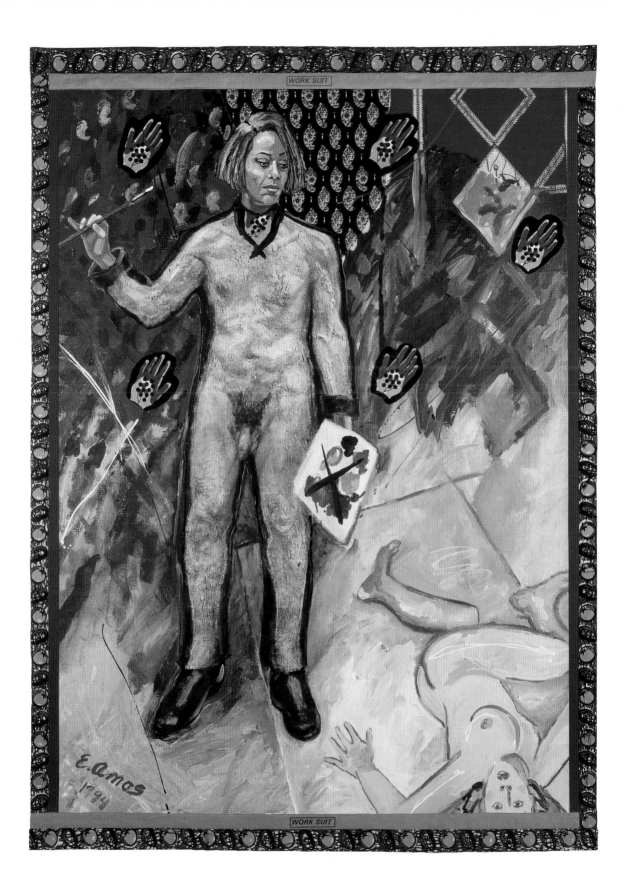

effectively substitutes the traditional male gaze with her own disdainful scrutiny. Amos's feet are firmly planted and clad in black work shoes, suggesting her readiness to get the job done. Her palette is marked with a black X, seeming to acknowledge those countless unsung women artists whose talents were unknown to the world. Invigorated by brightly colored and African-inspired fabric frames, as well as uncompromising brushwork, *Worksuit* and *Tightrope* challenge the perception of the art world as the dominion of white men.

The consistent use of fabric in Amos's work arose from her early professional experiences as a textile designer for the eminent fabric artist Dorothy Liebes. Indeed, Amos's art consolidates a variety of means and media, including tactile brushwork, silk collograph printing, unstretched linen canvas, African kente and kanga cloth, and batik. Multiple material processes aside, Amos might well be classified as a "colorist." Color is indispensable to her aesthetic framework and has, for her, both visual and theoretical implications:

> We're always talking about color, but colors are also skin colors, and the term "colored" itself—it all means something else to me. You have to choose, as a black artist, what to make your figures. . . . I find that I almost never paint white people. Butterscotch, brown, or really black—but rarely white. White artists never have to choose.[37]

Amos, who is often rankled by "color" as an ethnic locator, admits that she is also a hostage to it: "Every time I think about color it's a political statement. It would be a luxury to be white and never to think about it."[38] Realizing that such a "luxury" will forever elude her, Amos assimilates the politics of color into her work.

Measuring Measuring (1995) expresses Amos's thought processes with respect to color (fig. 7.9). Trimmed in West African kente cloth, the painting integrates laser-transfer photographs and acrylic pigment. It depicts, on the left, a faceless figure dressed in the white gloves and black hat of a minstrel. The apparition holds up a picture of a voluptuous, nude, bronze body seemingly appropriated from the sculpture of Aristide Maillol, which stands armless (a reference to the *Venus de Milo*) and in classic *contrapposto*. The second and central figure is an extrapolation of the first, this time with arms and head (that of a black woman) completed. Superimposed over this partially nude form is a printed essay on Greek art and several lengths of a measuring tape. The third and flanking figure portrays the fifth-century Greek *Kritios Boy*—an idiom for ideal Western male beauty (with the exception of his curly hair, which has been "touched up" by the artist to make it more pronounced).[39]

Figure 7.8
Emma Amos
Worksuit, 1994
acrylic on linen canvas, African fabric border, photo transfer,
74 1/4 x 54 1/2" (190 x 138.4 cm)

Three hands, which in the artist's parlance symbolize identity, like the unique quality of a fingerprint, round out the composition. The border consists of transferred photos of pairs of black legs, but they are not what they seem, in that some of the legs belong to the artist and others belong to two white models. Adding to the conundrum, all three sets of legs are clad in black stockings to spotlight the superficial or "skin [stocking] deep" nature of assessments based on pigmentation.[40] Together, these multiple ciphers speak to the untold Others who have been designated as such by their skin color, body type, or facial appearance. *Measuring Measuring* enjoins them to rebuild and recast their self-images based upon their own standards and criteria, not upon the measurings of the dominant culture.

After becoming a professor of art at Rutgers University in 1980, Amos became a member of the editorial board of the feminist journal *Heresies*. In the late 1980s, she joined Fantastic Women in the Arts, an ensemble that attempted to close the gap between white and black feminists. As Amos explains, Fantastic Women in the Arts chose to tackle "the question of the white liberal northern understanding of class, race, and the privileges of whiteness . . . and to discuss why the education, learning, and civil rights actions of the sixties and seventies that should have caused racism and sexism to abate had not done so."[41] Amos was also active in another feminist art group, the Women's Action Coalition (WAC); however, she found that women of color were only an "afterthought" in this group. While Amos applauds the efforts of some sororities, like the Guerrilla Girls (whose anonymous membership worked effectively to spotlight art world sexism) and Entitled: Black Women Artists (a support group founded in the 1990s), she recently conceded:

> At this point, the number of women artists who get press, are given museum shows, and have avid dealers and collectors hardly reflect the numbers of fine women artists turned out by advanced art programs. Those artists who are *not* white . . . and who *are* openly political, and feminist, seem to still be on the margins.[42]

Despite ongoing discrimination, the numbers of African-American women who have joined the professional art circuit since the beginning of the women's art movement have steadily increased. **Betye Saar** (b. 1926) is one example. Saar completed undergraduate and graduate study in fine arts in her home state of California. Early in her professional career, she became receptive to the philosophies of black power and to "agitprop" (vigorously crusading) aesthetics, and in the 1960s, she began to collect black memorabilia—popular culture *tchotchkes*, figurines, and advertisements left over from the bygone era of Jim Crow. According to author and

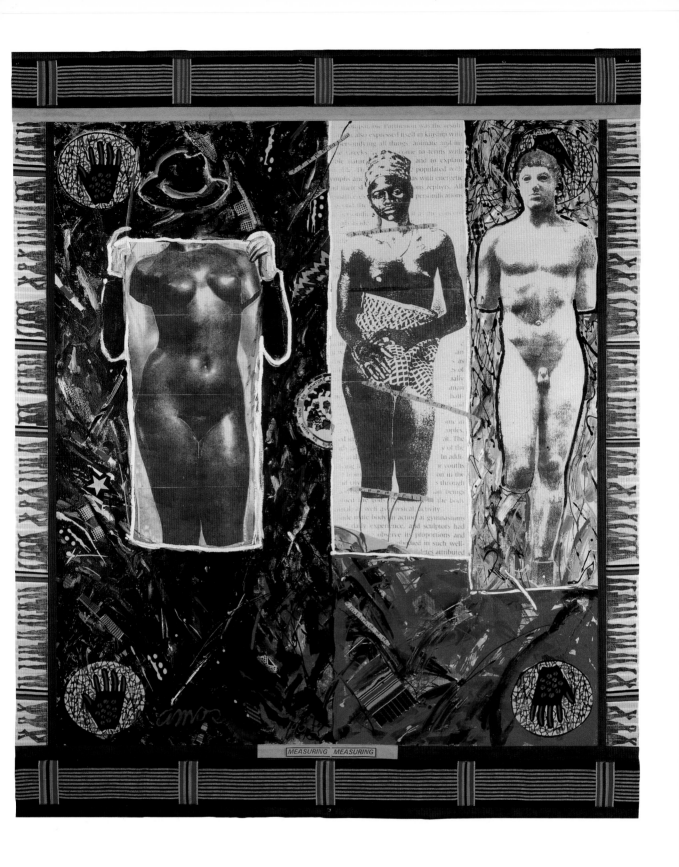

MEASURING MEASURING

collector Kenneth W. Goings, black collectibles of the type Saar found so alluring are relics of a corpus of

> literally tens of thousands of such items [salt and pepper shakers, cookie jars, ashtrays, and so on] that were produced in the United States, Europe, and Asia from the 1880s to the late 1950s. They were almost universally derogatory with exaggerated racial features that helped to "prove" that, indeed, African Americans were not only different but inferior.[43]

These items, however unconsciously, functioned to perpetuate conceptions of African-American subservience for more than a half century.[44] Saar was among the first of a now overwhelming group of African-American antiques collectors who reclaimed these objects—an act that many believe has worked to dispel the insidious implications of these facile objects. In the hands of the progeny of civil rights and black power, black collectibles and the typecasting they propagated are now "owned" and thus controlled by the one-time victims of racial stereotyping.

Saar went beyond mere ownership. She chose to deconstruct these mementos of Jim Crow, both literally and figuratively. In 1972, she critiqued the ubiquitous African-American stereotype of the Mammy in a startling mixed-media construction entitled *The Liberation of Aunt Jemima* (fig. 7.10). In this assemblage, Saar utilizes real and figurative layers of symbolism. She incorporates the face of Aunt Jemima, coopted from the well-known pancake box, and repeats it in a patterned backdrop. In front of this pop art screen stands a modified version of the same icon, a vintage black figure (in this case, a memo holder). The figure's bulging eyes, thick, intensely red lips, and smile that is more grimace than grin are evidence of the demeaning nature of these items. The rotund Jemima wears her traditional bandanna and apron, upon which is embedded another variation on the theme—a third Mammy who holds an infant in her left arm.

This last figure is partially obscured by an enlarged fist—the sign for black power—and the infant she holds is resting upon the apex of that fist. The baby cries and its brows are deeply furrowed with anxiety. This is hardly a conventional rendition of the subject, which traditionally portrays Mammy as a helpful caregiver to white children. Instead, Saar offers her viewers a disturbing alternative—a child of

Figure 7.10

Betye Saar

The Liberation of Aunt Jemima, 1972

mixed media, 11 3/4 x 8 x 2 3/4" (29.9 x 20.3 x 7 cm)

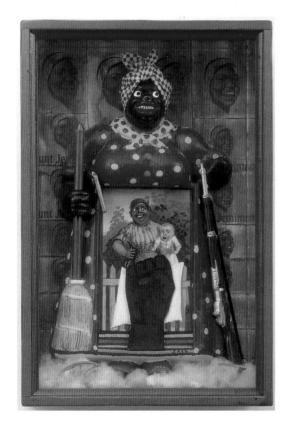

mixed race, the product of the Mammy's forced submission to her white master and a signifier of the enslaved woman's servile status as breeder and chattel. As the viewer's attention is turned away from this disturbing scene to reenter the larger framework of the composition, he or she is made to acknowledge the broom which the stout, leering figure holds in her right hand. Almost as an afterthought, one notes the small pistol held in the same hand and the larger rifle, potent with lethal energy, which is positioned at the left side of the figure, visually balancing the broom.[45]

Art historians Moira Roth and Yolanda Lopez describe *The Liberation of Aunt Jemima* as "psychologically as well as politically explosive." In their eyes, Saar's Aunt Jemima is transformed from "a willing servant . . . to a woman participating in her own liberation."[46] In conceiving this and related works, Saar reifies Aunt Jemima "with newer, bigger weapons and a tougher attitude." (One such work from 1997 replaces the arm of the Mammy memo holder with an automatic weapon rather than a rifle.) The artist states that the icon "symbolizes the painful ancestral memories of the middle passage, of slavery, of Jim Crow, of segregation, and of continuing racism. Aunt Jemima is back with a vengeance and her message [is]: *America, clean up your act!*"[47] Gone is the benevolent matron. In her place stands an angry and violent fighting machine, ready to do battle with guns or fists. The combination of grotesquery, pop icons, and symbols of violence in *The Liberation of Aunt Jemima* encapsulates both the fury of the Black Power era and the decisiveness of women's liberation.

Saar's creative means consist, almost exclusively, of found objects, including what most would consider refuse, which the artist gathers up from the streets or discovers in junkyards and secondhand stores. One of her most profound inspirations was Italian tile-setter Simon Rodia who, between 1921 and 1954, built the 100-foot-tall *Watts Towers* in Los Angeles entirely from debris such as broken glass, crockery, and bottle caps. As a child, Saar remembers watching the *Nuestro Pueblo* ascend slowly upward over the horizon until it reached its final staggering height. Rodia's determination to create "from nothing" a monument that was at once beautiful and epic in size made a lasting impression on Saar, as she conveys in her autobiographical *Black Girl's Window* (1969) (fig. 7.11).[48]

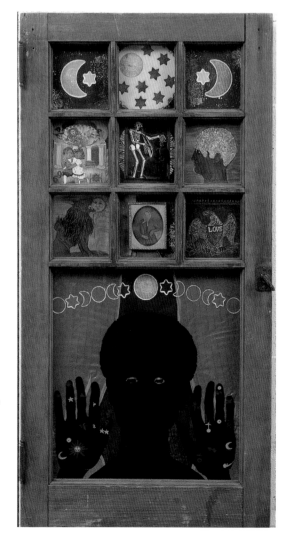

Figure 7.11
Betye Saar
Black Girl's Window, 1969
mixed-media assemblage,
35 3/4 x 18 x 1 1/2"
(91 x 45.72 x 3.81 cm)

Black Girl's Window makes use of an outworn window frame, complete with rusted hinges and latch. In the bottom half of the window, Saar has placed the silhouetted shadow of a little girl whose hands are pressed against the pane and whose vacant eyes resemble black glass marbles. The child is trapped by the transparent sheet of glass, between day and night, dream and waking, past and future, life and death. Visible on her palms are stars and lunar crescents which imply a future foretold. These insignia and others, including a wolf howling at a "sun-flower," a skeleton, an eagle, and an antique picture frame, are displayed in the small upper casements and hint at unfulfilled childhood hopes and dreams, and the relationships among life, death, and rebirth.

Saar's subject matter is as diverse as the elements that make up her constructions. Descended from African, Irish, and Native American stock, Saar demonstrates a latitude in her choice of topics that reflects her heterogeneous pedigree. Themes of Vodou, shamanism, and palmistry customarily turn up in her works. For Saar, art making is a ritualistic experience that involves five essential steps: conceiving an idea, scavenging, assembling materials, converting those materials into an art form, and sharing the final work with an audience. Using this formula, she created an array of "boxes," inspired by the works of New York dada artist Joseph Cornell. Saar's constructions, such as the 1968 *Africa*, do not, however, adopt Cornell's affinity for dada incoherence and disjuncture (fig. 7.12). On the contrary, Saar's boxes are small-scale domains for spiritual energy, containing ancestral relics that assert life-affirming messages of filial preservation and endurance. In the case of *Africa*, the keepsakes are, of course, from Saar's African past. Nestled within the tiny wooden chest, which is lined with kente cloth, and amplified by strips of mirrored glass are half of a toy elephant and a faded photograph of an African woman.[49]

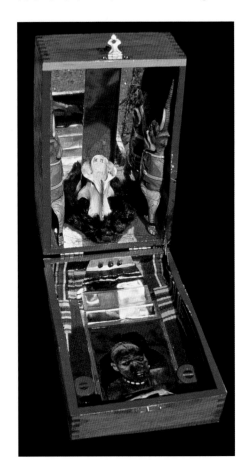

Figure 7.12

Betye Saar

Africa, 1968

mixed-media construction,

10 x 6 x 3"

(25.4 x 15.24 x 7.62 cm)

Over time, Saar's bantam boxes grew into room-sized installations, of which *Diaspora* is an example (fig. 7.13). Nearly eighteen feet long and twelve feet high, the setting, installed in 1992 at the Barnsdall Gallery in Los Angeles, was meant to be experienced from the inside out. Each visitor to the installation became a part of its space and thus a participant, rather than a mere observer, in the exchange between artist and audience. The interactive construction enveloped its viewers with textured wall coverings and ethereal lighting. A long and eerie cast shadow of the artist was silhouetted

against an image of sunbaked earth, linking Saar to both the past and the future. In the center of the room stands a French door, which the artist refers to as a "spirit door." On its glass pane are etched Vodou *vèvè* and omniscient eyes. On the floor below is a diagram of a slave ship. Jointly, these components bespeak African religious and cultural dispersion.[50]

Though her use of media tends to be more traditional than that of Betye Saar, Faith Ringgold, or Emma Amos, Kay Brown's subject matter and her political activities suggest her affinity with them. Brown is noted for her 1960s political collages, which were made while she was engaged in the Black Arts movement (fig. 6.17). After graduating in 1968 from Harlem's City College, Brown was welcomed into New York's Weusi artists' collective as its only female member. Brown found the alliance to be nurturing and instructive. Under the guidance of the collective, she advanced her skills in printmaking, painting, and collage methods and became conversant in the self-styled "black aesthetic."[51]

Figure 7.13

Betye Saar

Diaspora, from the exhibition "With the Breath of Our Ancestors," 1992

mixed-media installation,

12 x 18 x 14 1/2'

(3.6 x 5.5 x 4.4 m)

Unlike Amos, Kay Brown was well acquainted with several female proponents of the Black Arts movement, including **Vivian Browne** (1929–1993) and fellow Harlemites **Dindga McCannon** (b. 1947) and Ringgold. In 1971 they, along with a dozen other women, persuaded artist and art dealer Nigel Jackson to schedule a showing of African-American women artists at his Greenwich Village gallery. The resultant exhibition was titled "Where We At: Black Women Artists: 1971," and showcased fourteen women including, among others, Ringgold, McCannon, Brown, Browne, and **Carole Byard** (b. 1941). Arguably "the first group show of professional black women artists in known history," the WWA exhibit was a local success and prompted participants to form their own cooperative.[52]

The Brooklyn-based group undertook to form and maintain ties with the grassroots urban community and to provide one another with moral and professional support. In order to fulfill these goals, the ambitious consortium obtained funding from several nonprofit sources, including the New York State Council on the Arts and the Brooklyn Educational and Cultural Alliance. Donated funds made it possible for WWA partners to underwrite exhibitions, as well as to organize panel discussions, seminars, arts and crafts apprenticeships for local youth, and prison art workshops. Kay Brown worked as WWA's president and executive director until 1982, when she relocated to Washington, D.C., to teach art and creative writing and to complete a master's degree at Howard University.[53]

Brown, who has been an unshakable advocate of women's rights for several decades, nonetheless takes issue with those who believe that the feminist art movement was the force behind the advances that African-American women artists made in the 1970s:

> I don't believe this is an accurate assessment. Although WWA members and other black women artists agreed that women should empower themselves to gain economic and artistic equity, we generally viewed ourselves as integral to the black arts movement. Our struggle was principally against racial discrimination—not singularly against sexism. We were not prepared to alienate ourselves from our artist brothers.[54]

Brown's evaluation gets to the heart of the dichotomy between the majority liberal white disciples of the feminist art movement and their black artist sisters. The brand of frontal attack against patriarchy that a preponderance of feminist artists espoused did not sit well with many African-American women.

Notwithstanding her fidelity to her male peers, Brown was described as early as 1973 as a "radical feminist." She wrote articles that appeared regu-

larly in the *Feminist Art Journal* and in *Heresies*, and she composed poetry on the tribulations of black women.[55] Brown's works from the 1970s corroborate her womanist fervor, an explicit example of which is the self-referential *Sister Alone in a Rented Room* (fig. 7.14). This representation differs from Brown's prefeminist images, such as *The Devil and His Game* (1968) and *The Black Soldier* (fig. 6.17), which deify the male protagonists of black liberation. *Sister Alone*, in contrast, assigns the principal narrative position to women and attests to Brown's growing sense of isolation and self-awareness.

Dindga McCannon is a versatile artist whose talents, like those of Brown and Ringgold, extend to the use of diverse media and to writing. McCannon was a member of Weusi in the 1960s (prior to Brown), which sparked the embers of her aesthetic sensibilities and fed her interests in the Black Arts movement.

Figure 7.14
Kay Brown
Sister Alone in a Rented Room, 1974
etching 30/35, 20 x 16 1/2"
(50.8 x 42 cm)

"I was heading in an Afrocentric direction," the artist explains, "but floundering because I had no role models."[56] Weusi provided a paradigm of politically engaged artists of color for McCannon, and their support gave her entrée into the world of the professional artist. McCannon exhibited with the group beginning in 1966 with the First Annual Harlem Outdoor Show. She further participated in a number of mural projects throughout the city. Beginning in 1971, however, when McCannon joined WWA, she became immersed in the difficult work of promoting the art of African-American women.[57]

Though not an overtly feminist or otherwise political painting, McCannon's *Morning After* (1972) offers insight, on a more intimate level, into the

Figure 7.15
Dindga McCannon
Morning After, 1972
linocut, 18 x 24"
(45.72 x 61 cm)

social changes that were taking place in the early 1970s, namely the sexual revolution (fig. 7.15). *Morning After* is an erogenous portrayal of two nude lovers. Its corporeal sensations are optimized by the grainy textures of hair, white ground, and dark horizon, while the couple's skin, conversely, is devoid of texture. Their bodies are contoured with precise sensuous lines, which resonate in the heavy, arching ligatures that overlay the backdrop. McCannon has conceived a relatively androgynous pair, although the reclining docility of the figure on the left, vis-à-vis the more alert position of the body on the right, may offer a clue to sexual identity. The artist's treatment of both genders signals the sexual freedoms attained by women in the 1970s, and *Morning After* implies McCannon's own assimilation of this newfound boudoir parity.

Other McCannon works of this period reveal that she, too, had an Afro-femcentric agenda, and they offer definitive examples of McCannon's womanist mindset. In *A Day in the Life of a Black Woman Artist* (1978), McCannon couples the painted image of an amorphous nude black woman

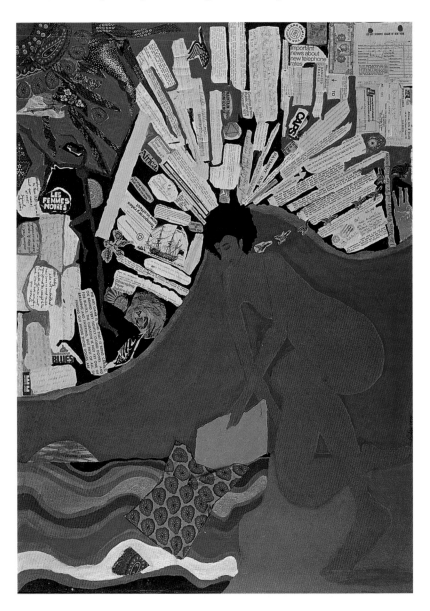

Figure 7.16

Dindga McCannon

A Day in the Life of a Black Woman Artist, 1978

collage and mixed media on canvas, 51 x 36" (130 x 91.4 cm)

with a compilation of cloth and *papier collé* (fig. 7.16). The female figure kneels upon an apocryphal shoreline, retrieving squares of fabric from the sea. On the remote horizon, a slowly setting sun is stamped with the words "original Africa." Additional bits of patterned paper and cutout pictures of birds, a lion, a sixteenth-century sailing vessel, and foreign currency connote Africa, slavery, the Middle Passage, and the "flight" of escaped slaves. A palimpsest layering of paper and newsprint emerges like dialogue bubbles from the head of the female figure. Typed, handwritten, and printed over these tattered fragments are words and phrases, specifically, "payment due," "Are your kids healthy? Find out for sure," "Africa," "*les femmes noires* [the black women]," "Life mixes with art and we are frightened," and "CAPS: Creative Arts Public Service Program 1971." Also inset are sections of phone bills, library notices, train ticket stubs, exhibition announcements, personal letters, and shipping wrappers which, all told, allow the viewer a glimpse into the world of the black woman artist.

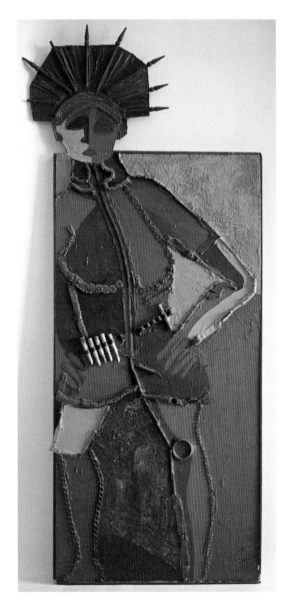

Figure 7.17

Dindga McCannon

Revolutionary Sister, 1974

assemblage, 60 x 30"

(152.4 x 76.2 cm)

Revolutionary Sister (1974) is a construction of wood, paint, sequins, and bullets, dominated by the black power color scheme of red, black, and green (fig. 7.17). Breaching the rectangular confines of the picture space is the head of a woman warrior whose crown of thorns (or spikes) implies her composite identities as a holy crusader, an African queen, and a helmeted combatant. She wears a T-shirt that doubles for armor; she carries ammunition prominently on her belt; and she plants her hands determinedly on her hips. The flat and abstract planes of the rebel's face create a mien that is both mysterious and unyielding.

The black feminist artists discussed here distinguished themselves in a number of ways. They declined to succumb to social pressures requiring them to subordinate their personal interests to those of African Americans as a group. They refused to accept the patriarchal orientation of the Black Arts movement as a necessary evil, and they repudiated those who sought to eliminate them from both the black power and feminist equations. Instead, they skillfully negotiated the precarious tightrope that linked the two domains. These artists chose feminism at a time when most African Americans were rejecting it, taking on in their work the highly politicized and polarized milieu of the decade.

PART II

Resisting the allure of political art, which occupied the black and feminist art movements, a corps of African-American women artists embraced abstraction. These "formalists" (artists concerned as much with painterly and sculptural form as with narrative content) were the inheritors of abstract expressionism, which rose to national prominence in the 1950s and included such painters as Jackson Pollock, Willem DeKooning, and Mark Rothko. The first wave of abstract expressionism, known as the New York School because of its origins in that city, included nonfigurative styles such as action painting, which emphasized vigorous paint application, and "color field" compositions dominated by large areas of pigment. In the 1960s and 1970s, hard-edged and minimalist art emerged, incorporating Spartan geometric forms and industrial materials.[1] Swayed by these developments, a number of African-American women artists began to integrate nonfigurative imagery into their work. Despite its nonrepresentational nature, however, much of their art contained elusive political references.

The life and career of **Barbara Chase-Riboud** (b. 1939), artist, author, and intellectual, which include widely divergent intellectual pursuits, an international lifestyle, and strict academic training (at the Fleisher Memorial Art School, the Philadelphia Museum School, and Temple University's Tyler School of Art), harks back to that of sculptor Edmonia Lewis. After completing her education in 1957, Chase-Riboud embarked on a tour of Europe under the auspices of a John Hay Whitney fellowship. She spent much of her time abroad engaged in postgraduate study at the American Academy in Rome, and began a lifelong career in direct wax casting at a local bronze foundry.[2] The sculpture *The Last Supper* (1958), which springs from this early period, is an abstract work with some elements of figural representation (fig. 8.1). It features masklike proxies for Christ and the twelve apostles, arranged beneath a metal canopy that appears to be slowly decomposing. A restyled Egyptian ankh—the symbol of life—occupies the

E I G H T **Abstract Explorations**

fulcrum position of Christ and doubles as a Christian cross. Christian and non-Christian subtexts are further revealed in the Gabon Bakota reliquary figure, fourth from the right, whose African diadem substitutes for an apostolic halo. A comparable reference is apparent in the adjacent effigy, which replicates a Kalabari Ijo headdress from Nigeria.

Chase-Riboud also spent time in Egypt, Turkey, and Greece. During her stay in Egypt—an impromptu visit that lasted three months—Chase-Riboud found "the blast of Egyptian culture . . . irresistible. The sheer magnificence of it. The elegance and perfection, the timelessness, the depth. After that," the artist reports, "Greek and Roman art looked like pastry."[3] Suffused with the thrill of Egyptian culture, Chase-Riboud returned to the United States in 1958. Another fellowship award brought her to Yale University, where she was the only African-American woman in attendance at the School of Design and Architecture. There, she studied under Bauhaus devotee and nonobjective painter Josef Albers, international style architect Philip Johnson, and design "spiritualist" Louis Kahn. These assorted stimuli influenced the direction of Chase-Riboud's oeuvre, which matured to comprise a matchless blend of visceral and rational determinants within a largely abstract idiom.

After receiving her master's degree from Yale in 1960, Chase-Riboud moved permanently to Europe, where her career flourished in both France and Italy. In 1961, while working in Paris as an art director for the *New York Times*, Chase-Riboud met and married photographer Marc Riboud, a member of the prestigious Magnum Photos cooperative. The two traveled extensively during the 1960s to Morocco, Spain, the Soviet Union, and the People's Republic of China. Chase-Riboud had the distinction of being the first American woman since the Cultural Revolution to be invited to visit China and to meet Communist leaders Zhou Enlai and Mao Zedong. During these years, the artist bore two sons and began to nurture her passion

Figure 8.1
Barbara Chase-Riboud
The Last Supper, 1958
bronze, 8 x 24 x 6"
(20.32 x 61 x 15.24 cm)

for writing. Her sculptures of this period of exploration and growth are similar to *The Last Supper.* They evoke the artist's existentialist proclivities as well as the work of Swiss artist Alberto Giacometti, whose decaying surface textures Chase-Riboud restyled into a distinctive visual language of her own.[4]

In 1966, Chase-Riboud traveled to Algeria to attend the Pan-African Festival. There she met several of the American leaders of the Black Panther party, including Eldridge and Kathleen Cleaver and Huey Newton. Her involvement with the struggle for black liberation, while indirect, was nevertheless genuinely experienced, as she explains: "I found myself with all the freedom fighters and liberation groups, the Algerians, the South Africans, the Black Panthers from America. . . . Though I didn't know it at the time, my own [aesthetic] transformation was part of the historical transformation of the blacks that began in the '60s."[5] This transformation manifested itself in the artist's keynote style, evident in her *Malcolm X* series, which was exhibited in 1970 at the Massachusetts Institute of Tech-

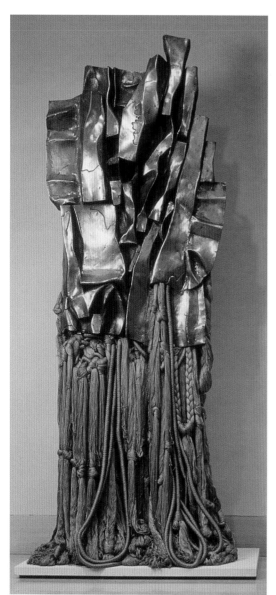

nology's Hayden Gallery and at the Bertha Schaeffer Gallery in New York. The series comprises a collection of polished bronze sculptures that incorporate black and gold patinas and silk or wool cords (fig. 8.2). Metal "heads" cast from folded wax sheets are balanced on hidden armatures. Below these creased and cumbersome monoliths are "skirts" of hand-made rope that hang from and support (at least ostensibly) the upper tiers of each structure. Ever mindful of the yin and yang, or contradictory forces, that according to Chinese philosophy exist in all things, Chase-Riboud contrasts, within a given work, hard and soft, dull and polished, and within the series, light and dark, and bulky and reedlike forms. She also transposes obverse ideals so that the yin, or "female," fleeciness of the fibers becomes the yang, or "masculine," strength that buttresses the weight of the sculpture. "That moment when the bronze becomes soft [and] the silk skirt becomes hard" is when the artist regards a piece as complete.[6]

A Yale classmate, Fulbright fellow and fiber artist Sheila Hicks, first suggested that Chase-Riboud use woven cords in her work. A second motivator was the art of Warsaw sculptor Magdalena Abakanowicz, especially her burlap and resin figures and her fiber

installations. A third inspiration emerged from an extensive tour of Africa which Chase-Riboud made in the mid-1970s. In Senegal, Mali, Ghana, and Sierra Leone, Chase-Riboud familiarized herself with the widespread use in African art of raffia, hemp, feathers, and other natural materials. She also had the rare opportunity to see African sculptures in situ and came to understand these objects as part of the "interplay of sculpture, costume, dance, and dream" which comprises African devotional customs. As a result of this experience, Chase-Riboud began to see her own art as endowed with spiritual energy, approximating the transcendent élan of African icons.[7]

With the Hayden and Schaeffer showings of the *Malcolm X* series, Chase-Riboud became an artist celebrity in the United States, though not an uncontroversial one. An arguable shortcoming of the Blacks Arts movement was the propagation of a "black aesthetic" to which Chase-Riboud's refined modernism did not conform. Across the board, critics had come to expect a certain narrative legibility in the works of African-American artists. *New York Times* critic Hilton Kramer complained of the "very French refinement" of the *Malcolm X* monuments and lamented Chase-Riboud's achievement of a "considerable elegance that unfortunately suggest[s] the ambience of high fashion rather more than . . . the theme of heroic sufferance and social conflict."[8] Art activist and curator Henry Ghent resoundingly challenged Kramer in a statement that appeared in the *New York Times* a couple of months later:

> [Mr. Kramer has a] stereotype [*sic*] idea that the work of black artists must by nature be crude, lacking in craftsmanship, and totally devoid of sophistication. . . . One strongly suspects that the real motive behind Kramer's severe criticism of Mrs. Riboud's work stems from the fact that she chose to create tasteful and dignified sculptures in memory of Malcolm X. She, like millions of blacks, has come to see the memory of the civil rights activist as an eloquent and beautiful human being.[9]

As Ghent notes, the *Malcolm X* series was not intended as a lamentation, but rather as an esoteric celebration of the unparalleled life of the black Muslim leader.[10] The Kramer-Ghent debate underscored the challenges faced by African-American abstractionists.

Chase-Riboud's "French refinement" became her strength. Infused as it was with global references and disparate materials that paradoxically formed congruent wholes, it was greeted by many U.S. curators with genuine enthusiasm. As exhibitions of her work began to appear throughout the country, at such venues as the Whitney Museum and the University Art Museum at Berkeley, Chase-Riboud's second career as a writer burgeoned.

Figure 8.2
Barbara Chase-Riboud
Malcolm X #3, 1970
polished bronze and silk,
9' 10" x 3' 11 1/4" x 9 7/8"
(300 x 115 x 24 cm)

In 1974, Random House published her collection of poems *From Memphis to Peking*, which was edited by the distinguished author Toni Morrison. In 1979, Chase-Riboud's friend and supporter Jacqueline Kennedy Onassis edited the artist's bestselling book *Sally Hemings*, which plotted the life of President Thomas Jefferson's slave and lifelong mistress. Subsequent volumes published over the next two decades, such as *Validé, The President's Daughter*, and *Echo of Lions* (a chronicle of the Amistad slave mutiny), were honored as Literary Guild selections. *Validé* also garnered for the artist the Carl Sandburg Prize for best American poet.[11]

Writing fast became an integral factor of Chase-Riboud's overall aesthetic, and her literary and historic interests hastened her artistic productivity. Chase-Riboud's *Cleopatra* series, for example, foregrounds elements of writing (in the form of mixed-media displays of scrolls and handwritten notebooks) while, at the same time, giving equal prominence to monumental bronze sculptures, such as *Cleopatra's Bed* (1997) (fig. 8.3). Stirred by her earlier trip to China where she observed Han dynasty royal sarcophagi mantled in squares of jade and gold, Chase-Riboud produced several large-scale works based on a similar design of thousands of small cast-bronze tiles linked to form chain-mail drapery. This compendium of sculptures was more than twenty-five years in the making and includes a pharaonic chair, bed, door, and cape. *Cleopatra's Bed* is adorned at the foot

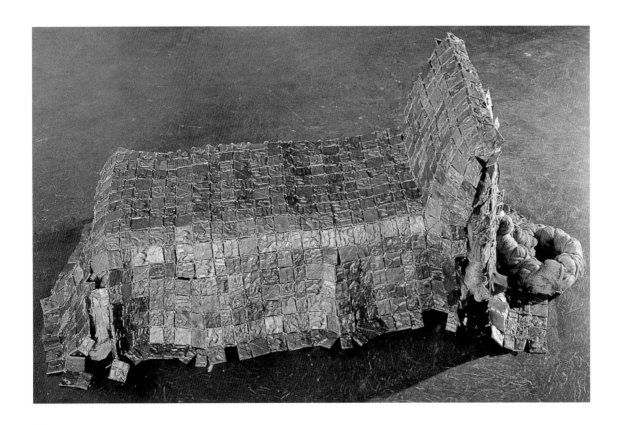

and the head with thick cords. The divan is draped with a blanket of luminescent bronze squares that create a supple mosaic, and each tessera bears an incised or relief impression in the artist's own abstruse hieroglyphics. Composed by a connoisseur of history, Chase-Riboud's sculptural commemoration breathes life into the first-century description of Cleopatra recorded by Greek biographer Plutarch, who described the Egyptian queen standing beneath "a canopy of gold" as she dazzled the Roman general Mark Antony "with many chandeliers lighted at once in patterns of squares."[12]

The 1980s was an equally eventful decade for Chase-Riboud. She continued to write and to publish, and after divorcing Riboud in 1980, she married art expert, archaeologist, and publisher Sergio Tossi, who owned New York's Stampatory Gallery where Chase-Riboud exhibited. The Metropolitan Museum acquired Chase-Riboud's *All That Rises Must Converge*, a monumental adaptation of the *Malcolm X* archetype which measures nearly ten feet in height.[13] The 1990s were no less fruitful and brought to the artist an ambitious public commission, *Africa Rising* (1998), sponsored by the U.S. General Services Administration's Art-in-Architecture program (fig. 8.4). Designed to honor the historic African burial ground in New York City, *Africa Rising* is located in the lobby of the Federal Office Building at 290 Broadway. It shares this space with *The New Ring Shout* (a forty-foot-diameter terrazzo floor design conceived by African-American artist Houston Conwill) and with Clyde Lynds's stone relief *America Song*, both of which commemorate the once-forgotten grave site of Lower Manhattan's eighteenth-century African population. Unearthed in 1991 during excavation for the Federal Office Building, the burial ground is now a National Historic Landmark.

At nearly twenty feet tall, Chase-Riboud's *Africa Rising* dominates its space and is the artist's "first explicitly political work of art."[14] It is also one of very few figurative sculptures produced since her early years as an artist. Mounted high on an arklike structure, the allegorical figure of Africa summons up the second-century B.C.E. *Winged Victory* (*Nike of Samothrace*), braced against imaginary winds and anchored atop a marble prow (fig. 8.5). The parallels between *Africa Rising* and the Greek monument diminish, however, as the viewer modifies his or her sight line from a frontal to a sidelong view, at which point Chase-Riboud's supporting ark transmutes into a Shona (Zimbabwe) stool or an Ashanti (Ghana) headrest (figs. 8.6, 8.7).[15]

Billowing out behind the figure of *Africa*, in lieu of wings, are ribbons of cast bronze. The same streamers wrap and drape the colossal plinth and lead the viewer's attention to the base of the work, where small medallions, like discarded coins, lay partially obscured (a metaphor for much of

Figure 8.3

Barbara Chase-Riboud

Cleopatra's Bed, 1997

multicolored cast bronze

plaques over steel armature

and silk mattress,

39 3/8 x 51 1/8 x 23 5/8"

(100.3 x 130 x 59.7 cm)

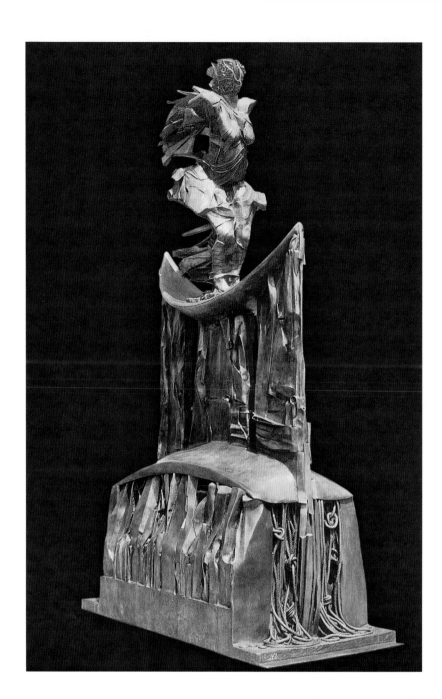

Figure 8.4
Barbara Chase-Riboud
Africa Rising, 1998
bronze with silver patina,
19' 7" x 9' 2" x 4' 3"
(597 x 279.4 x 129.54 cm)

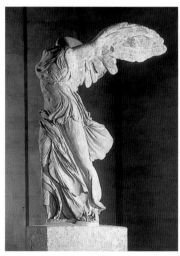

Figure 8.5
*Victory of Samothrace
(Nike of Samothrace)* (3/4 view
with galley), marble, Greek
Hellenistic, c.190 B.C.E., marble,
approx. 8' high (2.44 m)

Figure 8.6
Barbara Chase-Riboud
Africa Rising (side view), 1998
bronze with silver patina,
19' 7" x 9' 2" x 4' 3"
(597 x 279.4 x 129.54 cm)

Figure 8.7
Anonymous
Headrest, Shona culture,
Zimbabwe

African-American history). Each of these fifteen pendants bears the likeness of a historic black leader, including Malcolm X, W. E. B. Du Bois, Frederick Douglass, Sojourner Truth, and Toussaint L'Ouverture; the portraits lie silently at the viewer's feet. The sumptuous opulence of *Africa Rising* may be likened to the bronze sculptures of baroque artist Gianlorenzo Bernini, with whose works Chase-Riboud was certainly familiar. The twisting cast-bronze ropes that seem to fill the base of *Africa Rising* evoke Bernini's mammoth *baldachin*—the bronze high-altar canopy at St. Peter's in Rome (where Chase-Riboud once resided). *Africa Rising* also echoes the textural virtuosity and dynamic plasticity of works such as Bernini's *Ecstasy of St. Theresa* (an adaptation of which Chase-Riboud fashioned in 1994).

There is also a surrealist element in the personage of Africa, whose head has the quality of a cyborg—part flesh and part metal. The human portion of her face assumes the features of a Botticelli Venus, while, in profile, the protruding buttocks of the Hottentot Venus are unmistakable (fig. 1.15). The Hottentot reincarnation in *Africa Rising* is one of exultation and triumph. The figure's body urges forward even as it stands firm against the illusory buffeting winds, and it is more than the equal of the winged Greek *Nike*; it is the earlier work's better, surpassing the *Nike* in beauty and legend by virtue of the sculpture's identity as a universal woman of both African and European descent.[16]

As yet unrealized, Chase-Riboud's *Middle Passage Monument* promises to transcend the majesty and import of *Africa Rising*. The *Monument* is envisioned as a memorial to the 11 million Africans who died on slave ships during the passage from Africa to the New World. Presently extant only in mock-ups, the *Monument* in its final form will soar to sixty feet and consist of two monolithic stele from which an immense spool of golden chain will be suspended. The pillars, which will symbolically join East and West with 11 million links of chain, will be inscribed with the names of African cities from which enslaved prisoners were taken.[17]

In a proposal sent to President Bill Clinton in 1994, Chase-Riboud suggested that the U.S. government sponsor the monument as part of a Declaration of Reconciliation which would incorporate a formal apology to America's African descendants for the centuries of slavery that their ancestors withstood:

> The United States has apologized to the Japanese, the American Indians, even to the Queen of Hawaii; the Japanese have apologized to Southeast Asia, Korea, and China; the Germans have apologized to the Jews; de Klerk has apologized to black South

Africans. But never has the United States government expressed one iota of regret for imposing the institution of slavery based solely upon race, on the ancestors of its fellow citizens, and on the United States itself.[18]

Her dispatch also noted that no monument exists anywhere in the world to the memory of the African deportees of the "triangular trade" among Africa, America, and Europe. The artist's letter was accompanied by a detailed plan that advocated a site for the monument on Theodore Roosevelt Island in the Potomac River (near the Lincoln and Jefferson memorials in Washington, D.C.). No government-sanctioned apology has yet been forthcoming, and the sculpture remains unrealized.[19]

The career of **Alma Woodsey Thomas** (1891–1978) unfolded poles apart from the measured successes of Chase-Riboud. Born in the late nineteenth century, acknowledgment did not come to Thomas until the end of her life. Ironically, given her Old World origins, when recognition did come, it was for her achievements as a modernist. In fact, she was the first African-American woman to receive national critical acclaim as a nonfigurative painter. In 1972, only three years after Thomas had become a full-time artist, the Whitney Museum in New York honored Thomas with a solo exhibition. When critics viewed her immense and luminous canvases, they reacted with candid delight. In response to the Whitney showing, the *New York Times* published four separate and highly favorably reviews, as well as an interview with the artist. A few months later, the Corcoran Gallery sponsored a second retrospective, and Washington, D.C., reviewers were equally enthusiastic. All the more extraordinary was that Thomas was eighty-one years old at the time.[20]

A consummate colorist, Thomas was affiliated with the Washington Color School (a group of color field and hard-edge artists, including Gene Davis, Kenneth Noland, and Morris Louis). Unlike fellow Washington School abstractionists, however, Thomas counted nature as her greatest inspiration. Also digressing from the thrust of the Washington School, Thomas rarely conceded the power of her brush, nor did she adopt the color field practice of "staining" (applying sheer layers of paint to the canvas), nor the hard-edge technique of creating clean-edged stripes using masking tape. Due to the character of her brushwork, Thomas was more a paragon of the "older abstract expressionist generation" of action painters such as Pollock and DeKooning.[21]

Thomas derived her subject matter from flowers, landscapes, and outer space explorations, which especially enthralled her. She developed her ideas on canvas using oversized impressionist brush strokes and resplendent

colors. *Wind and Crepe Myrtle Concerto* (1973) presents a segmented color field made up of many constituent strokes of the brush (fig. 8.8). Its color scheme of luxuriant pinks brushed over vaporous clouds of yellow, blue, and green is impressionism reinvented. One can almost distinguish the poplar trees and French countryside of Monet's visions in Thomas's. Washington's formal gardens or "the light glittering through a holly tree" in Thomas's own yard, however, were her inspirations.[22]

Thomas was a lifelong Washingtonian and friend of Lois Jones, with whom she worked and exhibited in the Little Paris Studio (located in Washington) that Jones organized for her artist colleagues. Thomas first came to D.C. from Columbus, Georgia, when she was fifteen years old, leaving behind segregated secondary schools. In the nation's capital, she had access to the kind of education that would have been denied her in Columbus, and in 1924, she became the first student to graduate from Howard University's newly founded art department. Ten years later, she earned a master's degree in education from Columbia University and spent the next thirty-five years as an educator at D.C.'s Shaw Junior High School.[23]

Throughout her years as a teacher, Thomas worked diligently to refine her painting skills. Most influential was a period of study at American University with colorist Jacob Kainen and other abstract artists, such as Ben "Joe" Summerford and Robert Gates. Although her earliest works of the 1920s were academic still lifes (fig. 8.9) and representational renderings of nature, by the 1950s Thomas's style had taken on a decidedly cubist tenor. After joining the celebrated Washington Workshop Center for the Arts, she began to absorb the principles of abstraction from some of the most influential thinkers and painters of the day, including art critic Clement Greenberg and painters Willem DeKooning and Morris Louis.[24]

Figure 8.8

Alma Woodsey Thomas

(1891–1978)

Wind and Crepe Myrtle

Concerto, **1973**

acrylic on canvas, 35 x 52"

(88.9 x 132.1 cm)

In 1966, Howard University organized a retro-spective of the art of its first fine arts graduate. In preparation for the exhibition, Thomas painted a series of compositions that revealed how completely she had assimilated nonobjective processes. Thomas described these works as "geometric abstractions composed of mosaic-like patterns of vivid color rhythmically arranged in concentric circles or parallel lines."[25] These parallel lines, dubbed "Alma stripes," can be observed in *Lunar Surface* (fig. 8.10) and are composed of relatively homogeneous brush

strokes, separated by subtle areas of underpainting.[26] Thomas's concentric circles appear in a sequence of works that she conceived around the themes of earth and space. *The Eclipse, March 1970*, reworked from prototypes such as Noland's stained *Beginning* of 1958, features a dense blue disk that is situated asymmetrically near the right edge of the canvas (fig. 8.11). Irregular brush strokes form ever-expanding chromatic circles around the focal orb. The viewer can sense the entire composition shifting unhurriedly, but relentlessly, beyond the picture space, just as an actual eclipse of the sun might be a compelling and concrete spectacle one moment, and an elusive memory the next.

A few years later, Thomas created a *Music* series, which included vast canvases such as *Red Azaleas Singing and Dancing Rock and Roll Music* (1976) (fig. 8.12). This effervescent design, unlike earlier works, is monochromatic and introduces a swirling trellis of vivid scarlet tiles over white spaces. Changeable fragments of red paint break up like fluttering petals as they approach the right side of the elongated picture space. Thomas's love of flowers and nature's flush interlocks here with a second theme of musical

rhythms, expressed through simulated movement and carefully orchestrated directional forces. The lively animation of this composition revisits Thomas's days as a marionette maker (the focus of her master's thesis); and one can almost follow the leaps and surges of invisible dancers on strings hurtling across the canvas.[27]

An agitated clamor of flickering figures seems to take possession of Thomas's last paintings (fig. 8.13). Her final works dispense entirely with the Byzantine daubs of previous pictures. In their place are calligraphic sweeps and arabesques that dart and dash from left to right in ever more dispersed throngs. With the exception of occasional bravura ventures into the all-over stylistic domain of colorists like Barnett Newman, Thomas's penchant for broad expressive brush strokes remained fairly consistent during the last decade of her life. Hers was a long and prolific existence that incredibly spanned post-Reconstruction, the Harlem Renaissance, the Great Depression, and the ages of civil and women's rights. Asked shortly before her death why she declined to respond through painting to the polemically charged eras in which she lived, she answered: "Through color I have sought to concentrate on beauty and happiness, rather than on man's inhumanity to man."[28] Thomas wished her art to stand independent of time and place, and thus far it seems her wish has been granted.

Figure 8.11
Alma Woodsey Thomas
(1891–1978)
The Eclipse, 1970
acrylic on canvas, 62 x 49 3/4"
(157.48 x 126.36 cm)

Figure 8.12
Alma Woodsey Thomas
*Red Azaleas Singing and
Dancing Rock and Roll Music*,
1976
acrylic on canvas,
72 1/4 x 156 3/4"
(183.5 x 398.2 cm)

Figure 8.13
Alma Woodsey Thomas
*Wind Tossing Late Autumn
Leaves*, 1976, acrylic on canvas,
72 x 52" (183 x 132 cm)
New Jersey State Museum
Collection, Trenton. Museum
Purchase FA 1987.26.
Photograph by Dan Dragan

Along with sculpture and painting, mixed media also has its place within the abstract canon, as manifested in the works of **Howardena Pindell** (b. 1943). After earning a B.F.A. from Boston University (1965) and an M.F.A. from Yale (1967), Pindell worked for some years as an associate curator at New York's Museum of Modern Art. As well, in the 1970s and 1980s, she allocated much of her time to exposing art world xenophobia, including the publication of "Art (World) and Racism: Testimony, Documentation, and Statistics," which was extolled as "stunning research on institutionalized racism within prestigious New York museums and galleries."[29] In 1973, Pindell became a founding member of the Soho-based women's art gallery A.I.R. (Artist in Residence) and later, among numerous achievements, founded the Committee against Racism in the Arts.[30]

To highlight the racial biases of the art community, Pindell produced and starred in a short film entitled *Free, White, and 21* (1980). Employing a bitingly satirical inverse of blackface, Pindell camouflaged her own brown skin with white makeup and donned a blonde wig. Enunciating in imperious tones, her whiteface persona engages in a dialogue with an off-screen narrator (the voice of the artist, as herself). The film's "free, white, and twenty-one-year-old" protagonist makes light of her black counterpart's indictments against bigotry and admonishes her to be grateful for the socioeconomic crumbs that she receives from whites. The film is a reflection of Pindell's personal encounters with race, gender, and class inequities.[31]

Pindell's sortie into filmmaking has been associated by curator Lowery Sims with the artist's interest in the grainy texture of video as an abstract composite of infinite minuscule dots. The artist had earlier realized her notion, in Sims's words, of "atomizing art" by creating works from thousands of paper dots obtained by using a hole-puncher to perforate poster board. The punctured cardboard then functioned as a template through which Pindell sprayed or brushed paint to create a grid of tiny circles. Pindell was influenced by fellow Yale student Nancy Murata to pursue the form of the circle as an elemental component in her art. Whereas most two-dimensional work is consigned to a rectangular space, Pindell's compositions are either constructed of circular modules or framed within an orbicular setting. The multimedia construction *Untitled #73* (1975) interposes one of the artist's templates with adhesive, water color, gouache, crayon, and pen and ink (fig. 8.14). The end product is a flickering, iridescent hybrid of painting and sculpture that, as one art dealer put it, "winks" at the viewer with hundreds of tiny eyes, as if the artist herself were staring out from behind the many circular apertures.[32]

Figure 8.14

Howardena Pindell

Untitled #73, 1975

watercolor, gouache, crayon, ink,

punched paper, spray adhesive,

and thread on board,

7 1/2 x 9 1/2" (19 x 24.13 cm)

Pindell harvests her freewheeling aesthetic approach from a multiplicity of sources, including abstract expressionism, conceptualism (art that gives weight to words and ideas over artistry), minimalism, color field painting, graffiti art, adire-eleko dyeing techniques, and photography. Equally diverse are her narrative scenarios, which derive from personal, universal, racial, and feminist subjects. *Autobiography: Water/Ancestors/Middle Passage/Family Ghosts* (1988), for example, fixes within an abstract sea of dazzling and tactile brushwork elements of figuration such as a contorted silhouette of the artist's prone body, multiple cutout icons of eyes, and the negative space of an invisible slave ship (fig. 8.15). The half dozen arms of the central figure fan outward in a simulation of the breaststroke. Cocooned within this abstruse allegory are references to enslavement and helplessness.

Figure 8.15
Howardena Pindell
(United States)
Autobiography: Water/
Ancestors/Middle Passage/
Family Ghosts, 1988
acrylic, tempera, cattle markers,
oil stick, paper, polymer photo-
transfer, vinyl tape on sewn
canvas, 118 x 71"
(299.7 x 180.3 cm)

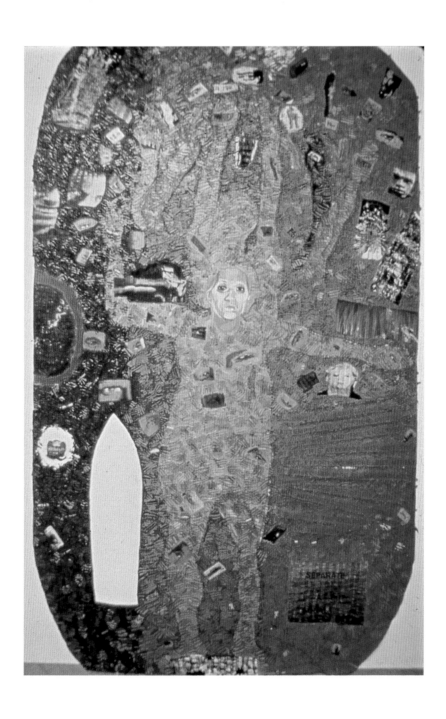

Despite her preoccupations with issues of culture and politics, Pindell has never compromised aesthetics for the sake of polemics. Instead, she has given equal precedence to both, and always with incisive wit and intellectual acumen. Once having chosen a conceptual catalyst, Pindell next embarks on a creative journey that is primarily about form. Her painterly, structural, chromatic, and kinetic inventions are as visually evocative as they are cerebrally scintillating. Such is the nature of Pindell's unique alchemy, which earned her in 1990 the College Art Association Award for most distinguished body of work.

While Chase-Riboud, Thomas, and Pindell occupy central places in the field of abstraction, they share the spotlight with others who are equally deserving of critical attention. The works of **Adell Westbrook** (b. 1935), for instance, reveal an interest in the accretion of circular forms similar to that of her younger contemporary Pindell. In Westbrook's works on canvas and paper, in particular her *Solar* series, the artist codifies clean-edged geometric disks into compositions that recall the Bauhaus configurations of Wassily Kandinsky (fig. 8.16). In the manner of Kandinsky's geometric paint-

Figure 8.16
Adell Westbrook
Solar, No. 4, 1985
acrylic on canvas, 50 x 36"
(127 x 91.44 cm)

ings of the 1920s, *Solar, No. 4* (1985) is teeming with crisp colorful circles in a variety of sizes that float like bubbles over a turquoise ground. Diamond patterns, rectangular forms, stripes, dripped paint, and discreet calligraphic insignia enliven the apparition.[33]

Westbrook's "colorful compositions of abstract, energized forms and movement . . . influenced by spatial and scientific interests" represent her vision of the cosmos. Her scientific interests resulted from a family directive that she study science and other practical subjects. After completing a program at Blair Business College in Colorado in the 1960s, however, Westbrook answered the call of art. She moved to the Washington, D.C., area and earned her B.F.A. and M.A. in 1974 and 1981, respectively. Visual delight in the decorative nature of Westbrook's paintings is perhaps the viewer's first response. A sense of the infinite and the infinitesimal, as well as of the "music" of the universe, are the more profound and lasting implications of her work.[34]

Colorist **Gaye Ellington** (b. 1951) works principally with acrylics. Her style matured in step with Thomas's rise to stardom and reflects a kinship between the two artists. Although Ellington succeeded Thomas by several generations at Howard University, both responded to the Washington School and its late modern exploitation of color. In Ellington's paintings, a kaleidoscopic palette of lilacs and plums, jades and ceruleans unite to create imagery that, while abstract, resonates with representational phantoms (fig. 8.17). Like visual riddles, Ellington's renderings at first appear to be purely formal—a series of flamelike and fluid shapes that dart across the surface of the canvas. Upon closer examination, specters of human faces and figures begin to emerge, and observers are drawn into the labyrinth.

Within a highly individualized pictorial vernacular, Ellington captures her subjects—vaguely discernible still lifes, street scenes, and portraits—like butterflies in a glass jar, which flutter and fan and display their unique

Figure 8.17
Gaye Ellington
The Blues Ain't, 1989
acrylic on canvas, 24 x 36"
(61 x 91.44 cm)

markings within the planar confines of the canvas. A native of New York, Ellington has long been inspired by the music of jazz, particularly the cadences of her grandfather Duke Ellington. Many of her compositions are, indeed, visual translations of the orchestral arrangements of Duke and Mercer Ellington, as well as of musical virtuoso Billy Strayhorn. The artist's painterly movements approach pure nonobjectivity and create the effect of light passing through a stained-glass window (fig. 8.18).

Like Ellington and Thomas, **Vivian Browne** (1929–1993) infused her abstract compositions with allusions to the figurative. While she began as a painter mainly of portraits and landscapes, her works of the 1960s depict deliberately malformed characters whose contorted bodies have been compared to the fantastic images of Dutch Renaissance painter Hieronymus Bosch, and to twentieth-century American magic realist Paul Cadmus. By the 1970s, Browne

Figure 8.18

Gaye Ellington

Oclupaca, 1983

acrylic on canvas, 28 x 22"

(71.1 x 55.9 cm)

Figure 8.19

Vivian Browne

Sempervirens, 1989

oil on canvas, 60 x 160"

(152.4 x 406.4 cm)

had repositioned herself as an abstract painter, inspired by the staining techniques of second-generation color field artists.[35] In time, Browne's compositions developed into extrapolations of flora that reprise Piet Mondrian's paintings of trees, as explorations of the latent infrastructure of nature (fig. 8.19). Browne's permutations of the theme range from dense and towering forest growth to agitated accumulations of crisscrossing lines, redolent of gnarled and ancient trees or impenetrable swamp vegetation.

Browne defines her paintings as "illusions . . . abstracted from real experience and . . . the embodiment of a deep reverence for the natural environment." Critics have responded to her "illusions" with equivocation. Some, such as *New York Times* writer Michael Brenson, acknowledge a dual nature

in Browne's system and see it as a fusion of "the geometric and the organic, technology and nature, man and woman."[36] Others, such as Lowery Sims, see the same work as evocative of an "emphatic realism."[37] In either case, the cogency of Browne's paintings is undeniable.

Although Browne's art remained nonpartisan, her politics did not. She was a stalwart supporter of civil and women's rights who contributed to the feminist journal *Heresies* and organized a series of exhibitions on women artists. Through these activities and decades of teaching and administration at Rutgers University and the Newark College of Arts and Sciences, Browne demonstrated her commitment to increasing academic knowledge about African-American women artists. In honor of her exemplary record, in 1989 she was awarded the Distinguished Teacher of Studio Award from the College Art Association.[38]

Betty Blayton's works of the Black Arts era, such as the 1971 Children's Art Carnival mural, provided an early indication of the artist's penchant for the nonobjective (fig. 6.7). Although the springboards for the Harlem mural were children's drawings, Blayton extracted the least figurative elements from these drawings. An oil collage of the same period situates Blayton well within the domain of nonfigurative art (fig. 8.20). Radiantly hued, *Reaching for Center* depicts a crisscrossing of red, pink, and gray forms within a circular framework. Works such as this one have inspired critics to

Figure 8.20
Betty Blayton
Reaching for Center, c. 1970
oil collage, 60" diameter
(152.4 cm)

describe Blayton as a "superb colorist" whose palette alternates between rich dark hues and pastel, almost impressionist mauves and pinks.

Blayton also received training in sculpture at the Brooklyn Museum School, but found the physical demands and space requirements of sculpture a deterrent. Painting has remained Blayton's medium of choice. She espoused its abstract potential early in her career when she apprehended that "the visceral [is] more important than the literal in visual communication." Blayton's painting, regardless of its nonobjectivity, is grounded in the experience of "being a black soul searching in a material world, trying to find balance." To detractors who suggest that African-American abstractionists are somehow trying to elude their heritage, Blayton responds, "I was never a conformist." When asked if she minds being classified as a "black" artist despite the politically neutral nature of her imagery, she answers simply, "It doesn't bother me. I'm black and I'm an artist."[39]

The stellar Fine Arts Department of Howard University has produced a great many prominent women artists. Another is **Mary Lovelace O'Neal** (b. 1942) who, after obtaining a B.F.A. from Howard (1964) and an M.F.A. from Columbia (1969), taught at the University of California, Berkeley. O'Neal's early works demonstrate a rapport with minimalist austerity which gradually yielded to a style that the artist herself has set forth as a "forceful and egocentric abstract expressionism."[40] O'Neal's method synthesizes an expansive and vigorous application of paint with line drawing that emanates from the surrealist tradition of "automatic," or unconscious, inscription. Recent images, such as *Racism Is Like Rain, Either It's Raining or It's Gathering Somewhere* (1993), actualizes social criticism (fig. 8.21). The left half of the composition consists of a dark, uncertain abyss. Chaos encroaches inevitably upon this quiet zone in the form of a mass of throbbing liquid colors and indistinct shapes—suggestions of birds, excised hearts, and anthropoid forms. *Racism Is Like Rain* is a testament to the power of abstract art as political expression.

Figure 8.21

Mary Lovelace O'Neal

Racism Is Like Rain, Either It's Raining or It's Gathering Somewhere, 1993

lithograph, 13 1/4 x 22"

(33.65 x 55.88 cm)

The Washington expressionist **Sylvia Snowden** (b. 1942) received her M.F.A. from Howard in 1965, a year after O'Neal completed her undergraduate work there. Works from the first stages of Snowden's development abound with symbolic references to the racial tensions that permeated her U.S. environment in the 1960s and 1970s. However, later works place greater emphasis on formal elements, such as "nervous brushstrokes and pen lines." Her more recent imagery is progressively less figurative, while maintaining the urban black context of previous efforts. The ostensible remnants of figuration in Snowden's later works (agitated nebulous forms distorted by veils of encrusted paint and aggressive gesture) test the boundaries between representation and abstraction (fig. 8.22). Snowden's ever-increasing use of thick impasto, robust colors, and surging, contorted shapes is reminiscent of the angst-ridden paintings of the German Expressionists, and since the mid-1980s, she has completely downplayed figuration and "the environmental conditions occasioned by race" in favor of expressionist form. Her nonobjective works give prominence to race not as a narrative but "as a wellspring of inner awareness and identification"—resulting in intensely abstract compositions.[41]

The interests of the art establishment continue to be piqued more by the cultural content of Snowden's art than by her virtuosity as a neo-expressionist, and critics persist in characterizing her as a "black" painter. Snow-

Figure 8.22
Sylvia Snowden
13, 1993
acrylic and oil pastel on canvas
72 x 132" (183 x 335.3 cm)

Figure 8.23
Sylvia Snowden
Age 13, from *Malik, 'Til We Meet Again*, 1994–1998
mixed media on canvas and enlarged jet-ink photo, 6 x 9′ (1.82 x 2.74 m)

den remains disenchanted by the fact that, on the basis of ethnic heritage, her work and that of many of her peers is recurrently treated, in historian Alice Thorson's words, "as a subcultural product . . . [on] separate but unequal footing with mainstream 'white' art."[42] A 1994 installation of ten abstract paintings, thirty-eight altered artifacts (painted and decorated toys and objects belonging to the artist's son), and thirty-eight works on paper refute any claims made by critics that black artists' works must be solely composed of narrative and racial political imagery. The composite creation *Malik: 'Til We Meet Again* (1994–1998) memorializes in an efficient marriage of abstraction and figuration a personal calamity—the shooting death of Snowden's eighteen-year-old son on a Washington, D.C., street—and it underscores the kinds of tragic misfortunes that bind, rather than separate, all of humankind (fig 8.23).

The prints of **Stephanie Pogue** (b. 1944) also hail from the abstract expressionist genre, particularly in their reinforcement of brushwork and gesture. Another in the contiguous line of Howard University graduates, Pogue received a B.A. there in 1966. She coupled a master of fine arts degree from Michigan's Cranbrook Academy of Art with a second M.A. in art history from Vanderbilt University in Nashville. Pogue's expertise in cultural history extends to Byzantine mosaics, Bamana (Mali) and Bakota sculp-

ture, and the relief carvings of the Hindu temples at Khajuraho (India), studied firsthand while traveling through India on a Fulbright-Hayes fellowship in 1981.[43]

Between the early 1970s and the 1980s, Pogue shifted from a representational to an abstract aesthetic, as the "concept of the universal" became more central to her thinking. According to Pogue, "My visual vocabulary has expanded to include not just the world around me, but the world within. . . . I try to reach inward to the level of my subconscious." Pogue's introspective methodology manifests itself in prints filled with "elements of texture, muted color, and universal motifs" that persist in alluding, however indirectly, to nature.[44] This rooting in the natural world is evident in *India Pattern/Pattern of India*, which reiterates the lotus blossom design of a marble palace floor that the artist recalled from her travels to India (fig. 8.24). With the sovereignty of a blazing sun seen at close range, *India Pattern* introduces a wedge of the lotus silhouette into the upper right area of the composition. Layers of texture and translucent color create a shimmering effect, displaying Pogue's command of her medium. Recently, Pogue has begun to explore new materials and three-dimensional forms by tearing her monotypes and reconstructing them to create printed paper sculptures.[45]

While not a Howard graduate, painter and printmaker **Joyce Wellman** (b. 1949) availed herself, like so many others, of the D.C. art scene. In 1981, after studying with artist Valerie Maynard at the Studio Museum in Harlem and with virtuoso printmakers Robert Blackburn and Krishna Reddy (at his NYU Coop Print Atelier), she moved to Washington to join the W. D. Printmaking Workshop. Wellman later attended the Maryland Institute College of Art as a Ford Foundation fellow (1988), where she subsequently completed an M.F.A. (1998). In the mid-1980s, Wellman turned from printmaking to painting with imagery that is stylistically related to

Figure 8.24
Stephanie Pogue
India Pattern/Pattern of India,
from the *Fan* series, 1986
mixed media on paper,
15 x 22 1/2" (38.1 x 57.15 cm)

the Washington Color School. The thoroughgoing nonobjectivity of the Washington School is not, however, what Wellman achieves in her painted gesticulations, which instead invoke livelier allusions to "walking legs, flexed torsos, and arms akimbo."[46] While other works educe Wellman's affinities with the geometric abstractions of Kandinsky or with the textures of German dada collage, works like *Under Sea Life* (1985) pair fields of color with restless inscriptions and call to mind the early works of Jackson Pollock (fig. 8.25). This composition along with many of Wellman's abstractions are, in the artist's judgment, instinctive and sentient: "My work . . . reveals itself through an unconscious process of placing color, form, cryptic signs, and marks onto the surface of my paintings. . . . I push and pull these abstractions in order to create visual sensations that evoke . . . an emotional response. This is my attempt to bring the viewer closer to a nonmaterial . . . world."[47] Drawing and painting merge in Wellman's works to create highly active, kinetic surfaces that are as much writing and gesture as they are painting and design. The surrealist automatism hitherto seen in the works of O'Neal is more emphatic in Wellman's idiom. Indeed, actual numbers—a recurrent theme in the artist's work and a metaphor for human beings—crop up in her pictograms, intriguing viewers with the potential import of their codex.[48]

Returning to three-dimensional art, **Geraldine McCullough** (b. 1922) is, along with Chase-Riboud, one of an exclusive number of African-American women for whom abstract sculpture is their primary mode of expres-

sion. In the tradition of Picasso collaborator Julio Gonzales, who pioneered metalwork sculpture in the 1920s and 1930s, McCullough's direct welded pieces obfuscate the divide between industrial rusticity and high art refinement. McCullough's structures in copper and other metals have both the clarity of form of African statuary and the quality of abstract expressionist gesture seen in the works of twentieth-century abstract sculptors such as David Smith and Theodore Roszak. In fact, in 1964 McCullough won the Widener Memorial gold medal from a Pennsylvania Academy of Fine Arts jury upon which Roszak served.[49]

The Widener award catapulted McCullough into national prominence. Her style was described by a *New York Times* critic as "abstraction carrying echoes of mutilated organic forms that seem to rise toward rebirth."[50] In this vein, *Ancestral Parade* (1994) warps and bends what would otherwise be perceptible human and animal figures until only the

Figure 8.26
Geraldine McCullough
Ancestral Parade, 1994
bronze, 46 x 37"
(116.84 x 94 cm)

Figure 8.27

Geraldine McCullough

Echo 5, 1993

brass, brazed copper, brass rods,

61 1/2 x 37 x 57 1/2"

(156.2 x 94 x 146 cm)

most equivocal of inklings remain (fig. 8.26). One senses the presence of titivated elephants, camels, royal riders, and their retinues, but no such assembly can be precisely discerned. Yet, the formations in bronze that constitute *Ancestral Parade* have been deployed in a manner so plastic that the metal itself seems corporeal and teeming with robust life. *Ancestral Parade* is a testament to "a certain magic . . . a certain inner vitality"[51] for which McCullough strives. Even those works that appear to be wholly nonrepresentational resonate with allusions to the figure and seem on the verge of commuting from a nonobjective to a bodily state. A collection of varied and textured metal forms, *Echo 5* (1993) pulsates with inferences to seated African icons, raffia headdresses, and body scarifications (fig. 8.27). Even without such hominid references, McCullough's sculptures are

imbued with inner vitality by way of their variegated surfaces, composite elements, and other embellishments.[51]

Also a metal sculptor, **Helen Evans Ramsaran** (b. 1943) is inspired by the cultures and aesthetics of Asia, Africa, and Mexico (where she has traveled extensively). She creates organic abstractions in bronze, which radiate with an austere and haunting beauty that is the artist's signature. Often abstracted from creatures and forms found in the natural and human-created world—exotic mammals, reptiles, architectural structures, and sacred burial mounds—Ramsaran's works move far beyond their initial inspirations. The skeletal infrastructure of her *Prehistoric Giraffe* (1991), for example, is veiled in little more than a delicate patina (fig. 8.28). Yet, its surfaces give the effect of having eroded over many years of exposure to the elements, making this otherworldly specter of a stooping giraffe both a timeless and a universal totem. In addition to her work as a sculptor, Ramsaran has studied photography and drawing at the New School and the Art Students League and spent several years in western and southern Africa honing her craft and photographing indigenous architecture.

The list of African-American women who have either assimilated elements of abstraction into their art or who have remained categorically faithful to a nonobjective protocol is a long one. What sets their work apart from the canonical abstract schools is its eclecticism. Among many others, "neofuturist" **Shirley Woodson** (b. 1936), figural expressionist **Gilda Snowden** (b. 1954), color field painter **Cynthia Hawkins** (b. 1950), and multimedia abstractionist **Nanette Carter** (b. 1954) extend the abstract legacy. Carter, for instance, who trained with British sculptor Anthony Caro, nimbly blends the calligraphic elegance of Japanese prints, the frenetic gesture of abstract expressionism, and the minimalist geometry of hard-edge painting

Figure 8.28

Helen Evans Ramsaran

Prehistoric Giraffe, 1991

bronze, 12 x 13 x 5"

(30.5 x 33 x 12.7 cm)

Figure 8.29
Nanette Carter. *Point-
Counterpoint #12*, 1996
oil on canvas with collage,
77 x 73 1/2" (195.6 x 185.7 cm)

Figure 8.30
Nanette Carter
Detour Left #2, 2001
oil on mylar with collaged
and painted canvas,
24 x 24" (61 x 61 cm)

(fig. 8.29).[52] Her most recent paintings inventively employ transparent mylar as a painting surface. *Detour Left #2*, for example, consolidates textural and monolithic cruciform elements (the latter obliquely symbolic of the World Trade Towers and of human sacrifice) painted on opposite sides of the sheer surface to generate a three-dimensional effect (fig. 8.30).

The roster continues with sculptors **Mildred Thompson** (b. 1936), **Denise Ward-Brown** (b. 1953), **Ruth Lampkins** (b. 1957), and many others. Lampkins's art transmutes the look of paper into that of metal and the feel of two dimensions into three. Such an inversion occurs in Lampkins's untitled sculpture of 1990, which is composed of layers of paper draped over a dowel and then painted and dusted with metallic powder to resemble sheets of folded metal (fig. 8.31). Works such as this are proof positive that the nonobjective legacy among African-American women artists is stronger now than ever, and their laudable contributions warrant intellectual consideration. The custom of presupposing that art made by African Americans must inherently be the art of social protest has slighted much nonpartisan imagery. Historian Ann Gibson maintains that the failure of the art community to recognize the achievements of early African-American abstractionists was a direct result of racist exclusionism.[53] For the majority of African-American women abstractionists today, this denial of place has yet to be redressed.

Figure 8.31

Ruth Lampkins

Untitled, 1990

paper, oil paint, metallic

powder, 6 x 10' (1.82 x 3 m)

Toward the end of the twentieth century, the pervasiveness of abstraction yielded to a new interest in the art of ideas. Minimalist artist Sol LeWitt argued in 1967 that the thought processes that spawned a work of art were more important than the art object itself. LeWitt proposed that artists embrace words as well as images to express their ideas.[1] His views were echoed and expanded by artist Joseph Kosuth, who launched the conceptual art movement to foster art that would challenge established aesthetic criteria by serving as vehicles for intellectual discourse rather than as objects of visual interest. The ensuing wave of conceptual art, which climaxed in the 1970s and 1980s, advocated both cognitive expression and alternative media, such as audio- and videotape, photography, and industrial materials.[2]

Creative skill and visual beauty were no longer crucial to the art-making process, outweighed as they were by theoretical substance. Ideas were so valued that many conceptual artists did away with the traditional art object altogether. Performances, installations, body art, and earthworks became especially fashionable, since they did not result in a permanent work of art. Transient art ideally suited the logic of conceptualism because, since the existence of the "work" was brief, its meaning and the act of creating it (often a joint activity involving artist and viewer) became more important than the artwork itself. Performances, earth art, installations, and body art—all temporary—could not be hung in museums, collected by the wealthy, or sold as high art commodities. Conceptual art thus contested convention by giving precedence to the capacity of art to communicate ideas. Despite its transitory nature, conceptual art could be, and was, preserved in artists' plans, diagrams, written records, and photographs. These documents, ironically, became the very preservable artifacts that conceptualism debunked and acquired high art value in and of themselves.

NINE **Conceptualism** Art as Idea

Philosopher **Adrian Piper** (b. 1948) was the first major African-American artist to come under the spell of conceptualism. A native of Harlem, she spent the 1960s studying at the Art Students League, the Museum of Modern Art, and the School of Visual Arts. During this early stage, her artistic style vacillated between figuration and minimalism. As time passed, however, she became interested in the theoretical implications of conceptualism and decided to amplify her visual arts education with study in philosophy. Over the next decade, Piper earned her Ph.D. in Kantian philosophy from Harvard University and established herself as a conceptual artist. Her approach to conceptualism, which was influenced by 1970s politics, minimalism, and performance art, resulted in works that combined sociopolitical happenings (a type of performance predicated on unanticipated audience interactions) with the stark forms and detached objectivity of minimalism.[3]

Although the prodigious events that were taking place in the 1960s and 1970s, in particular the Black Power, antiwar, and feminist movements, were extraneous to the first wave of minimalism, Piper became convinced that this politically neutral rubric was a less-than-adequate means of expression. As an African-American woman who moved in diverse ethnic and social circles, Piper was especially sensitive to discrimination and felt that her art must respond to the environment of imperialism, sexism, and racism that "governed how she and her work were viewed within the art world and the academy."[4] Her decision to synthesize the impersonal character of minimalism with the ideological cogency of conceptualism gave rise to a body of work that is considered among the most innovative of the late twentieth century.[5]

One of Piper's first creative examinations of social intolerance was a collaborative performance entitled *Mythic Being* (1972–1976), during which the artist cross-dressed as an African-American man in dark sunglasses, an Afro wig, bell bottoms, and a mustache. In this camouflage, she toured New York theaters, gallery openings, concerts, films, and plays. She wandered city streets, rode buses and trains. She also accosted white students on the Harvard University campus in Cambridge. With the aid of an assistant, Piper went so far as to enact a public mugging, while her unwitting audience either ignored the skirmish or observed it with alarm and panic. As the much-maligned and stereotypical "black brute," Piper was able to incite her audiences to all manner of reactions, including fear, distrust, aversion, and belligerence while seeming to remain emotionally detached from the response of her viewers. The performance was documented in drawings, collages, photographs, and in *Village Voice* ads that featured a retouched

photograph of Piper in disguise for the benefit of a wider audience (fig. 9.1).[6]

In her role as the Mythic Being, Piper shed (or shrouded) her own physical appearance, gender, and class identity and became fully immersed in the black male persona. According to the artist, the transformation was exhaustive: "My behavior changes. I swagger, stride, lope, lower my eyebrows, raise my shoulders, sit with my legs wide apart on the subway."[7] Extrapolated from *Mythic Being*, the altered photograph *I Embody* documents the artist's appearance as a man. It pictures her in drag, smoking a cigarette and thinking (by way of a cartoon balloon), "I embody everything you most hate and fear." As the quintessence of Otherness, Piper impugns her xenophobic audience while ingeniously synthesizing within herself the three principal elements of the artistic experience: artist, object, and viewer.

As a happening, *Mythic Being* was seamlessly aligned with the ethos of conceptualism, in that it was performed outside of "the institutional boundaries of the art world—the rarefied, well-behaved realm of the museum [and] the gallery."[8] Piper's rejection of the establishment was both tactical and judicious. Whereas, during previous years, she had exhibited in galleries and museums both in the United States and abroad, *Mythic Being* underscored Piper's resolve to sidestep any protracted attempts to breach institutional boundaries. Instead, she wished to beat a more immediate path to her audience and to "the world she wanted most urgently to change."[9] Piper hoped that, through her work, she might "contribute to the creation of a society in which racism and racial stereotyping no longer exist."[10] Although much of Piper's art since the 1970s has paradoxically found a venerated place within the art academy, she nonetheless has dedicated her career to striking at the foundations of complacency and denial that characterize the lingering racism inherent in that very arena.[11]

Piper's preoccupation with the subtleties of modern-day chauvinism manifested itself in a controversial "guerrilla" performance entitled *My Calling Card #1 (For Dinners and Cocktail Parties)*. The happening, which was played out on multiple occasions, necessitated the distribution of business cards by the artist to persons who made discriminatory statements in her presence. Piper, who appears to be of Anglo-American descent, was often unwillingly made a party to racist conversations by persons who did not realize that she was African American. In such instances, cards printed with the following statement were presented to the offenders:

Dear Friend, I am black. I am sure you did not realize this when you made/laughed at/agreed with that racist remark. In the past, I have attempted to alert white people to my racial identity in advance. Unfortunately, this invariably causes them to react to me as pushy, manipulative, or socially inappropriate. Therefore, my policy is to assume that white people do not make these remarks, and to distribute this card when they do. I regret any discomfort my presence is causing you, just as I am sure you regret the discomfort your racism is causing me.

My Calling Card #1 has been described as a "little survival tool" that allowed the artist to disengage herself from social confrontation while at the same time making her feelings known.[12]

My Calling (Card) #2: Reactive Guerrilla Performance for Bars and Discos likewise disrupts the recipient's mindset by suggesting that all women who visit nightclubs are not, in fact, interested in a sexual encounter. The card reads in part: "I am not here to pick up anyone or to be picked up. I am here alone because I want to be alone." The performance acknowledges Piper's experiences with sexism, not the least of which occurred while she worked as a go-go dancer in a Manhattan nightclub in the mid-1960s. Both *Calling Card* performances are predicated on the minimalist renunciation of overt "signs of artistic personality and effort" (hence the impersonal act of silently handing out preprinted cards).[13] The performances are also based on the Kantian theory that the mind compulsively imposes order on the world around it, by way of artificial categories and preconceptions that disallow the existence, within the human population, of countless individual identities. Piper's performances force a paradigm shift and insist that presumptions about race and gender are imprecise and destructive, as well as part and parcel of the human will to compartmentalize and classify all that is unfamiliar.[14]

Like the earlier *Mythic Being*, the installation *Four Intruders Plus Alarm System* (1980) correspondingly engages the abhorrence of difference that plagues our society, specifically our culture's fear of black men (fig. 9.2). The work consists of a minimalist (monochromatic and austere) architectural structure into which observers must venture in order to view back-lit photographs of the uncompromising faces of four young black men—the "intruders." Within the confines of this dark, claustrophobic environment, one is constrained to accept the proximity of an ample and menacing black male presence and to face one's own sense of alarm and trepidation. An audio element is added to the mix, comprising music (a rendition of "Night People" by the group War) and Piper's own voice, contrived to parody the

Figure 9.2

Adrian Piper

Interior view of *Four Intruders Plus Alarm System*, 1980

installation of circular wood environment, four photographs, silk-screened lightboxes with attached headphones, and sound (five cassette units),

72 x 60" diameter

(183 x 152.4 cm)

indignant, querulous, and bigoted reactions of white viewers to the work. The installation imparts a visual, temporal, and spatial experience, which Piper hopes will "jolt the viewer into new levels of [self-awareness]."[15]

In 1988, Piper took on the subject of miscegenation with a construction entitled *Cornered*, in which a video monitor, partially obscured by an overturned table, is situated beneath two birth certificates identifying the artist's lineage as both black and white (figs. 9.3, 9.4). The monitor displays Piper as she recites a litany about the probable presence of African blood in most self-proclaimed white Americans. She argues logically and dispassionately that, given the many centuries of racial mixing in America, the existence of "pure" European or African blood at this stage is highly improbable. The capsized table signifies the artist's attempt to "overturn" misguided beliefs in genetic racial difference, and it suggests a vehement struggle of either physical (as in the racial and sexual violence associated with miscegenation) or metaphysical proportions (as in the mental struggle of Piper's audience to accept the truth of what she is proposing). The purpose of *Cornered* is to prevail upon white viewers to "transcend that deeply entrenched, carefully concealed sense of privilege, specialness, and personal superiority" that survives only because convictions regarding inherent ethnic differences persist.[16] By pointing out that the blood of all Americans is intermingled, *Cornered* exposes racism as an "ocular" pathology—"an anxiety response to the perceived difference of a visually unfamiliar 'other.'"[17]

Piper's is an art of both communication and confrontation. Her works broach subjects that many of her viewers would prefer not to engage, and

are intended to modify viewers' perceptions of themselves. Piper believes that the roots of social oppression begin with individuals and must best be challenged on a one-on-one basis. The fact that white audiences find her art thought-provoking at best and offensive at worst hardly unsettles the artist, who has engineered precisely this response in order to compel viewers to rethink their ingrained beliefs. As catalysts for change, Piper's works, ideally, prompt the first step in a long process of transformation.[18]

Figures 9.3, 9.4
Adrian Piper
Cornered, 1988
installation with video, table,
lighting, and birth certificates
and detail of birth certificates

The art of **Deborah Willis** (b. 1948) entails a novel integration of photography and fabric design. *Tribute to the Hottentot Venus: Bustle* (1995) joins the ranks of a number of works by African-American women that reawaken the memory of Saartjie Baartman in order to symbolically reclaim and venerate her body and to deliver it from the abasement that has so long been associated with black female nudity and sexuality (figs. 1.15, 9.5). Willis's *Homage* consolidates a pieced and appliquéd quilt in the form of a triptych. Two of the panels frame silhouettes of Baartman's body, highlighting her distended buttocks, with ethnographic drawings made during her lifetime. The central section converts this same silhouette into a floral tribute to late nineteenth-century women's fashions which, ironically, incorporated bustles (à la Baartman) in order to enlarge the appearance of the wearer's hips. The artist's use of the quilt format is, in Willis's estimation, an opportune reference to the pictographic narratives of African-American story quilts and, in the artist's own words, "reminds us who we are and who and what our ancestors have been to us in the larger society."[19]

A graduate of the Philadelphia College of Art and Pratt Institute, Willis was initially inspired by her father, who was a photographer. Her imagery often pictures or alludes to familial occasions such as weddings, funerals, and reunions in an attempt to enshrine, with veracity and eminence, the seemingly prosaic but appreciable human customs. *Daddy's Ties: Tie Quilt II* (1992) raises the comforting specters of father, brother, and husband; of wives knotting their husbands' neckties; and of fathers teaching their sons how to loop their first bow ties (fig. 9.6). *Daddy's Ties* is a collage of fabric cravats and trim, photo linen, a button, and tie clips formed into a supple, irregularly shaped memorial. The work also memorializes black soldiers who fought in World War II, and it reiterates their experiences through the filter of Willis's informed and very private perspective.[20]

Through scholarly and curatorial work, Willis found further outlets for her interests in historic and cultural documentation and preservation. Projects in these veins include some twenty books on African-American photographers and on the representation of blacks in photographic imagery, as well as curatorial work with both the Schomburg Center and the Smithsonian Institution. Her academic, exhibition, and awards credits are equally extensive, including most recently the prestigious MacArthur fellowship.[21]

Another award-winning artist is National Endowment for the Arts (NEA) fellow and Tyler School of Art graduate **Vicki Meek** (b. 1950), who hails from Dallas and specializes in installations that center on sociopolitical conditions in the African-American community. Meek's works mediate between the radical art of the Black Power era and the flexibility and dynamics of conceptual media. She incorporates within the theater of alter-

native spaces, such as schools and community centers, a mix of audio and video components, fabric and natural fibers, acrylic paints, Plexiglas, paper, stone, and other materials that create transcendental and affective environments. Pop imagery, hand renderings, texts, and symbols of both American and African origin convey her messages of rage against injustice. Favorite symbols are the feathered calabash, which signifies creative acumen, and the Yoruba symbol for sixteen, which stands for comprehensive intelligence. Meek believes that by inserting African pictograms into her imagery, she can impress upon her audiences the prolific nature of African heritage. Meek has deliberately chosen to target an urban African-American audience, which she feels will benefit most from the lessons that her works impart.[22]

Figure 9.5
Deborah Willis
Tribute to the Hottentot Venus:
Bustle, 1995
fabric and photo linen, 23 x 28"
(58.42 x 71.12 cm)

Figure 9.6
Deborah Willis
Daddy's Ties: Tie Quilt II, 1992
photo linen, button, tie clips, and
pins, 27 x 34" (68.58 x 86.36 cm)

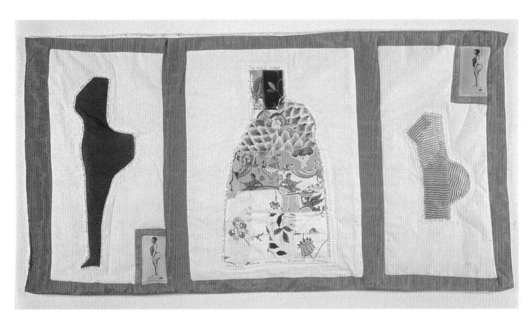

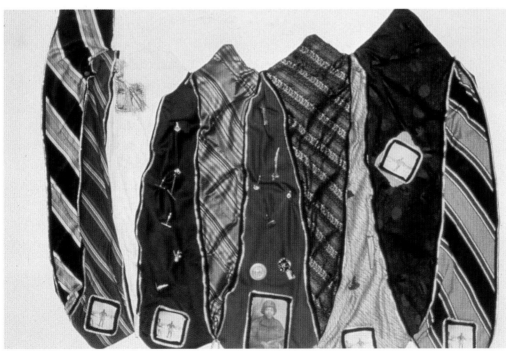

Meek's creative installations, such as *A Man in Touch with His Origins Is a Man Who Never Dies* (1989) and *In Homage to Lady Day, Part III* (1990), tackle such topics as black cultural history and black-on-black crime (figs. 9.7, 9.8). To underscore themes of death from violence and drugs, she utilizes crack (cocaine) vials, overturned and broken crockery, empty chairs, newspaper articles, framed obituaries, and the Yoruba symbols for murder and sorrow (which resemble Vodou *vèvè*, themselves derived from West Africa). Meek's perceptions are further qualified by discursive phrases such as "Strong women are rarely hurt," or "I could be angry all the time if I think too hard." The texts, which are painted onto fabric banners, sheets of black paper, or Plexiglas and gallery walls, are sometimes translated into Yoruba, as is the case with *A Man in Touch with His Origins*, in which the title phrase is translated as "mu kala kintwadi ya tubu i mu zingu."[23]

The artist revels as much in formal processes as she does in mental ones. She relishes the task of arranging and rearranging her installations to suit each new space. Every time a work is reinstalled, there are novel challenges to face, occasioned by architectural shifts, wall heights, pillars, windows, and other impediments unique to the individual exhibition space. "I go into a room," Meek explains, "and figure out how I can best say what I need in the space provided."[24] Despite any necessary modifications to the original design, however, Meek is comfortable in the knowledge that her installations will invariably preserve their intended implications with every new configuration. Her most recent installations are departures from her politically explicit works in their classic austerity, but no less conceptually engaging.[25]

Carrie Mae Weems (b. 1953) spent her youth in Portland, Oregon, where she became involved in the women's movement as well as in a number of socialist groups. She later earned a B.F.A. from the California Institute of the Arts and graduate degrees in photography and African-American folklore from the University of California. A photographer, multimedia, and installation artist, Weems's researches in the field of storytelling (particularly the "earthy wit" and "bawdy candor" of African-American writer and folklorist Zora Neale Hurston) induced her to incorporate textual elements into her visual arts projects. The literary components of Weems's works function to clarify and enhance their otherwise ambiguous symbolism. Her oeuvre can best be described as a delicate balance between pictorial and verbal narratives that pivots on questions of ethnic, cultural, and sexual identity.[26]

The notion of archaeological process, or "palimpsest"—the slow and painstaking peeling away of layers of signification to allow for multiple

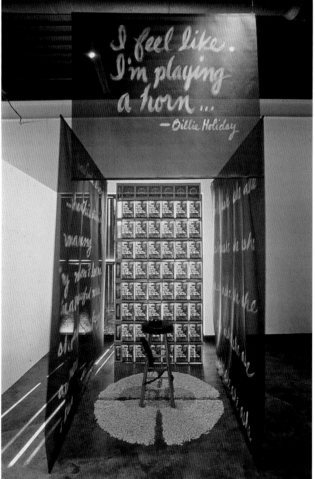

Figure 9.7
Vicki Meek
*A Man in Touch with His Origins
Is a Man Who Never Dies*, 1989
installation, mixed media,
18 x 25' (5.48 x 7.62 m)

Figure 9.8
Vicki Meek
*In Homage to Lady Day,
Part III*, 1990
mixed media with
audio installation

interpretations—is crucial to Weems's art. Her works include a variety of elements, such as sculpture, ceramics, fabric, photography, ready-made items, printed texts, audiotaped music, narratives, and poetry, so that each feature heightens the others while yet carrying its own particular significance. This can be seen in Weems's *Hampton Project*, which was installed at the Williams College Museum of Art in the year 2000 (fig. 9.9). For the *Project*, Weems assembled more than two dozen carefully chosen documentary photos that provided both literal and figurative "layers" of meaning.[27]

In *The Hampton Project*, digitally enlarged photographs drawn from the works of several nineteenth-century picture makers were printed on fabric. Most notable among Weems's sources was the presidential journalist Frances B. Johnston, who was commissioned in 1900 to document campus life at Virginia's Hampton University. The resultant photographs, many of which now reside in the collection of the Museum of Modern Art, have become known as *The Hampton Album*. From Johnston's photographic essay, Weems chose portrayals of Native and African-American Hampton students. To these, she added modern news photos of race riots and police brutality and various historic images, which she then reprinted onto over-sized gossamer muslin and canvas screens that hung from ceiling to floor.[28]

Figure 9.9

Carrie Mae Weems

***The Hampton Project*,**

installation view detail, mixed

media with sound recordings,

2000

Weems's recapitulation of Johnston's pictures centered on the false notion that "the camera never lies." As French literary theorist Roland Barthes argued in his 1964 structuralist essay "Rhetoric of Images," a photograph by virtue of its promise of veracity is, in fact, more deceptive than other two-dimensional media, such as painting and drawing, which viewers recognize as modified interpretations of reality. Those who suppose that photography captures objective truth overlook the fact that the camera is manipulated by a subjective and very human photographer whose agendas and predispositions affect creative decisions such as subject matter, lighting, cropping, and vantage point. In light of Barthes's observations, it would be more accurate to assume that the camera always lies, or at least tells an especially partisan tale.[29]

Both Weems's and Johnston's efforts constitute judiciously conceived "partisan tales" concerning one of the most prestigious historically black universities in the United States. Weems's goal in reinterpreting the original visual documents, however, was to get at the elusive "truth" of Hampton's history in a way that Johnston was unable to do because of her predetermined public relations itinerary. Johnston was commissioned to design, for presentation at the Paris Universal Exposition of 1900, a visual account of a school that was esteemed for the educational service it provided to people of color at the behest of its white philanthropic founder, General Samuel Chapman Armstrong. A one-time commander of black troops during the Civil War, Armstrong was possessed of a well-meaning but chauvinistic paternalism toward people of color, which climaxed in the establishment of Hampton. The university was envisioned as a "model vocational school" designed to turn out good Christian citizens with marketable skills and, according to Armstrong, was intended "to teach Negroes [and Indians] to become better workers, not political activists."[30] Johnston's album echoes Armstrong's program of cultural assimilation and indicates Johnston's position as an outsider. She "arranged her images to document the process that was supposed to change . . . slaves and wild Indians into self-respecting, self-supporting Americans."[31] Her friezelike pageants, while compositionally stunning, often avoid frontal views, so that the students become anonymous performers in silent montages that Johnston designed to lionize the feats of Armstrong and his school rather than the achievements of the individual students (fig. 9.10).[32]

Figure 9.10

Frances B. Johnston

Students at Work on a House

Built Largely by Them (Stairway

of the Treasurer's Residence:

Students at Work), c. 1899–1900

gelatin silver print

At the time of their exhibition in 1900, Johnston's photos were seen by many as ennobling—and indeed they were of very few sympathetic portrayals of blacks to reach such a wide audience. Modern critics, however, have cited the album as a propagandistic bolster to the notion that people of color must be made to conform (through the "Hampton method") to the "American (read Anglo-Saxon) dream and value system."[33] Weems's installation engages a poststructuralist debate outlined by Barthes in *Camera Lucida* (1981), which maintains that the gaze of the audience is less germane to a photograph than the author's vision—in the first case, the Johnston-Armstrong vision, and in the second case, Weems's retrospective retake of the initial imagery. With regard to the latter, Barthes argues that a photograph's "magic" springs from its ability to collapse time, to picture a past event for a contemporary audience, so that the new audience can interpret the image afresh.[34]

Weems's work affirms Barthes's critique by reinterpreting Johnston's photos from the point of view of a contemporary insider—an artist who is of both Native and African-American descent, whose "gaze" is by far more elastic and sophisticated than the "white gaze" for and by whom the original photos were taken. Weems's project "calls into question Johnston's ability as a [white] photographer to portray truth" and implicates educational institutions in the propagation of conformity.[35] In Weems's belief, her *Hampton Project* "addresses the ways education can result in stamping out carbon copies, creating people with the same moral code, who find value in the same things."[36]

Weems included an audiotaped narrative in her conceptual brew, in which her original prose is recited:

> Here and there you peek out from behind history's veil and glimmers of your brilliance can be seen in the contours shaping the New World. Before and After became the hallmarks of your existence. . . . Before Columbus. . . . Before Stanley and Livingston, the Portuguese, and the Dutch, and King Leopold. Before the British. After the Revolution and the exacting hand of tyranny. Before Jefferson's democracy. . . . Before Lewis & Clark and the Mason-Dixon line. Before Manifest Destiny . . . and after the opening of the West. . . . From a great height I saw you falling, Black and Indian alike.[37]

Weems's verse, which goes on at length, augments the theme of the installation—the historic suppression of Africans and Native Americans by Europeans and their institutions. The combination of words and images that comprise her *Hampton Project* creates a "site for meditation" through which, in the established vein of large-scale minimalist sculpture, audience

members must literally "navigate," walking slowly between the hanging screens in order to experience the work of art from the inside out, on temporal, spatial, and cerebral levels.[38]

So disturbing was Weems's revisionist reprisal of the Johnston album that Hampton University withdrew its space as a venue for the artist's installation. University museum director Jeanne Zeidler wrote a disclaimer for the show's catalog that outlined the university's objections to Weems's aesthetic vision and to its message of "education as conformity." On behalf of the museum, Zeidler took umbrage at Weems's inclusion of portraits of Hamptonites without specific names and histories. Weems responded by stating that the *Project* was not intended as a documentary history but rather as an avenue to "critical discussion, debate, and dialogue." Weems realized that "a critical approach would make the museum administration somewhat uncomfortable," but she believed that the risk was worth taking because, in her estimation, exposure of the "rough edges" and "bumpy surfaces" just beneath the veneer of historical order would be far more telling than any purported facts.[39]

Other of Weems's photographic tableaux are likewise socially critical, though on a less monumental scale. In particular, *Mirror Mirror* from the *Ain't Jokin'* series (1987–1988) disputes Western concepts of beauty and the ramifications of these conceptions for the women of color who have internalized them. In *Mirror Mirror*, a photograph of a black woman standing before a mirror is accompanied by the words

> *Looking into the mirror, the black woman asked, "Mirror, Mirror, on the wall, who's the finest of them all?" The Mirror says, "Snow White, you black bitch, and don't you forget it!!!"*

These telling words encapsulate the debilitating circumstance of being a black woman in a society whose standards of beauty have always excluded her. *The Hampton Project* and *Mirror Mirror* are indicative of Weems's aesthetic outlook and dedication to radical social change. With their emphasis on ideas as well as aesthetics, Weems's works are both "an incredible read" and an extraordinary sensory experience.[40]

The art of **Lorna Simpson** (b. 1960) integrates a similarly destabilizing mix of sentence fragments, word lists, and photography.[41] Her 1985 *Gestures/Reenactments* series juxtaposes radically cropped photos of a nonspecific man wearing a white T-shirt, who strikes a variety of poses (fig. 9.11). Each image is accompanied by a caption, for instance, "how his running buddy was standing when they thought he had a gun," "how Larry was standing when he found out," "when Buck was being himself," and "sometimes Sam stands like his mother." The word-image lesson counsels

viewers that the assumption of hostility associated with depictions of black men (particularly those who stand as Sam does, with arms folded, hip-hop fashion) are often erroneous. Rarely is it presumed that such body language is unaffected or merely an inherited family trait. So seldom are men of color seen as idiosyncratic individuals, distinct from typecasts, that even with the artist's textual aids some viewers find it difficult, if not impossible, to imagine that her subjects do not represent the embodiment of the inimical black male.

A Brooklynite, Simpson acquired early in life an understanding of the Pan-African urban culture that is peculiar to this borough of New York City, and her works reflect an innate responsiveness to the broader issues that affect the global black community. Though trained as a documentary photographer (at the School of Visual Arts and the University of California) and inspired by the compositional poise and equanimity of Harlem "street" and jazz photographer Roy DeCarava, Simpson's mature works "critique the objectivity, veracity, and authority with which documentary photographs are invested."[42] Simpson's images are often political in content and frequently focus on the problems faced by women—in particular, sexual harassment and domestic violence. Although, like many conceptualists, Simpson accompanies her photographs with texts, her use of language is designed to provoke, but not to dictate, critical thinking.[43]

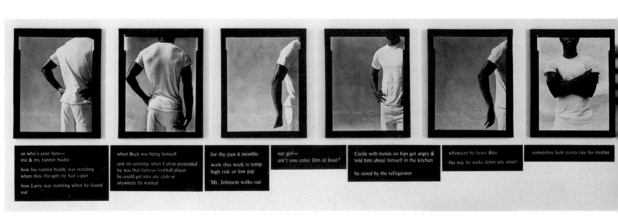

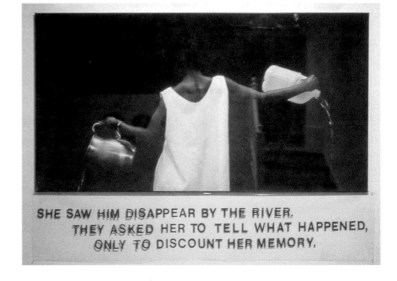

SHE SAW HIM DISAPPEAR BY THE RIVER.
THEY ASKED HER TO TELL WHAT HAPPENED,
ONLY TO DISCOUNT HER MEMORY.

Simpson's life-sized silver print *The Waterbearer* (1986) is a paradigmatic example of the artist's narrative restraint (fig. 9.12). The work, which has been extolled for its "grace" and "profound simplicity," pictures a youthful black woman in a white shift who acts as a corporeal scale, weighing water in two receptacles, one plastic and modern, one metal and antique. The tilt of her arms as she pours from both containers suggests differences in literal and nonliteral encumbrance; it alludes to the scales of justice; and it renders the photograph replete with political meaning. The dark background, into which the figure's face and body are turned, impeding any reading of her personality, is as difficult to fathom as she herself. Her character may be interpreted in any number of ways—as forlorn, mysterious, recalcitrant, or simply unaware of the presence of the spectator.[44] In this way, Simpson allows her audience a great deal of interpretive freedom and ensures their active participation in the work. Furthermore, Simpson universalizes her subject by denying viewers a face with which to identify, by alluding to the past and to the present, and by utilizing the least culturally charged props available to her—a plain white dress and indistinct objects.

Below the image are inscribed the words: "She saw him disappear by the river. They asked her to tell what happened. Only to discount her memory." Simpson's legend only vaguely achieves narrative status, due to the ambiguous nature of its implications, but therein lies its magic and, indeed, its power. The artist's provocative words read like the torn section of a journal page that stubbornly refuses to reveal a complete history. Each viewer must infer her or his own version of the facts and ask the obvious questions: Who disappeared? Who asked her what happened? The police? Neighbors? And why didn't anyone believe her? The interpretive possibilities are endless, making the work obstructive and enticing at the same time. Like the silent domestic interiors of the Dutch baroque painter Jan Vermeer, with which *Waterbearer* has been fittingly compared, the viewer cannot hope to wholly know the subject and is permitted only the narrowest glimpse of her existence.[45]

Simpson brings to her work an expertise in film and film theory, which is translated into installations that have the effect of moving film decelerated. Her 1986 *Screen No. 1* comprises three enlarged black-and-white photographs of the lap of a young woman, framed within a tripartite folding screen, which requires the viewer to negotiate the shallow space around it (FIG. 9.13). The three photos are captioned with the words, in red, "Marie said she was from Montreal although"—which achieve the effect of running subtitles and compel the viewer to seek out the continuation of the narrative on the back of the center panel—"she was from Haiti."[46] The inference is that the Haitian expatriate, pictured faceless and without

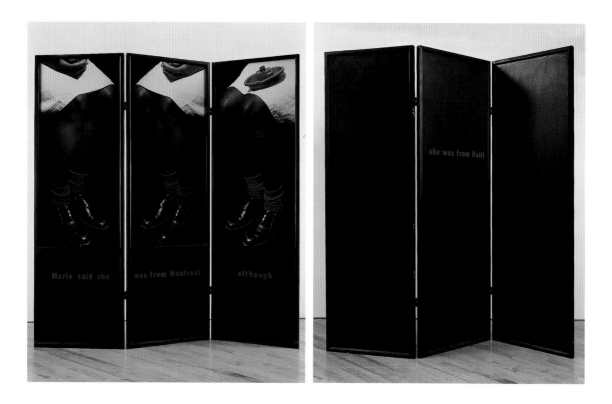

Figure 9.13
Lorna Simpson
Screen No. 1 (front and back
views), 1986
wooden accordion screen, 3
gelatin silver prints, 62 x 66 x 2"
(157.5 x 167.9 cm)

identity in the artist's characteristic white clothing, now lives in Montreal (where a substantial Haitian population resides) and has reconfigured her identity to divorce herself from her origins and all of the mythical associations that have been attached to Haiti (everything from zombies to AIDS).

Simpson's interest in reformed identities relates to her fascination with 1940s film noir, the independent films of John Cassavetes, the experimental works of Jean-Luc Goddard, and method acting. In recent years, she has made her own films centering on vigorous and intricate women characters whose roles blur distinctions between binary concepts, such as black and white, male and female, good and bad, celibate and sexualized, aggressive and passive. Highly regarded for its provocative formal orientation and alliterative nature, Simpson's art has been featured at museums nationwide and honored in 1994 with the College Art Association's Award for Distinguished Body of Work.[47]

Through multimedia installations and pioneering performances, **Lorraine O'Grady** (b. 1940) endeavors to lay bare the hypocrisies of the black middle class from which she hails and seeks to reform images of black women from sexual objects to subjects of conceptual discourse.[48] O'Grady's parents were West Indian immigrants and members of Boston's black elite. They provided for their daughter a well-heeled lifestyle (which

her art often critiques) and the best education, though not in the visual arts—a B.A. in economics from Wellesley College in 1961 and an M.F.A. in fiction from the University of Iowa in 1967. In 1970, O'Grady moved to New York and worked as a columnist for *Rolling Stone* magazine and the *Village Voice*. Inspired by Piper, O'Grady became interested in conceptualism and, by 1980, launched her own career as a conceptual artist. Utilizing texts, photographs, drawings, and sound, she created installations and performances that intrepidly critiqued conventional social attitudes.

At a reception held at JAM Gallery in 1980, and again at the New Museum in 1981, O'Grady executed her first major guerrilla performance as the now-legendary *Mlle Bourgeoise Noire* (fig. 9.14). Dressed in a tiara, a beauty contestant's sash, and an evening gown and cape fashioned from nearly two hundred pairs of white gloves, she strode in a stately manner amid the gallery's guests. In her hands she carried a whip which she used to flagellate herself. She shouted to the crowd, "That's enough! No more boot-licking. . . . No more ass-kissing. . . . No more buttering-up. . . . No more posturing of super ass-imilates. . . . Black art must take more risks!" Her performance surely lived up to its mandate. It ridiculed post–Black Power era artists for their reluctance to adopt a more aggressive political stance and for their fear of offending retrograde elements within the art community. O'Grady described her performance technique as a "hit-and-run" operation designed to disrupt a cultural event and to provide an "electric jolt" in order to provoke strong viewer/participant response.[49]

O'Grady also began performing *Nefertiti/Devonia Evangeline* in the 1980s (fig. 9.15). The work partnered a one-woman play with projected photographs that memorialized the artist's sister, who had unexpectedly

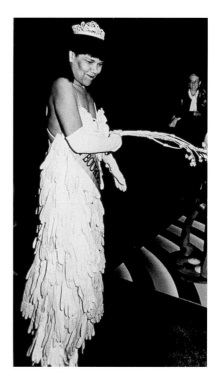

Figure 9.14
Lorraine O'Grady
Mlle Bourgeoise Noire,
performance at the New
Museum of Contemporary Art
during the opening of *Personae*,
September 1981

Figure 9.15
Lorraine O'Grady
Sisters IV, from *The
Miscegenated Family Album*,
installation of images taken from
the *Nefertiti/Devonia Evangeline*
performance, 1984/1990
cibachrome diptych, 27 x 38.5"
(68.6 x 97.8 cm)

passed away at age thirty-eight. Devonia's death occurred only weeks after she and O'Grady had reconciled after years of estrangement, and the artist felt the loss intensely. Two years later, O'Grady traveled to Egypt and found herself surrounded by a population of Africans who, in O'Grady's words, "looked just like me. . . . Here on the streets of Cairo, the loss of my only sibling was being confounded with the image of a larger family gained."[50] After returning to the United States, O'Grady began work on the *Nefertiti/Devonia Evangeline* performance and installation, which required her to thoroughly research the Amarna period of the ancient Queen Nefertiti and her royal court. O'Grady's investigations turned up Nefertiti's younger sibling, Mutnedjmet, with whom O'Grady identified, having always thought that her own sister resembled Nefertiti. In the definitive performance, pairs of images of women and their families from both eras were projected onto the gallery walls, and the artist described via audiotape the lives of both Nefertiti and Devonia, while performing an Egyptian death ritual, intended to honor the memories of each woman.[51] Though more contemplative and far less hard-hitting than O'Grady's guerrilla performances, *Nefertiti* is no less indicative of the artist's commitment to social change through intellectual and visual dialogue.

The work of **Renée Cox** (b. 1958) might well be described as guerrilla performance captured on film. Cox, who began as a professional photographer, emigrated to the United States from the West Indies. Following in the paths of Piper and Simpson, she studied at the School of Visual Arts, completing an M.F.A. in 1992. She also participated in the Whitney Museum Independent Studies Program and worked as a fashion photographer for *Details*, *Cosmopolitan*, *Essence*, and *French Glamour* magazines. Debates about the black female body and the scarceness of its presence in the fashion industry came to the artist's attention and, by way of reaction, Cox began to use her own body in conjunction with the "scrutinizing eye" of her

Figure 9.16

Renée Cox

The Liberation of Lady J and U.B., 1998

cibachrome, 48 x 60"

(122 x 152.4 cm)

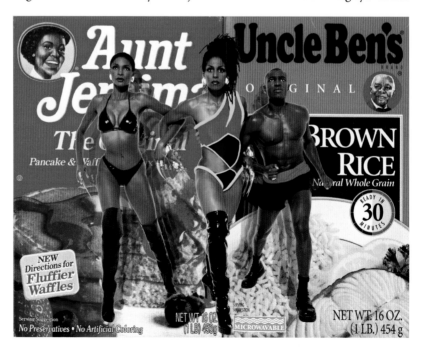

camera to consider matters of black female sexual empowerment.[52]

Cox embodied her vision in the character of a self-styled superhero named Rajé who took form as the artist in thigh-high black boots and an off-the-shoulder swimsuit of red, black, yellow, and green (a combination of colors from the Jamaican and the black nationalist flags). Rajé appears in a variety of Cox's photomontages, including *The Liberation of Lady J and U.B.*, a 1998 cibachrome (fig. 9.16). In this image, Rajé rescues the racial archetypes of Aunt Jemima and Uncle Ben from their respective perches on the covers of pancake and rice boxes. Rajé then commutes them from plump middle-aged matron and kindly elder into lean, swimsuit-clad icons of beauty and prowess. Sporting black patent leather clothing and boots, Rajé and her female companion exude the sexual power and control that is associated with the character of a dominatrix and that decisively sabotages the docility associated with the black servant.

Figure 9.17

Renée Cox

Hott-En-Tot Venus, 1998

cibachrome, 60 x 48"

(152.4 x 122 cm)

The deconstruction of stereotypes is also the objective of Cox's *Hott-En-Tot Venus* in which the artist has adorned her body with highly polished metallic prostheses that approximate the breasts and buttocks of Saartjie Baartman (figs. 1.15, 9.17). The significance of large hips for women of African descent, which can be traced directly to the early nineteenth-century analyses of Baartman's body, is profound, as historian Marilyn Jiménez explains:

> From the Hottentot Venus to Jennifer Lopez, large buttocks are presented as a racial characteristic that marks black women as a group [separate] from women of other races, ignoring equally black women with small buttocks or white women with large buttocks.... Needless to say, for the buttocks to gain significance—racial and sexual—they must be revealed; it is all about performance.[53]

Cox's performance, self-photographed, taunts the viewer with a tongue-in-cheek commentary on both the sexual cliché of "large-buttocks-equals-black-equals-carnal" and on the sardonic reality which obliged the petite Cox, whose breasts and hips are hardly large enough to fit the formula, to attach falsies. Furthermore, by staring directly at the viewer, à la Manet's *Olympia* (fig. 1.17), Cox disallows both the male gaze and the imperialist gaze.

Figure 9.18

Renée Cox

41 Bullets at Green River, 2001

archival digital c-print mounted

on aluminum, 40 x 32"

(101.6 x 81.3 cm)

The gap between early nineteenth- and late twentieth-century voyeurism is spanned in *Hott-En-Tot Venus* with the juxtaposition of a vintage African body and a modern one, outfitted with industrially manufactured materials. Cox wears her contrivance like a string bikini and poses with her hand on her hip as if in a beauty contest, asserting the beauty of black women. In a variation on the theme, entitled *Venus Hottentot 2000*, which was photographed by fellow conceptual artist Lyle Ashton Harris in 1994, Cox stands in the same costume, in front of a red, black, and green velvet screen to suggest the "black and proud" interpretation of her emboldened character. Cox's photo fearlessly examines the topics of "voyeurism, fantasy, memory, disguise, . . . the gaze, [and] consent . . . as it relates to the black body," and she transforms Baartman from a victim into an empowered woman at the controls of her own representation.[54]

Cox's use of her own body in her work was the subject of heated public debate when, following the showing of her *Yo Mama's Last Supper* at the Brooklyn Museum in 2001, New York mayor Rudolph Giuliani condemned the photograph of a nude Cox posing as Christ with black apostles as "disgusting" and "outrageous."[55] The association of black female nudity with hallowed Christian subjects was at the core of the censorious response to the work. But, in order to "consecrate" black bodies and draw attention to a variety of social ills, in this and other works from her *Grand Salon* series, Cox plundered canonical paintings such as Leonardo da Vinci's *Last Supper* (1495–1498) and Andrea Mantegna's *St. Sebastian* (c. 1460), replacing historical Western icons with contemporary black ones. Her adaptation of *St. Sebastian*, entitled *41 Bullets at Green River*, features the nude artist tied to a tree and posed as the Christian martyr (fig. 9.18). Her title indicates that the work is meant to draw attention to the "martyrdom" of unarmed West African immigrant Amadou Diallo, who was killed in 1999 by four New York City police officers when they fired forty-one bullets at him while he stood in the doorway of his Bronx apartment.

In a series entitled *The People's Project*, Cox departs radically from agit-prop themes and returns to her role as a portraitist (fig. 9.19). For this cycle, she photographed literally hundreds of subjects using austere contrasts of black and white lighting, surfaces, and skin tones. *Untitled #9* depicts a portrait of the model "Imfom" in profile with her head partially concealed by a black cloche that merges with the background. The subject's dark skin gleams and her lean body is silhouetted against the milky pallor of her lover's trim torso. The male figure provides several foils to Imfom, resulting in near-perfect formal balance. He stands a full half-head taller than she does; his black hair, like her bandanna, evaporates into the darkness; his frontal pose anchors her silhouette; and the impeccable smoothness of his skin weighs against her mastectomy scar.

Figure 9.19
Renée Cox
Untitled #9, from
The People's Project, 2000
black-and-white photograph

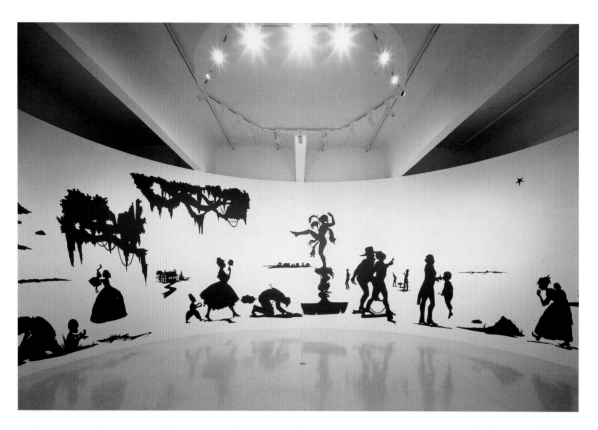

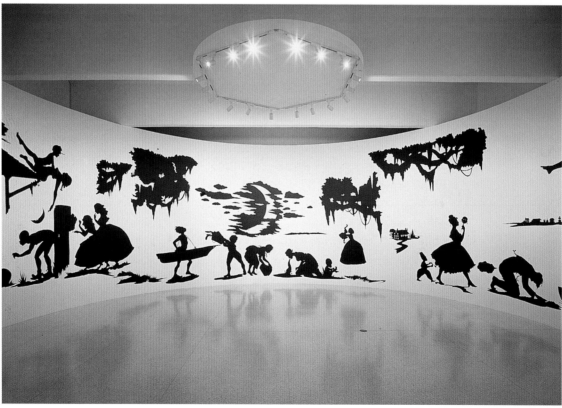

Cox's approach to *The People's Project* emphasizes the sculptural qualities of form and the altered "truth" of portraiture as expressed by Roland Barthes. While formally akin in its quietude and composure to the photographs of Lorna Simpson, *The People's Project* propels Cox beyond the era of conceptualism and black consciousness into a contemporary age of eclecticism and broader concepts of human identity. Comprised of Asians, Caucasians, and African Americans, multiracial and same-sex couples, the series (like Simpson's films) offers a redefinition of the Other that includes virtually everyone in a reappraisal of race.

One of the youngest and most controversial of the late twentieth-century conceptualists is **Kara Walker** (b. 1969). At the age of twenty-eight, after earning an M.F.A. from the Rhode Island School of Design, she became a recipient of the distinguished MacArthur Foundation fellowship. Her work provided a provocative element in the 1997 Whitney Biennial. Referred to as "the exhibit that people love to hate," the biennial undertakes to showcase art by the most trailblazing exponents of the avant-garde. Artists, such as Walker, who are invited to participate often find themselves catapulted to positions of national and even international prominence. Walker's "stunning and aesthetically seductive" black paper cutouts are precisely the kinds of works that have made the biennial legendary, and their display at the Whitney brought a barrage of both acclaim and vilification to the artist (figs. 9.20, 9.21).[56]

As a rule mounted onto white gallery walls, Walker's large-format, lyrical, and vintage-style illustrations at first beguile spectators, only to rivet or repel them after an exacting inspection of the imagery is made. Walker's silhouettes depict fetishism, slavery, death, interracial violence, and biological and sexual depravity acted out by characters from a lost antebellum era within the context of Victorian "clip art." Presented in such as way as to make censorship or mediation impossible, Walker's images relentlessly challenge cultural memory, high art sensibilities, and the viewer's sense of decorum. In order to fashion her terse tragicomedies, Walker draws from racial clichés such as Mammies, Sambos, "black bucks," and "pickaninnies." Walker also portrays white plantation masters, mistresses, and children in her scenarios. Virtually all of the protagonists are demeaned, and the entire history of slavery becomes, within this context, a ghastly farce.

In her graphic dramas, Walker self-identifies with the character of the "slave mistress," as the oft-abused young slave woman in her narratives has been termed. With unflinching candor, Walker admits that her own experiences of racial intolerance—particularly while dating white men—have psychologically scarred her, and that one of her fantasies had long been "to create a new identity for herself as the wife of a white man," so as to foil her

Figures 9.20, 9.21
Kara Walker
Slavery! Slavery! Presenting a Grand and Lifelike Panodramic Journey into Picturesque Southern Slavery; or, "Life at Ole Virginny's Hole (Sketches from Plantation Life)." See the Peculiar Institution as Never Before! All Cut from Black Paper by the Able Hand of Kara E. Walker, an Emancipated Negress and Leader in Her Cause, 1997 cut black paper installation, 11 x 85' (366 x 2584 cm) in the round

own negative self-image and sense of second-class citizenship. Indeed, her real life marriage to a white German prompted extravagant speculation on the psychobiographical nature of Walker's imagery. She has been defended, in psychoanalytic terms, as a victim of "abjection" (defined by psychoanalyst Julia Kristeva as an unbearable state of self- and other-awareness), who experiences self-loathing and internalized racism and sexism—a condition that Walker refers to as her "inner plantation."[57]

Walker's "inner plantation" is embodied in such works as the cyclorama *Slavery Slavery!* which was featured as the U.S. entry in the 2002 São Paulo Bienal. In a detail of this work, a young black woman transforms into a water fountain, spouting fluids from mouth, breasts, and bladder, while holding aloft a tuft of cotton (a reference to slave labor) (figs. 9.21. 9.22). Her body is balanced atop a squatting monkey which, in turn, rests upon a skull. Prostrate before the woman-fount is a white man who worships at the "altar" of the artist/Negress and simultaneously expels a black cloud of flatus. *Slavery Slavery!* and other Walker works are both sadomasochistic and obscene in their portrayals of sodomy, rape, incest, disfigurement, bestiality, and the excretion of bodily fluids and waste. Beneath the superficial resemblance to harmless and playful cartoons lie specters that stagger the imagination—elderly amputees conjoined to the buttocks of toddlers while simultaneously stabbing their preschool companions and prepubescent slave children copulating with animals or receiving oral sex from elderly white men. Historian Robert Hobbs describes Walker's art as a "pessimistic view of the world," an enslaving, "abject" house of mirrors in which self-awareness is only comprehended through distorted reflections received from others and thus, for blacks, can only give "rise to an alienating otherness."[58]

Some of Walker's critical supporters applaud her peculiar tribute to Jim Crow stereotypes and her use of irony, caricature, and alarming narrative as a means to deconstruct African-American stereotypes. Other advocates feel that Walker's reification of the history of slavery has "become enormously powerful to blacks" in the "current war on racist ideology" and that her compositions constitute a "sophisticated postmodern critique of racism."[59] Those who have embraced the artist's aesthetic find her work cathartic because, rather than "denying the unspeakable crime of slavery for fear of reawakening the nightmare," to paraphrase scholar Françoise Verges, Walker's work opens the graves, frees the ghosts, and mourns the dead.[60] Some, less certain as to the value of Walker's vision, grant that, at the very least, she should be allowed the artistic freedom to express herself as she wishes, even if it hurts.

Less empathic critics argue that despite the ability of Walker's images to radically engage the viewer, they ultimately function to reinforce,

Figure 9.22

Kara Walker

Detail of *Slavery! Slavery!*

rather than to subvert, negative stereotypes. Opponents have character-ized Walker's work as "essentially 'coon art' pandering to [the] white establishment . . . and absolving that same art establishment of the responsibility to show a diversity of black visual artists."[61] The staunchest opponents of Walker's brand of "visual terrorism" contend that her reprocessing of stereotypes is impertinent and degrading and should not be allowed a public forum. They have accused her of building her career on the suffering of her own people. Especially suspect, in the eyes of Walker critics, is the unprecedented rapidity with which the mostly white community of museum curators, gallery owners, collectors, academics, and patrons have embraced Walker's idiolect. Her most resolute detractor has been the artist Betye Saar who herself, ironically, collects and inte-grates images of black stereotypes into her own work (fig. 7.10). Saar, however, feels that her own use of racially offensive icons differs greatly from Walker's appropriations because Walker proffers her images with-out explanation, leaving ample room for misinterpretation on the part of her audience, while Saar strives, conversely, for a more explicit critique of racial stereotypes through art that deconstructs and empowers unequiv-ocally (often with the aid of written explanations to achieve complete clarity).[62]

In defending her radical approach, Walker takes the position that the past efforts of artists of color to create positive self-images have not entirely succeeded, as indicated by the continued proliferation of racial stereotypes and by the "impassioned" responses to her works.[63] Walker is fully aware that she is a bane to many, but she sees her work as a means to an end:

> To achieve success as an African American, one must spill one's guts constantly—like the old sharecropper in Ellison's *Invisible Man* who raped his daughter and kept telling his horrible story over and over; and the white people in the town gave him things. He's an embarrassment to the educated blacks and a fascination to the whites.[64]

Clearly, Walker is mindful of the fact that her success is contingent upon the appeal of her works to an art intelligentsia and art-buying public that is, by and large, Anglo-American. That her strategy is perceived as a "sellout" is of lesser importance to Walker than that her voice be heard. For good or bad, she is clearly unwilling to exult in obscurity for the sake of political correct-ness. The "double-edged beauty and horror" of Walker's art delves into the specifics of slavery, which most modern-day Americans, black and white, would prefer not to contemplate, but as scholar Elizabeth Sharpe points out, "Some corpses refuse to stay in the ground."[65]

On the heels of conceptualism, a group of obscure artists who, in some cases, had been practicing their craft for nearly a half century, came to the attention of the art-going public. Known by many designations—visionary, naïve, self-taught, folk, and outsider—these artists existed, for the most part, outside of the established art academy. They were the direct inheritors of the aesthetic legacy of the African-American antebellum past and were examples of "a substantial tradition of non-academic art-making [that had] long existed in the African-American" community.[1]

African-American folk art in the United States first came to national attention in the late 1930s, when the Museum of Modern Art exhibited the works of two acclaimed self-taught artists, William Edmonson and Horace Pippin. Interest in folk art waned by the 1950s, however, and did not rally until 1982 when the Corcoran Gallery sponsored the show "Black Folk Art in America, 1930–1980." Over the next two decades, the mainstream art world increasingly embraced "vernacular" art, a term that describes, in the words of connoisseur Paul Arnett, "a language *in use* that differs from the official languages of power and reflects complex intercultural relationships charged with issues of race, class, religion, and education."[2]

Arnett's definition is largely infallible, with the qualification that the language of vernacular art does not differ so greatly from the "official languages of power"; rather it is the mainstream perception of vernacular art that is out of kilter. In practice, vernacular art is not unlike that produced by trained artists such as **Aminah Robinson** (b. 1940), whose use of fabric, handmade paper, and other eclectic materials combined with her "nonacademic inventiveness and casual handling of material" has occasionally earned her "the misnomer of 'folk artist.'" Another such artist is **Carole Byard** (b. 1941), one-time member of Where We At: Black Women Artists, whose earth art installations are distinguishable from vernacular yard art (literally, the decoration of one's yard with dolls, crockery, and

T E N **Vernacular Artists** Against the Odds

other sundry materials) or from traditional African-American burial sites only in their finely tuned orchestration and exceptional carving (figs. 10.1, 10.4, 2.25).[3] In fact, the works of artist Alison Saar were once lambasted by critics as derivative because her roughly carved sculptures resembled vernacular art too closely (figs. 11.11, 11.12, 11.13). As it happens, formally trained artists routinely produce art that parallels those of their informally trained counterparts and vice versa, and vernacular art has done much to influence the art of the mainstream. Yet, artists who acquired their expertise without the benefit of sanctioned instruction are persistently segregated from the arena of high art. As art critic Dan Cameron affirms, the need to make such distinctions is rapidly becoming obsolete.[4]

Figure 10.1
Carole Byard
Praisesong for Charles, 1988
outdoor installation, mixed media

The discrepancies between unschooled artists from rural communities and trained professionals occur in the way the public defines them. For instance, "sculpture" for one group is "root art" for another; vernacular paintings become "visions"; and assemblages and installations are labeled "yard art." When French artist Jean Dubuffet began to collect and copy the style of *l'art brut* ("raw art," that is, art made by children or by adults who, for one reason or another, have been isolated from society), the result was commercial success for Dubuffet. The fact that he appropriated the original art of others did nothing to injure his professional reputation. Quite the contrary, his deliberate and conscious plundering of the art of the elderly and the insane was applauded as an innovative mechanism for infusing modern art with new vitality.

Vernacular artists are often perceived as the converse of more urbane talents like Dubuffet, as a cluster of "purists" who have not been sullied by art school instruction. The fine arts community considers them "rural and rustic, uneducated . . . , isolated, communal, spiritual, carnal, intellectually inferior, . . . backward, . . . helpless, childlike, wise, . . . and so forth, ad nauseam."[5] These qualifications, sadly, echo centuries-old black stereotypes and are the terms historically applied to oppressed cultures by prevailing societies. Fundamental to the art world's perception of vernacular artists is the notion of modern "tourism," which allows people of different cultural origins to cross over into one another's arenas and experience the Other, whose difference from their own actuality promises delight and amusement. One of the reasons vernacular art is so popular is that it assures the art tourist of a homespun experience that is "unfettered by opaque references" to some confounding intellectual argument.[6]

Also attractive to art market consumers is the notion that vernacular artists are "unself-conscious" in their aesthetic outlooks—a qualification that largely springs from a nostalgic desire to typecast these mostly southern blacks as "children of nature." Even the most erudite scholars have found themselves "guilty of the very same starry-eyed romanticism that has consistently trivialized discussions of [vernacular art] work."[7] For example, in an attempt to set vernacular artists apart from the mainstream, it has been argued that their reason for making art "is not to 'have fun,' not to while away the time, and not to make money."[8] This assertion has been embraced by many idealists, despite the fact that most professionally schooled artists likewise do not make art to "have fun," and conversely, many vernacular artists deliberately create art to "make money." Another viewpoint maintains that vernacular artists are "driven by a compulsion to speak, to share religious visions, [and] day-and-night dreams, with others," as if they did not share this same drive with many trained artists.[9]

Alyne Harris (born in Gainesville, Florida, in 1942) provides an enlightening example of the fundamental kinship between academic and vernacular artists. Hardly the unself-conscious rustic, she acknowledges having been something of a painting addict in elementary school when she would forgo recess and finish her homework ahead of schedule in order to spend time painting. After receiving as a gift a book on Vincent Van Gogh, she was inspired by his use of color, and her own compositions—mostly landscapes with a decisive postimpressionist tenor—bear out this influence (fig. 10.2). Having worked throughout her life at menial jobs (as a janitor,

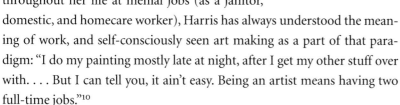

domestic, and homecare worker), Harris has always understood the meaning of work, and self-consciously seen art making as a part of that paradigm: "I do my painting mostly late at night, after I get my other stuff over with. . . . But I can tell you, it ain't easy. Being an artist means having two full-time jobs."[10]

Figure 10.2
Alyne Harris
Untitled, c. 1986
acrylic on canvas, 20 x 24"
(51 x 61 cm)

On a similar note, **Mary Tillman Smith** (1904–1995) has quixotically been ascribed with the "capacity to see the unseen and make it visible to others."[11] In more practical terms, like any skilled artist, she has the power to visualize her ideas. Many of Smith's works are executed with "broad, expressive strokes" that have been compared to the paintings of abstract expressionists Franz Kline, Clyfford Still, and Robert Motherwell (fig. 10.3). The full extent of Smith's sentience is established by the fact that, though literate, she often included indecipherable lettering and phrases in her works, which her audiences evidently found compatible with their expectations of an unschooled artist.

Figure 10.3
Mary Tillman Smith
Untitled (6 Heads), c. 1987
enamel on tin, 26.5 x 39"
(67.3 x 99.1 cm)

Like the artists themselves, vernacular art has been equated with a succession of conflicting epithets, including decorative and restrained, unsophisticated and abstruse, static and unstable, obsessive and unpretentious, serious and whimsical, and visionary and functional. Such a range of descriptive terms clearly suggests to what degree vernacular art resists classification and how important it is to examine this art on relatively fluid terms. The disparate ingredients that constitute vernacular art are ably displayed in one of its most provocative expressions: the yard show. Artists such as Smith, Minnie Evans, and **Nellie Mae Rowe** (1900–1982) created in and around their homes "fantasy gardens," which had roots in the swept dirt yards of the Old South and of Africa (fig. 10.4).

These artists adorned the exterior walls of their homes with paintings; they covered the surfaces of their gardens with sculpture; and they decorated their trees and shrubs with all manner of dolls, curios, and odds and ends, so that their gardens became self-expressive spaces that belonged both to the artists and to their communities. Variously referred to as "playhouses," "gardens of revelation," and "forms of public address," yard art differs from gallery-sanctioned installations only in that the makers install their creations in outdoor domestic environments. These yards are,

nonetheless, public displays and intended for public viewing. Rowe, in fact, kept a guest book and gave tours of her yard and home, as well as musical performances for hundreds of curious art aficionados. Yard art may also be interpreted as an artist's studio without walls, an extension of the interior home space and an answer to the perpetual problem that artists have of securing a gallery and funding the cost of a studio.

Given the affinities between yard art and gallery installations, one might question why so many have difficulty accepting yard art as valid (indeed Rowe experienced intense neighborhood animosity and accusations of witchcraft in response to her garden arrangements). To employ a poststructuralist argument (which questions the interrelated social, moral, verbal, and visual structures of society) posited by scholar Meyer Schapiro, yard art disturbs because it seems to ignore academic structures that call for agreed-upon formats, materials, and avenues of expression. Like graffiti artists, who forgo the tidy spaces of canvas and stretcher for the unrestricted

surfaces of subway cars and train yard walls, vernacular artists, too, bend and break the rules set forth by polite society. Their yard shows ignore conventions and are viewed by cynics as defiant or rebellious and deserving of censure. Indeed, these artists have paid for their insubordination through segregation from the mainstream and through scholarly inattention.[12] Feminist historian Lucy Lippard laments that vernacular women artists, in particular, were overlooked even by the exponents of the feminist art movement of the 1970s:

> As feminist artists rediscovered our mothers' and grandmothers' strategies for survival through beauty, as we began to marvel at quilts, china painting, hooked rugs, embroidery, and other home-made treasures, we should have been rediscovering the women making paintings, sculpture, and yard shows in a vernacular context.[13]

Not until a decade after the founding of the feminist art movement, with the mounting of the 1982 Corcoran show, were these artists "rediscovered."

However deferred the revelation, we benefit today from the creativity of these women, arguably the best known of whom is **Clementine Hunter** (c. 1886–1988), whose art was greatly affected by her home surroundings on the legendary Melrose (Yucca) Plantation in Natchitoches, Louisiana, on the Cane River. The compelling history of the plantation dovetails with Hunter's own and ends with a rare consolidation of African architecture and vernacular painting, which mediates among multiple generations and centuries. The plantation was originally owned in the 1790s by an emancipated slave woman named Marie-Thérèse Coincoin (Quanquan). After fathering several sons with Coincoin, the French slaveholder Claude Metoyer freed his mistress (by some accounts, his wife) Marie-Thérèse and their children, and ceded to them seventy acres of land. Coincoin and her sons Louis and Augustin successfully raised cattle and farmed tobacco, corn, cotton, and indigo on their estate, ironically with the help of nearly sixty slaves of their own. By the 1830s, the Metoyer heirs owned some 10,000 acres and "an agricultural empire second to none in the region," making them one of the wealthiest black families in America.[14]

The Melrose Plantation is today renowned for its eclectic architecture and for its preservation of the original Metoyer buildings, the oldest in the state. Most notable of these is the infamous "African House," where Coincoin interred "recalcitrant slaves" (fig. 10.5).[15] It was built of baked brick by these same Africans, and its immense ten-foot eaves replicate, in style if not materials, Bamileke civic architecture from Africa's Cameroon— specifically, Batufum *chefferies*, or meeting houses. It and the manor and

Figure 10.4

Nellie Mae Rowe's Yard, 1971

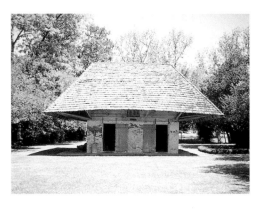

Figure 10.5

African House, c. 1798–1800,

Melrose Plantation

plantation houses are all that remain of the Metoyers who, shortly before the Civil War when political and economic instability began to plague the South, were reportedly evicted by local whites and dispersed.[16]

After fifty years of sales and title transfers, the Melrose Plantation was purchased in 1898 by the family of John and Carmelita "Cammie" Henry and is today preserved as a National Historic Landmark. For much of the twentieth century, until the Henrys sold Melrose in 1970, Clementine Hunter spent her life as their field hand, laundress, maid, nanny, seamstress, and cook, residing with her husband, Emmanuel, in a small cottage on the grounds. Hunter had come to Melrose from the Hidden Hill Plantation in Cloutierville, Louisiana, where she worked in the cotton fields with her six siblings and parents, Antoinette and Janvier Reuben, who were descended from French, Irish, Native American, and African ancestors—an archetypal Louisiana Creole mix. Clementine (nicknamed "TeeBay," short for *petite bébé*) was the eldest and, as such, benefited from a brief period of schooling from French-speaking nuns at a local Catholic academy.[17]

When Hunter was in her midteens, agricultural jobs became scarce in Cloutierville, and the Reuben family moved north, settling permanently

Figure 10.6

Clementine Hunter

Quilt, c. 1940

cotton fabric and thread on

paper, 45 x 39 1/2"

(114.3 x 100.33 cm)

on the Melrose farm as cotton, corn, and sugarcane harvesters. After her parents' deaths, Hunter "kept company" and had two children with an older man named Charlie Dupree, widely respected for his acumen as a mechanical engineer and maker of musical instruments. Dupree died in 1914 and, a decade later, the artist married Emmanuel Hunter, who also worked at Melrose, living with him on the grounds and raising three more children.[18]

Hunter had yet to realize her vocation as a painter, due to the strenuous demands of farm life and motherhood. She recalls picking nearly eighty pounds of cotton on the morning of the birth of one of her children and, after bearing the child, returning within a few short days to her work in the fields. When Hunter reached middle age, she was reassigned to full-time domestic service. In this capacity, her creativity found its first real outlets in the making of dolls, clothing, and quilts for the Henry children (fig. 10.6); the weaving of ornately conceived baskets; the sewing of intricate lace curtains; and the creation of recipes for family meals that, years later, became the subject of the venerable *Melrose Plantation Cookbook*, co-authored by Hunter and Melrose curator François Mignon. In part due to the acclamations of American expatriate author and chef Alice B. Toklas, Hunter's recipes were selected for inclusion in the register of the French Academy in Paris. In the 1940s, the Melrose Plantation had become something of an artists' colony, frequented by writers such as Toklas and William Faulkner, as well as by visual artists. Exposed to the creative element, and having access to art materials left behind by visiting painters, at about age fifty Hunter began to experiment with palette and brush.[19]

Over the next half century, Hunter documented the Cane River life that she knew so well. Her paintings portray scenes of "planting and harvesting, baptisms, weddings, funerals, people going to church, playing cards, fishing, and drinking on a Saturday night" (fig. 10.7).[20] Hunter's designs incorporate multiple ground planes and viewpoints and continuous narratives. Another hallmark of Hunter's style is her handling of the figures and forms that populate her paintings, which are composed of a few minimal building blocks—abridged icons that indicate clouds, hats, heads, torsos, limbs, trees, and cotton. Design factors such as balance, unity and variety, rhythm and repetition, and directional forces are each carefully considered in Hunter's narratives, as well as in her landscapes, floral still lifes, and abstractions (fig. 10.8).

Figure 10.7
Clementine Hunter
Saturday Night at the Honky Tonk, c. 1976
oil on canvas board, 17 x 23 1/4"
(43.18 x 59 cm)

Hunter's works first came to the attention of the public in 1946 when Mignon, who had befriended the artist a decade earlier, arranged for an informal exhibition of her paintings in a drugstore window. Mignon quickly became, along with writer James Register, one of Hunter's champions, and remained so until his death in 1980. Mignon, with what little spare income he had, gave Hunter art supplies and financial support and published dozens of articles on her work in his "Cane River Memo," a column that he wrote for the *Natchitoches Enterprise*. Hunter painted prolifically, completing thousands of works in her lifetime and exhausting her supplies often faster than Mignon could provide them. She likewise continued for many years to make quilts, dolls, and baskets, moving with ease between craft and high art designations. Hunter's creative energy flowed mostly at night, after her duties for the Henrys and for her aged and bedridden husband were fulfilled. One evening after midnight when Emmanuel advised Hunter to stop painting and get some sleep before she went crazy, the artist replied, "If I don't get this painting out of my head, I'll sure[ly] go crazy."[21]

Hunter's patron Register eventually left a position at Oklahoma University to move to Natchitoches permanently, having become enthralled both by the artist and by her Louisiana community. In the 1940s, he arranged for Hunter to receive grant funds to pursue her work, most notably a Rosenwald fellowship. He also encouraged her to experiment with abstraction (fig. 10.8). After only a brief period, however, Hunter returned to the figurative style she preferred, claiming that the abstractions "made her head sweat."[22] Nevertheless, even in later works such as *Big Sky*, echos of abstraction persist as in the upper portion of this painting (fig. 10.9). Mignon and Register worked vigorously to foster Hunter's creativity and to educate critics, museum curators, dealers, and collectors about the artist and her oeuvre.[23] While their devotion to Hunter was instrumental to her success, believers in the alleged purity of vernacular art took exception to the presence of these advocates in the artist's life on the grounds that such self-ordained agents invariably take advantage of their less-than-sophisticated artist-wards. This, however, mistakenly assumes a certain fatuity on the part of vernacular artists who have agreed to the artist-dealer or artist-patron arrangement, and it overlooks the conflicting opinion that the acquisition of patrons and dealers by more cosmopolitan artists adds to, rather than detracts from, their credibility.

Whatever their motives, Hunter's supporters were influential in securing an exhibition of the artist's paintings at the New Orleans Arts and Crafts

Show in 1949, which elicited positive critical responses and a lengthy review from columnist Carter Stevens, who commented that her entries were "the most exciting discovery of the show."[24] A few years later, in the mid-1950s, the Delgado Museum (now the New Orleans Museum of Art) chose Hunter for its first one-person exhibition of the works of an African-American artist. A second such show was mounted by Northwestern State College in Natchitoches, which was then a segregated institution. Hunter was permitted to view her paintings on display at Northwestern—but only after special arrangements could be made to bring her into the university's gallery when no white visitors were present.[25]

Figure 10.9
Clementine Hunter
Big Sky (Clouds), c. 1950
oil on artist's board,
29 1/2 x 29 1/2" (75 x 75 cm)

These two exhibitions, along with the completion of a historic mural project, secured for Hunter a permanent place in the annals of art history. The mural enterprise was undertaken at the suggestion of Mignon, who hoped to make the Melrose Plantation a permanent setting for Hunter's work. For the commission, Hunter designed a nine-panel opus (and additional smaller connecting panels) for the second-floor walls of African House (fig. 10.10). The subject of the mural was Hunter's favorite: Louisiana life. Working from master cartoons (sketches), Hunter, at age sixty-eight, designed what has been termed "the most colorful room in the Old South."[26] The various mural segments depict a plan of the Cane River area, cotton fields, farm workers, animals, folkloric narratives, washerwomen, pecan tree harvesters, and religious and secular events such as revival meetings, funeral processions, and honky-tonk patrons drinking, fighting, and "shooting craps."[27] The mural cycle attracts scores of annual visitors and provides an element of closure to the history of Melrose and to that of its one-time slave oubliette, African House.

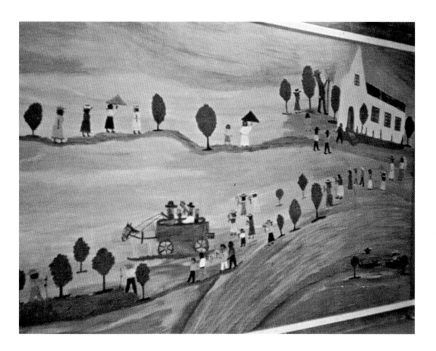

Figure 10.10
Clementine Hunter
African House Mural Panel
(St. Augustine Church on Cane
River), Melrose Plantation, 1956
oil on plywood

239

At the end of her life, Hunter purchased her own home about fifteen miles south of Natchitoches, where she continued to paint until well into her nineties. During this last stage of her life, Hunter favored religious scenes, although none from this period are so memorable as an earlier rendering of the crucifixion of a black Christ (c. 1960) (fig. 10.11). The composition portrays Hunter's own particular vision of Christ with broad hips, a reductive loincloth, and a crop of dark curls, whose blood trails like streamers from his wounds. The cross—eggshell white against a pastel ground—provides an ethereal, floating support for the bold, black figure of Christ, who is prayed over by Hunter's hieroglyphic seraph. Composed of four painted flanges—robes, two wings, and towering coiffure—Hunter's black angel is a trademark of her clerical imagery. Joy and life, as opposed to sorrow and death, are the implications of her narrative.

Early and midcareer paintings such as this one are considered to be Hunter's best. Like any great artist, she has her detractors, who find her later works "uneven" and "clumsy." The supposed "commercialization" of Hunter's latter compositions, which were sometimes painted to satisfy specific buyer requests, is believed to have reduced their quality. Nevertheless, as Robert Bishop, the one-time director of New York's Museum of American Folk Art, stated, "Every artist's work is uneven. Not every Rembrandt is a wonderful Rembrandt."[28] Few would argue that Hunter, who is today considered one of America's finest vernacular artists, produced more than her fair share of wonderful pictures.

The career trajectory of **Minnie Evans** (1892–1987) bears some comparison to that of Hunter. Born in North Carolina, Evans was descended from Caribbean slaves, the only child of farmers Joseph and Ella Kelley. Evans spent her youth in Wilmington, North Carolina, in the care of her grandmother and attended school through the sixth grade. Soon afterward, Evans began hawking shellfish for a living until, at age sixteen, she married Julius Evans and moved to the Pembroke Park estate at Wrightsville Beach in coastal North Carolina. The estate, where Evans worked as a domestic servant from 1918 to 1948, became the permanent home of the artist, her husband, and their three sons. Evans's duties at Pembroke Park initially monopolized her waking hours, but in 1948, after she was appointed gatekeeper of the estate's Arlie Gardens (a position she would hold until the mid-1970s), Evans found that the simple task of collecting admission fees to the gardens afforded her a great deal of leisure time. She quickly succumbed to the visual stimuli of the lush, flowering grounds at Arlie and began to render drawings of the vista before her each day.[29]

It has often been mentioned that a dream vision first aroused in Evans the painter's spirit and that this and similar visions provided fodder for her many compositions. According to Evans, on Good Friday 1935, a divine voice came to her in a dream and declared, "Why don't you draw or die?" The results were Evans's first two drawings—semi-abstract landscapes composed of recurrent linear patterns (fig. 10.12). The artist's own words, however, point equally to a more mindful stimulus for her creativity: "I've seen the most beautiful cities in the sky . . . cities of rainbow colors. . . . In mornings, I have laid up in my bed, looking out of the windows . . . and seen beautiful clouds. Rainbows come on those clouds. I sit and watch them."[30] By Evans's own account, her dreams were not entirely the dreams of sleep or of divine disclosure, but were also the conceptions of an active and creative mind.

Evans's early works, before 1948, were either abstract and diagrammatic or anthropomorphic and infused with organic energy. These works, however, were not yet suggestive of the influence that nature would ultimately have on her imagery (fig. 10.13). The artist's understanding of compositional structure, organic form, and color are nevertheless evident even at this stage. Evans's initial designs gave way in the late 1940s to the nature-inspired imagery for which she is best known; her style, however, retained the balance, rhythms, and vibrant pigments of her pre-1948 drawings. Evans's Arlie Gardens pictures, for example, are prized for their intricacy, incandescent colors, frontality, symmetry (on the order of a kaleidoscope),

Figure 10.12

Minnie Evans

My Very First (top), 1935

ink on paper,

5 1/2 x 7 7/8" (13.97 x 20 cm);

My Second (bottom), 1935

5 3/4 x 5 7/8" (14.61 x 19.37 cm)

Whitney Museum of American
Art, New York. Gift of Dorothea
M. and Isadore Silverman
75.8. 1/2. Courtesy of Luise Ross,
Luise Ross Gallery, New York

Figure 10.13

Minnie Evans

Untitled (Abstract Shape),

G #156, 1944–1945

graphite and wax crayon on

paper, 12 x 9" (30.5 x 22.9 cm)

and illusory nature, which links Evans (as is the case with many vernacular artists) to the surrealists (fig. 10.14). The flora that fill Evans's surreal compositions serve as both environment and adornment for the tranquil human characters that inhabit her imaginary worlds, and whose faces resemble the courtly personages of Egyptian wall paintings. Her iconography is equally recondite. According to Evans, her designs circumscribe an antediluvian world, where humans, animals, flowers, and trees are part of a seamless and cohesive reality. Evans's rainbow palette intentionally signifies the rainbow that God placed in the heavens after the biblical flood, and the recurrent motif of disembodied eyes further suggests God's omnipresence in the artist's nirvana.[31]

Evans's art was heightened by a visit in 1966 to the Metropolitan Museum of Art. Thereafter, her work featured increased picture size, an intensified complexity of composition, and the incorporation of collage. Other influences on the artist's works were the floral and organically abstract motifs of Chinese and Persian carpet design, and Asian and European porcelain and flatware patterns to which Evans had access at Pembroke. Indeed, her works have impressed scholars as so comprehensive in their visual and contextual derivations that sources as disparate as Buddhist, Yoruba, and Jaina religions and Indian, African, and Jungian philosophy have been inferred from her imagery.[32]

Evans found a staunch advocate in Nina Howell Starr, a former photography student from the University of Florida, who learned of Evans's work in 1962. After relocating to New York, Starr served as an unpaid agent for the artist, writing and publishing about Evans's art and securing exhibitions for her. Starr's committed sponsorship, coupled with Evans's aesthetic endowments, ultimately led to major museum exhibitions, as well as to purchases by such prestigious institutions and individuals as the Smithsonian and

Figure 10.14
Minnie Evans
Design Made at Arlie Gardens,
1967
oil and mixed media on canvas
mounted on paper board,
19 7/8 x 23 7/8" (50 x 60 cm)

Jean Dubuffet. A 1969 *Newsweek* article brought national fame to Evans who, in 1974, retired from her job at Arlie Gardens and painted and lived for another fourteen years with her son in Wilmington.[33]

The art of Nellie Mae Rowe has come to light more recently than that of Hunter and Evans. She began as a doll- and quiltmaker, learning these crafts as a child and, by the time she reached her teens, she had become an accomplished artist. Rowe credited her love of art to the encouragement of her father, ex-slave Sam Williams, who was an enterprising cotton, vegetable, and fruit farmer, as well as a blacksmith and basket weaver, and to her mother, Luella Swanson Williams, who was a quilt- and dressmaker. Rowe first had the occasion to explore the profundity of her artistic gifts a few years after the 1948 death of her second husband, an elderly widower named Henry "Buddy" Rowe. Until that time, she had been fully engaged, first as a child field worker with her nine siblings in Fayetteville, Georgia; later as a wife and homemaker; and finally as a domestic employee.[34]

When Rowe was in her sixties, she decided to create an installation of yard art at her home in Vinings, Georgia, placing made and found objects on public display in her garden (fig. 10.4). Included in her "playhouse" were quilts and life-sized dolls, chewing gum sculptures, stuffed animals, drawings, Christmas ornaments, plastic toys, and other cherished objects that decorated the artist's fence, clothesline, and trees. Rowe even trimmed her hedges topiary-style in the shapes of animals such as sheep, birds, and pachyderms. Due to its proximity to a main thoroughfare and to the governor's mansion, it was not long before Rowe's installation came to the attention of the art-buying public. With the help of art dealer Judith Alexander, Rowe benefited from a great deal of critical exposure, exhibitions, and an ever-growing patron base.[35]

Once having commenced her work as an artist, Rowe immersed herself in the enterprise. Art making offered her a release from the daily grind of housekeeping (work which she continued to do well into the 1970s). Rowe's two-dimensional designs, particularly those of the 1960s and early 1970s, are extremely reductive, consisting of austere line drawings of single figures. Her later painting style, however, is rich with pattern and detail, for example, her 1978 drawing *Cow Jump over the Mone* [*sic*], which displays elaborate tessellation and hatching, an all-over arrangement of vegetation and wildlife, and a central figure—the artist in the role of the cow (Rowe favored the conflation of human and animal forms in her work) (fig. 10.15). Her use of undulating linear rhythms and organic decorative motifs results in an almost art nouveau ambience for which the artist is renowned. The large static forms in the lower left region of this composition are aptly balanced by the frenetic drawing and smaller elements that

fill the upper right quadrant, countering flora and fauna in two distinctly constructed spaces.[36]

As subject matter, Rowe wove the stuff of everyday life—scenes such as picking cotton, washing clothes, and making soap—into a tapestry of droll and high-spirited caprice. Consistent with her Christian devotion, Rowe credited God with bestowing upon her such expansive artistic talents, but she chose not to represent specifically prophetic or ecclesiastical imagery in her works. Instead, Rowe's creations offer Chagall-like fantasies and environments that also evoke painted apparitions such as Van Gogh's *Starry Night*. To enhance their meanings, Rowe often incorporated written proverbs, song lyrics, and quotations into her compositions, recalling the *tanka* paintings of Ringgold.[37] Rowe's sculptures are as surrealistic in flavor as her paintings. Sculptural works incorporate such unorthodox materials as human hair, rhinestones, pearls, marbles, and ribbons, as well as the aforementioned chewing gum, which substituted for clay. In their macabre appearances, certain of Rowe's sculptures resemble nineteenth-century Afro-Carolinian face vessels common to the Edgefield district of South Carolina near the Georgia border (and elsewhere) (fig. 10.16).[38]

Sadly, Rowe was diagnosed with terminal cancer in 1981 and died soon after. Rowe reacted to the news of her illness by raising the stakes of her creativity. In her last year, "her vision, ambition, skill, and the complexity of her work expanded considerably."[39] Rowe's last paintings proliferate with symbols of her own mortality, such as cliff edges, demonic figures,

trees of life, hand prints, and empty chairs, which signify her passing, and with self-referential animals coupled with phrases like "I Am Worrie[d]," "I Might Not Come Back," and I'm [on] the Wrong Road"— words that express the artist's state of mind. *Brown Mule* is a fatalistic narrative infused with unexpected spiritual optimism (fig. 10.17). A smiling mule gazes down upon a distorted dark figure whose only clearly recognizable human trait is a listless hand. This "dying" figure, representative of the artist's impending death, appears reified in the vigorously articulated form of the mule—a metaphor for Rowe's immortal spirit.[40]

Shortly before her death, Rowe was invited by First Lady Nancy Reagan to produce a Christmas card for the White House. The artist declined the commission, presumably due to her poor health, but she admitted to a friend that she was not enthusiastic about designing a holiday greeting that would be shared with few, if any, African Americans and certainly none who were poor or disadvantaged, as she had been for most of her life. While many in Rowe's audience might take pleasure in imagining her as a social naïf, plainly she was not. She intended her art to be shared with the black community, and she articulated that her paramount gift was the ability to "make something out of nothing"—an apt metaphor for her own evolution from dire and humble beginnings to distinguished stature as a revered artist.[41]

New Orleans evangelist preacher **Sister Gertrude Morgan** (1900–1980), like Evans and Rowe, attributed her talents to the Lord. Her paintings arose from her profound spirituality and from her involvement in the Baptist

Figure 10.16
Nellie Mae Rowe
Two-Faced Head (back), 1980
chewing gum, bottle cap,
costume jewelry, ceramic tile,
ribbon, artificial hair, marbles,
acrylic paint, 5 1/4 x 4 3/4 x 5 1/2"
(13.3 x 12 x 14 cm)

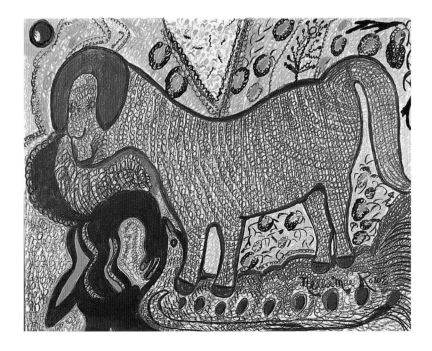

Figure 10.17
Nellie Mae Rowe
Untitled (Brown Mule), c. 1979
crayon and graphite on paper,
18 x 23 1/2" (46 x 60 cm)

church. In fact, Morgan initially utilized her paintings, drawings, and modified "ready-mades" as missionary teaching tools and as barter to help support the Everlasting Gospel Mission that she sponsored in New Orleans. Born in Lafayette, Alabama, Morgan spent her formative years in Columbus, Georgia, almost simultaneously with Alma Thomas, whose family left the town for Washington, D.C., in 1906 in order to, among other things, provide Thomas with the higher education that eluded Morgan. Eventually, Morgan moved on as well, first to Montgomery and then to Mobile, Alabama, finally settling in New Orleans in the late 1930s.[42]

Not only an artist but also a shrewd businesswoman, Morgan and two partners purchased in the early 1940s the real estate necessary to build a modest mission and childcare center. Twenty years later, after a hurricane destroyed the property, Morgan rented another building to house her new Everlasting Gospel Mission. At this time, coincident with the adoption of a persona as "prophetess and bride of Christ," Morgan began to paint seriously. In her newly conceived role as a prescient, she followed the tradition of Catholic nuns and dressed in a habit of white (frock, hat, and shoes) and decorated most of her home and furnishings to match.[43] Her paintings were far more vivid, however, integrating a palette of intense colors, including bright blues, greens, and reds.

Morgan utilized a variety of media—pencils, pastels, crayons, pen and ink, acrylic, gouache, and watercolor paints—and she applied her materials to whatever surfaces were at hand, including cardboard, wallpaper, window shades, fans, glass and ceramic objects, and even her guitar case (Morgan was also a gifted musician and singer). As subject matter, she chose to illus-

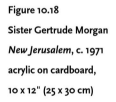

Figure 10.18

Sister Gertrude Morgan

New Jerusalem, c. 1971

acrylic on cardboard,

10 x 12" (25 x 30 cm)

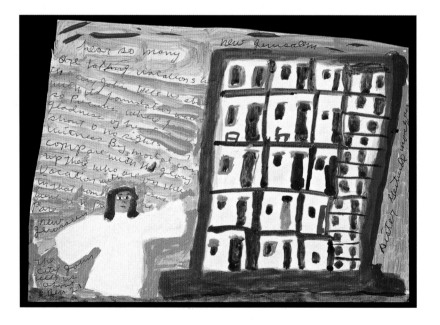

trate scenes from Scripture, often accompanied by written biblical passages as in *New Jerusalem*, which is inscribed with a commentary on Revelations chapter 21 (fig. 10.18). Her imagery oscillates between narrative tableaux and signboards augmented by brown- and pink-skinned seraphs who hover ghostlike near the picture's surface.[44] Morgan, whose life and art awaits more comprehensive inspection, merged her two greatest passions, religion and art, in a way that harks back to a premodern era.

Sculptor **Bessie Harvey** (1929–1994) ascribed her talent in a Nietzschean sense, to the God within her. According to Harvey, God and art are one and the same, and she cites as proof a reference in the Lord's prayer to "Our Father, who *art . . .*" In fact, as early as the thirteenth century, God was portrayed in European paintings as an architect who created the universe just as an artist creates sculpture, and Harvey subscribed to this interpretation of her Maker, "the Creator of all things" who deigned to make Harvey "a little creator . . . like he is. . . . I am the sculptress that God has taught me to be."[45] Born in the Georgia countryside, Harvey was raised along with twelve siblings in grim poverty by an alcoholic and somewhat dispassionate mother (her father was deceased). Harvey developed a resourceful form of self-nurturing in which she placed God in the role of artist-parent—an unseen but ever-present champion who manifested himself in the artist's natural surroundings.[46]

Harvey saw nature and the spirit as contiguous and as sources of "peace, joy, happiness, prosperity, [and] healing," and her works reflect an appreciation for both the physical and the metaphysical universes.[47] Harvey derived her materials from the physical world of nature—mostly firewood—and her ideas from the metaphysical domain of religion and the Bible, which she had learned to read by the fourth grade, when her schooling ended. Thus, the focus of many of her works is religious—though not always biblical, such as in *Voodoo Queen*, which illustrates, through a surrealistic treatment of color and form, a bejeweled and bizarre priestess with pink feathers for hair (fig. 10.19).[48] An example of her treatment of a biblical subject can be seen in *Black Horse of Revelation*—an eerily animated rearing horse and rider (fig. 10.20). In this work, Harvey has painted and altered with chain, beads, and fiber an existing piece of wood, transforming it into an apocalyptic vision.

Harvey, who married at age fourteen, mothered eleven children. According to the artist, during her childrearing

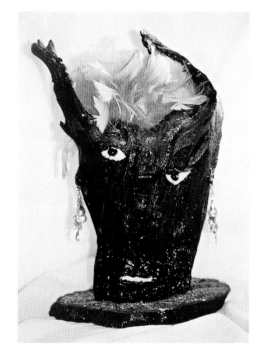

Figure 10.19

Bessie Harvey

Voodoo Queen, c. 1980s

found wood, paint, beads,

feathers, metal earrings,

14" h (35.5 cm)

years, she "was little better than an animal trying to scrape together food and shelter" for her family. As far as Harvey was concerned, she "didn't really become human until [her] youngest was half-grown," at which point art making became a redemptive form of self-avowal for Harvey.[49] Beginning in 1972, Harvey began to create her "little people" (the artist's term for her sculptures) out of tree branches and kindling that she found near her home (fig. 10.21). The search for materials was a critical part of the creative process for Harvey. She had an ability to see her figures straining to be released from the confines of the raw material. As Harvey explained, "You can go into the wood pile and all at once you see a face . . . just asking for help, help to come out."[50]

Into her sculptures, Harvey inculcated spectral companions whom she recognized as ancestral spirits. With them she shared her thoughts, pondered life's great and small questions, and resolved day-to-day problems. Because Harvey believed so completely in the incarnate properties of her little people (who were undoubtedly miniature extensions of herself), some speculated that her creations were variations on the theme of the "voodoo doll." As Harvey well knew, however, such opinions arose from a general misunderstanding of Vodou practice which, in Harvey's words, "is a religion and it's not evil."[51] Despite popular speculation to the contrary, Vodou is a benign and tolerant compendium of beliefs with its roots in venerable

Figure 10.20

Bessie Harvey

Black Horse of Revelations,
c. 1985

polychromed wood, mixed
media, 57 x 44 x 9"
(144.8 x 111.8 x 22.9 cm)

West African creeds, and completely unrelated to "black magic."[52] Harvey's c. 1980 *The World* (fig. 10.21) is an exemplar of the works that so intrigue and even alarm a segment of her audience. Seemingly animate right down to their hair and teeth, Harvey's figures radiate life, in large part due to the fact that they are the organic outgrowths of a once-living tree. *The World* reveals Harvey's conceptual facility, refined sense of color, doll-making skills, and creative whimsy. From bits of cloth, wood, paint, and ready-made materials, she fashioned a work of art that combines performance (on the order of a puppet show), sculpture, painting, and assemblage. The effect is quintessentially contemporary.

In the years prior to her death in 1994, Harvey made her home in Alcoa, Tennessee, supporting herself as a doll maker. Like so many vernacular artists, she has emerged as a folksy eccentric, a social recluse, and a religious visionary. This terminology, however, might just as well be applied to a score of Western artists from Bosch to Gauguin, whose art did not suffer from exclusion from the mainstream as a result of its visionary nature and whose reclusiveness or eccentricity was understood as an inherent part of artistic genius. As scholar Jenifer Borum justly claims, vernacular masters like Harvey are neither saints nor visionaries, but rather accomplished artists whose works have yet to receive the serious critical attention they deserve.[53]

If vernacular artists, to paraphrase philosopher Arthur C. Danto, live in "worlds unto themselves" and make art for no one but themselves, if they are oblivious to their own profession and its ramifications, then no such artists have been discussed here.[54] Paul Arnett successfully argues that, for vernacular artists, "there is rarely 'a world of one's own': a human interaction, a transaction of perceptions, is almost always there."[55] Even if one conceded that vernacular artists harbor a certain guilelessness at the outset of their careers, a sense of locality within art history inevitably settles upon any artist who, over time, develops a national reputation.[56] These not-so-naïve folks know full well the significance of the art market. Indeed, as early as 1963, Hunter's Melrose cottage bore a sign that read "Clementine Hunter—Artist, 25¢ a look," and Evans sold her works to tourists who visited Arlie Gardens long before she came to the attention of the art world.[57]

Figure 10.21

Bessie Harvey (1929–1994, Alcoa, Tennessee)

The World, c. 1980s–1990s

polychromed wood, glass and plaster beads, hair, fabric, glitter, sequins, shell, duct tape,

53 x 38 x 28"

(134.6 x 96.5 x 71.1 cm)

Collection of American Folk Art Museum, New York. Blanchard-Hill Collection, gift of M. Anne Hill and Edward V. Blanchard, Jr. 1998.10.26

As demonstrated by the rise of conceptualism and vernacular art, the modernist impulses of the early and mid-twentieth century gave way in the 1970s to a wave of postmodern diversity and empiricism. Increases in the Asian, Latino, and black middle-class populations, and the relegation of whites to minority status in major U.S. cities, resulted in an outpouring of interest in cultural and aesthetic pluralism. By the 1990s, a deflated art market added to these developments, and dealers who had nothing to lose and everything to gain by opening their doors to minority artists did precisely that. Art historians, educators, critics, and curators of color—the products of educational desegregation, curricular changes, and the art world protests that took place in the 1960s and 1970s—were now represented in the art establishment, and their ranks began to erode the covert, liberal racism that had for so long infected the art community. Along with these changes came radical experiments in materials, venues, and ideas that had seldom, if ever, before been considered suitable for high art. Postmodern artists, who comprised an exceedingly diverse population, employed all manner of innovative media to critique the concept of difference through art, and they confounded the once clear-cut boundaries between life and art, arts and crafts, object and environment.[1]

As a catchword, *postmodernism* resists classification almost as much as the art to which it refers. Despite widespread use of the term in literary arenas since the 1970s, its application to the visual arts has been inconsistent and equivocal. As a concept, postmodernism, according to David Driskell, "lacks a single inclusive definition" and cannot be associated with a definitive style. At the most basic level, the term is a chronological signifier, defining art produced since the 1960s, when formalism (the study of artistic styles based upon differences in visual form) was replaced by revisionism (such as feminism) as an art historical approach, and when the preeminence of painting and sculpture succumbed to unconventional media.[2]

ELEVEN **Postmodern Pluralism**

From a less rudimentary standpoint, postmodernism is a response to and an implementation of semiotic theories that examine multiple implications of a verbal or visual "text" (such as a work of art); these alternate corollaries can often refute the work's apparent meaning. A postmodern analysis of a female nude, for example, might consider such an image to be both an homage to feminine beauty and a marker of patriarchy and misogyny. Postmodernism also espouses the idea that the meaning of a text or work of art is "constructed" and is subject to infinite interpretations— "a chameleon, with no basis in lived reality."[3]

To clarify, a standard modernist reading of Picasso's *Les Demoiselles* might identify the semiotic "sign" (the painting itself) as an image of five nude prostitutes, and the "signifier" (that which the painting represents) as a memento mori (a reminder of death and the ephemeral nature of corporeal pleasures) and as a milestone work of modernist abstraction (fig. 1.20). On the other hand, a postmodern assessment of the same work both challenges its explicit significance and offers an inexhaustible number of surrogate possibilities. As articulated by art historian Ann Gibson, such an assessment would allow for

> meaning to be reassigned again and again, and the physical object [the painting] may carry more than one of these meanings, old and new, at the same time. Thus it is impossible to say which is the "true" meaning. In fact, in postmodern thinking, it is when several meanings are read in the same work or object so that they may resonate and clash, that the actual nature of the production of meaning is most evident.[4]

Accordingly, a postmodernist critic would be free to read *Les Demoiselles* as a breakthrough precubist picture; as a reflection of male aggression, racism, and misogyny; as an image of female empowerment; as a symbolist or Late Rose Period composition; as an homage to African sculpture; and so on. In postmodern ontology, any of these interpretations is plausible, and the "true" gist of the picture lies in one's grasp of the rapport among all of its disparate significations.

Postmodernism also debunks long-standing assumptions about the existence of one true ethnic, racial, cultural, or gender identity, to which all others should defer. As art theorist Christopher Reed opined, postmodernism "challenges formalist [modernist] beliefs in a transcendent or universal art that just happens to have been created overwhelmingly by and for a specific demographic group: white, Western, apparently heterosexual men of the upper middle class."[5] In parsing the hierarchies of modernist aesthetics, postmodernism critiques the ascendancy of the white male

masters of the (art) universe. The monolith of modernism, which is associated temporally and ideologically with colonialism, was thus destabilized during the postmodern/postcolonial era of cultural politics.

According to theorist Thomas McEvilley, "Modernism—let's describe it loosely as the ideology behind European colonialism and imperialism—involved a conviction that all cultures would ultimately be united, because they would all be Westernized." Alternatively, postmodernism posited that cultural difference and Western homogeneity could "contain and maintain one another."[6] For African Americans, the problem with this hypothesis is that it suggests a circumstance of social parity that has not yet taken conclusive shape. Postmodernism might more accurately be described as "late modernism," since the chain of command associated with modernist aesthetics (Eurocentric male art, rigid linear art history, and hermetic institutions that value form over content) is, to a great extent, still in place.[7]

Another drawback in correlating the postmodern idiom to African-American art concerns the fact that, to varying degrees, artists of African descent have long been hostile to the formalist principles of modernism, preferring instead to assert ideological substance and cultural identity in their work. Even during the era of modernism, much African-American art was already postmodern. For that reason, artist and historian David Driskell has argued that, while postmodernism is certainly a "revision of Eurocentric global hegemony," it is primarily "a civil war between the Eurocentric past and its present" and only indirectly related to African-American aesthetics. Others have suggested that the very particularized political and social agendas of many African-American works of art do not lend themselves to infinite semiotic readings and, as such, cannot properly be examined from a postmodern perspective. Whatever one's take is on these mostly undeterminable questions, it is certain that postmodernism has cleared the way for new theoretical and visual paradigms. As a doctrine, it challenges the inflexible programs of modernism and at the same time elevates difference over conformity. Owing to this reinforcement of cultural pluralism, artists of African descent have become a force to be reckoned with on the postmodern American art scene.[8]

Within this pluralistic context, women artists of color have successfully found access to the mainstream art world. Furthermore, they have demanded the right to express themselves in virtually any manner they choose, as well as the right to question the premises of art making and, indeed, the very nature of art. The generation of women artists of color who helped to chart this new frontier are the inheritors of the Black Power and women's movements. They have reaped the benefits of waning racial and gender-based discrimination, yet they continue to grapple with the

considerable vestiges of these biases that refuse to give way.[9] Accordingly, their art, while diverse in form and content, shares a common thread of concern for the well-being of women and people of color and for the pressing issues that affect them.

The eclectic mien of postmodern art ranges from recondite installations to vernacular-style painting and sculpture, from multimedia assemblages to various forms of craft work such as tapestry weaving, jewelry making, and fashion design. **Xenobia Bailey** (b. 1956) is an exponent of the latter. Using crochet, beadwork, and embroidery and capitalizing on her own superior color sense and sculptural abilities, Bailey produces raiment that traverses the art-craft divide with astounding agility (fig. 11.1). Her hats, outerwear, wall pieces, and figures (inspired by African ceremonial adornment, Afro-Caribbean *mas* costumes, and African-American funk music) are scintillating hybrids of fashion design, millinery art, beading, and sculpture. Bailey began her professional career as a costume designer in community theater. After moving to the East Coast from her native Seattle under the auspices of a national organization of women of color (the Links) and the Benefit Guild of Seattle, Bailey studied industrial design at Pratt Institute and fine arts at the Maryland Institute College of Art.[10]

Bailey's gift is her ability to subsume the characteristics of fine arts into her more commercial "wearable art." This ability has resulted in costume design assignments with television's "The Cosby Show" and "A Different World," and with Spike Lee's movie *Do the Right Thing*. Later in her career, Bailey introduced performance into her repertoire, as well as large-scale, shaped-fabric sculptures evocative of the works of hard-edge abstractionist Frank Stella. These later works by Bailey (featured in a 2003 "Absolut Bailey" ad for Absolut vodka) are configured of dazzling concentric forms and constitute sculpture, painting, and craft combined (fig. 11.2). Bailey identifies her artistic goal as the advancement of "an aesthetic that would have been created if there hadn't been the trauma of slavery."[11] Bailey sees her art as the extension of an interrupted continuum—a path that might have been taken by women of African descent if they had been permitted to fully develop their own distinctive design skills over the past 400 years.[12]

Figure 11.1

Xenobia Bailey

Mojo Medicine Hat (Wind), 1999

23" circumference at rim, 4-ply acrylic and cotton yarn, hand-crocheted, single stitch, hand-sculpted, shaped, and sized with lacquer

Figure 11.2

Xenobia Bailey

Trilogy, 2000

4-ply acrylic and cotton yarn,

plastic pony beads, hand-

crocheted, single stitch, attached

with embroidery stitches and

cotton canvas backing, 8 x 7'

(2.43 x 2.13 m)

One of the contingent of fiber artists, **Carol Ann Carter** (b. 1947) received her training at Purdue University's Herron School of Art and the University of Notre Dame. A 1984 sojourn to Nigeria to study the weaving techniques of Hansa men shifted her creative drives permanently to the arena of textile design. Since that time, Carter has dedicated herself to developing a creative language that fuses traditional African cloth-making and dyeing methods with African-American quilting, abstract painting, and intaglio printing. Her works, such as *Living Room: Garment Apron on Her Chair* (1994), confound artistic conventions, gender-based craft practices, and media expectations to create genuinely catholic objects, assemblages, and installations that are visually, texturally, and genealogically diverse (fig. 11.3).[13]

Carter's materials include raw silk, canvas, cotton, fur, and found segments of carpeting and plush drapery. To these, she adds beads, buttons, shells, sequins, plastic flowers, costume jewelry, wire, and pigment—in other words, anything that suits her aesthetic eye and sensibilities. Carter's method of choosing and organizing her pieces and installations (as well as her performances) is painstaking and methodical. Her assiduousness is evident in *Living Room*, which invites audiences into a meticulously orchestrated, serenely picturesque space that offers a lived-in alternative to the sterility of the museum gallery. Its collection of lavish fabrics, carpeting, and ornaments undercuts the authority of high art, as does the minimalist-inspired industrial environment in which *Living Room* is installed.[14]

Figure 11.3
Carol Ann Carter
*Living Room: Garment Apron
on Her Chair* (detail of
installation with shelf by
Lisa Olson), 1994
mixed-media installation

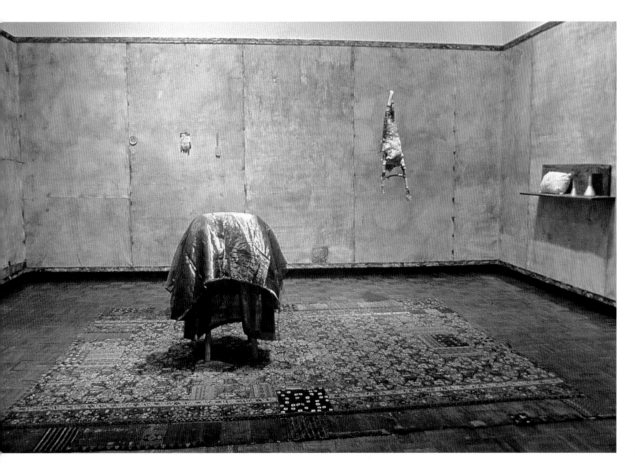

In addition to fabric art, ceramics took on new import during the postmodern era. In 1976 and 1977, after completing a B.F.A. in crafts at the Philadelphia College of Art (1971) and an M.F.A. in ceramics at Howard University (1974), **Winifred Owens-Hart** (b. 1949) journeyed to the Nigerian town of Ipetu-modu to study traditional pottery-making methods with Yoruba women masters. Having first visited Nigeria as a representative to FESTAC (the Festival of Arts and Culture), Owens-Hart was overwhelmed by her initial exposure to African culture and to its colors, sights, and sounds, which raised her cultural consciousness to an unprecedented level and attuned her to the need for positive representations of blackness that corresponded more closely with the reality she had discovered in Africa. Thanks to the sponsorship of the National Endowment for the Arts (NEA), Owens-Hart was able to make repeated trips to Ipetumodu in the 1970s. Within the cooperative environment of an adobe *ebu*, or workshop, and using simple tools, such as bamboo logs to fire pots and wooden pestles to pound clay, the artist spent her time in Ipetumodu enhancing her skills.[15]

The Ipetumodu encounter was reciprocal in that Owens-Hart shared her own ceramic-making techniques with the potters in the workshop and with the students at Nigeria's Awolowo University. Her experience was a fruitful one in which she reestablished a connection with her African aesthetic heritage and, in an impressive effort to spread the wealth, Owens-Hart spent the next two decades disseminating what she had learned to scholars and ceramicists in the United States. As an art professor, she taught the low-tech but highly developed forming and firing methods of Ipetumodu to her students at Howard University. As a scholar, she published on the specific practices of Nigerian ceramicists; and as an artist, she created hand-thrown objects that were neither earthenware nor sculpture, but an amalgamation of both, as is the case with *Life Is A Beach . . . Howard Beach* (c. 1988), which reveals the range of Owens-Hart's aptitude and thematic interests (fig. 11.4).[16]

Life Is a Beach comprises an expertly formed ovoid, deftly modeled human features, and topical narrative, resulting in an inimitable blend of African and American aesthetics. The work portrays the pained witness of a hate crime that took place in the predominantly white community of Howard Beach in New York City during the summer of 1986. Michael Griffiths, one of three black men accosted by a group of whites, was chased onto

a highway and killed by an oncoming vehicle. Though the residents of Howard Beach were quick to tell the media that theirs was not a racist enclave, the brutality of the assault outraged the African-American community and served as a reminder, yet again, that racial prejudice was alive and well. In articulating her thoughts on the attack, Owens-Hart stated:

> Historically, the North has been a safe haven for Americans of African descent . . . when, in actuality, places like Boston and New York have the most racist attitudes of all. What struck me most about this incident is that as we're moving into the twenty-first century, this crap is still happening. What happened to that man was akin to a lynch mob.[17]

Figure 11.5

Winifred Owens-Hart

Trimesters, 1990

clay, 63 x 18 x 24"

(160 x 45.72 x 61 cm)

The incident moved Owens-Hart to articulate her rage and disgust in a work of art that is a fitting commentary on the persistence of race hatred in America's northern urban centers.

Predominant in the orbicular design of this sculpture is a grimacing face with a furrowed brow, gaping mouth, and red, white, and blue tears coursing like streamers from its tightly closed eyelids. The unseeing apparition shrieks in horror and is loath to witness the imminent collision that is being played out along the upper radius of the sculpture. The impeccable realism of the anguished portrait (modeled on the artist's own features) contrasts acutely with the cartoon cutout of a running black man and the automobile that menaces him. The hood of the car is transformed into a veritable shark's jaw that extends to devour its victim. Inside the vehicle, three sets of jagged teeth snicker gleefully. The near-irreconcilable relationship between graphic animation and portraiture in *Life Is a Beach* is akin to the polarity between the objective journalistic reports of the episode that proliferated in its aftermath and the depth of the distress felt by a horrified local and national citizenry.

Much of Owens-Hart's subject matter is an aggregate of "experienced and empathized" motifs. *Trimesters* (1990) is an exemplar of the former, a self-referential commemoration of the birth of Owens-Hart's daughter (fig. 11.5).[18] Constructed from six discreet clay fragments that are aligned vertically with increasing intervals

Figure 11.6

René Magritte

Delusions of Grandeur II (La Folie des Grandeurs II), 1948

oil on canvas, 39 1/8 x 32 1/8"

(99 x 81.3 cm)

between them, the work portrays a nude and pregnant body of a type seldom witnessed in the fine arts. Depicted are two hands holding a water jar, two bands of blue water, and three representations of a woman's abdominal and pubic areas. In the fourth and fifth segments, the figure's hands cup and caress her abdomen in a gesture of self-veneration. Evident in Owens-Hart's treatment of the brown skin, pubis, and swelling stomach is an understanding that black female nudity is natural and beautiful. The reference to water in this piece has multiple allusions. It suggests the moment when a pregnant mother's "water breaks"; it implies the amniotic fluid in which the unborn child "swims"; and it refers to the artist's creative endeavors as a ceramicist who uses water as a vehicle to mold clay. Owens-Hart also relates the creative process of making sculpture to the biological process of making a child by placing two hands on the water jar as if to shape it, and by placing the same hands (darker and illuminated by glaze) on the figure's abdomen.

Trimesters bears comparison to the 1948 painting *La Folie des Grandeurs II* by Belgian surrealist René Magritte (fig. 11.6). The two works share a similar subject—the headless and limbless torso of a nude woman and the modular configuration of her body. The similarities, however, end here. The discrepancies between the two works are enlightening and encapsulate the contradictions between images of women created by women and those conceived by men. Magritte (as has long been the common practice in Western representations of the nude) idealized his figure by painting a relatively flawless skin surface and by eliminating any evidence of body hair. The skin of Owens-Hart's figure exhibits creases, folds, depressions, and uneven coloring, and the pubic hair is not only evident but emphasized by the use of glaze.

In his *Image of the Black in Western Art*, Hugh Honour explains that standard representations of the female nude are "deprived of pubic hair" because men recognize hair "as the first symptom of their own sexuality." In denuding the female body, an artist denies the presence of active sexual prowess and empowerment and returns the woman to a prepubescent state. "This denial of female sexuality," states Honour, "is paralleled by the denial of virility in images of black [slave men], eunuchs, or literally dead men," which allows viewers to construct an image of both women and blacks as powerless.[19] In light of these observations, Owens-Hart's rendering of a dark area of pubic hair can be construed as an insistence on the power of her own maternal sexuality. Finally, Magritte's title, which can be

translated as "Delusions of Grandeur," suggests that the wonder and beauty of a woman's body is, in fact, a fallacy—the converse of the positive symbolism of Owens-Hart's sculpture. *Trimesters* and *Life Is a Beach* demonstrate the substance and dynamism of the artist's works, which have earned her countless accolades and both national and international exhibition credits.[20]

The art of **Joyce J. Scott** (b. 1948) is informed by an expansive interest in global cultures, signaled by the sculpture *Buddha Supports Shiva Awakening the Races* (1993) (fig. 11.7).[21] A figurative hybrid of fine art and craft, this dynamic invention portrays the head and broad, dark shoulders of a Buddha holding aloft the Hindu avatar Nataraja, or Shiva as Lord of the Dance. Though the pose of Nataraja corresponds to the configuration of classic Hindu statuary, Scott's account of the work's symbolism suggests more broad-based allusions: "The Buddha is contemplative, knowing. Shiva is much more active. In his hands he holds an egg impregnated by a sperm. This combination represents the four ethnic destinations: Europe, Asia, Africa, and the Americas."[22] By replacing the traditional drum of creation and flame of destruction, normally held in the hands of Shiva, with an egg and sperm, Scott has universalized the meaning of these otherwise explicit religious icons. Furthermore, her deliberate obfuscation of the distinction between Buddhism and Hinduism has occasioned a work of art that is indisputably pluralistic.

Other Scott works engage racial themes. In particular, she has demonstrated an idée fixe for watermelon as an index of black stereotyping. An entire series of Scott's constructions focus on this icon and feature such facetious titles as *Aunt Jemelon* (a reference to Aunt Jemima), *Venus de Melon* (a parody of the classic Greek *Venus de Milo*), and *P-Melon #1*, A 1995 blown-glass construction of anthropoid and vegetal components (fig. 11.8). Blooming from several leafy layers of pink, green, and white glass and beads, *P-Melon* offers a forlorn brown countenance encircled by a collar etched with the words "so juicy." In form and allegory, the structure refers to the literal fruit of watermelon as a racial prosaicism as well as to feminine or vaginal "fruit," the latter of which is emphasized by the sculpture's enlarged pink lips. Scott's works of this type, which are at once comic

Figure 11.7

Joyce J. Scott

Buddha Supports Shiva

Awakening the Races, 1993

sculpture with fabric, beads,

thread, wire, and mixed media,

15 x 14 x 6"

(38.1 x 35.56 x 15.24 cm)

Figure 11.8

Joyce J. Scott

P-Melon #1, 1995

glass beads and blown glass,

11 x 14 x 8"

(28 x 35.56 x 20.32 cm)

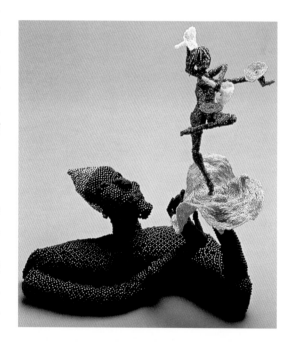

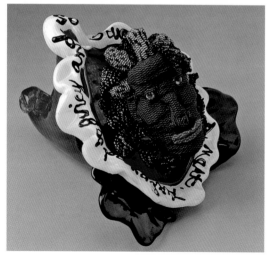

and tragic, "illustrate her belief that stereotypes can set you free and clarify your perception of yourself and your world."[23]

Scott, who was born in Baltimore, hails from a creative Carolina family of blacksmiths, basket weavers, and canoe builders. Her mother, with whom the artist has collaborated on several projects, is the admired fiber artist Elizabeth Scott, known for her innovations in appliqué and embroidery. The exquisite craftsmanship and aesthetic ingenuity of the works of Joyce Scott, who trained at the Maryland Institute College of Art and the Instituto Allende in Mexico, were honored in a solo exhibit held at the Baltimore Museum of Art (2000)—one of more than sixty exhibitions to the artist's credit.[24] Scott's investigations of craft as high art and her hard-hitting subject matter—which includes lynching, apartheid, domestic violence, and cultural imperialism—have earned her a privileged place in the postmodern firmament.

A cursory read of the prose of installation and assemblage artist **Renée Stout** (b. 1958) provides a ready insight into the level of her skill as a wordsmith:

> I had been wandering aimlessly around the French Quarter . . . when I found myself a few doors away from Victoria's Shoe Store. The place is like an opium den. . . . I lost all peripheral vision. The most beautiful mule I had ever seen had been well placed. . . . One of my fantasies is to slay a man with the perfect pair of mules. I want him to look down at my feet and turn into a babbling idiot. . . . Now here it was in front of me, the ultimate weapon. One black silk grosgrain mule sitting on the edge of a glass pedestal . . . heels three inches high. I could already see the possibilities.[25]

Stout's gift for conceiving crystalline images and sensory experiences through narrative extends to her facility with visual arts, a gift that is heightened by her exploitation of wide-ranging materials, including found objects, photographs, paint, fabrics, and beads. Whether describing a shoe fetish, as in the above excerpt from the artist's collaborative book *Hoodoo You Love*, or visualizing the *Houseguest from Hell* (a 1995 assemblage in which a photo of the aforementioned shoe is featured), Stout is able to infuse her surreal fairytales with almost magical allure.

Stout received her undergraduate fine arts degree from Carnegie Mellon University in Pittsburgh. The Carnegie Museum was an early and persuasive influence on Stout, who saw her first Kongo *nkisi nkondi*, or power figures, there at the age of ten (fig. 2.5). These nail- and fiber-encrusted wooden figures left an indelible impression on Stout, and their influence would resurface in her works many years later. Like her contemporaries,

Stout received inspiration from family members who were artists. Her mother boasted expertise in needlework; her grandfather was a toy maker and musician; and an uncle was a painter. Other oeuvre-shaping stimuli hail from the artist's childhood recollections of a local occultist named Madame Ching, who worked with roots and did herbal conjuring, and from remembrances of placing "memory jars" on family graves. Stout found additional catalysts in the dada constructions of New York artist Joseph Cornell and in the writings of art and cultural historian Robert Farris Thompson, whose groundbreaking book *Flash of the Spirit* details African retentions in the diaspora.[26]

Stout's assemblage *Trinity* reveals the extent to which these various influences have shaped her creativity (fig. 11.9). This triptych incorporates photos of Stout, her sister, and her mother within an architectural context inspired by medieval altars. The three women, as the title of the piece indicates, embody the artist's own particular Holy Trinity. When opened, the wings of the altar reveal, along with the three family portraits, corresponding birth dates, pictorial and written references to Christian and African religions, and a combination of encrypted and legible narratives that describe the personalities of each woman and their relationships to one another. When closed, the assemblage, which was reworked from a piece of old furniture, is locked with a rusted latch, etched with abstruse symbols, and mounted with a small square to approximate the mirror-sealed abdominal containers of Kongo power figures.[27] A conjurer of a different sort, Stout has intermingled art, magic, ritual, religion, and verse in *Trinity* to produce a fetish of a decidedly postmodern nature.

Another updated power figure is the multimedia sculpture *Fetish # 2* (1988), which consists of a life-sized plaster cast of Stout's body painted with several layers of rich dark pigment (fig. 11.10). The figure stands immobile and silent with primordial vigilance, and mounted on its stomach is a glass-covered *nkisi* box. Like its Kongo counterparts, the container on Stout's figure holds symbolic materials: a weathered photograph of a baby, representative of innocence and of the future; dried flowers that allude to the ephemeral nature of life and to memories; and a postage stamp from Niger, emblematic of the artist's long-distant African past. Stout empowers her sculpture as might a Kongo shaman, with a

Figure 11.9
Renée Stout
Trinity, 1992
wood and mixed media,
open: 45 x 22" (114.3 x 56 cm),
closed: 45 x 11" (114.3 x 28 cm)

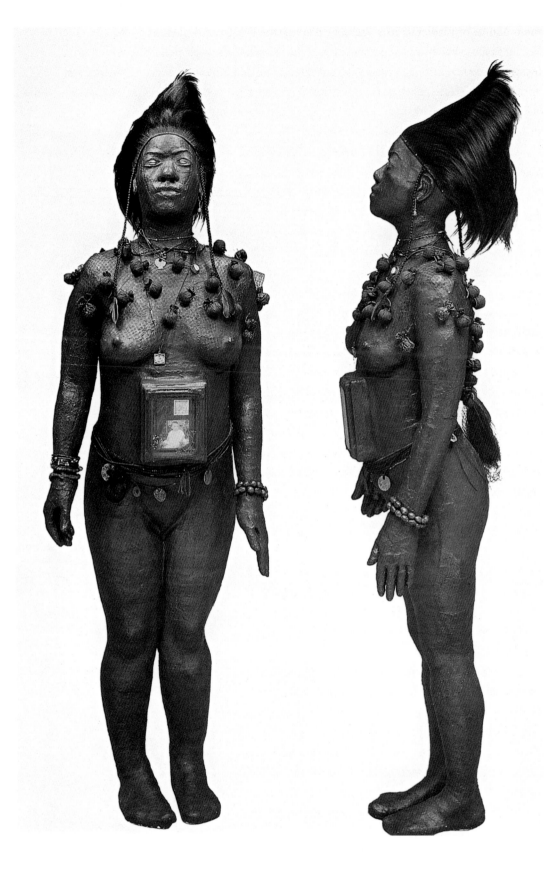

mesh mantel of medicinal *nkisi* sacks, or *bilongo* (the Kongo equivalent of Vodou *pakèts*), which are intended to protect the wearer. The sculpture also features monkey hair and beaded braid extensions that allude to both African and Western cultures. Finally, there are cowrie-shell eyes that forestall the male (or any) gaze and reduce or eliminate the sexual voyeurism normally associated with the female nude.[28]

"This is ritual nudity," affirms historian Michael Harris, "not the available female nude of Western art."[29] A "psychic self-portrait," *Fetish #2* was designed to aid Stout in meeting life's more rigorous challenges—just as an actual Kongo *nkondi* figure would be designed to do. The artist affirmed that, "in creating this piece, if I never created another one, I had . . . all that I needed to protect me for the rest of my life."[30] In its "unmistakable air of conviction,"[31] *Fetish #2* has been compared to Sargent Johnson's *Forever Free* (fig. 1.3). Stout's matron, however, bares her body and exudes an ethereal mystique that seems to elevate her to the realm of the gods. Debuted at the Dallas Museum in 1989, *Fetish #2* brought immediate acclaim to Stout, who has since forged a formidable professional career.

The art of California native **Alison Saar** (b. 1956) likewise recontextualizes the black female nude. Drawing upon Vodou iconography, in 1985 Saar created a secular equivalent to the Vodou *drapo* entitled *Mamba Mambo* (figs. 2.12, 2.13, 11.11).[32] In Saar's interpretation of the genre, the painted canvas *drapo* serves as a heraldic backdrop for a nude black woman, who stands atop a mosaic stool in bright red high heels (the artist's code for the female element), sporting equally vivid red lipstick. The title of the assemblage suggests a Vodou *mambo*, or priestess, as well as the African-derived Cuban dance, the mambo. In Haitian culture, the Vodou priestess is a powerful and revered community leader; and the mambo dance is known for its energetic movements. Thus, even in titling the piece, Saar imbues her figure with authority.

Saar reinforces this agency by positioning a burst of golden rays around the figure's form and by arranging for her to grasp a coiling snake firmly in her fist as it encircles her body. Indeed, the word *mamba* (from the Zulu *im-amba*) refers to a poisonous and hoodless green cobra found in southern Africa. This reference to a deadly serpent asserts the somatic potency and audacity of Saar's woman, who holds the snake intrepidly within biting distance, and whose sexual clout is

Figure 11.10

Renée Stout

Fetish #2, 1988

mixed media and plaster body

cast, 64" high (162.56 cm)

Figure 11.11

Alison Saar

Mamba Mambo, 1985

mixed media, 5' 4" x 2' 10" x 1' 5"

(162.56 x 86.35 x 43.18 cm)

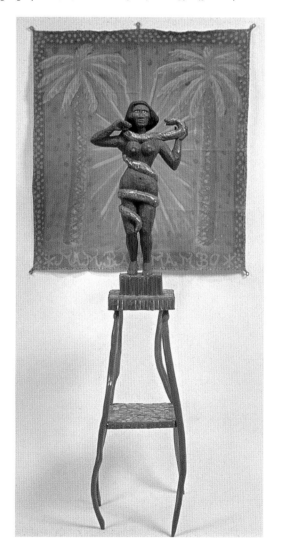

confirmed by her ability to control this symbolic phallus. Within the neo-African ontology of Saar's work, the snake represents the positive life force of the serpent deities Dambalah and Ayida Wèdo, who are represented in Vodou art as double snakes coiled around a palm tree (note the palm trees in Saar's *drapo*). The wood figure, sheathed in a skin of hammered tin, replaces the Vodou tree, or *poteau mitan* (center pole), which is the epicenter of every Vodou temple and a metaphor for the pathway between earth and the spirit world of Ginen. Saar, like Stout and Owens-Hart, conceives the female nude as a prodigious assertion of the postfeminist woman who celebrates and venerates both her sexuality and her spirituality.

As a multiracial artist of Western and non-Western antecedents (and the daughter of artist Betye Saar), Alison Saar is in a unique position to interpret our changing society as a diverse and complex cultural landscape. Her works are framed by her interests in ethnicity, womanhood, Western and non-Western art, neo-African religions, and Catholicism. She is also a devotee of African-American folk art—a subject upon which she wrote her undergraduate thesis at Scripps College, under the sponsorship of professor and artist Samella Lewis (fig. 6.15). In the thrall of folk inspiration, Saar has produced works that evoke the unprocessed execution of the vernacular, to which she adds cultural narratives of a decidedly urbane nature, which reveal her training as an art historian.[33]

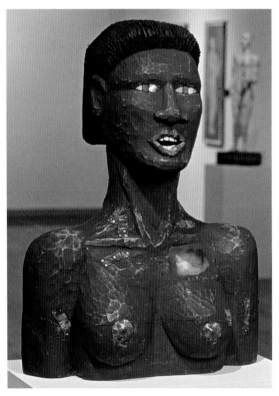

Figure 11.12
Alison Saar
Diva, 1988
wood, tin, paint,
and shell,
32 x 30 x 10"
(81.28 x 76.2 x 25.4 cm)

All of these qualities are evident in *Diva* (1988), a sculpture that externalizes feminine prowess even in its name (fig. 11.12). To create a heightened sense of the figure's raw energy, Saar deliberately leaves the gouges of her chisel visible, as red veins across the electric blue surface of the work. She augments this coarseness with squares and rectangles of hammered tin that form metallic bits of epidermis over the rigid bust. The open mouth and bared teeth allude obliquely to the Freudian concept of the *vagina dentata*—women's capacity to emasculate (or, quite literally, to bite off the penis with vaginal teeth). Further suggesting female supremacy are the golden metal nipples that have been hammered onto the figure's breasts like armor plating (and like pasties, a reference to the sexual spell cast over men by striptease dancers). Finally, in place of a heart, there is a cavernous hole that jointly insinuates cold-heartedness, an empty heart, and a broken heart.

Saar's *Dying Slave* of 1989 refers directly to the art historical past (fig. 11.13). Its pose has been extrapolated from Michelangelo's Renaissance sculpture of the same name. In Saar's rendition, however, the suffering figure is a man of color, a fact that is made evident by the forthright carving of his broad nose and ample mouth, and by his brown skin, which is composed of rusted ceiling tin. Anchoring the solar plexus of the roughly hewn *Dying Slave* is the same *nkisi* cavity seen in Stout's work. Rather than a receptacle for curative and preternatural substances, however, Saar's aperture is a shallow crater that denotes injury, suffering, and transcendence—a confluence of vulnerable interior and protective façade. Wrist shackles corroborate the work's title, but the splendid physical bulk and vigor of the figure belie the implications of slavery and imminent death. On the contrary, the slave's powerful haunches pulsate with energy, and Saar has placed metal over his chest like an impenetrable, protective shell. While Michelangelo's sculpture signifies a neoplatonic enslavement expressed in physical form, Saar's captive, though bound bodily, exudes spiritual and even physical sovereignty.

The great majority of Saar's sculptures include elements of salvaged refuse, like the metal components in both *Diva* and *Dying Slave*. Saar relishes the use of recycled materials because she believes that these objects (which she collects copiously from city streets and flea markets) have their own "memory" and hence bring something unique to the work. Saar's interest in reprocessing secondhand odds and ends was triggered by a childhood visit to the famed *Watts Towers*, which were constructed almost entirely of cast-off tiles, glass, and crockery cemented to a steel rod skeleton (and which inspired her mother a generation earlier). What most impressed the young Saar was the folk art resourcefulness that allowed Rodia, who constructed the towers, to make "something out of nothing." Saar's use of ready-made objects is also conceptually related to dadaism, but unlike the dadaists, who embraced nihilism, Saar's works are infused with logic and meaning. Her exploitations of wood, broken glass, rusted nails, old linoleum, and other found ingredients result in

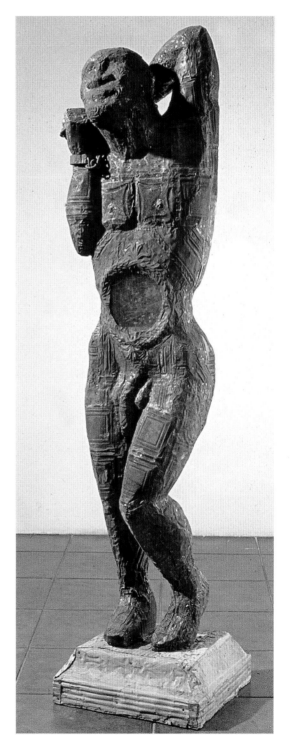

Figure 11.13
Alison Saar
Dying Slave, 1989
wood, tin, Plexiglas,
and nails,
9' high (2.74 m)

monumental human forms that are imbued with emotional, spiritual, sexual, and often politically charged import.[34]

The trademark rusticity of Saar's sculptures briefly made her the target of criticism as the maker of synthetic pastiches of black vernacular sculpture, but this hardly seems an appropriate assessment. Prior to graduating from college in 1978, Saar received no formal studio art training, and although she eventually obtained a fine arts graduate degree from L.A.'s Otis Art Institute (1981), she at no time availed herself of traditional art courses or study in academic drawing or modeling. Therefore, as Lippard reasons, Saar "maintains a core of technical innocence . . . that connects her to the great untrained artists she admires."[35] Her creativity, like that of her vernacular kin, was bolstered by family influences more than by academic ones—by the example of her mother and by her father, Richard, who was an art conservator. He exposed his daughter to museums and art books as a child and, by hiring her as his assistant (working mainly on the restoration of African and Afro-Caribbean artifacts), he taught her the value of preserving old and decaying objects, a lesson that Saar has never forgotten. Her eccentric methods and unsettling visual statements, now widely acclaimed, merge to form evocative and commanding structures of extraordinary vitality.[36]

Unlike Saar and the mixed-media artists thus far discussed, historian and artist **Freida High W. Tesfagiorgis** (b. 1946) prefers straightforward two-dimensional media as her primary means of expression. Tesfagiorgis's work, despite its modernist form, points nonetheless to the pluralistic nature of her aesthetic and personal orientation as well as to her insights as a historian. One such composition is the 1982 pastel *Aunt Jemima's Matrilineage* (fig. 11.14). Taking advantage of familiar cultural signs, this image unites twentieth-century African-American women with their long and heterogeneous history. The bulky figure of an angst-ridden Aunt Jemima anchors one quadrant of the drawing. The portly maid is confronted by the wildly gesticulating tentacles of a Zulu doll, which dominates and obscures the domestic icon in a haze of lively chalk lines. Resting near the hem of Aunt Jemima's skirt is Tesfagiorgis's rendition of slave-made pottery in the form of an Afro-Carolinian face vessel. Likewise, the left edge of the composition disports African-derived sculpture: a Benin-style totem (which bears an intriguing resemblance to Tlingit art from America's Northwest Coast) and a carving of a seated mother and child of the type produced in Mali and the Ivory Coast.[37]

Counterbalancing these five figures are two-dimensional details of simulated fabric: a section of the American flag, a star quilt, and a checkered textile that together refer to national history and to craft traditions. Also

depicted is a bookcase that houses an Akan fertility figurine known as an *akua ba*, which is used in Ghana to ensure the unbroken continuation of a family line. The grasslike reeds that sprout from the base of the picture bracket its various elements and formally underscore the concept of an inviolate bloodline between past and present-day persons of African descent. There is also the suggestion that this cherished heritage has the potential to obliterate stereotypes such as those embodied in the figure of Aunt Jemima. According to Tesfagiorgis, *Aunt Jemima's Matrilineage* represents "an individual empowered by the knowledge of her ancient and contemporaneous cultural history."[38]

While the keynotes of *Aunt Jemima's Matrilineage* emanate from the Black Art and feminist movements, other works by Tesfagiorgis align her with modern and postmodern artists and with artists of color from generations past. *Hidden Memories: Mary Turner* (1985) invokes the subject matter of Meta Fuller's 1919 *Mary Turner*, which memorializes the ruthless lynching of a black woman in Georgia and the murder of her unborn child (figs. 3.18, 11.15). In Tesfagiorgis's rendering, a vertical beam of white irradiates the abstracted symbol of Turner. Barblike projections evoke the physical agony of her death, and an organic orb corresponds to the infant who was torn from her uterus by her assailants and crushed under their feet. The same form emits roots, but these are truncated, insinuating the demise of the

Turner family line. Below this spherical shape, Tesfagiorgis has outlined what appears to be a commemorative plate and stamped it with a news article describing the shocking violation of Turner. Finally, the striations of line and color throughout the composition reiterate its narrative implications.

Tesfagiorgis has had an extensive education in and outside of the field of art, including degrees in education, art history, and studio art. At her alma mater, the University of Wisconsin, she has served as chair and professor of art history in the Department of Afro-American Studies. Her intellectual expertise in African and African-American art unquestionably informs her work, as do her memories of her rural childhood in Mississippi. Acknowledged for having coined the term "Afrofemcentric" in 1984, Tesfagiorgis's paintings are as multifarious in design and substance as her watchword suggests.[39]

Figure 11.15
Freida High W. Tesfagiorgis
Hidden Memories:
Mary Turner, 1985
pastel, 40 x 30"
(101.6 x 76.2 cm)

Artist and educator **Margo Humphrey** (b. 1942) interprets the shifting racial and gender paradigms of the late twentieth century with an apparent sense of burlesque, self-effacement, and celebration in *The Last Bar-B-Que* (1988–1989) (fig. 11.16).[40] Situated amid layered patterns of flora, grass mats, and checkered flooring are nine brown, one yellow, and three blue-skinned figures, who appear to correspond to Christ and the twelve apostles, but in fact represent a group of Samoan dignitaries with whom the artist dined at the University of California, Santa Cruz. Viewers are reminded of Leonardo da Vinci's solemn *Last Supper* (c. 1495–1498) and kindred paintings in the Western tradition. Instead of partaking of wine and bread, however, Humphrey's delegation dines on African-American and Polynesian fare of watermelon, chicken, papayas, pineapples, and bananas. Other Humphrey works, such as *The Great Yam, Bowl of Black Eye Peas*, and *The Collard King*, suggest that her renderings of foodstuffs are replete with consequential inferences regarding the staples that feed and sustain black life and culture. Indeed, Humphrey likens the "chemistry" of lithography, her primary medium, to that of food preparation.[41]

The presence of two women apostles in *The Last Bar-B-Que* brings considerations of gender as well as racial diversity into this conformation of a traditionally white male repast. The suspended pyramid and the Egyptian-style papyrus columns that frame the composition interject

Figure 11.16

Margo Humphrey

The Last Bar-B-Que, 1988–1989

lithograph with variegated red

foil and gold metallic powder,

22 x 48" (56 x 122 cm)

African ancestry into the Christian motif, and a yellow "Bethlehem University" T-shirt on the standing figure who occupies the place of the disciple Philip both alludes to the artist's heterogeneous religious upbringing and introduces elements of the secular and the academic into an otherwise apostolic gathering. Taking these multiples citations into account, *The Last Bar-B-Que* emerges as a far less farcical statement than its title suggests. More appropriately, the work is revealed as a postmodern interpretation of the Last Supper as a historic, multiracial, gender-diverse, and philosophically unrestricted gathering. Through composite thematic references and an effervescent color and design scheme, Humphrey's votive painting fortifies a normally grave and ceremonial tableau with warmth, hope, and elation.

Humphrey's expertise extends to sculpture, assemblage, installation, and teaching. Since earning a B.F.A. and an M.F.A. from the California College of Arts and Crafts and Stanford University, respectively, she has lectured and taught at universities worldwide—in Fiji, Nigeria, and Uganda—and she has drawn much creative motivation from these locales. In general, Humphrey's subject matter addresses broad-based issues of racism and feminism, as well as personal narratives. Her aesthetic is inspired by the lively colors and bucolic forms of Haitian and Brazilian art; by similar qualities in the French artists Gauguin and Rousseau; and by African-American vernacular artists, explicitly Sister Gertrude Morgan. Although her works often center on the black experience, Humphrey stresses that this is a logical outcome of her own identity as an African American and should not be perceived as a narrowly constructed artistic agenda. Her wish, as a scion of the age of pluralism, is to be understood as a unique individual who happens to be of African descent, rather than as a "black artist."[42]

Like Humphrey, the creative imagination of **Valerie Maynard** (b. 1937), a Harlem native, often gives precedence to social or political schema. Despite this propensity, however, personal themes and design and media experimentation retain criticality for Maynard. Especially catholic in her use of materials, Maynard's works range from collages, prints, and set designs to painting, sculpture, and photography, and sometimes one medium may suggest another. For example, her *No Apartheid* series (approximately 250 paintings that protest racism on personal and global levels) effects through airbrushed paint the impression of a rayograph or photogram (an image produced when objects are placed on photographic paper and exposed to light).[43]

Within a clarifying monochromatic idiom, the *No Apartheid* compositions contain scores of template-derived shapes of conceivably benign but in fact hazardous objects, such as keys, nails, grates, screws, chains, forks,

pins, scissors, saws, and hammers. In the artist's syntax, visual references to pins that "prick," blades that "cut," nails that "pierce" and "crucify," chains that "shackle," and hammers that "pound" are exploited to underscore the meaning of each work. Within the context of apartheid, these shapes allude to the violence associated with race hatred, and they highlight broader themes of human suffering and mental and spiritual aguish.[44] In *Get Me Another Heart, This One's Been Broken Many Times* (1995) from the series, the nails embedded in the head and trunk of the nude female, and the scores of keys that supplant her blood and veins, impart a message of grief associated with love and loss (fig. 11.17). Further links can be made between these pictorial devices and phrases such as a "broken heart," "the key to one's heart," "nailed to the wall," and "cut to the quick." The rendering of so many objects and the shadowy, grainy textures in the work create mental noises—the clanging of metal, the grating of surfaces—and also appeal to the viewer's sense of sight and touch, making *Get Me Another Heart* a deeply sensual experience.

Figure 11.17
Valerie Maynard
Get Me Another Heart, This One's Been Broken Many Times, from *No Apartheid* series, 1995
acrylic paint on oaktag, 56 x 36"
(142.24 x 91.44 cm)

Figure 11.18
Camille Billops
The Story of Mom, 1981
ceramic, 47 x 11 x 7"
(119.4 x 28 x 17.8 cm)

Maynard is more than a successor to the Black Arts movement; she participated fully in its agenda. As early as 1970, she was producing protest imagery that, in the words of one historian, was "commonly associated with the movement" and constituted "powerful indictments" against American injustice and the "poverty, violence and fear that plagued the black community."[45] In recent years, however, Maynard's oeuvre has come to share more in common with the transcendent creations of artists like Stout than with the politics of the Black Power era. Maynard's late twentieth-century works reflect her "deeply spiritual position" as well as her perception of the art object as both an aesthetic forum and a sacred one.[46] In articulating this philosophy, Maynard draws upon the abstract and universal language of music to achieve a sublime effect in her art. She creates "in a music-filled environment" whenever possible and allows the pace of the music—gospel, jazz, and the blues—to dictate the wax and wane of her creative élan.

A woman who boasts multiple fine arts talents, Maynard studied painting and drawing at New York's Museum of Modern Art, printmaking at the New School, and sculpture at Vermont's Goddard College. For nearly four decades, she has managed parallel careers as an artist, teacher, and curator. Her record of honors, exhibitions, and public commissions is prolific as are her faculty credits, which include the Studio Museum, Howard University, and the University of the Virgin Islands. Most recently, she was appointed artist-in-residence at both the Rochester and Massachusetts Institutes of Technology.[47]

Los Angeles–born artist and author **Camille Billops** (b. 1933) is likewise a creator of intensely personal statements that center around aspects of her life and family. Billops, who studied with printmaker Robert Blackburn and distinguished University of Southern California faculty Vivika and Otto Heino, is best known for cofounding (with James Hatch) the Hatch-Billops Collection, an archive of literally tens of thousands of drawings, reproductions, audiotapes, films, and publications on black art, which is located in New York City and open to scholars. This invaluable resource arose from Billops's belief that artists should not remain isolated in their studios, but rather should contribute to cultural edification in as many ways as possible.[48]

While Billops's archive is proof of her commitment to the community of artists of color, her art is more private in its creative and thematic intentions. The character of Billops's drawing style has been likened to the comic-strip techniques of pop artist Roy Lichtenstein. Her ceramic sculpture *The Story of Mom* (1981) and the four accompanying drawings, *From the Story of Mom*, combine this pop quality with the affectations of op art—in this case, a confluence of radiating lines that stripe the mother figure like

a zebra (figs. 11.18, 11.19). A 1986 drawing from the repertoire features a close-up view of Mom at the wheel of a car. The woman seems to be held hostage within the confines of a cartoon cell, emphasized by the stripes that cover her body. *From the Story of Mom* conveys further tension and urgency through a compression of the picture space and a tight cropping of the image frame. Billops's Mom honors the artist's godmother and namesake, whose combined sense of style, authority, and discipline influenced the artist throughout her life (long after her godmother's death, when the artist was twelve years old). In the sculpture, the credibly flaccid nude figure of Mom is held captive by the specter of death in the form of a grimacing gnome, which clutches at her ankle.[49]

Billops is also a filmmaker, a talent that served her well in the development of the Hatch-Billops library. Her films range from biographies to docudramas and are, in many ways, as abstruse as her visual narratives. Her 1982 film *Suzanne, Suzanne* documents the aftereffects of child abuse and the impact of drug addiction on the life of the artist's niece. The film also outlines certain of life's conundrums as these are experienced by the black middle class. As a testament to the caliber of Billops's filmmaking, in the year following its release, *Suzanne, Suzanne* was screened at the Museum of Modern Art's New Directors series, at the Film Society of Lincoln Center, and on WNET's (PBS) "Independent Focus." Another film, the 1991 *Finding Christa*, chronicles Billops's reunion with the daughter she gave up for adoption twenty years earlier; this movie won a first prize honor at the Sundance Film Festival in 1992. Billops continues to document, collect, and sell African-American art. Her extensive travels as an archivist, artist, and filmmaker have taken her to India, Japan, and Sri Lanka, among other countries. The daughter of domestic employees who strove to provide their children with a solid cultural education, Billops has spent her life building upon this legacy.[50]

Figure 11.19
Camille Billops
From the Story of Mom, 1986
colored pencil on paper, 15 x 22"
(55.88 x 88.1 cm)

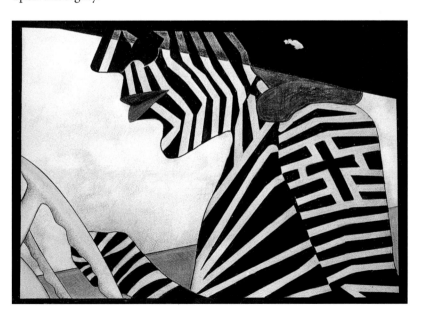

Assemblage and installation are the preferred methods of artist **Martha Jackson-Jarvis** (b. 1952). Her "environments," first undertaken in the mid-1980s, create the effect of a controlled explosion, achieved through the planned placement of clay shards and other mosaic pieces. *The Gathering*—a site-specific installation designed for the University of Delaware in 1988—resulted in precisely this whirling-dervish effect (fig. 11.20). One has the impression that whole objects were hurled at the walls and floor with violent centrifugal force, causing them to shatter. On a perceptual plane, audiences are reminded of the type of primordial whorl of gas and matter that brought about the creation of our galaxy. Various interpretations of this "lyrically orchestrated spatial panorama" include descriptions of it as a "frenetic syncopation" of jazz music translated into physical form, and as an epitaphic celebration of burial practices in the African diaspora. As a young girl, Jackson-Jarvis recalls, she collected fragments of pottery for her grandmother to consign to family resting places. Perhaps for this reason, her preferred medium is clay, which the artist links ideologically to concepts of alchemy, nature, birth, and death. *The Gathering* incorporates "myth and magic, chance and motion" on an imposing scale, and the work cannot fail to provoke strong physical and mental responses.[51]

In the early 1990s, Jackson-Jarvis explored the cycles of life and death in a series of seven sarcophagi, which she designated *Last Rites*. These coffin-

Figure 11.20
Martha Jackson-Jarvis
The Gathering, **1988**
ceramic shard installation

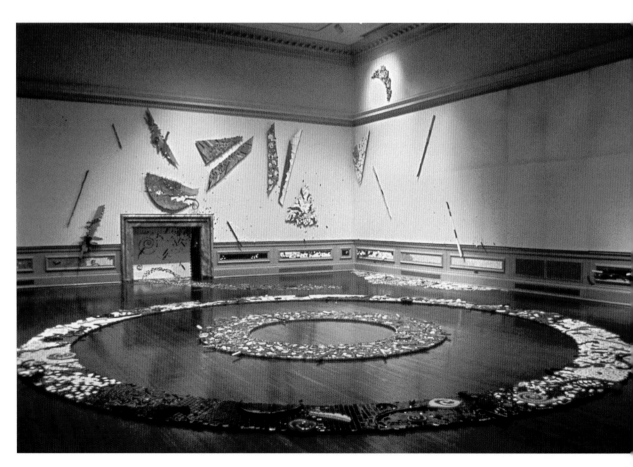

like structures are monuments to Jackson-Jarvis's preoccupation with the earth's environment and its failing ecological systems. At the same time, each casket functions as a power object or talisman to "promote the resuscitation of the Earth and its biosphere."[52] The seven reliquaries are dedicated to the themes of vegetation, earth, air, water, healing, ancestors, and blood. With regard to the last, Jackson-Jarvis was especially concerned at the time with blood as the primary transmitter of AIDS.[53] *Sarcophagus I* from the series is composed of glittering gold and turquoise elements, "fossilized" forms, and geological shards (fig. 11.21). These components are layered on top of a mosaic bed of black tesserae. Raised on an angle, the coffin, which Jackson-Jarvis has decorated with an organic plant and spiral root, threatens to spill its contents onto the viewer's feet. Leaf forms and watery whorls connote growth, while the jagged veins of the coffin's black lid suggest the death and decay of our natural environment. Made from Venetian glass, ceramic, stone, copper, cement, wood, and paint, the works in this evocative series mimic a collection of jewel-encrusted antiquities which seem to have fused, over an eternity, natural and manmade alloys.

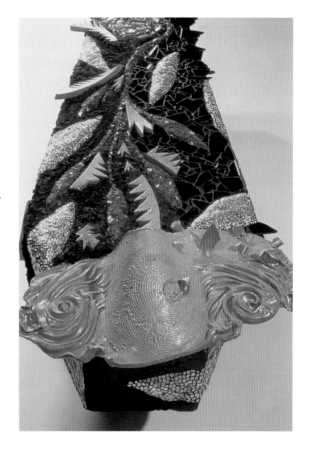

Figure 11.21
Martha Jackson-Jarvis
Sarcophagus I, from
Last Rites, 1992–1993
clay, glass, pigmented cement,
and wood, 36 x 72 x 30"
(91.44 x 182.9 x 76.2 cm)

Since her years as a student at Temple University's Tyler School of Art and Antioch University (M.F.A., 1981), Jackson-Jarvis has developed into an artist of tremendous personal convictions who is deeply in tune with nature and humanity, as her own words bear out:

> In the face of world issues about racism, sexism, ecological destruction, homelessness, economic and spiritual deprivation, war and possible planetary annihilation, contemporary artistic discourse has landed squarely on the spiritual in art. Using many cultures as resources from which to cull images and symbols, artists seek to evoke ancient knowledge and visions of man's primal strengths and fears. . . . Now is the time to invent healing medicines of our time.[54]

These sentiments encapsulate the spirit of the latter decades of the twentieth century and cast artists in the roles of shamans, druids, and healers—a throwback to the mindsets of modern spiritualists such as Kandinsky and Mondrian.[55]

Twins in the City (1987) by **Jean Lacy** (b. 1932) venerates "inner space" rather than the cosmological and ecological galaxies of Jackson-Jarvis (fig. 11.22). The work pays tribute to both urban and rural living, and it links the cultures of the present to those of the ancient past. Using an amalgam of collage and drawing, Lacy portrays Egyptian and Greek couples. The former are adapted from Old Kingdom sculptures of the pharaoh Menkaure and his queen, Khamerernebty; the latter are derived from Greek Janiform kantharos ceramics of the fifth and sixth centuries B.C.E. (fig. 1.5). The two Greek figures, one white and one blue, flank the Egyptian pair and face each other. The one on the left wears a floral house dress and balances plants in her hand and on her head. The one on the right holds a miniature plantation house in one hand and a hoe in the other, while farm fowl cluck at her feet. Behind these two figures, a Greek temple houses the Egyptian king and queen. The temple is decorated with urban graffiti and is similar in architectural style to the neoclassical manor that the blue figure clutches. Finally, looming in the distance is a nocturnal city skyline. *Twins in the City* implodes cultural, ethnic, lifestyle, and temporal fissures into an ambitious mnemonic of shared humanity.

Described as "reliquaries," the diminutive constructions that Lacy creates function as "religious objects for holding relics."[56] *Prayer for the Resurrection of a Row House in Baltimore* (1995) conforms to this designation and is a memorial to the artist's learned and aristocratic aunt who, given her

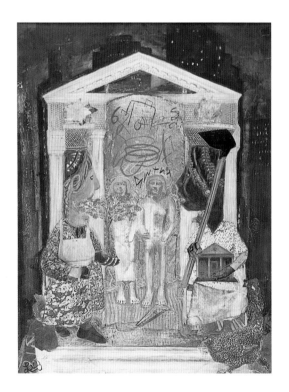

Figure 11.22

Jean Lacy

Twins in the City, 1987

mixed media on museum board,

11 1/2 x 8 3/4" (29.21 x 22.22 cm)

racial circumstances and the age and place in which she lived, was obliged to work throughout her life as a domestic servant (fig. 11.23). While residing in an urban brownstone in a low-income Baltimore neighborhood, Lacy's aunt earned her living as a maid in a fashionable vacation home on Gibson Island in Maryland. Lacy can still recall her aunt, who took great pride in her domestic surroundings, scrubbing the marble front steps of her own home. Lacy honors the vocation of her aunt and countless other domestic workers by including in the assemblage a scrub brush made precious by the application of gold leaf.

The row house, too, is garnished with gold so that it evokes an altar. As if to call attention to the structure's devotional underpinnings, on its outer walls an angel and a demon wage a battle between good and evil. A gold padlock on the graffitied front door, boarded windows, a metal safety gate, a marble step, and fiery red brick comprise the building's façade. The face of the house is hinged and slightly ajar, revealing the gutted interior of the building, which doubles as a reliquary container.[57] Next to the house sits a carved wooden doll, representing Lacy's aunt. Dressed in a black uniform trimmed with white lace and a matching lace cap and apron, the figurine leans intently over its scrub brush and ruched cleaning cloth. As a final tribute, the tiny maid is mounted atop a pedestal designed, both literally and figuratively, to elevate her and all that she represents.

Figure 11.23
Jean Lacy
Prayer for the Resurrection of a Row House in Baltimore, 1995
mixed-media construction with carved wooden doll,
8 1/2 x 6 1/2" (21.6 x 16.51 cm),
doll: 4" high (10.16 cm)

Figure 11.24
Beverly Buchanan
*Home of Reverend Beulah
Robinson*, 1995
tin, wood, plastic, collage,
17 1/4 x 15 x 11"
(43.8 x 38 x 28 cm)

Figure 11.25
Robin Holder
Show Me How III, 1990
stencil monotype, 32 x 25"
(81.3 x 63.5 cm)

Lacy has been a lifelong political activist as well as an artist. During and after her museum education at Southern University in Baton Rouge, Lacy was immersed in the Civil Rights movement and "participated in demonstrations, sit-ins, boycotts, and other civil disobedience."[58] She is also committed to the church and has devoted much of her creative energies to designing tapestries and stained-glass windows for the St. Luke United and Trinity Methodist churches in Dallas and Houston. Lacy coalesced her political and clerical allegiances by designing biblical imagery that took as its models African rather than European personages, costumes, histories, and myths. Lacy's choice of sources for her liturgical art acknowledges the "ineffectiveness of Euro-American iconography" for Christians of color, and it reflects Lacy's belief that Western theological art is a form of cultural programming that precludes knowledge of African history and the indisputable Afro-Christian past.[59]

The multifaceted epoch of postmodernism and the wide range of African-American women artists for whom it opened the doors of art history, criticism, and patronage cannot be amply assessed in these few brief pages. The coalition of artists discussed here represents only a fraction of hundreds whose merit must not be judged by their exclusion from this abridged history. Among the noteworthy are mixed-media sculptor **Catti** (b. 1940), whose formal vehicles range from Plexiglas to raffia and whose iconography taps into traditions from both Europe and Africa; painter **Ann Tanksley** (b. 1934), whose stylized figural compositions bear comparison to the works of Henri Matisse and Jacob Lawrence, and whose art explores motifs of spirituality and African culture; **Beverly Buchanan** (b. 1940), whose idiosyncratic representations of southern cabins, or "shacks," honor African-American working-class and rural society (fig. 11.24); and painter-printmaker **Robin Holder** (b. 1952), who creates gossamer images of women and nature as indexes of universal harmony and healing (fig. 11.25). Indeed, Holder's description of her own oeuvre is a fitting characterization of the art of many of her pluralist peers: "My work is motivated by my multi-cultural background in which layers upon layers of various racial, economic, and spiritual worlds exist within one family."[60]

A rt critic Holland Cotter recently predicted that the cultural pluralism
that evolved with postmodernism will define the art of the late twenti-
eth century as surely as pop art defined the 1960s. Pluralism revolutionized
the art scene, altered art world demographics and contexts, challenged racial
and gender exclusion within the art establishment, and provided access to
the art mainstream for inveterate outsiders. It offered hope of an ideal con-
dition of diversity in which social and cultural prejudices would not only be
contested but eliminated, and in which artists of color would share the stage
equally with their white compatriots. This multicultural Wonderland, how-
ever, was never fully realized. Instead, as the twentieth century passed into
the twenty-first, pluralism served to make art contiguous with culture, race,
and gender, and it "reinforced certain narrow and distorting views of ethnic
identity that 'diversity' should have dispelled."[1] Although the pluralist epoch
provided high-profile exposure to a token "A-list" of minority artists, it also
kept them and their art insular by promoting "black" (as well as Asian,
Latino, and women's) shows and by elevating artists to star status based
upon their sociocultural personae rather than their artistic merit. By the
same token, artists of color, regardless of their national heritage, were often
lumped together in emulsified groups that denied their intracultural multi-
plicity. By the 1990s, the aesthetic ghettoization that pluralism was to have
demobilized had instead become entrenched.

The questions that have arisen in the wake of the rise of the pluralist
epoch are profound. How valid and how productive are the premises of
identity politics? And, to paraphrase Cotter, what, after all, can identity pol-
itics really be expected to mean to an art establishment that continues to be
overwhelmingly white and middle class? Women artists of color at the turn
of the twenty-first century are asking these very questions and, as a conse-
quence, shifting discreetly beyond the agitprop and ethnic aesthetics of pre-
vious decades. This new wave of artists is believed to be closer to the main-

TWELVE "Post-Black" Art and the New Millennium

stream than any who have gone before, due in large part to their espousal of alternative and technology-based media, and they have come to be known by the markers "postconceptual," "post-ethnic," and "post-black." The most fashionable of these designations—post-black, made famous by curator Thelma Golden—refers to artists who eschew ethnic markers as limiting to their personal identities and who, as second-generation progeny of the Black Arts movement, simultaneously embrace issues of race and gender as potentially exigent in their work.[2]

The art of **Ellen Gallagher** (b. 1965) exemplifies this paradox. The philological substance of her multimedia abstractions is rooted in postmodern semiotics, but the outward expressions of her erudite themes outstrip their intellectual sources. The result is a recondite collection of collages, assemblages, drawings, and paintings that conceal more than they reveal about their implications. Their sweeping contexts place Gallagher squarely within the post-black firmament. Persistent motifs in Gallagher's eclectic vision are science fiction, the vaudeville bow tie, calligraphy, and the minstrel. The latter becomes a reference point in Gallagher's *Dance You Monster* from 2000, which depicts an oddly constructed dancing figure (formed from scores of tiny white flourishes) on a black ground, and it insinuates, by way of its title, the love-hate relationship that Jim Crow audiences had with black entertainers (fig. 12.1).

Figure 12.1
Ellen Gallagher
Dance You Monster, 2000
right side of diptych, enamel, rubber, and paper on canvas, 120 x 96" (304.8 x 243.8 cm)

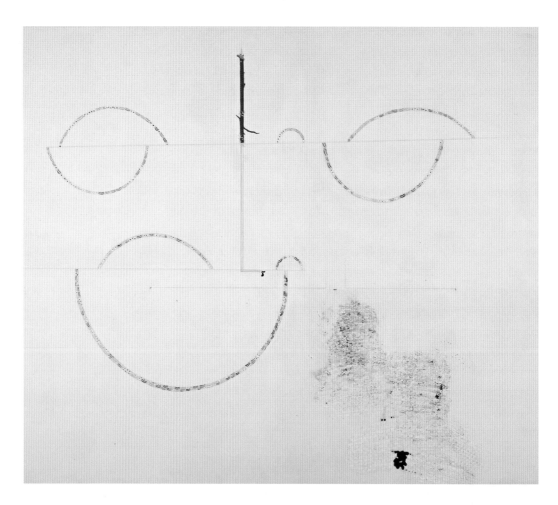

Figure 12.2
Ellen Gallagher
Untitled, 2000
oil, pencil, plasticine, and paper
on canvas, 72 x 84"
(182.88 x 213.36 cm)

Figure 12.3
Ellen Gallagher
Untitled, detail, 2000
oil, pencil, plasticine, and paper
on canvas, 72 x 84"
(182.88 x 213.36 cm)

Related works feature dozens of minuscule shapes on beige surfaces which, only after close inspection, reveal themselves as miniature drawings of the exaggerated lips and "bug eyes" of the stock minstrel "mask" (figs. 12.2, 12.3). Gallagher repeats these forms as one might repeat a word over and over again until it loses its original meaning and becomes a new sound altogether. The sheer numbers of these tiny mouths and eyes conspire to build a composition of larger shapes that are ultimately nonobjective (at least from a distance) and seemingly without narrative content. Gallagher relates this process to the performance style of the master black entertainer Bert Williams, who was able to take "this horrible art form [minstrelsy] and slow it down … sing it slowly … turn it into this uncanny piece."[3] Her intention is to literally and figuratively deconstruct a racial icon, which in turn is so completely transformed from its initial appearance and import that its identity recedes and is replaced by a new one.

Gallagher seems to have taken the word-drawings of Paul Colin, whose illustrations and caricatures captured the essence of the early twentieth-century Parisian minstrel show, as in his *La Revue Nègre* poster (fig. 1.1), and imploded them. Colin published in 1927 a portfolio of hand-colored lithographs entitled *Le Tumulte Noir* ("The Black Tumult"). In a word-drawing that accompanied the portfolio, he inscribed words in miniature to articulate the bug-eyed and big-lipped face of a black minstrel wearing a bowler hat (fig. 12.4). His words read, in part (in English): "These blacks inject movement. Their mouths resemble a crater that spits out slivers of glass. . . . Their eyes have brotherly pupils. India ink streams down their hot temples, and some say their granddaddies ate leopard. They have might in their guts."[4] But, just as Colin has constructed the archetypal face of a minstrel using racially charged language, Gallagher deconstructs the same icon using a hieroglyphic language that is so abstract it renders Colin's ramblings obsolete. An alumna of Oberlin College, the School of the Museum of Fine Arts in Boston, and the Skowhegan School of Art in Maine, Gallagher is an exemplar of a new age of artist-intellectuals whose take on ethnic identity is as circuitous as the history of identity politics itself.

Pamela Jennings (b. 1964) is part of the cadre of artists dubbed Afrofuturists, who use electronic media. This group was showcased in a critical 2001 exhibition, "Race in Digital Space," which was held at

Figure 12.4

Paul Colin

Word-drawing from *Le Tumulte*

***Noir* lithograph series, 1927**

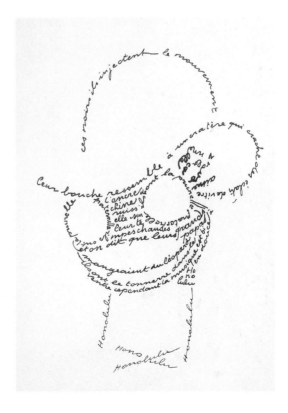

the Massachusetts Institute of Technology as part of the National Conference on Race and New Media. Cosponsored by several major universities, including MIT, NYU, the University of Southern California, and the University of California at Santa Barbara, the symposium analyzed the effects of technoculture on the public's perception of race and ethnicity and on sociopolitical power structures. The exhibition featured more than fifty artists (including Jennings) whose media ranged from film, video, and CD-ROMs to Internet art. Jennings, who studied computer arts at the School of Visual Arts (SVA) and did Ph.D. research in interactive art and computer science, creates CD-ROMs and ArTronic™ interactive sculptures. As a faculty member at Carnegie Mellon and the Human Computer Interaction Institute, she has published widely on the new media phenomena.[5]

Jennings's *Solitaire Game Board* (1996) from the CD-ROM project *Solitaire Dream Journal* is an interactive visual computer program consisting of fifteen screens. Each screen is accessed by strategically making a move on a checkers-like game board that features animated running figures (fig. 12.5). *The Bridge* from this project presents enigmatic and surrealistic scenes that are part video, part photography, and part computer graphics (fig. 12.6). *The Bridge* depicts an apparently bound and indigent figure doubled over on a dirty subterranean ledge. The cement walls behind the protagonist are covered with graffiti and ghostly, spray-painted black figures. The composition is offset by a barren red tree which grows upward from the edge of the platform. One is reminded by the tree of the fairytale "Jack and the Beanstalk," an inference that is reinforced by the "giant" child who peers at her captive through the bars of an arched window. Jennings's art offers commentary on both class and personal oppression, and on social and psychological anguish. It also provides multiple visual and interactive stimuli within a single project and a cutting-edge reconstitution of outdated expectations of black art.

Though not digitized, the paintings of **Laylah Ali** (b. 1968) are mechanized in their style, and the artist (also a Skowhegan graduate) has been dubbed "a technologist of the highest order."[6] The circular heads and rigidly uniformed cartoon bodies of Ali's "Greenheads"—the figures that populate her paintings—approximate comic-strip characters and the seri-

Figure 12.5

Pamela Jennings

Solitaire Game Board, 1996

Figure 12.6

Pamela Jennings

The Bridge, 1996

ality of commercial printing and bear a not-so-vague resemblance to the animated players in the popular television cartoon series *South Park* (figs. 12.7, 12.8). Like the scenarios in *South Park*, Ali's vignettes signal the widespread acceptance of violence in children's television that circumscribes the current era. Aesthetically, Ali's compositions represent a kind of high art that would not have been conceivable before the computer age, or certainly not before the innovations of pop art.

Figure 12.7

Laylah Ali

Untitled, 2000

gouache on paper, 7 x 6"

(17.8 x 15.24 cm)

Ali's Greenheads are brown-skinned anthropoids with painfully thin bodies and disproportionately large heads, whose lives are inevitably sadistic. In one painting, a female Greenhead stands in her underwear while using her panties (still on her hips) to lash to her side the neck of a gasping child and a bundle of dynamite (fig. 12.7). In another illustration, three men hang from their necks while holding the severed limbs of a living figure who witnesses their hanging (fig. 12.8). Yet another composition portrays Ku Klux Klan Greenheads, in tall cone-shaped white hats, examining a decapitated head. What astounds in Ali's parables of race, comparable to Kara Walker's antebellum horrors, is the anomalous rendering of savage narrative and Spartan color schemes, empty background fields, and graphic precision—a fitting editorial on the insensitivity to violence that is part and parcel of new millennium culture and a direct result of the profusion of brutality made available through all forms of media, from "Taliban" computer games, to hip-hop lyrics, to untold numbers of grisly sci-fi and action films.[7]

Figure 12.8

Laylah Ali

Untitled, 2000

gouache on paper, 13 x 19"

(33 x 48.26 cm)

Ali's oeuvre, with its open-ended theses and "overwhelming sense of individuality" is paradigmatic of a contingent of post-black artists who were showcased in Golden's recent "Freestyle" exhibition—a show of new millennium black art that was held at the Studio Museum in Harlem and the Santa Monica Museum of Art.[8] Like other "Freestyle" artists, **Deborah Grant** (b. 1968) enjoyed early career successes. She likewise studied at Skowhegan and completed an M.F.A. at the Tyler School of Art. Grant, too, employs pictographic icons in her paintings, though of a markedly dissimilar design from Ali's Greenheads. Grant's *Cryptic Stages* and *Verdicts* (both 2000) offer intense social commentary in hybrid configurations of graffiti art, illustration, and cartoon renderings (figs. 12.9, 12.10). Unlike Ali's sparse arrangements, each of Grant's compositions is a feverishly executed *horror vacui* in which every available space is occupied. All manner of emblems abound—drug needles, guns, monsters, dollar signs, satellite dishes, the U.S. Capitol building, eerie portraits, an Afro pick, skeletons, and Mickey Mouse ears—all gyrating around a central hot spot that features, in *Verdicts*, an unlikely red snow man (heated, horrified, and on the verge of a meltdown) and, in *Cryptic Stages*, a like-hued pair of glasses that suggests angry blinders rather than tools through which to see.

Graphic mazes and scores of markings fill the spaces between the various pictograms, as do words that carry hard-hitting import. In *Verdicts*, a "pickaninny" and a skull are coupled with the phrases "Who bought the myth?" and "Dig, dig, dig." Close in proximity to these inscriptions is another: "Anthropology lives." The statements and pictures invoke the quasi-anthropological studies that fixed the pickaninny and other black stereotypes into the Western psyche. The words "Guilty, guilty, guilty" accompany a judge's gavel, and the words "Economy" and "Soup for the rich" offer equivocal critiques on justice, class, and modern angst. In *Cryptic Stages*, the image of a man pushing a shopping cart laden with a war missile is labeled "war missiles cheap." References to Desert Storm and World War II appear in conjunction with swastikas and televisions, and a prison "shank" is captioned "black male prison system." Grant's self-described "random select" approach, which embraces a range of serious and facetious themes, draws pictorial inspiration from the urban graffiti art of her native Brooklyn, the works of graffiti-turned-fine artist Jean-Michel Basquiat, comic books, Disney films, and the *art brut* style of Dubuffet. Her guileless method of depiction is offset by the complex ebb and flow of chaotic and carefully constructed visual passages and by typically postmodern sound bites of "brevity, sarcasm, and paradoxical logic."[9]

While Grant and Ali work in two dimensions, the media and content of their "Freestyle" cohorts are both wide-ranging and innovative. Brooklyn

Figure 12.9
Deborah Grant
Cryptic Stages, 2000
acrylic, enamel, oil, and
markers on linen, 38 x 38"
(96.52 x 96.52 cm)

Figure 12.10
Deborah Grant
Verdicts, 2000
acrylic, enamel, oil, and
markers on linen, 38 x 38"
(96.52 x 96.52 cm)

artist **Tana Hargest** (b. 1969), an M.F.A. graduate of RISD, is a product designer and the chief executive officer of a corporation known as Bitter Nigger, Inc., founded in 1997. Her firm provides a consumer-accessible forum for dialogues about race by producing tongue-in-cheek packaging and products, such as medicines called "Tominix" (as in Uncle Tom), designed to eliminate hostility and cynicism in people of color who have endured "years of fruitless struggle and strife" in their unsuccessful attempts to realize the American dream. *Homage to an Unknown Suburban Black Girl* by **Jennie C. Jones** (b. 1968), another Skowhegan alumna, is a site-specific photo installation that surveys the "black is beautiful" phenomenon through a nostalgic, deeply sympathetic, and understated lens.[10]

Adia Millet (b. 1975), a product of the California Institute of the Arts, uses handmade and manufactured props to meticulously construct dollhouses. Her assemblages, however, do not reproduce ideal suburban homes as one might expect, but rather rundown, threadbare urban dwellings that connote the lower classes. A variety of either decorative or functioning audio equipment (playing rhythm-and-blues songs, patriotic hymns, and political and intellectual speeches) comprise the aesthetically challenging and socially critical "boom paintings" and sound installations of the Skowhegan- and NYU-trained artist **Nadine Robinson** (b. 1968). The video *Sometimes* (1999) by **Susan Smith-Pinelo** (b. 1969) presents a close-up image of the artist's cleavage framed by a low-cut white T-shirt and adorned with a pendant necklace that spells out the word "ghetto." In this and other videos, Smith-Pinelo proffers gyrating images of scantily clad women moving to pop and hip-hop music, to draw attention to the unrelenting fetishism of the black female body in modern society.[11]

The works of still other "Freestyle" contributors, as the exhibition's title suggests, explore less proselytizing and more neoplatonic themes. Cal Arts graduate **Kira Lynn Harris** (b. 1963) creates amorphous light experiments in both photography and installation to explore the nature of space and darkness. The conceptual and minimalist sound installations of **Camille Norment** (b. 1970), who has postgraduate degrees in both fine arts and interactive telecommunications, affect the physical self-awareness of the viewer through sound vibrations and by controlling the viewer's movements through a site. The architectural renderings of RISD-trained **Julie Mehretu** (b. 1970) are amalgams of expressionistic drawing and futuristic design. Her compositions are contemporary distillations in two dimensions of the "Merzbau," a chaotic living environment constructed in the 1920s and 1930s by German dadaist Kurt Schwitters in his Hannover home.[12]

As the "Freestyle" contingent suggests, for a considerable number of new millennium artists, identity politics are alive and well (although the

modes of expression have surely changed). At the same time, an equally significant percentage have dispensed with culturally rooted art. The New York painter **Philemona Williamson** (b. 1951) is an example of the latter; her works represent a distinctly postmodern return to the figurative in art and actualize the artist's exploration of her private identity. At the same time her imagery (mainly depictions of children) is collective in nature and without clearly defined references to political or social platforms. "I do not make 'black art'," explains Williamson. "If my work bridges racial gaps, it is because I am sharing a part of myself and I happen to be black. My paintings are about my fascination with color and shape."[13] As this statement reflects, Williamson is most concerned with formal issues. Her preference for figurative imagery, which she embraced while a student at Bennington College in Vermont despite the fact that the art department advocated abstraction, would become a hallmark of 1970s postmodernism. Williamson's art not only foresaw the resurgence of the figurative, but also boasted the iridescent colors and self-conscious naïveté that would soon bring folk art to the fore. Indeed, her avowed appreciation for the works of Nellie Mae Rowe and Gertrude Morgan and her experience as an artist-in-residence at the Centre d'Art in Port-au-Prince—long-time headquarters of a colorist vernacular art movement in Haiti—are clearly evident in her work.[14]

Williamson produces surrealistic images of children at play, using a variegated palette and cogently defined forms. These works are drawn directly from her childhood. As a youngster, Williamson lived on New York's exclusive Sutton Place, but her parents were North Carolinians who had come to work and live in the home of affluent Greek émigrés; her father was the family chauffeur and her mother the housekeeper. Truisms about classical Greek reserve and the visceral nature of African Americans were reversed in Williamson's Sutton Place apartment. Williamson described her family's employers as the perpetrators of an interminable "Greek passion play," while she and her parents conversely maintained "a kind of quiet gentility." To Williamson, who lived in this environment until her teen years, the experience was oddly cloistered and out of sync with the reality she faced when her family moved to an urban black neighborhood, where "she was brought abruptly face to face with her heritage."[15]

Williamson considers her paintings an attempt to reckon with her childhood: who she was, what her values were, and where she belonged. Their narratives explore the artist's powerful memories of the "high drama" of life with her Greek extended family. Her compositions grapple with the psychological "pain and peculiarity" of her childhood and, as the artist has insisted, do not address race or gender in explicit or polemical terms.[16]

Rather, these paintings depict a variety of young players who share their pictorial stage and offbeat experiences equally. The range of pigments that define the skin of many of Williamson's figures is more visually than racially descriptive, and is part of an overall zest for color that denotes the artist's style.

In the manner of the surrealists, Williamson's paintings do not depict actual or even constructed events, but are instead windows into a developmental stage of the artist's mind. Elements of play and danger abound in these portraits of prepubescent female gestation, as is the case in *Curiosity's Path* (1995), which portrays two girls in prone positions (fig. 12.11). One girl

Figure 12.11
Philemona Williamson
Curiosity's Path, 1995
oil on linen, 48 x 60"
(122 x 152.4 cm)

Figure 12.12
Philemona Williamson
Prickly Pear, 2002
oil on linen, 48 x 60"
(122 x 152.4 cm)

is being pulled by an unseen force into a yellow bus, while the other seems to have stumbled over a tree stump, falling dangerously close to four metal spikes (a recurring emblem of peril in the artist's iconography). The incongruity of the girls' ingenuous attire—bobby socks, cotton blouses, and Mary Janes—coupled with their vulnerable positions and states of dishabille suggest the Freudian fourth stage of child development and the onset of puberty with all of its attendant psychosexual hazards.[17]

The atmosphere in Williamson's *Prickly Pear* (2002) is seething with the portent of violence swathed in the illusion of child's play. Here the artist employs oblique Cezannesque perspectives, precarious poses, evidence of bloodshed (note the hands of the girls who have handled the spiked fruit), and a violet slingshot strapped to one child's knee like a splint, to suggest a dream vision of profound psychological and iconographical import (fig. 12.12). Features such as the bra worn by one girl outside of her dress as she peers apprehensively over her shoulder, the barbs that cover the fruit she holds, and the presence of a blood stain on the corner of a table that projects phallically and hazardously toward her resonate with sexual tension and violence.

Working for the most part in oil on linen with relatively small brushes, Williamson maintains strict control of the textures and colors in her compositions. Her work as a book jacket illustrator for a publishing company in the mid-1970s contributes to the artist's narrative and visual dexterity and clarity. Recurring motifs of broken dolls and of little girls clambering and plummeting through perilous fairy worlds toward potential calamity suggest the artist's destabilizing history, while the expressions of serenity and sagacity that mark each child's face remind viewers of the cognitive stamina required to maintain sanity in a topsy-turvy world. The artist's ability to encapsulate the childhood experience on canvas is strengthened by her ongoing work as an art teacher to youngsters, in whom she tries to instill a sense that art should be "fun and honest, and always magical."[18]

The drawings and prints of **Gail Shaw-Clemons** (b. 1953) depict the visual equivalents of inner and outer space imploded. Using a subtly hued palette, Shaw-Clemons renders sumptuous protozoan forms enveloped either by cavernous spaces or energized ribbons of color that stand as hieroglyphs for nature and the environment (fig. 12.13). The artist is especially concerned with the destructive human forces that threaten the ecosystem; her self-described "fantasy figures" and "dreamlike characters from another place and time [proffer] a haunting warning from the future to save our world."[19]

Figure 12.13
Gail Shaw-Clemons
In Flight, 2001
colored pencil and graphite,
22 x 30" (55.88 x 76.2 cm)

Shaw-Clemons began her career studying business, but shifted directions to complete an M.F.A. in printmaking and, later, to study at the Blackburn studio in New York. She has traveled worldwide, but much of her imagery is clearly reflective of the natural phenomena of the places she visits rather than their cultural marvels, as indicated by her *Indigo* series, inspired by the midnight sun in Ödeshog, Sweden, where she spent summers as an artist-in-residence.[20]

Also born in 1953, **Chakaia Booker** transforms alternative media—most recently recycled rubber tires—into densely textured, composite forms that are both aesthetically and conceptually sumptuous. Booker is a successor to the legacy of neo-dada abstractionists such as Louise Nevelson, whose mid-twentieth-century "found" wood assemblages seem to inform the younger artist's aesthetic. Booker, however, has brought the genre into the new millennium by fusing a minimalist interest in industrial materials, a dada concern for the obfuscation of high and low art, and conceptual foci that center on such wide-ranging subjects as race, beauty, privilege, and spirituality. Her themes do not manifest themselves in narrative form, however, but rather in the overwhelming blackness of her rubber pieces, in their inherent physicality, and in their evocative titles—*Echoes in Black*, *Spirit Hunter (Industralized Nkisi Nkondi)*, and *Repugnant Rapunzel (Let Down Your Hair)*. Viewers are challenged to read Booker's works as both postmodern objects and as post-black "texts."

Figure 12.14

Chakaia Booker

Vertical Flight, 2003

rubber tires and wood,

46 x 39 x 28"

(116.84 x 99.06 x 71.12 cm)

Booker manipulates her materials—truck, car, and bicycle tires and inner tubes—into variegates forms by cutting, folding, twisting, and turning them inside out to create an assortment of curving, whip-like projections and orbicular shapes that are anchored to wood or metal armatures. The end results are nothing short of startling—from animate, free floating sculptures such as *Vertical Flight* (2003) (fig. 12.14), which writhes like some primordial Medusan creature, to monumental outdoor works and wall-sized reliefs, including the critically acclaimed *It's So Hard to Be Green*, which was exhibited at the Whitney Biennial in 2000. An MFA graduate of City College (1993), Booker began her career making "wearable" art (clothing and jewelry) and assemblages from castoff furniture, plumbing, and debris found at construction sites. She con-

tinues to work as a weaver, ceramicist, and assemblage artist, and her art has recently entered the prestigious collections of Vera G. List and New York's Metropolitan Museum of Art.

The art of **Debra Priestly** (b. 1961) straddles the divide between figuration and abstraction, insinuating the physical world through amorphous forms and gestures as well as through representational imagery. Priestly, an M.F.A. graduate of Pratt Institute, composes in several media, including painting, printmaking, and assemblage. *Patoka #10: Dried Apples* (1994) is a configuration of broad segments of color that suggest a rugged shoreline in black, a sea in green, and a glowing twilight horizon (fig. 12.15). Inscribed into the painting's black zone is a bright red, arched passageway which seems to reveal the burning center of a dormant volcano into which the viewer's gaze is irresistibly drawn. Littered upon the craggy edge of the "shoreline" are sliced apples, some painted and some merely etched into the black ground. The form of a ladder tipped over on its side, or train tracks that lead to nowhere, floats overhead, nearly obscuring the golden sunset. The hermetic psychological narratives of surrealism, the coarse gestures of abstract expressionism, and color-field expanses of pigment combine in this painting to produce a design that is more than the sum of its parts. Priestly's art transcends politics and instead prioritizes the artist's aesthetic platform.

Through the *Patoka* series, named for the Indiana home town of her parents, Priestly delves into her own family history and those aspects of the past that will remain for her viewers eternally elusive and unknown. In her more recent work, Priestly's Patoka theme has evolved into a mixed-media series entitled *Patoka Hill*—part of a multiseries collection that includes

Figure 12.15
Debra Priestly
Patoka #10: Dried Apples, 1994
mixed media on birch,
32 x 48 x 4"
(81.3 x 122 x 10.16 cm)

Figure 12.16

Debra Priestly

Strange Fruit #18, 2001

mixed media on wood, 36 x 24"

(91.44 x 60.96 cm)

other cycles such as *Mattoon* and *Strange Fruit*. As an ensemble, these works have been assigned the appellation *Preserves* because they comprise mounted photos of Mason or bell jars in which are "preserved" (through the use of digitized news and personal photographs, documents, objects, and drawings, both new and antique) the artist's personal history as part of the macrocosm of the social and political history of the United States.

Priestly's *Strange Fruit*, named for the antilynching ballad popularized by jazz singer Billie Holiday, includes diagrams of slave ships, abolitionist and runaway slave placards, portraits of black leaders, and an autopsy diagram of the entry wounds in the body of police-shooting victim Amadou Diallo. *Strange Fruit #18* (2001) features twenty photographs taken by Priestly following the 11 September 2001 terrorist attacks (fig. 12.16). Encased within pictures of individual preserve jars and sealed beneath a blue glassine patina are photos of American flags, personal altars, mourning crowds, and war monuments—bringing the artist's personal and cultural history into the contemporaneous realm of an unfolding history that has global ramifications. Priestly's pictorial arrangements take their cues from truly heterogeneous sources: current and past events, early Christian illumination, colonial American portraiture, folk art and quilts, Maori philosophy (the artist taught printmaking in New Zealand), and even game boards. The eclectic stimuli that surface in Priestly's art points to her investment in the ever-shrinking global community. As one observer put it, Priestly's photo-based imagery in particular functions as "memento mori for the twenty-first century."[21]

While still concerned with the politics of race, class, and sex, the sources for post-black subject matter expanded to encompass such wide-ranging themes as time and space, hip hop, new media, alternative rock, global culture, and the Internet. Indeed, according to theorist Horace Brockington, by the end of the 1990s, "the preoccupation with identity representation in art was beginning to look dated," as artists of color began to explore alternative motifs with the same fervor that their predecessors had invested in cultural expression.[22] As Golden has assessed, there is an ongoing effort to reevaluate the persistence of race as a concept in contemporary culture. The national census taken in 2000 disclosed that an increasing segment of the

U.S. population has chosen to reject racial labeling. "Other" has become the self-identification of choice for a growing number of Americans whose racial profiles are composites of two or more ethnicities, and many are claiming entitlement to several cultural birthrights at once.[23]

Similarly, artist and critic Keith Morrison has questioned whether the old racial labels of black, white, and yellow are still valid. In his estimation, they have become little more than descriptive terms, adjectives to describe differences in hue, rather than nouns to describe race:

> As color distinctions proliferate, white may become not a race apart, but another color among many. But will this eliminate racism in America? The likely answer is no, since without a mass redistribution of wealth . . . people of color will remain the poorest. By virtue of being poor—and disenfranchised—artists of color will likely continue to work outside of the art establishment for the foreseeable future.[24]

As Morrison correctly assesses, although there are more women and artists of color populating the mainstream than ever before, their numbers are still fractional. Post-ethnicity may yet prove to be "another exercise in control from above, a marketing label of greatest benefit to the privileged . . . a rejection of identity-based art at the behest of a white-dominated art market."[25]

African Americans have born the cross of segregation from the mainstream and regulation by the "white-dominated art market" for too long. Social, cultural, and scholarly biases continue to foil their efforts to attain lasting recognition. In the realm of art scholarship, insular thinking has kept African-American women artists especially isolated in their own exhibitions and written histories. While, ideally, they should be integrated into surveys of American and Western art, studies like this one are still necessary to inform members of academia and the art world of the relatively unknown and unrecognized achievements of African-American women artists. Post-black artists who are now creating both within and without the confines of their socially conceived identities represent a primary and crucial philosophical realignment within the art community, which may someday result in the bias-free utopia that has thus far eluded women artists of color. If indeed the members of the fledgling post-black brigade somehow succeed in repositioning themselves as individuals rather than as women or of color and in creating art that reifies their distinctive humanity, they could produce, as Cotter affirms, "a new American art on a truly cosmopolitan model, and render contingent, culture-war labels like post-black and post-ethnic"—indeed, even postgender— "obsolete."[26]

CHAPTER ONE

1. Steven C. Dubin, "Symbolic Slavery: Black Representations in Popular Culture," *Social Problems* 34, no. 2 (April 1987): 122.

2. Jean Devisse, *The Image of the Black in Western Art*, vol. 2 (Cambridge, Mass.: Harvard University Press, 1979); Hugh Honour, *The Image of the Black in Western Art*, vol. 4 (Cambridge, Mass.: Harvard University Press, 1989); Peter Mark, *Africans in European Eyes: Portrayal of Black Africans in Fourteenth- and Fifteenth-Century Europe* (Syracuse, N.Y.: Syracuse University Press, 1974); Jan N. Pieterse, *White on Black: Images of Africa and Blacks in Western Popular Culture* (New Haven, Conn.: Yale University Press, 1992).

3. Devisse, *Image of the Black*, vol. 2, part 1, 81–148.

4. Ibid.; Mark, *Africans in European Eyes*, 10–15; Pieterse, *White on Black*, 24–29.

5. Devisse, *Image of the Black*, vol. 2, part 1, 81–148.

6. Pieterse, *White on Black*, 28.

7. Ibid., 64–75.

8. Ibid.

9. Carolus [Carl] Linnaeus, *Systems Naturae* (1758; reprint, Göttingen, Germany: Vandenhoeck, 1772), quoted in Peter James Marshall and Glyndwr Williams, *The Great Map of Mankind: British Perceptions of the World in the Age of Enlightenment* (Cambridge, Mass.: Harvard University Press, 1982), 245.

10. David Hume, "Of National Character," in *The Philosophical Works of David Hume*, 4 vols. (Boston: Little, Brown, 1854); Philip D. Curtin, *The Image of Africa: British Ideas and Action, 1780–1850*, vol. 1 (Madison: University of Wisconsin Press, 1964), 1, 42.

11. Petrus Camper, *Dissertation physique de M. Pierre Camper* (Utrecht: Wild and Altheer, 1791); Johann Blumenbach, *On the Natural Variety of Mankind* (Göttingen, Germany: Dietrich,1795); H. W. Debrunner, *Presence and Prestige: Africans in Europe* (Basel, Switzerland: Basler Afrika Bibliographien, 1979), 141–143, 301; Georg Wilhelm Friedrich Hegel, *Vorlesungen über die Philosophie der Geschichte* (Leipzig: Reclam, 1925?; reprint, Stuttgart: Reclam, 1949, 1961), 137–140; Pieterse, *White on Black*, 34, 40.

12. Anonymous Franciscan Friar, *Book of the Knowledge of All the Kingdoms, Lands, Lordships that Are in the World and the Arms and Devices of Each Land and Lordship or of the Kings and Lords Who Possess Them*, ser. 2, vol. 29, trans. Clements Markham (London: Hakluyt Society, 1912); Mark, *Africans in European Eyes*, 36–37; Charles Darwin, *Origin of the Species* (New York: D. Appleton, 1860).

13. Georges Louis Leclerc, Comte de Buffon, *Histoire naturelle*, 14 vols. (Paris: Dufart [1802–1805]); John Herbert Eddy, Jr., "Buffon, Organic Change, and the Races of Man" (Ph.D. diss., University of Oklahoma, 1977), 109; Julien Joseph Virey, *Histoire naturelle du genre humain*, vol. 2 (Paris: Crochard, 1824), 151; Sander L.

Notes

Gilman, *Difference and Pathology: Stereotypes of Race, Sexuality and Madness* (Ithaca, N.Y.: Cornell University Press, 1985), 85.

14. Robert Rydell, *All the World's a Fair: Visions of Empire at American International Expositions* (Chicago, Ill.: University of Chicago Press, 1984), ch. 2; Deborah Willis and Carla Williams, *The Black Female Body: A Photographic History* (Philadelphia, Pa.: Temple University Press, 2002), 60–61.

15. Phyllis J. Jackson, "(In)forming the Visual: (Re)presenting Women of African Descent," *International Review of African-American Art* 14, no. 3 (1997): 34. Not until 2002 were Baartman's remains at last returned to South Africa for burial.

16. Honour, *Image of the Black*, vol. 4, part 1, 52; Georges Cuvier, *Le règne animal distribué d'après son organisation, pour servir de base à l'histoire naturelle des animaux et d'introduction à l'anatomie comparée*, v. 3 (Paris: Deterville), 259–274, reprint of essay first published in four issues of *Annales du Muséum d'Histoire Naturelle* [18, 19.1, 19.20, 19.30], [1816]. Gilman, *Difference and Pathology*, 85; Pieterse, *White on Black*, 180–181.

17. Gilman, *Difference and Pathology*, 85; Dominique Octave Mannoni, *Prospero and Caliban: The Psychology of Colonization* (New York: Praeger, 1956; reprint, 1964), 18, 197–201; Pieterse, *White on Black*, 173.

18. Pieterse, *White on Black*, ch. 12.

19. Wassily Kandinsky, "Reminiscences," in *Kandinsky: Complete Writings on Art*, vol. 1 (Boston: G. K. Hall and Co., 1982), 372; Max Kozloff, "The Authoritarian Personality in Modern Art," *Artforum* 12 (May 1974): 46.

20. Stéphane Mallarmé, "The Impressionists and Édouard Manet," *Art Monthly Review* (Sept. 1876); T. A. Gronberg, ed., *Manet: A Retrospective* (New York: Park Lane, 1988), 146.

21. Gilman, *Difference and Pathology*, 102.

22. Mary Mathews Gedo, "Art as Exorcism: Picasso's 'Demoiselles d'Avignon,'" *Arts Magazine* 55, no. 2 (Oct. 1980): 70–83; Leo Steinberg, "The Philosophical Brothel,"

October 44 (Spring 1988): 7–74; William Rubin, "Picasso," in *Primitivism in Twentieth-Century Art: Affinity of the Tribal and the Modern*, vol. 1 (New York: Museum of Modern Art, 1984), 240–343; William Rubin, "Painting and Sculpture," in *The Museum of Modern Art: The History and the Collection* (New York: Museum of Modern Art, 1984), 95.

23. Barbara Welter, "Cult of True Womanhood, 1820–60," *American Quarterly* 18 (1966): 151–174.

24. Joseph Tillinghast, *The Negro in Africa and America* (New York: Macmillan, 1902), 2; Robert E. Park, "Education and Its Relation to the Conflict and Fusion of Cultures with Special Reference to the Problems of the Immigrant, the Negro and Missions," *PASS* 13 (Dec. 1918): 40–41; Vernon J. Williams, Jr., *From a Caste to a Minority: Changing Attitudes of American Sociologists toward Afro-Americans, 1896–1945* (Westport, Conn.: Greenwood, 1989), 36–37, 86; Gunnar Myrdal, *An American Dilemma: The Negro Problem and Modern Democracy*, 2 vols. (New York: Harper and Row, 1944).

25. Park, "Education and Its Relation to the Conflict and Fusion of Cultures," 40–41; Myrdal, *An American Dilemma*, 1073–1077.

26. Howard Odum, *Social and Mental Traits of the Negro: Research into the Condition of the Negro Race in Southern Towns* (New York: AMS Press and Columbia University, 1910), 36–42, 250–276, 213–237; Arthur W. Calhoun, *A Social History of the American Family from Colonial Times to the Present*, vol. 3 (Cleveland, Ohio: Clark, 1917–1919), 41–50; Herbert G. Gutman, *The Black Family in Slavery and Freedom, 1750–1925* (New York: Random House, 1977), 459.

27. Nathan Glazer and Daniel Patrick Moynihan, *Beyond the Melting Pot: The Negroes, Puerto Ricans, Jews, and Italians of New York City* (Washington, D.C.: Government Printing Office, 1967); Michele Wallace, *Invisibility Blues: From Pop to Theory* (New York: Verso, 1990), 20.

28. Melvin Patrick Ely, *The Adventures of Amos 'n' Andy: A Social History of an Ameri-*

can Phenomenon (New York: Maxwell Macmillan, 1991); Beverly Guy-Sheftall, "Sapphire," in *Black Women in America: An Historical Encyclopedia*, vol. 2, ed. Darlene Clark Hine et al. (Bloomington: Indiana University Press, 1993), 1009–1010.

29. Patricia Morton, *Disfigured Images: The Historical Assault on Afro-American Women* (Westport, Conn.: Praeger, 1991), 5; Toni Cade Bambara, ed., *The Black Woman: An Anthology* (New York: Penguin, 1970); Robert Staples, "The Myth of Black Matriarchy," *Black Scholar* 1 (1970): 9–16; Michele Wallace, *Black Macho and the Myth of the Superwoman* (New York: Dial, 1978; reprint, New York: Verso, 1990), 107.

30. Quoted in Wallace, *Black Macho*, xii, 1–16, 99–111.

31. See Carolyn Bird, "Woman Power," *New York*, March 1969, 38; cf. Paula Giddings, *When and Where I Enter: The Impact of Black Women on Race and Sex in America* (New York: Bantam, 1988), 329.

32. Giddings, *When and Where I Enter*, 314; Angela Davis, *Angela Davis: An Autobiography* (New York: Random House, 1974), 181, 187; Floyd McKissick, quoted in Howard Sitkoff, *Struggle for Black Equality, 1954–1980* (New York: Hill and Wang, 1981), 215; Hugh Pearson, *The Shadow of the Panther: Huey Newton and the Price of Black Power in America* (New York: Addison-Wesley, 1994), 173–175, 178–179; Barbara E. Sizemore, "Sexism and the Black Male," *Black Scholar* (March–April 1973): 6; Essien-Udosen, Essien-Udom, *Black Nationalism: A Search for an Identity in America* (New York: Dell, 1967), 79–99.

33. Abbey Lincoln, "Who Will Revere the Black Woman," *Negro Digest* 15, no. 11 (Sept. 1966): 18.

34. Eldridge Cleaver, "The Allegory of Black Eunuchs," in *Soul on Ice* (New York: McGraw-Hill, 1968), 155–175, esp. 162.

CHAPTER TWO

1. Nkiru Nzegwu, "Spiritualizing Craft: The African-American Craft Art Legacy," *International Review of African-American Art* 11, no. 2 (1994): 18; Cuesta Benberry, "African-American Quilts: Paradigms of Black Diversity," *International Review of African-American Art* 12, no. 3 (1995): 35.

2. Arthur Danto et al., *ART/artifact: African Art in Anthropological Collections* (New York: Center for African Art, 1988).

3. Floyd Coleman, "Mediating the Natural: Craft Art and African-American Cultural Expression," *International Review of African-American Art* 11, no. 2 (1994): 25.

4. John Vlach, *The Afro-American Tradition in Decorative Arts* (Cleveland, Ohio: Cleveland Museum of Arts, 1978); Maude Wahlman, *Signs and Symbols: African Images in African-American Quilts* (New York: Studio Books, 1993); Gladys-Marie Fry, *Stitched from the Soul: Slave Quilts from the Ante-Bellum South* (New York: Dutton, 1990); Benberry, "African-American Quilts," 30–37.

5. Fannie Moore, quoted in Norman Yetman, *Life under the "Peculiar Institution": Selections from the Slave Narrative Collection* (New York: Holt, Rinehart and Winston, 1970), 227.

6. Patsy Orlofsky and Myron Orlofsky, *Quilts in America* (New York: McGraw-Hill, 1992), 15–17; Vlach, *Afro-American Tradition*, 45–48, 55, 75; Benberry, "African-American Quilts," 31–32.

7. Kenneth Combs, Warrensville Heights, Ohio, letter to author, April 2003; Wahlman, *Signs and Symbols*, 21, 25, 67, 86, 105, 109; Joseph Holloway, *Africanisms in American Culture* (Bloomington: Indiana University Press, 1990), 3; Vlach, *Afro-American Tradition*, 55, 75; Robert Farris Thompson, *Flash of the Spirit: African and Afro-American Art and Philosophy* (New York Random House, 1984), 207–208, 218–220; Jacqueline L. Tobin and Raymond G. Dobard, *Hidden in Plain View: The Secret Story of Quilts and the Underground Railroad* (New York: Random House, 1999), 48.

8. Judith Chase, "Afro-American Heritage from Ante-Bellum Black Craftsmen," *Southern Folklore Quarterly* 42 (1978): 156.

9. Vlach, *Afro-American Tradition*, 67; Mary Eunice Covington Jones, interview by Mildred Arnold, Richard Hulan, and Kathleen Hulan, 18 August 1978, transcript

Richard Hulan and Kathleen Hulan, Springfield, Va. There is some indication in this interview that Josie Covington used quilt pieces made by her employer, Mrs. Alice Page Pettus (1855–1905), who aided in the construction of the quilt.

10. Thompson, *Flash of the Spirit*, 227; Robert Farris Thompson, "Black Ideographic Writing: Calabar to Cuba," *Yale Alumni Magazine* (November 1978): 29–33; David Dalby, "The Indigenous Scripts of West Africa and Surinam: Their Inspiration and Design," *African Language Studies* 11 (1968): 156–197; Wahlman, *Signs and Symbols*, 77–78.

11. Donald J. Cosentino, ed., *Sacred Arts of Haitian Vodou* (Los Angeles, Calif.: UCLA Fowler Museum of Cultural History, 1995), 84–85; Thompson, *Flash of the Spirit*, 125–127, 147, 179; Alfred Metraux, *Voodoo in Haiti* (New York: Schocken, 1972), 310–312.

12. Ibid.

13. The quilt code, outlined in Tobin and Dobard's *Hidden in Plain View*, has been questioned by scholars such as Marsha MacDowell, folk arts curator of the Michigan Museum in East Lansing. See Desiree Cooper, "Sewing Up Facts on Slave Quilts," *Detroit Free Press* online, 18 Feb. 2003, http://www.freep.com/news/metro/des18_20030218.htm (accessed 11 Feb. 2004).

14. Tobin and Dobard, *Hidden in Plain View*, 1–3, 74; Mary Ellen Cummings, "Was There a Quilt Code, or Not?" *Emmitsburg Dispatch* 2, no. 7 (July 2003), available online at http://www.emmitsburgdispatch.com/2003/July/quilters.shtml (accessed 9 Feb. 2004).

15. Tobin and Dobard, *Hidden in Plain View*, 97–104; Sandi Fox, "The Log Cabin: An American Quilt on the Western Frontier," *Quilt Digest* 1 (1985): 6–10; Wahlman, *Signs and Symbols*, 85, 89.

16. Tobin and Dobard, *Hidden in Plain View*, 29, 59.

17. Ibid., 104–126, 182–183.

18. Author's telephone interview with art historian and iconographer Jack Jarzaveck, 11 and 13 July 2000; Leonard W. Moses and Stephen C. Cappannari, "In Quest of the Black Virgin: She Is Black Because She Is Black," in *Mother Worship: Theme and Variations*, ed. James J. Preston (Chapel Hill: University of North Carolina Press, 1982), ch. 3; Ean Begg, *The Cult of the Black Virgin* (London: Penguin, 1996), 248–250; China Galland, *Looking for Darkness: Tara and the Black Madonna, a Ten-Year Journey* (London: Penguin, 1990), chs. 9–15.

19. Milo Rigaud, *Secrets of Voodoo* (San Francisco, Calif.: City Lights, 1985), 45; Phyllis Galembo, *Vodou: Visions and Voices of Haiti* (Berkeley, Calif.: Ten Speed, 1998), x, xx, xxi, 6, 8, 10, 11, 44, 47, 48, 98; Cosentino, *Sacred Arts of Haitian Vodou*, 300; David Nicholls, *From Dessalines to Duvalier: Race, Colour and National Independence in Haiti* (New Brunswick, N.J.: Rutgers University Press, 1996), 265.

20. Cosentino, *Sacred Arts of Haitian Vodou*, chs. 8, 9, 11, 15.

21. Fry, *Stitched from the Soul*, 86; Gladys-Marie Fry, "Harriet Powers: Portrait of a Black Quilter," in *Missing Pieces: Georgia Folk Art 1776–1976*, ed. Anna Wadsworth (Atlanta: Georgia Council for the Arts and Humanities, 1976), 16–23; Wahlman, *Signs and Symbols*, 2, 60, 64.

22. Tobin and Dobard, *Hidden in Plain View*, 29, 59, 124–125; Wahlman, *Signs and Symbols*, 89.

23. Fry, *Stitched from the Soul*, 86, 90; Fry, "Harriet Powers," 16–23; Wahlman, *Signs and Symbols*, 2, 60, 64; Vlach, *Afro-American Tradition*, 48–52; Rosalind Jeffries, "African Retentions in African-American Quilts and Artifacts," *International Review of African-American Art* 11, no. 2 (1994): 29–37.

24. Oneita Virginia "Jennie" Smith, quoted in Fry, "Harriet Powers," 86; Kate P. Kent, "Appliqué," in *Black People and Their Culture: Selected Writings from the African Diaspora*, ed. Linn Shapiro (Washington, D.C.: Smithsonian Institution Press, 1976), 59; cf. Vlach, *Afro-American Tradition*, 45–47, 50–51, 54.

25. Ibid.

26. Ibid.; Venice Lamb, *West African Weaving* (London: Duckworth, 1975), 14–15; Melville Herskovitz, *Dahomey: An Ancient West African Kingdom*, 2 vols. (New York:

Augustin, 1938); Roy Sieber, *African Textiles and Decorative Arts* (New York: Museum of Modern Art, 1972), 29, 41, 206; Raymond G. Dobard, "Quilts as Communal Emblems and Personal Icons," *International Review of African-American Art* 11, no. 2 (1994): 41.

27. Darlene Clark Hine et al., eds., *Black Women in America: An Historical Encyclopedia*, vol. 1 (Bloomington: Indiana University, 1993), 394–397, 405–406; Darlene Clark Hine et al., eds., *Facts on File Encyclopedia of Black Women in America: Dance, Sports, and Visual Arts* (New York: Facts on File, 1997), 147–149.

28. Ibid.

29. Kathleen Thompson, "Elizabeth Keckley," in Hine et al., *Black Women in America*, 672–673; Eva N. Wright, "Elizabeth Keckley," in *Homespun Heroines and Other Women of Distinction*, ed. Hallie Q. Brown (Xenia, Ohio: Aldine, 1926; reprint, New York: Oxford University Press, 1988), 147–149.

30. Ibid.; Elizabeth Keckley, *Behind the Scenes; or, Thirty Years a Slave and Four Years in the White House* (New York: Carleton, 1868; reprint, New York: Arno, 1968); Benberry, "African-American Quilts," 36.

31. Gerald L. Davis, "Afro-American Coil Basketry in Charleston County, South Carolina: Affective Characteristics of an Artistic Craft in Social Context," in *American Folklife*, ed. Don Yoder (Austin: University of Texas, 1976), 153; Regenia A. Perry, "African Art and African-American Folk Art: A Stylistic and Spiritual Kinship," in *Black Art, Ancestral Legacy: The African Impulse in African-American Art*, ed. David C. Driskell (New York: Abrams, 1989), 35–36; Judith Chase, *Afro-American Art and Craft* (New York: Van Nostrand Reinhold, 1971), 78.

32. Ibid.

33. Lisa LeMaistre, "In Search of a Garden: African Americans and the Land in Piedmont, Georgia" (M.A. thesis, University of Georgia, 1988); Frances Kemble, *Journal of a Residence on a Georgia Plantation in 1838–1839* (Athens: University of Georgia Press, 1984); Richard Westmacott, *African-American Gardens and Yards in the Rural South* (Knoxville: University of Tennessee Press, 1992), 1–4, 15–17.

34. Ibid.; James C. Bonner, "House and Landscape Design in the Antebellum South," *Landscape* 21 (1977): 5; Lydia M. Pulsipher, "They Have Saturdays and Sundays to Free Themselves: Slave Gardens in the Caribbean," *Expedition* 2, no. 2 (1990): 24–33, esp. 28; Westmacott, *African-American Gardens*, 1–4, 13–20, 79–80; Paul Arnett and William Arnett, eds., *Souls Grown Deep: African-American Vernacular Art of the South* (Atlanta, Ga.: Tinwood, 2000), 38–39.

35. Patricia Jones-Jackson, *When Roots Die: Endangered Traditions of the Sea Islands* (Athens: University of Georgia Press, 1987), 8; cf. Westmacott, *African-American Gardens*, 31, 33, 39, 43, 79–80.

36. Vlach, *Afro-American Tradition*, 5.

37. Sarah Torain, "Notes and Documents: Antebellum and War Memories of Mrs. Telfair Hodgson," *Georgia Historical Quarterly* 27, no. 4 (Dec. 1943): 352; E. J. Glave, "Fetishism in Congoland," *Century Magazine* 41 (1891): 825; cf. Herskovits, *The Myth of the Negro Past* (1941; reprint, Boston: Beacon, 1958), 197–206; Robert Farris Thompson, "Kongo Influences on African-American Artistic Culture," in Robert Farris Thompson and Joseph Cornet, *The Four Moments of the Sun: Kongo Art in Two Worlds* (Washington, D.C.: National Gallery of Art, 1981), 165, 169.

38. Thompson and Cornet, *Four Moments of the Sun*, 200.

39. Georges Balandier, *Daily Life in the Kingdom of Kongo from the Sixteenth to the Eighteenth Century* (New York: Pantheon, 1965), 251–252; Janet MacGaffey, "The West in Congolese Experience," in *Africa and the West*, ed. Philip D. Curtin (Madison: University of Wisconsin Press, 1972), 52–56.

40. Sarah Washington, Rosa Sallins, and Jane Lewis, quoted in Georgia Writers Project, *Drums and Shadows: Survival Studies among Georgia Coastal Negroes* (Athens: University of Georgia Press, 1940), 130–136.

41. John D. Combes, "Ethnography, Archaeology, and Burial Practices among Coastal South Carolina Blacks," *Conference*

on Historic Site Archaeology Papers 7 (Columbia, S.C.: Institute of Archaeology and Anthropology, 1972), 52.

42. William Faulkner, *Go Down Moses* (New York: Random House, 1955), 135.

CHAPTER THREE

1. Tritobia Hayes Benjamin, introduction to *Facts on File Encyclopedia of Black Women in America: Dance, Sports, and Visual Arts*, ed. Darlene Clark Hine et al. (New York: Facts on File, 1997), 151.

2. Steven Loring Jones, "A Keen Sense of the Artistic: African-American Material Culture in Nineteenth-Century Philadelphia," *International Review of African-American Art* 12, no. 2 (1995): 9–10, 26; Sarah Mapps Douglass, "Adress" in "Ladies Department: Mental Feasts," *Liberator* (Boston), 21 July 1832, [2].

3. Jones, "A Keen Sense of the Artistic," 10.

4. Ibid., 26; Francis J. Grimké Papers, box 40–44, folder 1809, Moorland-Spingarn Research Center, Howard University, Washington, D.C.

5. Jones, "A Keen Sense of the Artistic," 10, 27; *Pennsylvania Freeman* (Philadelphia), no. 7, 11 April 1844, [4]; no. 16, 22 Aug. 1844, [4]; no. 17, 5 Sept. 1844, [4]; Douglass to Angelina Grimké Weld, 18 March 1874, and Douglass to Charles Stuart Faucheraud Weld, 10 Aug. 1874, Weld-Grimké Papers, Manuscript Division, William L. Clements Library, University of Michigan, Ann Arbor.

6. E. L. Thornton, "The Cancer of Prejudice: Eating Deep into American Character," *New York Age*, 23 May 1891, 1; Tritobia Hayes Benjamin, "Triumphant Determination: The Legacy of African-American Women Artists," in *Bearing Witness: Contemporary Works by African-American Women Artists*, ed. Jontyle Theresa Robinson (New York: Rizzoli, 1996), 54–55.

7. Frederick Douglass to S. H. Kaufman, Edward Clark, and F. D. McGuire, 3 Nov. 1891, Butcher Collection, Butler Library, Columbia University, New York.

8. Marcia M. Mathews, *Henry Ossawa Tanner: American Artist* (Chicago, Ill.: University of Chicago Press, 1969), 55.

9. Ibid., 55–60, 71–76; Benjamin, "Triumphant Determination," 54–55.

10. Ibid.; Arna Bontemps, ed., *Forever Free: Art by African-American Women, 1862–1980* (Alexandria, Va.: Stephenson, 1980), 178.

11. Benjamin, "Triumphant Determination," 55; "Wife of Thomas Walker Dead. Achieved Fame as Artist, Had Picture Accepted by French Salon," Obituary, *Washington Tribune*, 14 June 1929, 1.

12. Ibid., 52; Robert S. Fletcher, *History of Oberlin College*, vol. 2 (Oberlin, Ohio: Oberlin College, 1943), 414–415; Geoffrey Blodgett, "John Mercer Langston and the Case of Edmonia Lewis: Oberlin, 1862," *Journal of Negro History* 53, no. 3 (July 1968): 203.

13. Ibid.; Marilyn Richardson, "Edmonia Lewis's *The Death of Cleopatra*: Myth and Identity," *International Review of African-American Art* 12, no. 2 (1995): 44, 52; Lydia Maria Child, letter published in the *Liberator*, 19 Feb. 1864, 31; Samuel Lewis's obituary, *Avant-Courier* (Bozeman, Mont.), 4 April 1896, n.p.; N. A. Lesson, *History of Montana, 1793–1885* (Chicago, Ill.: Warner, Beers, [1885]), 1141; Romare Bearden and Harry Henderson, *A History of African-American Artists from 1792 to the Present* (New York: Pantheon, 1993), 54–56.

14. Ibid.; Blodgett, "John Mercer Langston," 201–218.

15. Fletcher, *History of Oberlin College*, vol. 1, 379; Bearden and Henderson, *History of African-American Artists*, 57–58; Blodgett, "John Mercer Langston," 206; Nancy G. Heller, *Women Artists: An Illustrated History*, 3d ed. (New York: Abbeville, 1997), 86.

16. Blodgett, "John Mercer Langston," 206; John Mercer Langston, *From Virginia Plantation to the National Capitol* (Hartford, Conn.: American, 1894), 176; Bearden and Henderson, *History of African-American Artists*, 57–59.

17. Child, letter published in the *Liberator*, 19 Feb. 1864, 19; Bearden and Henderson, *History of African-American Artists*, 60; Monroe A. Majors, *Noted Negro Women* (Chicago, Ill.: Donohue and Henneberry, 1893), 28.

18. Edmonia Lewis, quoted in "Seeking Equality Abroad: Why Miss Edmonia Lewis, the Colored Sculptor, Returns to Rome. Her Early Life and Struggles," *New York Times*, 29 Dec. 1878, sec. 5, 5; Richardson, "Edmonia Lewis's *The Death of Cleopatra*," 50; Bearden and Henderson, *History of African-American Artists*, 75.

19. Luis F. Emilio, *History of the 54th Regiment of Massachusetts Volunteer Infantry, 1863–1865* (New York: Arno, 1969); Sharon F. Patton, *African-American Art* (New York: Oxford University Press, 1998), 92; Anne Whitney to Sarah Whitney, 12 Dec. 1968 and 19 March 1870, Anne Whitney Correspondence, Wellesley College Library, Wellesley, Mass.; Bearden and Henderson, *History of African-American Artists*, 70–71; Margaret Just Butcher and Alain Locke, *The Negro in American Culture* (New York: Knopf, 1956), 216; Elsa Honig Fine, *The Afro-American Artist: A Search for Identity* (New York: Holt, Rinehart and Winston, 1973), 66.

20. Henry James, *William Wetmore Story and His Friends* (Boston: Houghton Mifflin, 1903; reprint, New York: Grove, 1957), 57; Benjamin, "Triumphant Determination," 53.

21. Phebe Ann Hanaford, *Daughters of America; or, Women of the Century* (Augusta, Maine: True, 1882), 297; Bearden and Henderson, *History of African-American Artists*, 62–64; Lewis to Child, copied to Theodore Tilton, 5 April 1866, in *The Collected Correspondence of Lydia Maria Child*, ed. Patricia G. Holland and Milton Meltzer (Millwood, N.Y.: KTO [Kraus-Thomson Organization] Microform, 1979), microfiche no. 64/1716; Joseph Leach, *Bright Particular Star: The Life and Times of Charlotte Cushman* (New Haven, Conn.: Yale University Press, 1970), 210.

22. Lewis to Child and Tilton, 5 April 1866, in *Collected Correspondence of Lydia Maria Child*, 64/1716.

23. Frederick Douglass, in *Inaugural Ceremonies of the Freedmen's Memorial Monument to Abraham Lincoln, Washington City, April 14, 1876* (St. Louis, 1876), 18–19; Hugh Honour, *Image of the Black in Western Art*, vol. 4 (Cambridge, Mass.: Harvard University Press, 1989), 264–267; John W. Blassingame and John R. McKivigan, eds., *The Frederick Douglass Papers, Series One: Speeches, Debates, and Interviews*, vol. 4: 1864–1880 (New Haven and London: Yale University Press, 1991), 431–432.

24. Judith Wilson, "Hagar's Daughters: Social History, Cultural Heritage, and Afro-U.S. Women's Art," in Robinson, *Bearing Witness*, 99; Patton, *African-American Art*, 95, 97; Marilyn Stokstad, *Art History* (New York: Harry N. Abrams, 1995), 928.

25. [Elizabeth Peabody], *Christian Register* (1869), in Hanaford, *Daughters of America*, 296–298.

26. Bearden and Henderson, *History of African-American Artists*, 64.

27. Anne Whitney to Sarah Whitney, 2 May 1867 and 7 Feb. 1869, Whitney Correspondence; Bearden and Henderson, *History of African-American Artists*, 66–67; William Gerdts, "Celebrities of the Grand Tour," in *The Lure of Italy: American Artists and the Italian Experience, 1760–1916*, ed. Theodore E. Stebbins (Boston, Mass.: Museum of Fine Arts, 1992), 69–71; Kirsten P. Buick, "A Way Out of No Way: African-American Artists in the Nineteenth Century," in *The Walter O. Evans Collection of African-American Art*, ed. Andrea A. Barnwell (Seattle: University of Washington Press, 1999), 38.

28. Laura Curtis Bullard, "Edmonia Lewis," *Revolution* (New York) 7, no. 16 (20 April 1871), reprinted in the *New National Era* 2, no. 17 (4 May 1871): 1; Buick, "A Way Out of No Way, 38.

29. Lewis, quoted in "Edmonia Lewis: The Famous Colored Sculptress in San Francisco," *San Francisco Chronicle*, 26 Aug. 1873, 5, and *San Jose Daily Mercury*, 19 Sept. 1873, 3, reprinted from *Pacific Appeal* (San Francisco), 16 Aug. 1873, 1; William Gerdts, *American Neo-Classic Sculpture: The Marble Resurrection* (New York: Viking, 1973), 136; Buick, "A Way Out of No Way," 36; Fine, *Afro-American Artist*, 64; "The Colored Sculptress: Exhibition of Her Works at the Rooms of the Art Association," *San Francisco Chronicle*, 30 Sept. 1873, [3]; Bearden

and Henderson, *History of African-American Artists*, 65, 72–73.

30. "The Colored Sculptress," *San Francisco Chronicle*, 30 Sept. 1873, [3]; Bearden and Henderson, *History of African-American Artists*, 72.

31. *San Jose Patriot*, 27 Sept. 1873, cited in Philip M. Montesano, "The Mystery of the San Jose Statues," *Urban West* (May–June 1968): 26; Fine, *Afro-American Artist*, 66.

32. Fine, *Afro-American Artist*, 65, 67.

33. Genesis 16–17, King James Version (hereafter KJV); Angela Davis, "The Legacy of Slavery," in *Women, Race and Class* (New York: Random House, 1981), 3–30; Bearden and Henderson, *History of African-American Artists*, 66.

34. Genesis 16:8 KJV.

35. Henry T. Tuckerman, *Book of the Artists: American Artist Life, Comprising the Biographical Sketches of American Artists* (New York: Putnam, 1876), 603–604; James A. Porter, *Modern Negro Art* (New York: Dryden, 1943), 61–62.

36. Bearden and Henderson, *History of African-American Artists*, 68; Child to Shaw, 1870, in *Collected Correspondence of Lydia Maria Child*, 74/1958; Linda Nochlin, *Women, Art, and Power, and Other Essays* (New York: Harper and Row, 1988), 158–164.

37. *Chicago Daily Tribune*, 29 Aug. and 6 Sept. 1870; Bearden and Henderson, *History of African-American Artists*, 68–69.

38. Buick, "A Way Out of No Way," 37–38; Henry Wadsworth Longfellow, *Song of Hiawatha* (1855; reprint, New York: Bounty, 1968); Bearden and Henderson, *History of African-American Artists*, 70.

39. J. S. Ingram, *The Centennial Exposition* (Philadelphia, Pa.: Hubbard, 1876), 372; *People's Advocate* 1, no. 15 (22 July 1876): 3; Richardson, "Edmonia Lewis's *The Death of Cleopatra*," 36; Bearden and Henderson, *History of African-American Artists*, 45, 73.

40. Richardson, "Edmonia Lewis's *The Death of Cleopatra*," 45–46; Walter J. Clark, Jr., *Great American Sculptures* (Philadelphia, Pa.: Gebbie and Barrie, 1878), 141–142; Bearden and Henderson, *History of African-American Artists*, 74.

41. Clark, *Great American Sculptures*, 141.

42. Richardson, "Edmonia Lewis's *The Death of Cleopatra*," 40, 43, 45; Martin Bernal, *Black Athena: The Afroasiatic Roots of Classical Civilization*, vol. 1 (New Brunswick, N.J.: Rutgers University Press, 1987), 123; Kirsten P. Buick, "Edmonia Lewis in Art History: The Paradox of the Exotic Subject," in *3 Generations of African-American Women Sculptors: A Study in Paradox*, ed. Leslie King-Hammond and Tritobia Hayes Benjamin (Philadelphia, Pa.: Afro-American Historical and Cultural Museum, 1996), 14; Luce Hughes-Hallett, *Cleopatra: Histories, Dreams and Distortions* (New York: HarperCollins, 1991), 23.

43. Ron Grossman, "Two Saviors Vie for Cleopatra," *Chicago Tribune*, 20 June 1988, sec. 5, 1, 5; Bearden and Henderson, *History of African-American Artists*, 76–77.

44. *Rosary* (Feb. 1909): 322–323, in Bearden and Henderson, *History of African-American Artists*, 56, 76; Lydia Marie Child, *The Broken Fetter* (Detroit: Ladies Michigan State Fair for Relief of Destitute, Detroit Commercial Advertiser and Tribune Co., March 1865), 25–26; "Frederick Douglass, 1886–94," Library of Congress, Manuscript Division, Frederick Douglass Papers, microfilm reel no. 1; Kirsten P. Buick, "Edmonia Lewis in Art History," in King-Hammond and Benjamin, *3 Generations* 14; Benjamin, introduction to Hine et al., eds., *Facts on File*, 153–155.

45. Judith N. Kerr, "Fuller, Meta Vaux Warrick (1877–1968)," in *Black Women in America: An Historical Encyclopedia*, ed. Darlene Clark Hine et al. (Bloomington: Indiana University Press, 1993), 470; Elizabeth Robins Pennell and Joseph Pennell, *Our Philadelphia* (Philadelphia and London: Lippincott, 1915), 257; Judith N. Kerr, "God-Given Work: The Life and Times of Sculptor Meta Vaux Warrick Fuller, 1877–1968," (Ph.D. diss., University of Massachusetts, 1986), 27–29; Tritobia Hayes Benjamin, "May Howard Jackson and Meta Warrick Fuller: Philadelphia Trailblazers," in King-Hammond and Benjamin, *3 Generations*, 21.

46. Benjamin, "May Howard Jackson, Meta Warrick Fuller," 20.

47. Porter, *Modern Negro Art*; Kerr, "Fuller," 470.

48. Kerr, "God-Given Work," 67; Benjamin, "May Howard Jackson, Meta Warrick Fuller," 20.

49. Ibid.; [Samella Lewis?], "Meta Vaux Warrick Fuller (1877–1968)," *International Review of African-American Art* 12, no. 2 (1995): 56; Benjamin, introduction to Hine et al., eds., *Facts on File*, 158.

50. William Francis O'Donnell, "Meta Vaux Warrick, Sculptor of Horrors: The Negro Girl Whose Products Are Being Compared to Rodin's ," *World Today* (Nov. 1907): 1139; Benjamin, "May Howard Jackson, Meta Warrick Fuller," 21; Benjamin, introduction to Hine et al., eds., *Facts on File*, 159.

51. Porter, *Modern Negro Art*, 77–78; Fine, *Afro-American Artist*, 75; [Lewis?], "Meta Vaux Warrick Fuller," 56; Kerr, "Fuller," 471.

52. Fine, *Afro-American Artist*, 75; Benjamin, "May Howard Jackson, Meta Warrick Fuller," 20, 54; [Lewis?], "Meta Vaux Warrick Fuller," 56; Kerr, "Fuller," 471.

53. *Amsterdam Art News* 3, 11 Feb. and 4 Mar. 1905; cf. Fine, *Afro-American Artist*, 75.

54. Fine, *Afro-American Artist*, 75; Kerr, "Fuller," 471; [Lewis?], "Meta Vaux Warrick Fuller," 56; Benjamin, "May Howard Jackson, Meta Warrick Fuller," 54.

55. Patton, *African-American Art*, 128; [Lewis?], "Meta Vaux Warrick Fuller," 56; Kerr, "Fuller," 472; Wilson, "Hagar's Daughters," 104–105.

56. Ibid.

57. Kerr, "Fuller," 470–471.

58. Ibid., 472; [Lewis?], "Meta Vaux Warrick Fuller," 56; Benjamin, introduction to Hine et al., eds., *Facts on File*, 158.

59. Phyllis J. Jackson, "(In)Forming the Visual: (Re)Presenting Women of African Descent," *International Review of African-American Art* 14, no. 3 (1997): 35; Fine, *Afro-American Artist*, 75.

60. David Driskell, *Harlem Renaissance Art of Black America* (New York: Abrams, 1987), 27.

61. Kerr, "God-Given Work," 261.

62. Benjamin, "May Howard Jackson, Meta Warrick Fuller," 21; Fuller to Freeman Henry Morris Murray, 9 Jan. 1915, Freeman H. M. Murray Papers, Moorland-Spingarn Research Center, Howard University, Washington, D.C.; Kerr, "Fuller," 472; Abiola Irele, *The African Experience in Literature and Ideology* (London: Heinemann, 1981), 104; J. E. Casely Hayford, *Ethiopia Unbound: Studies in Race and Emancipation*, 2d ed. (1911; reprint, London: Cass, 1969); cf. Wilson, "Hagar's Daughters," 106.

63. Albert Boime, *The Art of Exclusion: Representing Blacks in the Nineteenth Century* (Washington, D.C.: Smithsonian Institution Press, 1990), 9; Wilson, "Hagar's Daughters," 106.

64. Freeman Henry Morris Murray, *Emancipation and the Freed in American Sculpture: A Study in Interpretation* (1916; reprint, Freeport, N.Y.: Books for Libraries Press, 1972), 92–93.

65. Kerr, "Fuller," 472.

66. Benjamin, "May Howard Jackson, Meta Warrick Fuller," 20, 21; King-Hammond, "Jackson, May Howard (1877–1931)," in Hine et al., eds., *Black Women in America*, 624.

67. [W. E. B. Du Bois?], "Men of the Month," *Crisis* (June 1912): 67; Benjamin, "May Howard Jackson, Meta Warrick Fuller," 20.

68. [W. E. B. Du Bois?], "Along the Color Line: Music and Art," *Crisis* (July 1916): 115; Benjamin, "May Howard Jackson, Meta Warrick Fuller," 20.

69. King-Hammond, "Jackson," 624.

70. Benjamin, introduction to Hine et al., eds., *Facts on File*, 159.

71. Alain Leroy Locke, *Negro Art, Past and Present* (1936; reprint, New York: Arno, 1969), 30.

72. King-Hammond, "Jackson," 624.

73. Locke, *Negro Art*, 30; Porter, *Modern Negro Art*, 92–93.

74. Mary Gibson Brewer, "May Howard Jackson Could Be White, Prefers Colored," *Afro-American Newspaper* (17 Nov. 1928), cited in Benjamin, "May Howard Jackson, Meta Warrick Fuller," 20.

75. Fuller to Murray, 9 Jan. 1915, Murray Papers.

76. Brewer, "May Howard Jackson Could Be White, Prefers Colored."

77. May Howard Jackson to Locke, 14 Jan. 1929, Alain Locke Papers, box 164-39, Moorland-Spingarn Research Center, Howard University, Washington, D.C.; Benjamin, "May Howard Jackson, Meta Warrick Fuller," 20.

78. W. E. B. Du Bois, "Postscript: May Howard Jackson," *Crisis* (1931): 351.

79. Porter, *Modern Negro Art*; Benjamin, "May Howard Jackson, Meta Warrick Fuller," 20; Elsa Honig Fine, *The Afro-American Artist: A Search for Identity* (New York: Holt, Rinehart and Winston, 1973), 91; Gary A. Reynolds and Beryl J. Wright, *Against the Odds: African-American Artists and the Harmon Foundation* (Newark, N.J.: Newark Museum, 1989), 27–29, 80–82.

80. Locke, *Negro Art*; Benjamin, "May Howard Jackson, Meta Warrick Fuller," 20.

81. Wilson, "Hagar's Daughters," 107.

82. Ibid.

CHAPTER FOUR

1. Richard Powell, *Black Art and Culture in the Twentieth Century* (London: Thames and Hudson, 1997), 34–35.

2. Ibid.; *Birth of a Nation* was based on a novel by Thomas Dixon, *The Clansmen* (1905).

3. Ira Reid, "A Critical Summary: The Negro on the Home Front in World Wars I and II," *Journal of Negro Education* 12 (Summer 1943): 516; David Levering Lewis, *When Harlem Was in Vogue* (New York: Knopf, 1981); Elton C. Fax, *Garvey: The Story of a Pioneer Black Nationalist* (New York: Dodd, Mead, 1971); Gary A. Reynolds and Beryl J. Wright, *Against the Odds: African-American Artists and the Harmon Foundation* (Newark, N.J.: Newark Museum, 1989), 79–80.

4. Ibid.

5. W. E. B. Du Bois, "The Immediate Program of the American Negro," *Crisis* 9, no. 6 (April 1915): 312.

6. Gilbert Osofsky, *Harlem: The Making of a Ghetto: Negro New York, 1890–1930*, 4th ed. (Chicago, Ill.: Dee, 1996), 2–12, 17, 20, 71–72, 75; Mary Schmidt Campbell, introduction to David C. Driskell, *Harlem Renaissance Art of Black America* (New York: Abrams, 1987), 14; Sharon Patton, *African-American Art* (New York: Oxford University Press, 1998), 110; Henry Louis Gates, Jr., "New Negroes, Migration, and Cultural Exchange," in *Jacob Lawrence: The Great Migration*, ed. Elizabeth H. Turner (Washington, D.C.: Phillips Collection and Rappahannock Press, 1993), 18.

7. Powell, *Black Art and Culture*, 42; Alain Leroy Locke, "Enter the New Negro," *Survey Graphic* 6, no. 6 (March 1925): 631.

8. Locke, "The Legacy of the Ancestral Arts," in *The New Negro: An Interpretation* (1925; reprint, New York: Atheneum, 1968), 254–267.

9. Ibid., 259–267.

10. Ibid., 264, 267.

11. Ibid., 264, 266.

12. Jan Niederveen Pieterse, *White on Black: Images of Africa and Blacks in Western Popular Culture* (New Haven, Conn.: Yale University Press, 1992), 140–142.

13. Ibid., 141.

14. Powell, *Black Art and Culture*, 57.

15. *Jazz: A Film by Ken Burns*, produced and directed by Ken Burns (Florentine Films and the Corporation for Public Broadcasting, 2000), 10 videocassettes.

16. Ibid.; Neil Leonard, *Jazz and the White Americans: The Acceptance of a New Art Form* (Chicago, Ill.: University of Chicago Press, 1962), 25–53.

17. "This Joint Is Jumpin'," written by Fats Waller; "Stompin' at the Savoy," coauthored by Chick Webb, Benny Goodman, and Edgar Sampson, lyrics by Andy Razaf.

18. Reynolds and Wright, *Against the Odds*, 80; Powell, *Black Art and Culture*, 24–25.

19. Locke, "Legacy of the Ancestral Arts," 266.

20. Jan Gleiter, "Waring, Laura Wheeler (1887–1948)," in *Black Women in America: An Historical Encyclopedia*, 2 vols., ed. Darlene Clark Hine et al. (Bloomington: Indiana University Press, 1993), 1225; Arna Bontemps, ed., *Forever Free: Art by*

African-American Women, 1862–1980 (Alexandria, Va.: Stephenson, 1980), 140; Reynolds and Wright, *Against the Odds*, 263.

21. Locke, "The African Legacy and the Negro Artist," in *Exhibition of the Work of Negro Artists* (New York: Harmon Foundation, 1931), 12.

22. *Negro Artists: An Illustrated Review of Their Achievements* (New York: Harmon Foundation, 1935), 4; Reynolds and Wright, *Against the Odds*, 84.

23. James A. Porter, *Modern Negro Art* (New York: Dryden, 1943), 107; Romare Bearden, "The Negro and Modern Art," *Opportunity* 12 (Dec. 1934): 371–373.

24. Romare Bearden and Harry Henderson, *A History of African-American Artists from 1792 to the Present* (New York: Pantheon, 1993), 128–129, 246.

25. Osofsky, *Harlem*, 34; Patton, *African-American Art*, 125–126, 157.

26. Ibid. The Dark Tower was ultimately redecorated by a noted Manhattan designer, rather than by Douglas and artist-writer Richard Bruce Nugent, who were originally chosen by Walker; see Driskell, *Harlem Renaissance Art of Black America*, 73–75.

27. Tritobia Benjamin, *The Life and Art of Lois Mailou Jones* (San Francisco, Calif.: Pomegranate, 1994), 5.

28. Ibid., 5–7.

29. Ibid., 7.

30. Ibid., 1–24, 125; Jones, quoted in *Against the Odds: Artists of the Harlem Renaissance*, produced and directed by Amber Edwards and Nila Aranow (New Jersey Network, 1994), videocassette.

31. Jones, interview in Edwards and Aranow, *Against the Odds*, videocassette.

32. Ibid.; Betty Laduke, "Lois Mailou Jones: The Grande Dame of African-American Art," *Woman's Art Journal* 8, no. 2 (Fall–Winter 1987/1988): 28–29; Benjamin, *Life and Art of Lois Mailou Jones*, 1–31, 125.

33. Patton, *African-American Art*, 128; Powell, *Black Art and Culture*, 78–80; Gerald Alexis, "Caribbean Art and Culture from a Haitian Perspective," in *Caribbean Visions: Contemporary Painting and Sculpture*, ed. Samella S. Lewis et al. (Alexandria, Va.: Art Services, 1995), 59–63; Jahnheinz Jahn, *Muntu: African Culture and the Western World* (New York: Grove Weidenfeld, 1990), 146–155.

34. Ibid.; cf. *Christian Science Monitor* (2 Feb. 1939).

35. Lois Mailou Jones, interview with Betty LaDuke, 8 Feb. 1986, published in LaDuke, "Lois Mailou Jones," 29.

36. Richard Powell et al., *Rhapsodies in Black: Art of the Harlem Renaissance* (Berkeley: University of California Press, 1997), 169–177; Benjamin, *Life and Art of Lois Mailou Jones*, 45; Carter G. Woodson, *African Heroes and Heroines* (Washington, D.C.: Associated Publishers, 1939).

37. *Lois Mailou Jones: Peintures, 1937–1951* (Tourcoing, France: Presses Georges Frères, 1952); Benjamin, *Life and Art of Lois Mailou Jones*, 126–127; Regenia A. Perry, *Free within Ourselves: African-American Artists in the Collection of the National Museum of American Art* (Washington, D.C.: Smithsonian Institution Press, 1992).

38. Perry, *Free within Ourselves*, 122; Jones, telephone interview by Betty Laduke, May 1987, quoted in Laduke, "Lois Mailou Jones," 32.

39. Beulah Ecton Woodard, quoted in Tritobia H. Benjamin, "Triumphant Determination: The Legacy of African-American Women Artists," in *Bearing Witness: Contemporary Works by African-American Women Artists*, ed. Jontyle Theresa Robinson (New York: Rizzoli, 1996), 64.

40. Woodard, personal statement, 25 July 1938, Harmon Foundation Files, Manuscript Division, Library of Congress, Washington, D.C.; cf. Benjamin, "Triumphant Determination," 65; Lizzetta LeFalle-Collins, "Working from the Pacific Rim: Beulah Woodard and Elizabeth Catlett," in *3 Generations of African-American Women Sculptors: A Study in Paradox*, ed. Leslie King-Hammond and Tritobia Hayes Benjamin (Philadelphia, Pa.: Afro-American Historical and Cultural Museum, 1996), 39.

41. Ibid.; Woodard, quoted in Verna Arvey, "By Her Own Bootstraps," *Opportunity* 22, no. 1 (Winter 1944): 42.

42. Miriam Matthews, "Woodard, Beulah Ecton (1895–1955)," in Hine et al., eds., *Black Women in America*, 1282; Benjamin, "Triumphant Determination," 65; Woodard, personal statement, 25 July 1938; Arvey, "By Her Own Bootstraps," 17, 42.

43. LeFalle-Collins, "Working from the Pacific Rim," 39–40.

44. Ibid.

45. Ibid.; anonymous *Citizen News* critic, quoted in Arvey, "By Her Own Bootstraps," 42.

46. Matthews, "Woodard, Beulah Ecton," 1282; Benjamin, "Triumphant Determination," 65.

CHAPTER FIVE

1. Bruce I. Bustard, *A New Deal for the Arts* (Seattle: University of Washington, 1997), 17, 22, 128.

2. Sharon Patton, *African-American Art* (New York: Oxford University Press, 1998), 146; Bustard, *New Deal for the Arts*, 4–6, 9, 11, 18.

3. Ibid.; Romare Bearden and Harry Henderson, *A History of African-American Artists from 1792 to the Present* (New York: Pantheon, 1993), 231–232.

4. Milton Brown, *Social Art in America, 1930–1945* (New York: ACA Galleries, 1981), 10; James Oles, *South of the Border: Mexico in the American Imagination, 1914–1947* (Washington, D.C.: Smithsonian Institution Press, 1993), 105; Melanie Anne Herzog, *Elizabeth Catlett: An American Artist in Mexico* (Seattle and London: University of Washington Press, 2000), 50.

5. Tritobia Hayes Benjamin, "Triumphant Determination: The Legacy of African-American Women Artists," in *Bearing Witness: Contemporary Works by African-American Women Artists*, ed. Jontyle Theresa Robinson (Atlanta, Ga.: Spelman College Press, 1996), 63; Bearden and Henderson, *History of African-American Artists*, 168–180; Gary A. Reynolds and Beryl J. Wright, *Against the Odds: African-American Artists and the Harmon Foundation* (Newark, N.J.: Newark Museum, 1989), 251; Samella Lewis, *African-American Art and Artists* (Berkeley: University of California

Press, 1990), 83–85; Leslie King-Hammond, "Quest for Freedom, Identity, and Beauty: New Negro Artists Prophet, Savage, and Burke," in *3 Generations of African-American Women Sculptors: A Study in Paradox*, ed. Leslie King-Hammond and Tritobia Hayes Benjamin (Philadelphia, Pa.: Afro-American Historical and Cultural Museum, 1996), 22–37; Norma Broude and Mary D. Garrard, *The Power of Feminist Art: The American Movement of the 1970s, History and Impact* (New York: Abrams, 1994), 13; Marlene Park and Gerald E. Markowitz, *New Deal for Art: The Government Art Projects of the 1930s with Examples from New York City and State* (Hamilton, N.Y.: Gallery Association of New York State, 1977), 20.

6. Arna Alexander Bontemps, ed., *Forever Free: Art by African-American Women, 1862–1980* (Alexandria, Va.: Stephenson, 1980), 114

7. Camille Billops, "Georgette Seabrooke-Powell," in *Artist and Influence* 12 (1993): 87–88; Bearden and Henderson, *History of African-American Artists*, 232, 236–237, 260–263, 282, 392–393; Victor N. Smythe, *Black New York Artists of the Twentieth Century: Selections from the Schomburg Center Collections* (New York: New York Public Library, 1998), 92; Darlene Clark Hine et al., eds., *Facts on File Encyclopedia of Black Women in America: Dance, Sports, and Visual Arts* (New York: Facts on File, 1997), 164, 242; Benjamin, "Triumphant Determination," 73–74.

8. Juanita Marie Holland, "Augusta Christine Savage: A Chronology of Her Art and Life, 1892–1962," in *Augusta Savage and the Art Schools of Harlem*, ed. Deirdre L. Bibby (New York: Schomburg Center for Research in Black Culture, New York Public Library, 1988), 12–13.

9. Ibid.; Benjamin, "Triumphant Determination," 61, 63.

10. Bearden and Henderson, *History of African-American Artists*, 168–180.

11. Ibid.; Holland, "Augusta Christine Savage," 14.

12. Poston died later that year, leaving Savage a widow; see Holland, "Augusta Christine Savage," 14.

13. Deirdre L. Bibby, "Savage, Augusta (1892–1962)," in *Black Women in America: An Historic Encyclopedia*, 2 vols., ed. Darlene Clark Hine et al. (Bloomington: Indiana University Press, 1993), 1012; Alain Locke, "The Legacy of the Ancestral Arts," in *The New Negro: An Interpretation* (1925; reprint, New York: Atheneum, 1968), 264–267.

14. Holland, "Augusta Christine Savage," 15; Patton, *African-American Art*, 147.

15. Ibid.; Benjamin, "Triumphant Determination," 64.

16. Holland, "Augusta Christine Savage," 16; Bearden and Henderson, *History of African-American Artists*, 174; Patton, *African-American Art*, 147.

17. Bearden and Henderson, *History of African-American Artists*, 131, 174, 234–240, 263–264, 281, 296–300, 305, 323, 407, 422.

18. Patton, *African-American Art*, 147; Bibby, "Savage, Augusta," 1010.

19. Benjamin, "Triumphant Determination," 64.

20. Bibby, "Savage, Augusta," 1010, 1013.

21. Ibid.; Patton, *African-American Art*, 146–147; Holland, "Augusta Christine Savage," 17; Reynolds and Wright, *Against the Odds*, 251; Lewis, *African-American Art and Artists*, 83–85; King-Hammond, "Quest for Freedom," 22–37.

22. Benjamin, "Triumphant Determination," 64.

23. Holland, "Augusta Christine Savage," 17–18; Bearden and Henderson, *History of African-American Artists*, 121, 125, 168–180, 223, 240, 375; Reynolds and Wright, *Against the Odds*, 251.

24. Bibby, "Savage, Augusta," 1013.

25. Selma Hortense Burke, interview by Tritobia Benjamin, Pittsburgh, Pa., 21 March 1970; Benjamin, "Burke, Selma Hortense," in Hine, ed., *Black Women in America*, 191–192; Burke, quoted in James G. Spady, "Three to the Universe: Selma Burke, Roy DeCarava, Tom Feelings," in *9 to the Universe: Black Artists* (Philadelphia, Pa.: Black History Museum, 1983), 18.

26. Ibid.; Tom Seig, [untitled article], *Sentinel* (Winston-Salem, N.C.), 24 Sept. 1983.

27. Benjamin, "Burke, Selma Hortense," 191–192; King-Hammond, "Quest for Freedom," 30.

28. Burke, interview by Benjamin, Pittsburgh, Pa., 21 March 1970; Benjamin, "Burke, Selma Hortense," 192.

29. Benjamin, "Burke, Selma Hortense," 192.

30. Ibid.

31. Nancy Elizabeth Prophet, nomination form, 1929, Harmon Foundation Collection, Manuscript Division, Library of Congress, Washington, D.C.

32. Charlotte Streifer Rubenstein, *American Women Artists from Early Indian Times to the Present* (Boston: Hall, 1982), 245; Benjamin, "Triumphant Determination," 61; Gloria V. Warren, "Prophet, Nancy Elizabeth," in Hine, ed., *Black Women in America*, 947; Reynolds and Wright, *Against the Odds*, 248; King-Hammond, "Quest for Freedom," 28; W. E. B. Du Bois, "Can I Become a Sculptor? The Story of Elizabeth Prophet," *Crisis* 39, no. 10 (Oct. 1932): 315.

33. Rubenstein, *American Women Artists*, 243; Benjamin, "Triumphant Determination," 61.

34. Countee Cullen, "Elizabeth Prophet: Sculptress," *Opportunity* 8, no. 7 (July 1930): 205; Benjamin, "Triumphant Determination," 61.

35. Reynolds and Wright, *Against the Odds*, 248; Warren, "Prophet, Nancy Elizabeth," 947.

36. Ibid.; King-Hammond, "Prophet," in *Four from Providence*, ed. Lawrence F. Sykes (Providence: Rhode Island College and Rhode Island Heritage Society, 1978), 9.

37. Rubenstein, *American Women Artists*, 245; Benjamin, "Triumphant Determination," 61.

38. Ibid.

39. Unsigned article, "Fine Arts at Spelman," *Spelman Messenger* 56, no. 2 (February 1940): 9; King-Hammond, "Quest for Freedom," 28; Cullen, "Elizabeth Prophet: Sculptress," 205.

40. "Fine Arts at Spelman," 9; King-Hammond, "Quest for Freedom," 28.

41. John Hope, "Atlanta University: A School of the Arts," TD, 31 August 1934;

Elizabeth Prophet, "A Report of My Work to President Hope," TD, 22 March 1935; Prophet, undated DS and TD, Archives Department, Robert W. Woodruff Library, Atlanta University Center, John Hope Pres. Rec. B163: F8; "Fine Arts at Spelman," 8, 10; Bearden and Henderson, *History of African-American Artists*, 208–209.

42. Warren, "Prophet, Nancy Elizabeth," 948; Blossom S. Kirschenbaum, "Nancy Elizabeth Prophet, Sculptor," *Sage: A Scholarly Journal on Black Women* 4, no. 1 (Spring 1987): 49; Reynolds and Wright, *Against the Odds*, 248, 251; King-Hammond, "Quest for Freedom," 22–37.

43. Benjamin, "Triumphant Determination," 60; Prophet, cited in Cedric Dover, *American Negro Art* (New York: New York Graphic Society, 1960), 56; Reynolds and Wright, *Against the Odds*, 248, 251; King-Hammond, "Quest for Freedom," 22–37.

44. Benjamin, "Triumphant Determination," 62.

45. Broude and Garrard, *Power of Feminist Art*, 13.

CHAPTER SIX

1. Bruce I. Bustard, *A New Deal for the Arts* (Washington, D.C.: National Archives and Records Administration, 1997), 123.

2. Melanie Anne Herzog, *Elizabeth Catlett: An American Artist in Mexico* (Seattle and London: University of Washington Press, 2000), 76.

3. Serge Gilbaut, *How New York Stole the Idea of Modern Art: Abstract Expressionism, Freedom and the Cold War* (Chicago, Ill.: University of Chicago, 1983); Clement Greenberg, "Avant-Garde and Kitsch," *Partisan Review* 4, no. 6 (Fall 1939): 34–49; Walter Benjamin, "The Work of Art in the Age of Mechanical Reproducibility" and "Theses on the Philosophy of History," in *Illuminations*, ed. Hannah Arendt (New York: Schocken, 1969), 217–264; David Summers, "'Form,' Nineteenth-Century Metaphysics, and the Problem of Art Historical Description," in *The Art of Art History: A Critical Anthology*, ed. Donald Preziosi (New York: Oxford University Press, 1998), 140–141; Sharon F. Patton,

African-American Art (New York: Oxford University Press, 1998), 150.

4. Romare Bearden and Harry Henderson, *A History of African-American Artists from 1792 to the Present* (New York: Pantheon, 1993), 398.

5. Elizabeth Catlett, interview with Glory Van Scott, 8 December 1991, Cuernavaca, Mexico; and Catlett, audiotaped interview with Melanie Anne Herzog, 14 June 1991, Cuernavaca, Mexico, reprinted in Herzog, *Elizabeth Catlett*, 15; Bearden and Henderson, *History of African-American Artists*, 419; Herzog, *Elizabeth Catlett*, 15–18.

6. Interview with Camille Billops, 1 Oct. 1989, Hatch-Billops Archive, New York; transcript published in James V. Hatch and Leo Hamalian, eds., *Artist and Influence*, vol. 10, *1991* (New York: Hatch-Billops Collection, 1991), 17; Elton Fax, *Seventeen Black Artists* (New York: Dodd and Mead, 1971), 17; Richard Powell, "Face to Face: Elizabeth Catlett's Graphic Work," in *Elizabeth Catlett: Works on Paper, 1944–1992*, ed. Jeanne Zeidler (Hampton, Va.: Hampton University Museum, 1993), 51; Bearden and Henderson, *History of African-American Artists*, 420; Herzog, *Elizabeth Catlett*, 18, 20, 21.

7. Catlett, audiotaped interview with Herzog, 14 June 1991, 19–21; Winifred Stoelting, "Teaching in Atlanta," in *Hale Woodruff: Fifty Years of His Art* (New York: Studio Museum in Harlem, 1979), 18.

8. Herzog, *Elizabeth Catlett*, 8, 24–29; Bearden and Henderson, *History of African-American Artists*, 370, 408.

9. Ibid., 21, 23; Alain Locke, *The Negro in Art: A Pictorial Record of the Negro Artist and of the Negro Theme in Art* (Washington, D.C.: Associates in Negro Folk Education, 1940); James A. Porter, *Modern Negro Art* (New York: Dryden, 1943).

10. Herzog, *Elizabeth Catlett*, 8, 21, 23, 25–28.

11. Arna A. Bontemps, *Forever Free: Art by African-American Women, 1862–1980* (Alexandria, Va.: Stephenson, 1980), 64; Charles White and Bernard Goss, quoted in Willard F. Motley, "Negro Art in Chicago,"

Opportunity 18, no. 1 (January 1940): 21; Herzog, *Elizabeth Catlett*, 26, 29, 52.

12. Hatch and Hamalian, eds., *Artist and Influence: 1991*, 20; Herzog, *Elizabeth Catlett*, 29.

13. Powell, "Face to Face," 51; Herzog, *Elizabeth Catlett*, 30–31, 36, 42, 189 n. 87; Samella Lewis, *The Art of Elizabeth Catlett* (Claremont, Calif.: Hancraft Studios, 1984), 18–20; Fax, *Seventeen Black Artists*, 22–24.

14. Lizzetta LeFalle-Collins and Shifra M. Goldman, *In the Spirit of Resistance: African-American Modernists and the Mexican Muralist School* (New York: American Federation of Arts, 1966); Herzog, *Elizabeth Catlett*, 47, 49, 50, 53.

15. Herzog, *Elizabeth Catlett*, 4, 49, 50, 51, 55–56, 70, 81–82, 85, 117; Bearden and Henderson, *History of African-American Artists*, 411; Leopold Méndez, prologue to *The Workshop for Popular Graphic Art: A Record of Twelve Years of Collective Work*, ed. Hans Meyer (Mexico City: La Estampa Mexicana, 1949), v.

16. Rosalyn M. Story, "Elizabeth Catlett," *Emerge*, March 2000, 51.

17. Herzog, *Elizabeth Catlett*, 3, 49; Beverly Guy-Sheftall, "Warrior Women: Art as Resistance," in *Bearing Witness: Contemporary Works by African-American Women Artists*, ed. Jontyle Theresa Robinson (Atlanta, Ga.: Spelman College Press; New York: Rizzoli, 1996), 39.

18. Herzog, *Elizabeth Catlett*, 111, 130–131; Shifra M. Goldman, *Contemporary Mexican Painting in a Time of Change* (Austin and London: University of Texas Press, 1995).

19. Herzog, *Elizabeth Catlett*, 39, 78–79.

20. Fax, *Seventeen Black Artists*, 27–28; Herzog, *Elizabeth Catlett*, 79, 107; Guy-Sheftall, "Warrior Women: Art as Resistance," 40.

21. Bearden and Henderson, *History of African-American Artists*, 419.

22. Patton, *African-American Art*, 185, 306; Bearden and Henderson, *History of African-American Artists*, 186, 200, 316, 400–402.

23. According to the artist, the print was acquired by the Museum of African-American Art in Washington, D.C., but seems to be no longer extant.

24. Amos, letter to the author, 21 June 2001.

25. Bearden and Henderson, *History of African American Artists*, 186, 200, 316, 400–402.

26. Larry Neal, "The Black Arts Movement," *Drama Review* 12, no. 4 (1968): 29–39.

27. Addison Gayle, Jr., ed., *The Black Aesthetic* (Garden City, N.Y.: Doubleday, 1972), xiii–xiv; Patton, *African-American Art*, 213.

28. Patton, *African-American Art*, 211–214, 306; Mary Schmidt Campbell et al., *Tradition and Conflict: Images of a Turbulent Decade* (New York: Studio Museum in Harlem, 1985), 83; Kay Brown, "The Emergence of Black Women Artists: The 1970s, New York," *International Review of African-American Art* 15, no. 1 (1998): 45.

29. Michael D. Harris, "Urban Totems: The Communal Spirit of Black Murals," in *Walls of Heritage, Walls of Pride: African-American Murals*, ed. James Prigoff and Robin J. Dunitz (San Francisco, Calif.: Pomegranate, 2000), 24.

30. Ibid., 24–25.

31. Ibid., 26; Catlett, "The Negro People and American Art at Mid-Century," speech delivered to the National Conference of Negro Artists, typed document, 1 April 1961, Elizabeth Catlett Papers, Amistad Research Center, Tulane University, New Orleans, La.

32. Harris, "Urban Totems," 26; Jeff R. Donaldson and Geneva Smitherman Donaldson, "Upside the Wall: An Artists' Retrospective Look at the Original 'Wall of Respect'," in *The People's Art: Black Murals, 1967–1978*, ed. Jeff R. Donaldson and Geneva Smitherman Donaldson (Philadelphia, Pa.: African-American Historical and Cultural Museum, 1986); Patton, *African-American Art*, 215.

33. Donaldson and Donaldson, "Upside the Wall"; Harris, "Urban Totems," 29; Patton, *African-American Art*, 215, 306; Jeff R. Donaldson, "10 in Search of a Nation," *Black World* 19, no. 12 (October 1970):

82–86; Ron Karenga, "Black Cultural Nationalism," in Gayle, ed., *The Black Aesthetic*, 31; Elsa H. Fine, *The Afro-American Artist: A Search for Identity* (New York: Holt, Rinehart, and Winston, 1973), 198–203.

34. Harris, "Urban Totems," 128.

35. Quoted in ibid.

36. Cherilyn C. Wright, "Reflections on CONFABA: 1970," *International Review of African-American Art* 15, no. 1 (1998): 37.

37. Catlett, quoted in Raquel Tibol, *Gráficas y neográficas en Mexico* (Mexico City: Secretaría de Educación Púlica, Universidad Nacional Autónoma de Mexico, 1987), 191, translated and reprinted in Herzog, *Elizabeth Catlett*, 148–149.

38. Elizabeth Catlett, "CONFABA," speech delivered via telephone from Mexico City to the Conference on the Functional Aspects of Black Arts in Evanston, Illinois, typed document, May 1970, Catlett Papers.

39. Herzog, *Elizabeth Catlett*, 113.

40. Ibid., 11, 147, 150–151, 213 n. 61.

41. Ringgold, "Faith Ringgold: Archives of American Art Oral History," interview with Cynthia Nadelman, 6 Sept.–18 Oct. 1989, transcript, Archives of American Art, Washington, D.C., and New York, 436–447; Richard Powell, *Black Art and Culture in the Twentieth Century* (London: Thames and Hudson, 1997), 230; Board of Directors meeting minutes, Spring 1951, and City College course catalogs for Spring and Fall 1951, City College Library Archives, New York.

42. Ringgold, *We Flew over the Bridge: The Memoirs of Faith Ringgold* (Boston: Little, Brown, 1995), 54–55, 59, 149.

43. Campbell, *Tradition and Conflict*, 54.

44. Terrie S. Rouse, "Faith Ringgold: A Mirror of Her Community," in *Faith Ringgold: Twenty Years of Painting, Sculpture, and Performance (1963–1983)*, ed. Michele Wallace (New York: Studio Museum in Harlem, 1984), 9; Moira Roth, "Keeping the Feminist Faith," in Wallace, ed., *Faith Ringgold*, 13–14.

45. Bearden to Ringgold, letter, 8 Nov. 1964, Ringgold Archive, Englewood, N.J.

46. Amiri Baraka, "Faith," *Black American Literature Forum* 19, no. 1 (Spring 1985): 12.

47. Lowery S. Sims, "Race Riots, Cocktail Parties, Black Panthers, Moon Shots, and Feminists: Faith Ringgold's Observations of the 1960s in America," in *Faith Ringgold: A 25-Year Survey*, ed. Eleanor Flomenhaft (Hempstead, N.Y.: Fine Arts Museum of Long Island, 1990), 17.

48. Ringgold, *We Flew over the Bridge*, 146.

49. James Baldwin, *The Fire Next Time* (1962; reprint, New York: Random House, 1995), 104–105; Rouse, "Faith Ringgold: A Mirror of Her Community," 9.

50. Sims, "Race Riots," 19; Ringgold, *We Flew over the Bridge*, 158.

51. Sims, "Race Riots," 17.

52. Ringgold, *We Flew over the Bridge*, 157–158.

53. Ibid. Not until 21 June 1989 did the Supreme Court rule that burning the American flag was a legal form of political expression.

54. Exhibition announcement for "The People's Flag Show," Ringgold Archive, Englewood, N.J.

55. Ringgold, "Faith Ringgold: Archives of American Art Oral History," 116–119.

56. John B. Hightower to Ringgold, letter, 4 November 1970, Ringgold Archive, Englewood, N.J.

57. Ringgold, "Faith Ringgold: Archives of American Art Oral History," 136–137, 160.

58. See discussion in next chapter.

59. Leslie King-Hammond et al., eds., *Gumbo Ya Ya: Anthology of Contemporary African-American Women Artists* (New York: Midmarch Arts, 1995), 122.

60. Ibid., 122–123.

61. Ibid., 148–149. Due to its popularity, in 1990 the University of California reissued *Art: African American* as *African-American Art and Artists*.

62. Robert Henkes, *The Art of Black American Women: Works of Twenty-Four Artists of the Twentieth Century* (Jefferson, N.C.: McFarland, 1993), 171.

63. Bontemps, *Forever Free*, 66; King-Hammond et al., *Gumbo Ya Ya*, 44.

CHAPTER SEVEN

1. Betty Friedan, *The Feminine Mystique* (New York: Norton, 1963).

2. Lucy Lippard, "Sweeping Exchanges: The Contribution of Feminism to the Art of the 1970s," *Art Journal* 39 (Fall–Winter 1980): 362 and n. 3.

3. Linda Nochlin, "Why Have There Been No Great Women Artists?" *ARTnews* 69, no. 9 (January 1971): 22–39.

4. Kenneth Clark, *The Nude: A Study in Ideal Form* (Princeton, N.J.: Princeton University Press, 1972), 28–29.

5. Mary D. Garrard, "Feminist Politics: Networks and Organizations," and Carrie Rickey, "Illustrated Timeline," in *The Power of Feminist Art: The American Movement of the 1970s, History and Impact*, ed. Norma Broude and Mary D. Garrard (New York: Abrams, 1994), 90, 306; Beverly Guy-Sheftall, "Warrior Women: Art as Resistance," in *Bearing Witness: Contemporary Works by African-American Women Artists*, ed. Jontyle Theresa Robinson (Atlanta, Ga.: Spelman College Press, 1996), 41.

6. Carrie Rickey, "Writing (and Righting) Wrongs: Feminist Art Publications" and "Illustrated Timeline," in Broude and Garrard, eds., *Power of Feminist Art*, 90, 120–129, 306.

7. Yolanda M. Lopez and Moira Roth, "Social Protest: Racism and Sexism," in Broude and Garrard, eds., *Power of Feminist Art*, 138–139.

8. Lopez and Roth, "Social Protest," 152.

9. Emma Amos et al., "Contemporary Feminism: Art Practice, Theory, and Activism: An Intergenerational Perspective," *Art Journal* 58, no. 4 (Winter 1999): 10.

10. bell hooks, "'Let's Get Real about Feminism': The Backlash, the Myths, the Movement," *Ms.*, Sept.–Oct. 1993, 38; Audre Lorde, *Sister Outsider* (Freedom, Calif.: Crossing Press, 1984), 114–123.

11. Lopez and Roth, "Social Protest," 138–139.

12. Faith Ringgold, "Higher Education and Women," interview with Margaret Mahoney, *Women and the Arts* 11, no. 1 (Spring–Summer 1974): 95–99.

13. E-mail interview with artist by author, 9 Feb. 2004; James Prigoff and Robin J. Dunitz, *Walls of Heritage, Walls of Pride: African-American Murals* (San Francisco, Calif.: Pomegranate, 2000), 125, 252.

14. Broude and Garrard, eds., *Power of Feminist Art*, 106.

15. Melanie Anne Herzog, *Elizabeth Catlett: An American Artist in Mexico* (Seattle and London: University of Washington Press, 2000), 110–111.

16. Samella S. Lewis, *The Art of Elizabeth Catlett* (Claremont, Calif.: Hancraft Studios, 1984), 102–104.

17. Ringgold, *We Flew over the Bridge: The Memoirs of Faith Ringgold* (Boston: Little, Brown, 1995), 175; Linda Dittmar, "When Privilege Is No Protection: The Woman Artist in *Quicksand* and *The House of Mirth*," in *Writing the Woman Artist: Essays on Poetics, Politics, and Portraiture*, ed. Suzanne W. Jones (Philadelphia: University of Pennsylvania Press, 1991), 149.

18. Nathan Glazer and Daniel Patrick Moynihan, "The Negro Family: The Case for National Action," in *Beyond the Melting Pot: The Negroes, Puerto Ricans, Jews, and Italians of New York City* (Washington, D.C.: Government Printing Office, 1967), reprinted in William L. Yancey, *The Moynihan Report and the Politics of Controversy* (Cambridge, Mass.: MIT Press, 1967); Ringgold, *We Flew over the Bridge*, 175; Jacqueline Jones, *Labor of Love, Labor of Sorrow: Black Women, Work, and the Family, from Slavery to the Present* (New York: Basic, 1985); Patricia Morton, *Disfigured Images: The Historical Assault on Afro-American Women* (Westport, Conn.: Praeger, 1991), 129; bell hooks, *Ain't I a Woman: Black Women and Feminism* (Boston: South End, 1981), 81.

19. Freida High W. Tesfagiorgis, "Afro-femcentric: Twenty Years of Faith Ringgold," in *Faith Ringgold: Twenty Years of Painting, Sculpture, and Performance (1963–1983)*, ed. Michele Wallace (New York: Studio Museum in Harlem, 1984), 17.

20. Amiri Baraka, "Faith," *Black American Literature Forum* 19, no. 1 (Spring 1985): 12.

21. Ringgold, autobiographical essay, 6 October 1973, Faith Ringgold Archive, Englewood, N.J.

22. Michele Wallace, "For the Women's House," *Feminist Art Journal* 1, no. 1 (April 1972): 14.

23. Ibid.

24. Ringgold, interview with Cynthia Nadelman, 6 September–18 October 1989, transcript, Archives of American Art, Washington, D.C., and New York, 175.

25. Wallace, "For the Women's House," 15.

26. Gerda Lerner, ed., *Black Women in White America: A Documentary History* (New York: Random House, 1972), 568–572.

27. Shirley Chisholm, speech delivered at the Conference on Women's Employment Hearing before the Special Committee on Education of the Committee on Education and Labor, House of Representatives, 91st Cong., 2d sess. (Washington, D.C.: Government Printing Office, 1970), 909–915.

28. Sojourner Truth, speech delivered at the Convention of the American Equal Rights Association, New York City, 1867, published in Elizabeth Cady Stanton et al., *History of Woman Suffrage*, 2 vols. (New York: Fowler and Wells, 1881–1882), 193–194.

29. Ringgold, interview with Nadelman, 136–137, 160.

30. Amos et al., "Contemporary Feminism," 9; Betty Wilde, "Emma Amos," in *Gumbo Ya Ya: Anthology of Contemporary African-American Women Artists*, ed. Leslie King-Hammond et al. (New York: Midmarch Arts, 1995), 1, 24–26, 176–178; Robert Henkes, *The Art of Black American Women: Works of Twenty-Four Artists of the Twentieth Century* (Jefferson, N.C.: McFarland, 1993), 50–74.

31. bell hooks, "Straighten Up and Fly Right: Making History Visible," in *Emma Amos: Paintings and Prints, 1982–1992*, ed. Thalia Gouma-Peterson et al.(Wooster, Ohio: College of Wooster Art Museum), 17–18, 21; Amos et al., "Contemporary Feminism," 9.

32. Robinson, *Bearing Witness*, 23.

33. Emma Amos, "Measuring Content," in *Looking Forward, Looking Black*, ed. Jo Anna Isaak (Geneva, N.Y.: Hobart and William Smith Colleges Press, 1999), 39.

34. Ibid.

35. Robinson, *Bearing Witness*, 24.

36. Sharon Patton, "Living Fearlessly with and within Difference(s): Emma Amos, Caron Ann Carter, and Martha Jackson Jarvis," in *African-American Visual Aesthetics: A Postmodern View*, ed. David C. Driskell (Washington, D.C.: Smithsonian Institution Press, 1995), 55–56.

37. Wilde, "Emma Amos," 1.

38. Ibid., 1–2; Amos et al., "Contemporary Feminism," 9.

39. Amos, "Measuring Content," 38.

40. Ibid.

41. Amos et al., "Contemporary Feminism," 10.

42. Ibid., 11.

43. Kenneth W. Goings, *Mammy and Uncle Mose: Black Collectibles and American Stereotyping* (Bloomington and Indianapolis: Indiana University Press, 1994), xii.

44. Steven C. Dubin, "Symbolic Slavery: Black Representations in Popular Culture," *Social Problems* 34, no. 2 (April 1987): 123, 127, 135.

45. Betye Saar, telephone interviews with the author, 29 September 1998 and 11 April 2002; Mary Schmidt Campbell et al., *Tradition and Conflict: Images of a Turbulent Decade, 1963 to 1973* (New York: Studio Museum in Harlem, 1985), 61.

46. Lopez and Roth, "Social Protest," 146.

47. Saar, "Unfinished Business: The Return of Aunt Jemima," in *Betye Saar, Workers and Warriors: The Return of Aunt Jemima* (New York: Michael Rosenfeld Gallery, 1998), 3.

48. David Irving, director, *Betye and Alison Saar: Conjure Women of the Arts*, videocassette (Chappaqua, N.Y.: L&S Video, 1994).

49. Lucy R. Lippard, "Betye Saar/Alison Saar," in King-Hammond et al., *Gumbo Ya Ya*, 239–247.

50. Ibid.; M. J. Hewitt, "Betye Saar: An Interview," *International Review of African-American Art* 10, no. 2 (1992): 6–23.

51. Kay Brown, "The Emergence of Black Women Artists: The 1970s, New York," *International Review of African-American Art* 15, no. 1 (1998): 45–46.

52. Ibid., 46.

53. Ibid., 46–49; Victor N. Smythe, *Black New York Artists of the Twentieth Century: Selections from the Schomburg Center Collections* (New York: New York Public Library, Astor Lenox and Tilden Foundation, 1998), 83.

54. Brown, "Emergence of Black Women Artists," 47.

55. Elsa Honig Fine, *The Afro-American Artist: A Search for Identity* (New York: Holt, Rinehart and Winston, 1973), 210; King-Hammond et al., *Gumbo Ya Ya*, 23.

56. Quoted in Susan Dyer, "Dindga McCannon," in King-Hammond et al., *Gumbo Ya Ya*, 157.

57. Smythe, *Black New York Artists of the Twentieth Century*, 89; Dyer, "Dindga McCannon," 157.

CHAPTER EIGHT

1. Sharon F. Patton, *African-American Art* (New York: Oxford University Press, 1998), 217.

2. Peter Selz and Anthony Janson, *Barbara Chase-Riboud: Sculptor* (New York: Abrams, 1999), 17–18, 120, 135–137.

3. Ibid.; Barbara Chase-Riboud, quoted in Eleanor Munro, *Originals: American Women Artists* (New York: Viking, 1988), 372.

4. Selz and Janson, *Barbara Chase-Riboud*, 21–22, 28, 135–137.

5. Ibid., 18, 32, 135–137; Chase-Riboud, quoted in Susan McHenry, "'Sally Hemings': A Key to Our National Identity: A Conversation with Barbara Chase-Riboud," *Ms.*, Oct. 1980, 40.

6. Chase-Riboud, quoted in *Gumbo Ya Ya: Anthology of Contemporary African-American Women Artists*, ed. Leslie King-Hammond et al. (New York: Midmarch Arts, 1995), 53; Selz and Janson, *Barbara Chase-Riboud*, 36.

7. Selz and Janson, *Barbara Chase-Riboud*, 23, 28, 31, 35, 135–137.

8. Hilton Kramer, "Black Experience in Modern Art," *New York Times*, 14 February 1970, 23.

9. Henry Ghent, "Art Mailbag," *New York Times*, 19 April 1970, sec. 2, 22.

10. Selz and Janson, *Barbara Chase-Riboud*, 36.

11. Ibid., 135–137; Barbara Chase-Riboud, *Validé* (New York: Morrow, 1986), *The President's Daughter* (New York: Random House, 1994), *Echo of Lions* (New York: Morrow, 1989), and *Sally Hemings* (New York: Viking, 1979).

12. Selz and Janson, *Barbara Chase-Riboud*, 49–50; John McFarland et al., *Lives from Plutarch* (New York: Random House, 1966), 270.

13. Selz and Janson, *Barbara Chase-Riboud*, 135–137; Barbara Chase-Riboud, *Portrait of a Nude Woman as Cleopatra* (New York: Morrow, 1988).

14. Selz and Janson, *Barbara Chase-Riboud*, 66.

15. Ibid., 65–66, 68, 70, 96.

16. Ibid.

17. Ibid., 68, 70.

18. Chase-Riboud to President Clinton, typed document, 26 April 1994, reprinted in Selz and Janson, *Barbara Chase-Riboud*, 128–130.

19. Ibid., 131.

20. Tritobia Hayes Benjamin, "Triumphant Determination: The Legacy of African-American Women Artists," in *Bearing Witness: Contemporary Works by African-American Women Artists*, ed. Jontyle Theresa Robinson (Atlanta, Ga.: Spelman College Press; New York: Rizzoli, 1996), 71.

21. Arna Alexander Bontemps, ed., *Forever Free: Art by African-American Women, 1862–1980* (Alexandria, Va.: Stephenson, 1980), 36; Jacob Kainen, "Alma W. Thomas: Order and Emotion," in *Alma W. Thomas: A Retrospective of the Paintings*, ed. Sachi Yanari et al. (San Francisco, Calif.: Pomegranate, 1998), 32–33.

22. Sachi Yanari, introduction to Yanari et al., *Alma W. Thomas*, 11; Thomas, undated statement, Alma Woodsey Thomas Papers, Archives of American Art,

Smithsonian Institution, Washington, D.C., quoted in Ann Gibson, "Putting Alma Thomas in Place: Modernist Painting, Color Theory, and Civil Rights," in Yanari et al., *Alma W. Thomas*, 40; Elsa Honig Fine, *The Afro-American Artist: A Search for Identity* (New York: Holt, Rinehart and Winston, 1973), 153.

23. Romare Bearden and Harry Henderson, *A History of African-American Artists from 1792 to the Present* (New York: Pantheon, 1993), 449; Benjamin, "Triumphant Determination," 70–71, 81 n. 113; Yanari, introduction to Yanari et al., *Alma W. Thomas*, 10.

24. Bearden and Henderson, *History of African-American Artists*, 450; Fine, *Afro-American Artist*, 152; Jonathan P. Binstock, "Apolitical Art in a Political World: Alma Thomas in the Late 1960s and Early 1970s," in Yanari et al., *Alma W. Thomas*, 59.

25. Bontemps, *Forever Free*, 132.

26. "A Life in Art: Alma Thomas, 1891–1978," Columbus Museum of Arts and Sciences press release (1982), Vertical File, Library, National Museum of American Art, Smithsonian Institution, Washington, D.C.; Fine, *Afro-American Artist*, 153.

27. Tritobia Hayes Benjamin, "From Academic Representation to Poetic Abstraction: The Art of Alma Woodsey Thomas," in Yanari et al., *Alma W. Thomas*, 23.

28. H. E. Mahal, "Interviews: Four Afro-American Artists' Approaches to Inhumanity," *Art Gallery* 18 (April 1970): 36; Fine, *Afro-American Artist*, 153.

29. Howardena Pindell, "Art (World) and Racism: Testimony, Documentation, and Statistics," *Third Text* 3, no. 4 (Spring–Summer 1988): 157–162; Beverly Guy-Sheftall, "Warrior Women," 45, 46 n. 23.

30. King-Hammond et al., *Gumbo Ya Ya*, 205–206.

31. Pindell, "Art (World) and Racism," 157–62, Guy-Scheftall, "Warrior Women," 45, 46 n. 23.

32. Andrea D. Barnwell, "Been to Africa and Back," *International Review of African-American Art* 13, no. 3 (1996): 45; Linda Freeman, producer, and David Irving, director, *Howardena Pindell: Atomizing Art*, videocassette (L&S Video, 1998); Linda Goode-Bryant, quoted in Judith Wilson, "Howardena Pindell Makes Art That Winks at You," *Ms.*, May 1980, 69.

33. King-Hammond et al., *Gumbo Ya Ya*, 319; Robert L. Hall, *Gathered Visions: Selected Works by African-American Women Artists* (Washington, D.C.: Smithsonian Institution Press, 1992), 30.

34. Ibid.

35. Ibid., 50; King-Hammond et al., *Gumbo Ya Ya*, 24.

36. Quoted in King-Hammond et al., *Gumbo Ya Ya*, 24.

37. Ibid.

38. Ibid., 26.

39. Betty Blayton, quoted in King-Hammond et al., *Gumbo Ya Ya*, 16–17.

40. Quoted in King-Hammond et al., *Gumbo Ya Ya*, 194; Bontemps, *Forever Free*, 106.

41. Bontemps, *Forever Free*, 126; Alice Thorson, "Sylvia Snowden," in King-Hammond et al., *Gumbo Ya Ya*, 269–271; Richard J. Powell, *Black Art and Culture in the Twentieth Century* (London: Thames and Hudson, 1997), 132.

42. Thorson, "Sylvia Snowden," in King-Hammond et al., *Gumbo Ya Ya*, 269–271.

43. King-Hammond et al., *Gumbo Ya Ya*, 213–214.

44. Quoted in ibid.

45. Adrienne L. Childs and Tuliza Fleming, "Artists' Chronologies," in *Narratives of African-American Art and Identity: The David C. Driskell Collection*, ed. David Driskell (San Francisco, Calif.: Pomegranate, 1998), 155.

46. Joyce Wellman, telephone interview by author, 23 April 2003; Richard Powell, "Joyce Wellman," in King-Hammond et al., *Gumbo Ya Ya*, 318; Richard Powell, "Journeying Beyond: The Prints and Paintings of Joyce Wellman," *International Review of African-American Art* 10, no. 3 (1993): 5–6.

47. Quoted in King-Hammond et al., *Gumbo Ya Ya*, 317.

48. Wellman, artist's talk presented at the Fourteenth Annual James A. Porter Colloquium, Howard University, Washington, D.C., 18–19 April 2003.

49. Lowery Stokes Sims, "Ancestralism and Modernism: Elizabeth Catlett, Geraldine McCullough, Barbara Chase-Riboud," in *3 Generations of African-American Women Sculptors: A Study in Paradox*, ed. Leslie King-Hammond and Tritobia Hayes Benjamin (Philadelphia, Pa.: Afro-American Historical and Cultural Museum, 1996), 48.

50. John Canady, "Art: A Debutante and a Grand Old Man," *New York Times*, 15 January 1964, 22; Sims, "Ancestralism and Modernism," 48.

51. Geraldine McCullough, quoted in Bontemps, *Forever Free*, 100.

52. Robert Henkes, *The Art of Black American Women: Works of Twenty-Four Artists of the Twentieth Century* (Jefferson, N.C.: McFarland, 1993), 262; Robinson, *Bearing Witness*, 121.

53. Ann Gibson, "Two Worlds: African-American Abstraction in New York at Mid-Century," in *The Search for Freedom: African-American Abstract Painting, 1945–1975* (New York: Kenkeleba Gallery, 1991), 13.

CHAPTER NINE

1. Sol LeWitt, "Paragraphs on Conceptual Art," in *Sol Lewitt: Critical Texts*, ed. Adachiara Zevi (Rome: Libri de AEIUO; Cologne: Bucchandlung Walker König, 1994), 78–82.

2. Bruce Altshuler, "Adrian Piper: Ideas into Art," *Art Journal* 56, no. 4 (Winter 1997): 100.

3. Maurice Berger et al., *Adrian Piper: A Retrospective* (Baltimore: University of Maryland Press, 1999), 16, 47, 185–189; Adrian Piper, *Out of Order, Out of Sight*, vol. 1: *Selected Writings in Meta-Art 1968–1992*, and vol. 2: *Selected Writings in Art Criticism 1967–1992* (Cambridge, Mass.: MIT Press, 1996).

4. Altshuler, "Adrian Piper: Ideas into Art," 100.

5. Berger et al., *Adrian Piper*, 16, 19.

6. Ibid., 22, 65, 179; Thelma Golden et al., *Black Male: Representations of Masculinity in Contemporary American Art* (New York: Whitney Museum and Abrams, 1994), 25.

7. Adrian Piper, "Notes on Mythic Being I: March 1974," in *Individuals: Post-Movement Art in America*, ed. Alan Sondheim (New York: Dutton, 1977), 268.

8. Ibid.

9. Ibid., 17, 188.

10. Leslie King-Hammond et al., eds., *Gumbo Ya Ya: Anthology of Contemporary African-American Women Artists* (New York: Midmarch Arts, 1995), 207.

11. Piper, *Out of Order*, vol. 2, 249; Berger et al., *Adrian Piper*, 21.

12. Phyllis J. Jackson, "(In)Forming the Visual: (Re)Presenting Women of African Descent," *International Review of African-American Art* 14, no. 3 (1997): 35.

13. G. Battcock, "Minimal Art," in *The Oxford Companion to Western Art*, ed. Hugh Brigstocke (Oxford: Oxford University Press, 2001), 480.

14. Berger et al., *Adrian Piper*, 70; Thomas Kuhn, cited in Altshuler, "Adrian Piper: Ideas into Art," 100.

15. Berger et al., *Adrian Piper*, 21; Golden et al., *Black Male*, 26; Maurice Berger, "Interview with Adrian Piper," May 1990, Washington, D.C., in *Art, Activism and Oppositionality: Essays from Afterimage*, ed. Grant H. Kester (Durham, N.C.: Duke University Press, 1998), 224.

16. Berger, "Interview with Adrian Piper," 216–217.

17. Ibid., 228.

18. Ibid., 219, 224; Altshuler, "Adrian Piper: Ideas into Art," 100; Berger et al., *Adrian Piper*, 20, 172; King-Hammond et al., *Gumbo Ya Ya*, 207.

19. Quoted in King-Hammond et al., *Gumbo Ya Ya*, 327.

20. Ibid.

21. Ibid.; for example, Deborah Willis, *Black Photographers, 1840–1940* (New York: Garland, 1985), *Van Der Zee: Photographer 1886–1983* (New York: Abrams, 1993), *Picturing Us: African-American Identity in Photography* (New York: New Press, 1994), *Reflections in Black: A History of Black Photographers, 1840 to the Present* (New York: Norton, 2000), *The Black Female Body: A Photographic History* (Philadelphia, Pa.: Temple University Press, 2002).

22. King-Hammond et al., *Gumbo Ya Ya*, 167.

23. Ibid., 166.

24. Quoted in ibid.

25. Ibid.

26. Judith Wilson, "Beauty Rites: Towards an Anatomy of Culture in African-American Women's Art," *International Review of African-American Art* 11, no. 3 (1994): 48; Vivian Patterson et al., *Carrie Mae Weems: The Hampton Project* (Williamstown, Mass.: Williams College of Art; New York: Aperture, 2000), 22–23.

27. Ibid., Ernest Larsen, "Between Worlds," *Art in America* 87, no. 5 (May 1999): 128.

28. Patterson et al., *Carrie Mae Weems*, 8, 32.

29. Ibid., 27; Roland Barthes, "Rhetoric of Images," in *The Responsibility of Forms* (New York: Hill and Wang, 1985), 21–40; Cherise Smith, "Fragmented Documents: Works by Lorna Simpson, Carrie Mae Weems, and Robert Middlebrook at the Art Institute of Chicago," in *African Americans in Art: Selections from the Art Institute of Chicago*, ed. Susan F. Rossen et al. (Chicago, Ill.: Art Institute of Chicago, 1999), 110.

30. Judith Fryer Davidow, *Women's Camera Work: Self/Body/Other in American Visual Culture* (Durham, N.C.: Duke University Press, 1998), 159; Patterson et al., *Carrie Mae Weems*, 9, 25, 27–28, 66–67.

31. James Guimond, *American Photography and the American Dream* (Chapel Hill: University of North Carolina Press, 1998), 31; Patterson et al., *Carrie Mae Weems*, 63.

32. Patterson et al., *Carrie Mae Weems*, 64.

33. Ibid., 29.

34. Roland Barthes, *Camera Lucida: Reflections on Photography* (New York: Hill and Wang, 1981), and *Responsibility of Forms*.

35. Patterson et al., *Carrie Mae Weems*, 9, 25, 27, 29; Linda Carmen, "New WCMA Exhibition Combines Great Contemporary and Historical Photographs," *Advocate*, 8 March 2000, 1–3.

36. Carmen, "New WCMA Exhibition," 1–3.

37. Patterson et al., *Carrie Mae Weems*.

38. Ibid., 26.

39. Ibid., 8–10, 76–80.

40. Ibid., 22; Thelma Golden and Thomas Piché, Jr., *Carrie Mae Weems: Recent Works, 1992–1998* (New York: Braziller; Syracuse, N.Y.: Everson Museum of Art, 1998), 30.

41. Wilson, "Beauty Rites," 48.

42. Ibid.; Smith, "Fragmented Documents," 110.

43. Smith, "Fragmented Documents," 110; King-Hammond et al., *Gumbo Ya Ya*, 262; Kellie Jones et al., *Lorna Simpson* (London: Phaidon, 2002), 8.

44. bell hooks, "Facing Difference: The Black Female Body," in *Art on My Mind: Visual Politics* (New York: New Press, 1995), 94; King-Hammond et al., *Gumbo Ya Ya*, 263.

45. hooks, "Facing Difference," 94.

46. Jones et al., *Lorna Simpson*, 82.

47. Ibid., 106–107; King-Hammond et al., *Gumbo Ya–Ya*, 262.

48. King-Hammond et al., *Gumbo Ya–Ya*, 190.

49. Ibid.; Lorraine O'Grady, "Nefertiti/Devonia Evangeline," *Art Journal* 56, no. 4 (Winter 1997): 64.

50. O'Grady, "Nefertiti/Devonia Evangeline," 64.

51. Ibid.

52. Jackson, "(In)forming the Visual," 33.

53. Marilyn Jiménez, "Naked Scene Seen Naked: Performing the Hott-En-Tott," in Isaak, *Looking Forward, Looking Black*, 13.

54. Andrea D. Barnwell, "Personal Reflections and the Fact of Blackness," *International Review of African-American Art* 14, no. 1 (1997): 59.

55. Elisabeth Bumiller, "Affronted by Nude 'Last Supper,' Giuliani Calls for Decency Panel," *New York Times*, 16 February 2001, http://www.nytimes.com/2001/02/16/arts/16MUSE.html.

56. Phyllis J. Jackson, "Irreverent Seductions: B(l)ack at the Whitney," *International Review of African-American Art* 14, no. 2 (1997): 50; Rossen, *African Americans in Art*, 83.

57. [Juliette Bowles, ed.], "Extreme Times Call for Extreme Heroes," *International Review of African-American Art* 14, no. 3 (1997): 7; Jerry Saltz, "Kara Walker, Ill-Will and Desire," *Flash Art* (Nov.–Dec. 1996): 84; Walker, quoted in *The High and Soft Laughter of the Nigger Wenches at Night* (New York: Wooster Gardens/Brent Sikkema Gallery, 1995), unpaginated; Robert Hobbs and Kara Walker, *Slavery Slavery!* (Washington, D.C.: International Art and Artists, 2002), 20, 33

58. Hobbs and Walker, *Slavery Slavery!* 38–39.

59. Jackson, "Irreverent Seductions," 50–51; Isaak, *Looking Forward, Looking Black,* 6; Hobbs and Walker, *Slavery Slavery!* 14–15; Christina Elizabeth Sharpe, "Kara Walker and Michael Ray Charles," in Isaak, *Looking Forward, Looking Black,* 40.

60. Françoise Verges, "Chains of Madness, Chains of Colonialism: Fanon and Freedom," in *The Fact of Blackness: Frantz Fanon and Visual Representation,* ed. Alan Read (Seattle, Wash.: Bay Press, 1996), 64; Kobena Mercer, "Keith Piper: To Unbury the Disremembered Body," in *New Histories,* ed. Milena Kalinovska et al. (Boston: Institute of Contemporary Art, 1996), 161–166.

61. Pindell, quoted in Robin M. Chandler, "Xenophobes, Visual Terrorism, and the African Subject," *Third Text* (London) (Summer 1996): 15; Pindell, *The Heart of the Question* (New York: Midmarch Arts, 1997), 23; [Bowles], "Extreme Times Call for Extreme Heroes," 3–4, 12.

62. [Bowles], "Extreme Times Call for Extreme Heroes," 3–4, 12.

63. Kara Walker, "The Debate Continues: Kara Walker's Response," *International Review of African-American Art* 15, no. 2 (1998): 48–49.

64. Walker, quoted in Sharpe, "Kara Walker and Michael Ray Charles," 41.

65. Sharpe, "Kara Walker and Michael Ray Charles," 41.

CHAPTER TEN

1. Lee Kogan, *The Art of Nellie Mae Rowe: Ninety-Nine and a Half Won't Do* (New York: Museum of American Folk Art, 1998), 8; Paul Arnett and William Arnett, eds., *Souls Grown Deep: African-American Vernacular Art of the South,* vol.1: *The Tree Gave the Dove a Leaf* (New York: Schomburg Center for Research in Black Culture, New York Public Library, 2000), xvi.

2. Arnett and Arnett, *Souls Grown Deep,* xiii, xiv, xvi, 483; Charles Lovell and Erwin Hester, eds., *Minnie Evans: Artist* (Greenville, N.C.: East Carolina University Press, 1993), 25.

3. Leslie King-Hammond et al., eds., *Gumbo Ya Ya: Anthology of Contemporary African-American Women Artists* (New York: Midmarch Arts, 1995), 232.

4. bell hooks, *Art on My Mind: Visual Politics* (New York: New Press, 1995), 12–13; Dan Cameron, "Southern Exposures," *Art and Auction* 17 (January 1995): 64; Arnett and Arnett, *Souls Grown Deep,* 26, 285.

5. Arnett and Arnett, *Souls Grown Deep,* xiii.

6. Michael D. Hall and Eugene W. Metcalf, eds., *The Artist Outsider: Creativity and the Boundaries of Culture* (Washington, D.C.: Smithsonian Institution Press, 1994), 214–217; Arnett and Arnett, *Souls Grown Deep,* xiii, 407, 414; Kogan, *Art of Nellie Mae Rowe,* 13.

7. Arnett and Arnett, *Souls Grown Deep,* 168.

8. Ibid., 282.

9. Ibid.

10. Ibid., 438.

11. Ibid., 17.

12. Ibid., xix, xviii, 28, 283, 293–296, 483; Kogan, *Art of Nellie Mae Rowe,* 18–20; John Beardsley, *Gardens of Revelation: Environments by Visionary Artists* (New York: Abbeville, 1995), 27–28; Meyer Schapiro, "On Some Problems in the Semiotics of Visual Art: Field and Vehicle in Image-Signs," *Semiotics* 1, no. 3 (1969): 223–242.

13. Quoted in Arnett and Arnett, *Souls Grown Deep,* 282.

14. James L. Wilson, *Clementine Hunter: American Folk Artist* (Gretna, La.: Pelican, 1988, 1990), 21, 34–35; Elsa Honig Fine, *The Afro-American Artist: A Search for Identity*

(New York: Holt, Rinehart and Winston, 1973), 30–33.

15. Ibid. The date of 1750 sometimes attributed to the original Melrose building seems unlikely, since Coincoin was only eight years old at the time and would not acquire and clear the land for building and farming until nearly fifty years later.

16. Ibid.; Patricia Brady, "A Mixed Palette: Free Artists of Color of Antebellum New Orleans," Sharon Patton, "Antebellum Louisiana Artisans: The Black Furniture Makers," and Richard Dozier, "John Henry and Sons, Builders of More Stately Mansions: African-American Contributors to Nineteenth-Century American Architecture," all in *International Review of African-American Art* 12, no. 3 (1995): 4–23, 38–48, 53–62.

17. Wilson, *Clementine Hunter*, 19–20.

18. Ibid., 22, 24.

19. Ibid., 24.

20. Ibid., 27–28; Lee Kogan, "Clementine Hunter," in Arnett and Arnett, *Souls Grown Deep*, 310.

21. Wilson, *Clementine Hunter*, 28–29.

22. Ibid., 7–8, 25–26, 29, 37.

23. Ibid., 8.

24. Carter Stevens, review from the *New Orleans Item*, cited in Wilson, *Clementine Hunter*, 33.

25. Wilson, *Clementine Hunter*, 34.

26. Ibid., 35.

27. Ibid., 36.

28. Robert Bishop, 1979 interview, and Roger Green, 1981 review, in the *Times Picayune/States Item*, both cited in Wilson, *Clementine Hunter*, 149.

29. Regenia A. Perry, *Free within Ourselves: African-American Artists in the Collection of the National Museum of American Art* (Washington, D.C.: Smithsonian Institution Press, 1992), 69; Arnett and Arnett, *Souls Grown Deep*, 308; Judith McWillie et al., *Another Face of the Diamond: Pathways through the Black Atlantic South* (New York: INTAR Latin American Gallery, 1988), 62; Lovell and Hester, *Minnie Evans*, 11.

30. Nina Howell Starr, "The Lost World of Minnie Evans," *Bennington Review* 3 (Summer 1969): 41–43.

31. Lovell and Hester, *Minnie Evans*, 11, 18–19; Arnett and Arnett, *Souls Grown Deep*, 308; Starr, "The Lost World of Minnie Evans," 41–43.

32. Arnett and Arnett, *Souls Grown Deep*, 308; Lovell and Hester, *Minnie Evans*, 12–13.

33. Lovell and Hester, *Minnie Evans*, 11–12, 70.

34. Arnett and Arnett, *Souls Grown Deep*, 285, 290, 293, 298; Kogan, *Art of Nellie Mae Rowe*, 16.

35. Arnett and Arnett, *Souls Grown Deep*, 285, 290, 293, 297; Regenia A. Perry, "Contemporary African-American Folk Art: An Overview," *International Review of African-American Art* 11, no. 1 (1994): 24–25; J. Richard Gruben and Xenia Zed, *Nellie Mae Rowe* (Augusta, Ga.: Morris Museum of Art, 1996), 9; Kogan, *Art of Nellie Mae Rowe*, 9, 19, 25; Anna Wadsworth, ed., *Missing Pieces: Georgia Folk Art 1770–1976* (Atlanta: Georgia Council for the Arts and Humanities, 1976), 52.

36. Arnett and Arnett, *Souls Grown Deep*, 297; Kogan, *Art of Nellie Mae Rowe*, 26.

37. Kogan, *Art of Nellie Mae Rowe*, 8, 20–21.

38. Ibid., 18; John Michael Vlach, *The Afro-American Tradition in Decorative Arts* (Athens: University of Georgia Press, 1990), ch. 5; Arnett and Arnett, *Souls Grown Deep*, 297.

39. Arnett and Arnett, *Souls Grown Deep*, 297.

40. Kogan, *Art of Nellie Mae Rowe*, 23–24.

41. Arnett and Arnett, *Souls Grown Deep*, 296; Perry, "Contemporary African-American Folk Art," 23.

42. Arnett and Arnett, *Souls Grown Deep*, 283, 286.

43. Arnett and Arnett, *Souls Grown Deep*, 286.

44. Ibid.

45. Arnett and Arnett, *Souls Grown Deep*, 158, 160–161, 168; *God as Architect* (thirteenth century), a manuscript illumination from the Bible Moralisée, fol. 1v, Reims, France, offers an example; Laurie Schneider Adams, *The Methodologies of Art:*

An Introduction (Boulder, Colo.: Westview, 1996), ch. 6.

46. Arnett and Arnett, *Souls Grown Deep*, 158, 160–161, 168; King-Hammond et al., *Gumbo Ya Ya*, 93.

47. Ibid., 158.

48. Ibid.

49. Ibid., 160, 168; King-Hammond et al., *Gumbo Ya Ya*, 93.

50. Quoted in King-Hammond et al., *Gumbo Ya Ya*, 93.

51. Ibid., 94.

52. Alfred Metraux, *Voodoo in Haiti* (New York: Schocken, 1972); Donald J. Cosentino, ed., *Sacred Arts of Haitian Vodou* (Los Angeles, Calif.: UCLA Fowler Museum of Cultural History, 1995).

53. Borum, in Arnett and Arnett, *Souls Grown Deep*, 160.

54. Arthur C. Danto et al., *Self-Taught Artists of the Twentieth Century: An American Anthology* (New York: Museum of American Folk Art, 1998), 19.

55. Arnett and Arnett, *Souls Grown Deep*, 487.

56. Kogan, *Art of Nellie Mae Rowe*, 20.

57. Arnett and Arnett, *Souls Grown Deep*, 501; Lovell and Hester, *Minnie Evans*, 11.

CHAPTER ELEVEN

1. Holland Cotter, "Beyond Multiculturalism: Freedom?" *New York Times*, 29 July 2001, sec. 2, 28; Horace Brockington, "After Representation," *International Review of African-American Art* 16, no. 4 (2000): 42, 46.

2. David C. Driskell et al., *African-American Visual Aesthetics: A Postmodern View* (Washington, D.C.: Smithsonian Institution Press, 1995), 36, 101.

3. Ibid., 84.

4. Gibson, in ibid., 82–83.

5. Christopher Reed, "Postmodernism and the Art of Identity," in Nikos Stangos et al., *Concepts of Modern Art: From Fauvism to Post-Modernism* (London: Thames and Hudson, 1993), 274; Driskell et al., *African-American Visual Aesthetics*, 115.

6. Thomas McEvilley, *Fusion: West African Artists at the Venice Biennale* (New York: Museum for African Art, 1993), 10–11;

Driskell et al., *African-American Visual Aesthetics*, 17.

7. Sharon Patton, "Postmodernism Made Easy," *International Review of African-American Art* 13, no. 2 (1996): 28; Driskell et al., *African-American Visual Aesthetics*, 127.

8. Driskell et al., *African-American Visual Aesthetics*, 18, 84, 89, 112; Calvin Reid, "How We Got to Now," *International Review of African-American Art* 16, no. 4 (2000): 16.

9. Ibid.; Brockington, "After Representation," 42; Susan F. Rossen et al., eds., *African Americans in Art: Selections from the Art Institute of Chicago* (Chicago, Ill.: Art Institute of Chicago, 1999), 109.

10. Alvia J. Wardlaw et al., *Black Art, Ancestral Legacy: The African Impulse in African-American Art* (Dallas, Tex.: Dallas Museum of Art; New York: Abrams, 1989), 260; Toni Wynn, "The Work Meditative and Blessed," *International Review of African-American Art* 15, no. 4 (1999): 15; Leslie King-Hammond et al., eds., *Gumbo Ya Ya: Anthology of Contemporary African-American Women Artists* (New York: Midmarch Arts, 1995), 4.

11. Bailey, quoted in Wynn, "The Work Meditative and Blessed," 15.

12. Ibid.; King-Hammond et al., *Gumbo Ya Ya*, 4; James Weaver, "Contemporary Expression of an Ancient Craft: Artist Xenobia Bailey Gives New Life to Crochet," *Crafts Report* (January 2003), http://www.craftsreport.com/january03/profile/html.

13. Ibid., 37.

14. Ibid., 38; Driskell et al., *African-American Visual Aesthetics*, 58.

15. King-Hammond et al., *Gumbo Ya Ya*, 196–197; Owens-Hart, "Traditions: Ipetumodu," *International Review of African-American Art* 11, no. 2 (1994): 59–60.

16. Ibid.

17. Owens-Hart, quoted in King-Hammond et al., *Gumbo Ya Ya*, 196.

18. Ibid.; Robert L. Hall, *Gathered Visions: Selected Works by African-American Women Artists* (Washington, D.C.: Smithsonian Institution Press, 1992), 14.

19. Hugh Honour, *The Image of the Black in Western Art*, vol. 4 (Houston, Tex.: Menil Foundation; Cambridge, Mass.: Harvard University Press, 1989), 184.

20. King-Hammond et al., *Gumbo Ya Ya*, 196–200.

21. Robyn Minter Smyers, "Re-making the Past: The Black Oral Tradition in Contemporary Art," *International Review of African-American Art* 17, no. 1 (2000): 48.

22. Joyce Scott, "The View from Now," *International Review of African-American Art* 13, no. 2 (1996): 3.

23. King-Hammond et al., *Gumbo Ya Ya*, 253; Jontyle Theresa Robinson, ed., *Bearing Witness: Contemporary Works by African-American Women Artists* (Atlanta, Ga.: Spelman College Press, 1996), 29.

24. Smyers, "Re-making the Past," 48; Robinson, *Bearing Witness*, 29, 88.

25. Renée Stout, "Tippy," in Renée Stout and Gary Lilley, *Hoodoo You Love: Prose, Poetry, and Art from the Black Rooster Workshop* (Washington, D.C.: Sister Space Books and Gary Lilley, 1998), reprinted in part in "Voodoo Shoes," *International Review of African-American Art* 16, no. 1 (1999): 53–54.

26. King-Hammond et al., *Gumbo Ya Ya*, 276; Michael D. Harris and Wyatt MacGaffey, *Astonishment and Power* (Washington, D.C.: Smithsonian Institution Press, 1993), 120–122; Wardlaw et al., *Black Art, Ancestral Legacy*, 292; Robert Farris Thompson, *Flash of the Spirit: African and Afro-American Art and Philosophy* (New York: Random House, 1984).

27. Harris and MacGaffey, *Astonishment and Power*, 111–117.

28. Ibid., 107–155.

29. Ibid., 131.

30. Stout, quoted in King-Hammond et al., *Gumbo Ya Ya*, 276; Clayton Corrie, producer, Christine McConnell, director, *Kindred Spirits: Contemporary African-American Artists* (Dallas KERA–TV, 1992), videotape; Harris and MacGaffey, *Astonishment and Power*, 134.

31. Wardlaw et al., *Black Art, Ancestral Legacy*, 231.

32. Alfred Metraux, *Voodoo in Haiti* (New York: Schocken, 1972).

33. bell hooks, *Art on My Mind: Visual Politics* (New York: New Press, 1995), 12–13.

34. Ibid.; Mary Jane Hewitt, "Alison Saar: The Persistence of the Figurative," *International Review of African-American Art* 9, no. 2 (October 1990): 4–6.

35. Lippard, in King-Hammond et al., *Gumbo Ya Ya*, 241.

36. hooks, *Art on My Mind*, 10–34; Hewitt, "Alison Saar," 4–11.

37. Joanne Butcher, "Freida High Tesfagiorgis," *International Review of African-American Art* 9, no. 2 (October 1990): 29.

38. Quoted in ibid.

39. Ibid.; King-Hammond et al., *Gumbo Ya Ya*, 289–292; Robinson, *Bearing Witness*, 128.

40. Richard Powell, *Black Art and Culture in the Twentieth Century* (London: Thames and Hudson, 1997), 160.

41. Artist's statement, made at the Fourteenth Annual James A. Porter Colloquium held at Howard University in Washington, D.C., 18–19 April 2003.

42. King-Hammond et al., *Gumbo Ya Ya*, 114–115.

43. Robinson, *Bearing Witness*, 22, 37 n. 27; Floyd Thomas, Jr., "Collecting the Art of Black Protest and Black Nationalist Movements," *International Review of African-American Art* 15, no. 1 (1998): 12; Nkiru Nzegwu, "Reality on the Wings of Abstraction," *International Review of African-American Art* 13, no. 3 (1996): 8.

44. Robinson, *Bearing Witness*, 22; Nkiru Nzegwu, "Reality on the Wings of Abstraction," 8.

45. Thomas, "Collecting the Art of Black Protest and Black Nationalist Movements," 12.

46. Nzegwu, "Reality on the Wings of Abstraction," 8.

47. Ibid.

48. King-Hammond et al., *Gumbo Ya Ya*, 14; Camille Billops, "My Life in Art: An Autobiographical Essay," *Black Art: An International Quarterly* (now *International*

Review of African-American Art) 1 no. 4 (Summer 1977): 32, 38, 50.

49. Ibid.; Camille Billops, telephone interview with author, 14 March 2003; Robert Henkes, *The Art of Black American Women: Works of Twenty-Four Artists of the Twentieth Century* (Jefferson, N.C.: McFarland, 1993), 149–159.

50. King-Hammond et al., *Gumbo Ya Ya*, 14–15; Billops, "My Life in Art," 32, 38.

51. A. M. Weaver, "Suspended Metaphors," *International Review of African-American Art* 13, no. 3 (1996): 33, 35; King-Hammond et al., *Gumbo Ya Ya*, 120–121.

52. Weaver, "Suspended Metaphors," 38, 40.

53. Ibid., 40; Patton, "Living Fearlessly with and within Difference(s)," 63–64.

54. Martha Jackson-Jarvis, quoted in Driskell et al., *African-American Visual Aesthetics*, 68.

55. King-Hammond et al., *Gumbo Ya Ya*, 120.

56. Robinson, *Bearing Witness*, 21.

57. Wardlaw et al., *Black Art, Ancestral Legacy*, 277.

58. Robinson, *Bearing Witness*, 21.

59. Ibid.; Wardlaw et al., *Black Art, Ancestral Legacy*, 277.

60. Robin Holder, quoted in Henkes, *Art of Black American Women*, 133.

CHAPTER TWELVE

1. Holland Cotter, "Beyond Multiculturalism: Freedom?" *New York Times*, 29 July 2001, sec. 2, 1, 28.

2. Ibid. Historian David A. Hollinger proposed the term "post-ethnicity"; Horace Brockington, "After Representation," *International Review of African-American Art* 16, no. 4 (2000): 46; Thelma Golden, ed., *Freestyle* (New York: Studio Museum in Harlem, 2001), 14.

3. Quoted in Thyrza Nichols Goodeve, *Ellen Gallagher* (London: Anthony d'Offay Gallery, 2001), 28–29.

4. Translated into English in Henry Louis Gates, Jr., et al., *Josephine Baker and La Revue Nègre: Paul Colin's Lithographs of "Le Tumulte Noir" in Paris, 1927* (New York: Abrams, 1998), 11.

5. Erika Dalya Muhammad, "Race in Digital Space: Conceptualizing the Media Project," *Art Journal* 60, no. 3 (Fall 2001): 92.

6. Alondra Nelson, "Aliens Who Are of Course Ourselves," *Art Journal* 60, no. 3 (Fall 2001): 99.

7. Olukemi Ilesanmi, "Laylah Ali," in Golden, *Freestyle*, 20.

8. Golden, *Freestyle*, 14.

9. Franklin Sirmans, "Deborah Grant," in Golden, *Freestyle*, 33.

10. Debra Singer, "Tana Hargest," and Blake Bradford, "Jennie C. Jones," in Golden, *Freestyle*, 40–43.

11. Jenelle Porter, "Adia Millet," Sarah Robins, "Nadine Robinson," and Claire Gilman, "Susan Smith-Penelo," in Golden, *Freestyle*, 59–65, 71, 73.

12. Lisa Gail Collins, "Camille Norment," David Hunt, "Julie Mehretu," and Susette Min, "Kira Lynn Harris," in Golden, *Freestyle*, 42–43, 59–61, 65.

13. Philemona Williamson, quoted in Carl Little, "Philemona Williamson," in Leslie King-Hammond et al., eds., *Gumbo Ya Ya: Anthology of Contemporary African-American Women Artists* (New York: Midmarch Arts, 1995), 325.

14. Ibid., 325–326.

15. Ibid., 325.

16. Ibid.; Philemona Williamson, quoted in Samella Lewis, "Philemona Williamson: Through the Looking Glass," *International Review of African-American Art* 9, no. 2 (1990): 60.

17. Jontyle Theresa Robinson, ed., *Bearing Witness: Contemporary Works by African-American Women Artists* (Atlanta, Ga.: Spelman College Press; New York: Rizzoli, 1996), 31–32.

18. Williamson, quoted in Little, "Philemona Williamson," 326; Robinson, *Bearing Witness*, 31–32.

19. Gail Shaw-Clemons, "Artist's Statement," in King-Hammond et al., *Gumbo Ya Ya*, 257.

20. Shaw-Clemons, "Artist's Statement," in *Gail Shaw-Clemons: Indigo* (New York: Cinque Gallery, 2002), 2.

21. Franklin Simans, "Debra Priestly: Preserving the Past/Making It New," in *Debra Priestly* (New York: June Kelly Gallery), 2; Kathleen McCann, "Debra Priestly," in King-Hammond et al., *Gumbo Ya Ya,* 217–218.

22. Brockington, "After Representation," 46.

23. Golden, *Freestyle,* 15.

24. Ibid.; Keith Morrison, "The Global Village of African-American Art," in David C. Driskell, ed., *African-American Visual Aesthetics: A Postmodern View* (Washington, D.C.: Smithsonian Institution Press, 1995), 38–39.

25. Cotter, "Beyond Multiculturalism: Freedom?" 28.

26. Ibid.

Arnett, Paul, and Arnett, William, eds. *Souls Grown Deep: African-American Vernacular Art of the South.* Vol. 1: *The Tree Gave the Dove a Leaf* and vol. 2: *Once That River Starts to Flow.* Atlanta, Ga.: Tinwood Books, 2000 and 2001.

Bambara, Toni Cade, ed. *The Black Woman: An Anthology.* New York: Penguin, 1970.

Barnwell, Andrea, ed. *The Walter O. Evans Collection of African-American Art.* Seattle: University of Washington Press, 1999.

Bearden, Romare, and Harry Henderson. *A History of African-American Artists from 1792 to the Present.* New York: Pantheon, 1993.

Beardsley, John. *Gardens of Revelation: Environments by Visionary Artists.* New York: Abbeville, 1995.

Begg, Ean. *The Cult of the Black Virgin.* London: Penguin, 1996.

Benjamin, Tritobia Hayes. *The Life and Art of Lois Mailou Jones.* San Francisco, Calif.: Pomegranate, 1994.

Berger, Maurice, et al. *Adrian Piper: A Retrospective.* Baltimore: University of Maryland Press, 1999.

Bernal, Martin. *Black Athena: The Afroasiatic Roots of Classical Civilization.* New Brunswick, N.J.: Rutgers University Press, 1987.

Bibby, Deirdre L. *Augusta Savage and the Art Schools of Harlem.* New York: Schomburg Center for Research in Black Culture, New York Public Library, 1988.

Boime, Albert. *The Art of Exclusion: Representing Blacks in the Nineteenth Century.* Washington, D.C.: Smithsonian Institution Press, 1990.

Bontemps, Arna Alexander. *Forever Free: Art by African-American Women, 1862–1980.* Alexandria, Va.: Stephenson, 1980.

Broude, Norma, and Mary Garrard. *The Power of Feminist Art: The American Movement of the 1970s, History and Impact.* New York: Abrams, 1994.

Burke, Selma, et al. *9 to the Universe: Black Artists.* Philadelphia, Pa.: Black History Museum, 1983.

Cameron, Dan, et al. *Dancing at the Louvre: Faith Ringgold's French Collection.* New York: New Museum, 1998.

Campbell, Mary Schmidt, et al. *Tradition and Conflict: Images of a Turbulent Decade.* New York: Studio Museum in Harlem, 1985.

Chase, Judith. *Afro-American Art and Craft.* New York: Van Nostrand Reinhold, 1971.

Collins, Lisa Gail. *The Art of History: African-American Women Artists Engage the Past.* New Brunswick, N.J.: Rutgers University Press, 2002.

Cosentino, Donald J., ed. *Sacred Arts of Haitian Vodou.* Los Angeles, Calif.: UCLA Fowler Museum of Cultural History, 1995.

Danto, Arthur C., et al. *Self-Taught Artists of the Twentieth Century: An American Anthology.* New York: Museum of American Folk Art, 1998.

Selected Bibliography

Davis, Angela. *Women, Race and Class.* New York: Random House, 1981.

Debrunner, H. W. *Presence and Prestige: Africans in Europe.* Basel, Switzerland: Basler Afrika, 1979.

Dent, Gina, ed. *Black Popular Culture: A Project by Michele Wallace.* Seattle, Wash.: Bay Press, 1992.

Devisse, Jean. *The Image of the Black in Western Art.* Vol. 2. Cambridge, Mass.: Harvard University Press, 1979.

Donaldson, Jeff R., and Geneva Smitherman Donaldson. *The People's Art: Black Murals, 1967–1978.* Philadelphia, Pa.: African-American Historical and Cultural Museum, 1986.

Dover, Cedric. *American Negro Art.* New York: New York Graphic Society, 1960.

Driskell, David, ed. *African-American Visual Aesthetics: A Postmodern View.* Washington, D.C.: Smithsonian Institution Press, 1995.

———. *Black Art, Ancestral Legacy: The African Impulse in African-American Art.* Dallas, Tex.: Dallas Museum of Art; New York: Abrams, 1989.

———. *Harlem Renaissance Art of Black America.* New York: Abrams, 1987.

———. *Narratives of African-American Art and Identity: The David C. Driskell Collection.* San Francisco, Calif.: Pomegranate, 1998.

———. *Two Centuries of Black American Art.* Los Angeles, Calif.: Los Angeles County Museum of Art; New York: Knopf, 1976.

Farrington, Lisa. *Art and Identity: The African-American Aesthetic at New School University.* New York: New School, 1999.

———. *Art on Fire: The Politics of Race and Sex in the Paintings of Faith Ringgold.* New York: Millennium, 1999.

———. *Faith Ringgold.* San Francisco, Calif.: Pomegranate, 2004.

Farrington, Lisa, et al. *Art by African Americans in the Collection of the New Jersey State Museum.* Trenton: New Jersey State Museum, 1998.

Fax, Elton C. *Seventeen Black Artists.* New York: Dodd and Mead, 1971.

Fine, Elsa Honig. *The Afro-American Artist: A Search for Identity.* New York: Holt, Rinehart and Winston, 1973.

Flomenhaft, Eleanor, ed. *Faith Ringgold: A 25-Year Survey.* Hempstead, N.Y.: Fine Arts Museum of Long Island, 1990.

Fry, Gladys-Marie. *Stitched from the Soul: Slave Quilts from the Ante-Bellum South.* New York: Dutton, 1990.

Fusco, Coco. *Lorna Simpson.* New York: Museum of Modern Art, 1996.

Galembo, Phyllis. *Dressed for Thrills: 100 Years of Halloween Costumes and Masquerades.* New York: Abrams, 2002.

———. *Vodou: Visions and Voices of Haiti.* Berkeley, Calif.: Ten Speed, 1998.

Gayle, Addison, Jr., ed. *The Black Aesthetic.* Garden City, N.Y.: Doubleday, 1972.

Giddings, Paula. *When and Where I Enter: The Impact of Black Women on Race and Sex in America.* New York: Morrow, 1984. Reprint. New York: Bantam, 1988.

Gilman, Sander L. *Difference and Pathology: Stereotypes of Race, Sexuality and Madness.* Ithaca, N.Y.: Cornell University Press, 1985.

Goings, Kenneth W. *Mammy and Uncle Mose: Black Collectibles and American Stereotyping.* Bloomington: Indiana University Press, 1994.

Golden, Thelma, ed. *Freestyle.* New York: Studio Museum in Harlem, 2001.

Golden, Thelma, and Piché, Thomas, Jr. *Carrie Mae Weems: Recent Works, 1992–1998.* New York: Braziller; Syracuse, N.Y.: Everson Museum of Art, 1998.

Golden, Thelma, et al. *Black Male: Representations of Masculinity in Contemporary American Art.* New York: Whitney Museum of American Art and Abrams, 1994.

Goodeve, Thyrza Nichols. *Ellen Gallagher.* London: Anthony d'Offay Gallery, 2001.

Gouma-Peterson, Thalia, ed. *Faith Ringgold: Painting, Sculpture, Performance.* Wooster, Ohio: College of Wooster Art Museum, 1985.

Gruben, Richard, and Xenia Zed. *Nellie Mae Rowe.* Augusta, Ga.: Morris Museum of Art, 1996.

Hall, Michael D., and Eugene W. Metcalf, eds. *The Artist Outsider: Creativity and the Boundaries of Culture.* Washington, D.C.: Smithsonian Institution Press, 1994.

Hall, Robert L. *Gathered Visions: Selected Works by African-American Women Artists.* Washington, D.C.: Smithsonian Institution Press, 1992.

Hatch, James V., and Leo Hamalian, eds. *Artists and Influence.* Vol. 10, *1991.* New York: Hatch-Billops Collection, 1991.

Henkes, Robert. *The Art of Black American Women: Works of Twenty-Four Artists of the Twentieth Century.* Jefferson, N.C.: McFarland, 1993.

Herzog, Melanie Anne. *Elizabeth Catlett: An American Artist in Mexico.* Seattle and London: University of Washington Press, 2000.

Hine, Darlene Clark, et al., eds. *Black Women in America: An Historical Encyclopedia.* 2 vols. Bloomington and Indianapolis: Indiana University Press, 1993.

———. *Facts on File Encyclopedia of Black Women in America: Dance, Sports, and Visual Arts.* New York: Facts on File, 1997.

Holloway, Joseph E. *Africanisms in American Culture.* Bloomington and Indianapolis: Indiana University Press, 1990.

Honour, Hugh. *The Image of the Black in Western Art.* Vol. 4. Cambridge, Mass.: Harvard University Press, 1989.

hooks, bell. *Art on My Mind: Visual Politics.* New York: New Press, 1995.

Huggins, Nathan Irvin. *Harlem Renaissance.* New York: Oxford University Press, 1976.

Irving, David, writer and director. *Betye and Alison Saar: Conjure Women of the Arts.* Videocassette. Produced by Linda Freeman. 1994.

Isaak, Jo Anna. *Looking Forward, Looking Black.* Geneva, N.Y.: Hobart and William Smith Colleges Press, 1999.

Jacobs, Mary Jane. *Carrie Mae Weems.* Philadelphia, Pa.: Fabric Workshop/Museum, 1996.

Jones, Kellie, et al. *Lorna Simpson.* London: Phaidon, 2002.

Jones, Lois Mailou. *Lois Mailou Jones: Peintures, 1937–1951.* Tourcoing, France: Presses Georges Frères, 1952.

Jones-Jackson, Patricia. *When Roots Die: Endangered Traditions of the Sea Islands.* Athens: University of Georgia Press, 1987.

Keckley, Elizabeth. *Behind the Scenes; or, Thirty Years a Slave and Four Years in the White House.* New York: Carleton, 1868. Reprint. New York: Arno, 1968.

Kent-Foxworth, Marilyn. *Aunt Jemima, Uncle Ben, and Rastus: Blacks in Advertising, Yesterday, Today, and Tomorrow.* Westport, Conn.: Greenwood, 1994.

Kester, Grant H., ed. *Art, Activism and Oppositionality: Essays from Afterimage.* Durham, N.C.: Duke University Press, 1998.

King-Hammond, Leslie, and Tritobia Benjamin, eds. *3 Generations of African-American Women Sculptors: A Study in Paradox.* Philadelphia, Pa.: Afro-American Historical and Cultural Museum, 1996.

King-Hammond, Leslie, et al., eds. *Gumbo Ya Ya: Anthology of Contemporary African-American Women Artists.* New York: Midmarch Arts, 1995.

Kogan, Lee. *The Art of Nellie Mae Rowe: Ninety-Nine and a Half Won't Do.* New York: Museum of American Folk Art, 1998.

LeFalle-Collins, Lizzetta, and Shifra M. Golden. *In the Spirit of Resistance: African-American Modernists and the Mexican Muralist School.* New York: American Federation of Arts, 1966.

Lewis, David Levering. *When Harlem Was in Vogue.* New York: Knopf, 1981.

Lewis, Samella. *African-American Art and Artists.* Berkeley and Los Angeles: University of California Press, 1990.

———. *The Art of Elizabeth Catlett.* Claremont, Calif.: Hancraft Studios, 1984.

Lewis, Samella, et al. *Caribbean Visions: Contemporary Painting and Sculpture.* Alexandria, Va.: Art Services, International, 1995.

Locke, Alain Leroy. *The Negro in Art: A Pictorial Record of the Negro Artist and of*

the Negro Theme in Art. Washington, D.C.: Association of Negro Folk Education, 1940.

———. The New Negro: An Interpretation. New York: Boni, 1925. Reprint. New York: Atheneum, 1968.

Lovell, Charles M., and Erwin Hester, eds. Minnie Evans: Artist. Greenville, N.C.: East Carolina University Press, 1993.

McConnell, Cristine, director. Kindred Spirits: Contemporary African-American Artists. Videotape. Produced by Clayton Corrie, Dallas KERA-TV. 1992.

MacGaffey, Wyatt, and Michael D. Harris. Astonishment and Power. Washington, D.C.: Smithsonian Institution Press, 1993.

McWillie, Judith, et al. Another Face of the Diamond: Pathways through the Black Atlantic South. New York: INTAR Latin American Gallery, 1988.

Metraux, Alfred. Voodoo in Haiti. New York: Schocken, 1972.

Meyer, Hans. The Workshop for Popular Graphic Art: A Record of Twelve Years of Collective Work. Mexico City: La Estampa Mexicana, 1949.

Morton, Patricia. Disfigured Images: The Historical Assault on Afro-American Women. Westport, Conn.: Praeger, 1991.

Murray, Freeman Henry Morris. Emancipation and the Freed in American Sculpture: A Study in Interpretation. Freeport, N.Y.: Books for Libraries, 1972.

Orlofsky, Patsy, and Myron Orlofsky. Quilts in America. New York: McGraw-Hill, 1992.

Osofsky, Gilbert. Harlem: The Making of a Ghetto: Negro New York, 1890–1930. 4th ed. Chicago: Dee, 1996.

Patterson, Vivian, et al. Carrie Mae Weems: The Hampton Project. Williamstown, Mass.: Williams College of Art; New York: Aperture, 2000.

Patton, Sharon. African-American Art. New York: Oxford University Press, 1998.

Perry, Regenia. Free within Ourselves: African-American Artists in the Collection of the National Museum of American Art. Washington, D.C.: Smithsonian Institution Press, 1992.

Pieterse, Jan Nederveen. White on Black: Images of Africa and Blacks in Western Popular Culture. New Haven, Conn.: Yale University Press, 1992.

Pinder, Kymberly N. Race-ing Art History: Critical Readings in Race and Art History. New York: Routledge, 2002.

Piper, Adrian. Out of Order, Out of Sight. 2 vols. Cambridge, Mass.: MIT Press, 1996.

Porter, James A. Modern Negro Art. New York: Dryden, 1943.

Powell, Richard J. Black Art and Culture in the Twentieth Century. London: Thames and Hudson, 1997.

Powell, Richard J., et al. Rhapsodies in Black: Art of the Harlem Renaissance. Berkeley: University of California Press, 1997.

Prigoff, James, and Robin J. Dunitz. Walls of Heritage, Walls of Pride: African-American Murals. San Francisco, Calif.: Pomegranate, 2000.

Reynolds, Gary A., and Beryl J. Wright. Against the Odds: African-American Artists and the Harmon Foundation. Newark, N.J.: Newark Museum, 1989.

Ringgold, Faith. Bonjour Lonnie. New York: Hyperion, 1996.

———. Dinner at Aunt Connie's House. New York: Hyperion, 1993.

———. My Dream of Martin Luther King. New York: Crown, 1995.

———. Tar Beach. New York: Crown, 1991.

———. We Flew over the Bridge: The Memoirs of Faith Ringgold. Boston: Little, Brown, 1995.

Robinson, Jontyle Theresa, ed. Bearing Witness: Contemporary Works by African-American Women Artists. New York: Rizzoli, 1996.

Rossen, Susan F., et al., eds. African Americans in Art: Selections from the Art Institute of Chicago. Chicago, Ill.: Art Institute of Chicago, 1999.

Rubin, William. Primitivism in Twentieth-Century Art: Affinity of the Tribal and the Modern. 2 vols. New York: Museum of Modern Art, 1984.

Selz, Peter, and Anthony F. Janson. Barbara Chase-Riboud: Sculptor. New York: Abrams, 1999.

Smythe, Victor N. *Black New York Artists of the Twentieth Century: Selections from the Schomburg Center Collections*. New York: Schomburg Center for Research in Black Culture, New York Public Library, 1998.

Stewart, Jeffrey C. *To Color America: Portraits by Winnold Reiss*. Washington, D.C.: Smithsonian Institution Press, 1989.

Stout, Renée, and Gary Lilley. *Hoodoo You Love: Prose, Poetry, and Art from the Black Rooster Workshop*. Washington, D.C.: Sister Space Books and Gary Lilley, 1998.

Sykes, Lawrence F., ed. *Four from Providence*. Providence: Rhode Island College and Rhode Island Heritage Society, 1978.

Thompson, Robert Farris. *Flash of the Spirit: African and Afro-American Art and Philosophy*. New York: Vintage/Random House, 1984.

Thompson, Robert Farris, and Joseph Cornet. *The Four Moments of the Sun: Kongo Art in Two Worlds*. Washington, D.C.: National Gallery of Art, 1981.

Tobin, Jacqueline L., and Raymond G. Dobard. *Hidden in Plain View: The Secret Story of Quilts and the Underground Railroad*. New York: Doubleday/Random House, 1999.

Vlach, John. *The Afro-American Tradition in Decorative Arts*. Cleveland, Ohio: Cleveland Museum of Arts, 1978.

Wadsworth, Anna, ed. *Missing Pieces: Georgia Folk Art, 1770–1976*. Atlanta: Georgia Council for the Arts and Humanities, 1976.

Wahlman, Maude Southwell. *Signs and Symbols: African Images in African-American Quilts*. New York: Studio, 1993; revised edition Atlanta, Ga.: Tinwood, 2001.

Wallace, Michele. *Black Macho and the Myth of the Superwoman*. New York: Dial, 1978. Reprint. New York: Verso, 1990.

Wallace, Michele, ed. *Faith Ringgold: Twenty Years of Painting, Sculpture, and Performance (1963–1983)*. New York: Studio Museum in Harlem, 1984.

Wallace-Sanders, Kimberly. *Skin Deep, Spirit Strong: The Black Female Body in American Culture*. Ann Arbor: University of Michigan, 2002.

Westmacott, Richard. *African-American Gardens and Yards in the Rural South*. Knoxville: University of Tennessee Press, 1992.

Williams, Carla, and Deborah Willis. *The Black Female Body: A Photographic History*. Philadelphia, Pa.: Temple University Press, 2002.

Wilson, James L. *Clementine Hunter: American Folk Artist*. Gretna, La.: Pelican, 1988.

Yanari, Sachi, et al., eds. *Alma Thomas: A Retrospective of the Paintings*. San Francisco, Calif.: Pomegranate, 1998.

Zeidler, Jeanne, ed. *Elizabeth Catlett: Works on Paper, 1944–1992*. Hampton, Va.: Hampton University Museum, 1993.

Figure 1.1. Paul Colin. *La Revue Nègre* (The Negro Revue), 1925, oil on plywood, 39 1/2 x 31 1/2" (100 x 80 cm). Design for advertising poster for Josephine Baker in "The Negro Review" at the Théatre des Champs-Elysées, Paris. © 2003 Réunion des Musées Nationaux/Artists Rights Society (ARS), New York/Inv.: MNB69CR. Photo: Gerard Blot. Musée de la cooperation franco-americaine, Blerancourt.

Figure 1.2. Richard Norris Brooke. *A Pastoral Visit* (detail), 1881, oil on canvas, 47 3/4 x 65 3/4" (121.28 x 167 cm). In the Collection of the Corcoran Gallery. Museum Purchase, Gallery Fund.

Figure 1.3. Sargent Claude Johnson. *Forever Free*, 1933, wood with lacquer on cloth, 36 x 11 1/2 x 9 1/2" (91.44 x 29.21 x 24.13 cm). © San Francisco Museum of Modern Art. Gift of Mrs. E. D. Lederman, 52.4695.

Figure 1.4. Workshop of the Niobid Painter. Attic red figure pelike, Greek, Classical period, about 460 B.C.E. Place of manufacture: Greece, Attica, Athens, ceramic red figure, height 17 15/16" (44 cm). © 2003 Museum of Fine Arts, Boston. Arthur Tracy Cabot Fund. 63.2663.

Figure 1.5. Kantharos. Greek, late Archaic period, about 510–480 B.C.E. Place of manufacture: Greece, Attica, Athens, ceramic red figure, height 7 9/16" (19.2 cm), diameter 5 5/8" (14.3 cm). © 2003 Museum of Fine Arts, Boston. Henry Lillie Pierce Fund. 98.926.

Figure 1.6. *Sculpture of a Young Black*, Greco-Roman from Aphrodisias, Turkey, 2–3d century A.D., black marble, 23 1/2" high (60 cm). Louvre Museum, Paris. Photograph by Herve Lewandowski. © Réunion des Musées Nationaux /Art Resource, New York.

Figure 1.7. *St. Maurice*, c. 1240–1250, polychromed sandstone. St. Mauritius Cathedral, Magdeburg, Germany. © Foto Marburg/Art Resource, New York.

Figure 1.8. Hieronymus Bosch. *Balthazar, the African Magus*, detail from *The Adoration of the Magi*, central panel, c. 1450–1516, oil on panel, 4' 5 7/8" x 28" (138.11 x 72 cm). Prado, Madrid. Photo © Scala/Art Resource, New York.

Figure 1.9. *Cetshwayo, King of the Zulus*, 1879. Illustration rendered from the British periodical *Judy*. Courtesy Beeldrecht Amsterdam.

Figure 1.10. *Cetshwayo kaMpande*, 1888. Portrait of the Zulu king rendered from George Thomas Bettany's *The World's Inhabitants; or, Mankind, Animals, and Plants* (London: Ward, Locke, 1888; rpt. Freeport, N.Y.: Books for Libraries Press, 1972). Courtesy of Beeldrecht Amsterdam.

Figure 1.11. Albrecht Duerer (1471–1528). *The Moorish Woman (Catherine, the Mulatto Woman of the Portuguese Bradao)*, 1521, silverpoint drawing. Galleria degli Uffizi, Florence, Italy. © Foto Marburg/Art Resource, New York.

Figure 1.12. Diego Rodriguez da Silva y Velazquez (Spanish, 1599–1660). *Juan de*

Illustration Credits

Pareja (born about 1610, died 1670), 1650, oil on canvas, 32 x 27 1/2" (81.3 x 69.8 cm). Metropolitan Museum of Art. Purchase, Fletcher and Rogers Fund, and Bequest of Adelaide Milton de Groot (1876–1967), by exchange, supplemented by gifts from Friends of the Museum, 1971 (1971.86). Photograph by Malcolm Varon. Photograph © 1989 Metropolitan Museum of Art, New York.

Figure 1.13. *The Orang-Outang Carrying off a Negro Girl*, 1795, illustration, Britain. Courtesy of Beeldrecht Amsterdam.

Figure 1.14. Anonymous. *Jardin zoologique d'Acclimatation, Achanti*, Paris, 1895, color lithograph, 51 1/8 x 37 3/4" (130 x 96 cm). Poster for *Petit Journal, supplément illustré*, 31 May 1903; printed by Émile Lévy Affiches français. Musée de la Publicité, Paris. All rights reserved. Inv.# 16592bis.

Figure 1.15. Léon de Wailly and Jean-Charles Werner. *Saartjie Baartman* or *Venus Hottentote*, 1815, lithograph extracted from Geoffroy Saint Hilaire and Georges Léopold Cuvier's *Histoire naturelle des mammifères* (Paris, 1819–1842). © Bibliothèque centrale du Muséum national d'Histoire naturelle (M.N.H.N.), Paris, 2003.

Figure 1.16. Prince Roland Napoleon Bonaparte (French, 1858–1924). *Three Unidentified African Women* in the Jardin Zoologique d'Acclimatation at the Exposition Universelle, Paris, c. 1889, from *Boschimans et Hottentots* (Bushmen and Hottentots). Collection and © J. Paul Getty Museum, Los Angeles.

Figure 1.17. Edouard Manet (1832–1893). *Olympia*, 1863–1865, oil on canvas, 51 1/4 x 74 3/4" (130.5 x 190 cm). Musée d'Orsay, Paris. © Erich Lessing/Art Resource, New York.

Figure 1.18. Bertall (Charles-Albert d'Arnoux). *Le queue du chat, ou la charbonnière des Batignolles*, 1865, wood engraving. By permission of the British Library, London. 1007628.011.

Figure 1.19. Pablo Picasso. Parody of Manet's *Olympia* (Sebastian Junyer-Vidal and Picasso), 1901, pen and ink and colored crayon, 6 x 9 1/8" (15.3 x 23 cm). Zervos VI, 343.D.B.D.IV.7. Collection Léon Bloch, Paris. © 2003 Estate of Pablo Picasso/Artists Rights Society (ARS), New York.

Figure 1.20. Pablo Picasso (1881–1973). *Les Demoiselles d'Avignon*, 1907, oil on canvas, 96 x 92" (243.8 x 233.7 cm). Museum of Modern Art, New York. Acquired through the Lille P. Bliss Bequest. © Estate of Pablo Picasso/Artists Rights Society (ARS), New York. Digital image © Museum of Modern Art, New York. Licensed by SCA LA/Art Resource, New York.

CHAPTER TWO

Figure 2.1. Louiza Francis Combs. Woven wool blanket, Kentucky, c. 1890, 79 1/2 x 61" (202 x 155 cm). Collection of Kenneth Combs, Warrensville Heights, Ohio.

Figure 2.2. Photograph of Louiza Francis Combs, c. 1900. Courtesy of Kenneth Combs, Warrensville Heights, Ohio.

Figure 2.3. Josie Covington. Album quilt, c. 1895, 81 x 80" (205.7 x 203.2 cm). Collection of Dr. Richard H. and Mrs. Kathleen L. Hulan, Springfield, Virginia. Photographed by Jeff Deemie.

Figure 2.4. *Pakèts Kongo*, 13 1/8" high (33.5 cm). UCLA Fowler Museum of Cultural History, FMCH X93.9.1C.D.

Figure 2.5. Kongo *nkondi/nkisi*, or power figure, undated, wood, mirror, glass, cane, fiber, bone, 10" high (25.5 cm). UCLA Fowler Museum of Cultural History. FMCH X65.8501. Gift of the Wellcome Trust.

Figure 2.6. Fon male *bocio* figure, Benin, undated, twine, wood, metal, 10.8" high (27.5 cm). UCLA Fowler Museum of Cultural History. FMCH X92.129. Gift of Mrs. Shirley Black.

Figure 2.7. Pierrot Barra. Doll/snake, 1993, plastic, fabric, synthetic hair, metallic ribbon, ribbon, length 20.86" (53 cm). UCLA Fowler Museum of Cultural History. FMCH X94.76.14.

Figure 2.8. *Altar for Ezili*, 1993, created by mambo Madame Celanie Constant Nerva of Jacmel, Haiti. Photograph by Phyllis Galembo. From Phyllis Galembo, *Vodou: Visions and Voices of Haiti* (Berkeley, Calif.: Ten Speed, 1998).

Figure 2.9. Jacob's Ladder quilt, c. 1890s. Collection/photograph Raymond G. Dobard, Washington, D.C.

Figure 2.10. Daughters of Dorcas and Sons of Washington, D.C. Sampler quilt, 1987–1988. Collection/photograph Raymond G. Dobard, Washington, D.C.

Figure 2.11. Log Cabin quilt made by descendants of fugitive slaves, c. 1840s. Collection of the Buxton National Historic Site and Museum, Buxton, Ontario, Canada. Originally from the collection of Rev. William King, founder of the Elgin Settlement of Free Blacks in Buxton, Ontario.

Figure 2.12. *Rose Anne and Andre Rose Mercilien* (with drapo for Ogoun Feraille and St. James), 1995. Photograph by Phyllis Galembo. From Phyllis Galembo, *Vodou: Visions and Voices of Haiti* (Berkeley, Calif.: Ten Speed, 1998).

Figure 2.13. *Vodou Drapo of Dambalah Woedo*, 31.5 x 32.3" (80 x 82 cm). UCLA Fowler Museum of Cultural History, FMCH X94.2.2B.

Figure 2.14. *Libation Bottle for Ezili Dantò*, glass, fabric, sequins, cork, faux pearls, metallic cord, thread, 20 5/8" high (52.5 cm). UCLA Fowler Museum of Cultural History, FMCH X94.76.19.

Figure 2.15. *Our Lady of Częstochowa (Black Madonna)*, Byzantine icon, c. 1312, paint on limewood, housed in the Jasna Gorà monastery in Częstochowa, Poland. © Nicolas Sapieha/Art Resource, New York.

Figure 2.16. Photograph of Harriet Powers (American, 1837–1911), about 1900, 2 3/16 x 1 1/4" (5.5 x 3.2 cm). © 2003 Museum of Fine Arts, Boston. VA21989.

Figure 2.17. Harriet Powers (American, 1837–1911). *Bible Quilt*, c. 1885–1886, 73 3/4 x 88 1/2" (187.3 x 224.8 cm). National Museum of American History, Smithsonian Institution.

Figure 2.18. Harriet Powers (American, 1837–1911). *Pictorial Quilt*, United States (Athens, Georgia), 1895–1898, pieced, appliquéd, and printed cotton embroidered with plain and metallic yarns, 68 7/8 x 105" (175 x 266.7 cm). © 2003 Museum of Fine Arts, Boston. Bequest of Maxim Karolik. 64.619.

Figure 2.19. Henri Matisse (1869–1954). *Icarus*, from *Jazz* series (originally published, Paris: E. Teriade, 1947, in an edition of 270 copies, 20 pochoire plates, each double sheet 16 5/8 x 25 5/8" [42.2 x 65.1 cm]). Spencer Collection, The New York Public Library, Astor, Lenox and Tilden Foundation. © 2003 Succession H. Matisse, Paris/ARS, New York. Photo © New York Public Library/Art Resource, New York.

Figure 2.20. *Blue and Gray Striped Dress* made by anonymous slaves in the nineteenth century; rendering by Joseph L. Boyd for the WPA, c. 1937, watercolor and graphite on paper, 16 15/16 x 12" (43.1 x 30.5 cm). Index of American Design. Image © Board of Trustees National Gallery of Art, Washington, D.C. 1943.8.1376 (LA-CO-58)/1A.

Figure 2.21. Photograph of Elizabeth Keckley, c. 1860s. Courtesy of the Moorland-Spingarn Research Center, Howard University.

Figure 2.22. Elizabeth Keckley. Gown designed for First Lady Mary Todd Lincoln, c. 1863. National Museum of American History, Department of Social History, Domestic Life Division, Smithsonian Institution.

Figure 2.23. *Sweetgrass Coiled Basket*, South Carolina, mid-nineteenth century. Smithsonian Institution, Behring Center, Division of Cultural History. Neg. #MAH-78 113-A.

Figure 2.24. Belin Berisaj. *Field: Slave Yard*, 2003, oil on canvas, 26 1/2 x 32 1/2" (67.31 x 82.55 cm). Collection of the artist, New York. Indicative of slave yard prototypes such as those in Lisa LeMaistre, "In Search of a Garden: African Americans and the Land of Piedmont, Georgia," master's thesis, University of Georgia, 1988. Photograph © Lisa Farrington.

Figure 2.25. Grave of Hackless Jenkins (1878–1928), Sea Islands, Ga., decorated with clocks, glassware, and other objects. Photograph by Doris Ulmann, 1933, photo mechanical print. © Photograph courtesy of the Library of Congress, Prints and Photographs Division, Washington, D.C. LC-USZ62-92907.

Figure 3.1. Sarah Mapps Douglass. *The Rose*, 1836–1837, watercolor, 3 3/4 x 2 3/4" (9.52 x 7 cm). Moorland-Spingarn Research Center, Howard University.

Figure 3.2. Sarah Mapps Douglass. *Vase of Flowers*, page 78 from the Martina Dickerson album, 1843, pencil, 4 x 2 3/4" (10.1 x 7 cm). Library Company of Philadelphia. 13859.Q.#2.

Figure 3.3. Annie E. A Walker. *La Parisienne*, 1896, pastel on paper, 25 1/2 x 19 3/4" (64.8 x 50 cm). Howard University Gallery of Art.

Figure 3.4. Edmonia Lewis. *Urania*, 1862, pencil on paper, 14 1/4 x 12" (16.2 x 30.5 cm). Oberlin College Archives, Oberlin, Ohio.

Figure 3.5. Edmonia Lewis. *Colonel Robert Gould Shaw*, 1866–1867, marble after original plaster cast of 1864, approx. life-sized. Museum of Afro-American History, Boston, Mass.

Figure 3.6. Edmonia Lewis. *Forever Free (Morning of Liberty)*, 1867–1868, marble, 41 1/4" high (104.8 cm). Howard University Gallery of Art.

Figure 3.7. Thomas Ball. *Emancipation Monument* (Freedmen's Memorial Monument to Abraham Lincoln), 1876, bronze, approx. 108 1/4" high (275 cm). Lincoln Park, Washington, D.C. Photograph © Lisa Farrington. Courtesy Brian Cooper.

Figure 3.8. Edmonia Lewis. *Awake*, 1871–1872, marble, 26 1/2" high (64.8 cm). California Room, San Jose Public Library. Gift of Mrs. Sarah L. Knox.

Figure 3.9. Hiram Powers. *The Greek Slave*, 1843, marble, 65 1/2" high (168 cm). Yale University Art Gallery. Olive Louise Dann Fund.

Figure 3.10. Edmonia Lewis (1843/5–c. 1911). *Hagar*, 1875, carved marble, 52 5/8 x 15 1/4 x 17" (133.6 x 38.73 x 43.18 cm). © Smithsonian American Art Museum, Washington, D.C./Art Resource, New York.

Figure 3.11. Edmonia Lewis. *Old Arrow Maker (The Old Indian Arrow Maker and His Daughter)*, 1872, carved marble, 21 1/2 x 13 5/8 x 13 3/8" (54.5 x 34.5 x 34 cm).

© Smithsonian American Art Museum, Washington, D.C./Art Resource, New York.

Figure 3.12. Edmonia Lewis (1843/5–c. 1911). *The Death of Cleopatra*, 1876, marble, 63 x 31 1/4 x 46" (160 x 79.37 x 116.84 cm). Gift of the Historical Society of Forest Park, Ill. © Smithsonian American Art Museum, Washington, D.C./Art Resource, New York.

Figure 3.13. Edmonia Lewis (1843/5–c. 1911). *The Death of Cleopatra* (3/4 view), 1876, marble, 63 x 31 1/4 x 46" (160 x 79.37 x 116.84 cm). Gift of the Historical Society of Forest Park, Ill. © Smithsonian American Art Museum, Washington, D.C./Art Resource, New York.

Figure 3.14. William Wetmore Story. *Cleopatra*, 1869, marble, 55 1/2 x 33 1/4 x 51 1/2" (141 x 84.5 x 131 cm). All rights reserved, The Metropolitan Museum of Art, New York. Gift of John Taylor Johnston, 1988.

Figure 3.15. Meta Warrick Fuller. *Man Eating Out His Heart (The Secret Sorrow)*, c. 1905–1906, painted plaster, 7 x 3 x 2" (17.8 x 7.6 x 5 cm). Estate of Solomon Fuller, Jr., Bourne, Mass.

Figure 3.16. Meta Warrick Fuller. *John the Baptist*, 1899, plaster, destroyed. Reproduced from Alain Locke, *The Negro in Art* (New York: Hacker Art Books, 1971).

Figure 3.17. Meta Warrick Fuller. *Emancipation Proclamation*, plaster produced in 1913; cast in bronze in 2000, 85 x 42 x 41" (216 x 106.7 x 104.1 cm). Location: Harriet Tubman Park, South End, Boston, Mass.; jointly owned by the Museum of the National Center of Afro-American Artists and the Museum of Afro-American History.

Figure 3.18. Meta Warrick Fuller. *Mary Turner (A Silent Protest against Mob Violence)*, 1919, painted plaster, 15 x 5 1/4 x 4 1/2" (38.1 x 13.3 x 11.4 cm). Museum of Afro-American History, Boston, Mass.

Figure 3.19. Meta Warrick Fuller. *Ethiopia Awakening*, c. 1921, bronze, 67 x 16 x 20" (170.2 x 40.6 x 51 cm). Art and Artifacts Division, Schomburg Center for Research in Black Culture, The New York Public Library, Astor, Lenox and Tilden Foundations.

Figure 3.20. Daniel Chester French. *Africa*, 1904, from *The Continents* (1903–1907), exterior of the U.S. Customs House, marble, 124" high (315 cm). Collection of the New-York Historical Society. Photograph by unidentified photographer, from the Cass Gilbert Collection.

Figure 3.21. May Howard Jackson. *Mulatto Mother and Child*, n.d., plaster, 24 x 17 x 13" (61 x 43.2 x 33 cm). University Archives, Virginia State University, Petersburg.

Figure 3.22. May Howard Jackson. *Clark Bailey (Head of a Negro Child)*, c.1916, terra cotta, 21 x 12 5/8 x 8" (53.3 x 32 x 20.3 cm). Location unknown. Photograph courtesy of the Moorland-Spingarn Research Center, Mary O. H. Williamson Collection, Howard University.

Figure 3.23. May Howard Jackson. *Paul Laurence Dunbar*, 1919, approx. 24" high (61 cm). Dunbar High School, Washington, D.C. Photograph courtesy of the Newark Museum.

CHAPTER FOUR

Figure 4.1. Scene from *Birth of a Nation*, directed by D. W. Griffith, 1915. Photograph courtesy of The Museum of Modern Art, New York.

Figure 4.2. Winold Reiss. Drawing of Roland Hayes, cover of *Survey Graphic* (Special Issue, March 1925). Photographs and Prints Division, Schomburg Center for Research in Black Culture, The New York Public Library, Astor, Lenox and Tilden Foundations.

Figure 4.3. Josephine Baker in the Ziegfeld Follies, 1927. Billy Rose Theatre Collection, The New York Public Library for the Performing Arts, Astor, Lenox and Tilden Foundations.

Figure 4.4. Laura Wheeler Waring. *Jazz Dancer I (Study)*, c. 1939, watercolor and gouache on paper, 10 x 8" (25.4 x 20.3 cm). Collection of Laura W. Murphy, Washington, D.C.

Figure 4.5. Laura Wheeler Waring. *Alice Dunbar Nelson*, 1928, oil on canvas, 25 x 21" (63.5 x 53.34 cm). Collection of Madeline Murphy Rabb, Chicago, Ill.

Figure 4.6. Laura Wheeler Waring (1887–1948). *Anna Washington Derry*, 1927, oil on canvas, 20 x 16" (50.8 x 40.5 cm). Gift of the Harmon Foundation. © Smithsonian American Art Museum, Washington, D.C./Art Resource, New York.

Figure 4.7. Laura Wheeler Waring. *Girl in Red Dress*, c. 1935, oil on board, 18 x 14" (45.7 x 35.5 cm). Collection of John P. Axelrod. Courtesy of Michael Rosenfeld Gallery, New York and Madeline Murphy Rabb.

Figure 4.8. Laura Wheeler Waring. *Susan Davis Lowery*, 1937, oil on canvas, 42 x 36" (106.68 x 91.44 cm). Collection of Madeline Murphy Rabb, Chicago, Ill.

Figure 4.9. Laura Wheeler Waring. *Rose of Sharon*, n.d., oil on canvas, 19 1/4 x 15 1/4" (48.9 x 38.7 cm). Collection of Professor and Mrs. David C. Driskell, Hyattsville, Md. Photograph by Gregory Staley.

Figure 4.10. Albert Alexander Smith. *Dancing Time*, 1930, oil on canvas, 22 1/2 x 26 1/2" (57.1 x 67.3 cm). Hampton University Museum, Hampton, Va.

Figure 4.11. Lois Mailou Jones. *Textile Design for Cretonne*, 1928, offset, 28 x 21" (71.1 x 53.3 cm). © Estate of the artist.

Figure 4.12. Lois Mailou Jones. *Jenny*, 1943, oil on canvas, 35 3/4 x 28 1/4" (88.3 x 77.7 cm). Collection of the Howard University Art Gallery. © Estate of the artist.

Figure 4.13. Lois Mailou Jones. *Les Fétiches*, 1938, oil on canvas, 25 1/2 x 21" (64.8 x 53.3 cm). National Museum of American Art, Smithsonian Institution. Museum purchase made possible by Mrs. N. H. Green, Dr. R. Harlan, and Francis Musgrave. © Estate of the artist.

Figure 4.14. Lois Mailou Jones. *Jardin du Luxembourg*, c. 1948, oil on canvas, 23 3/4 x 28 3/4" (60.3 x 73 cm). Collection of the National Museum of American Art, Smithsonian Institution. © Estate of the artist.

Figure 4.15. Lois Mailou Jones (American, 1905–1998). *Ubi Girl from Tai Region*, 1972, acrylic on canvas, 60 x 43 3/4" (152.4 x 111.1 cm). © Estate of the artist. Photograph © 2003 Museum of Fine Arts, Boston. The Hayden Collection. The Charles Henry Hayden Fund. 1974.410.

Figure 4.16. Beulah Ecton Woodard. *African Woman*, c. 1938, glazed terra-cotta, 11 1/4 x 10 3/4 x 5" (28.5 x 27.3 x 12.7 cm). Courtesy of the Miriam Matthews Collection. Photo by Darryl A. Smith.

Figure 4.17. Beulah Ecton Woodard. *Bad Boy*, c. 1936, bronze, 6 3/4 x 5 1/2 x 5 1/4" (17.14 x 14 x 13.3 cm). Courtesy of the Miriam Matthews Collection. Photography courtesy of Charles Matthews.

Figure 4.18. Beulah Ecton Woodard. *Maudelle*, c. 1937, fired clay, 16 x 13 1/2 x 10" (40.64 x 34.3 x 25.4 cm). Courtesy of the Miriam Matthews Collection. Photograph courtesy of Charles Matthews.

CHAPTER FIVE

Figure 5.1. Georgette Seabrooke-Powell. *Recreation in Harlem*, 1936, oil, 5' x 19' 5" (152.4 x 579.12 cm). Mural designed and executed by Georgette Seabrooke-Powell with project assistance provided by Louis Vaughn and Beauford Delaney. Harlem Hospital, Nurses' Recreation Room, 506 Malcolm X Boulevard, Harlem, New York. National Archives photo no. 69-AN-590-P629-A.

Figure 5.2. Georgette Seabrooke-Powell. *Woman in Profile*, 1930, linocut, 6 3/8 x 5 5/8" (16.2 x 14.3 cm). Art and Artifacts Division, Schomburg Center for Research in Black Culture, The New York Public Library, Astor, Lenox and Tilden Foundations. PR.X.104.

Figure 5.3. Augusta Savage. *Gamin*, 1930, bronze, 16 1/2 x 8 1/3 x 7" (42 x 21.2 x 17.8 cm). Art and Artifacts Division, Schomburg Center for Research in Black Culture, The New York Public Library, Astor, Lenox, and Tilden Foundations. Photograph by Manu Sassoonian.

Figure 5.4. Augusta Savage. *James Weldon Johnson*, 1939, painted plaster, 17 x 9 x 9 1/2" (43.2 x 22.9 x 24.1 cm). Art and Artifacts Division, Schomburg Center for Research in Black Culture, The New York Public Library, Astor, Lenox and Tilden Foundations.

Figure 5.5. Augusta Savage. *Green Apples*, 1928, bronze, 15 1/4" high (38.7 cm). James Weldon Johnson Collection, Yale University Collection of American Literature, Beinecke Rare Book and Manuscript Library.

Figure 5.6. Augusta Savage. *La Citadelle/Freedom*, 1930, bronze, 14 1/2" high (36.8 cm). Howard University Gallery of Art.

Figure 5.7. At the Harlem Art Workshop, James Wells oversees a group of children, c. 1935. National Archives photo no. 200-HNE-18-2.

Figure 5.8. Members of the Harlem Artists Guild picketing WPA cutbacks. *Right foreground*, Norman Lewis; *center foreground*, Gwendolyn Bennett; *behind Bennett in the white hat*, Frederick Perry; *right side behind Lewis*, Artists Union organizer; others unidentified. Photo courtesy of Harry Henderson.

Figure 5.9. Instructors of the Harlem Community Art Center, 1930s. *Front row (left to right)*: Zell Ingram, Pemberton West, Augusta Savage, Robert Pious, Sarah West, and Gwendolyn Bennett; *back row (left to right)*: Elton Fax, Rex Gorleigh, Fred Perry, William Artis, Francisco Lord, Louise Jefferson, and Norman Lewis. Photographs and Prints Division, Schomburg Center for Research in Black Culture, The New York Public Library, Astor, Lenox and Tilden Foundations. Photograph, Art Service Project/Andrew Herman.

Figure 5.10. Augusta Savage. *Lift Every Voice and Sing (The Harp)*, 1939, destroyed, painted plaster, 16' high (4.9 m). Photograph courtesy of the Yale University Collection of American Literature, Beinecke Rare Book and Manuscript Library. Photograph by Carl Van Vechten. Reproduced with permission of the Carl Van Vechten Trust.

Figure 5.11. Selma Burke. *Torso*, n.d., bronze, 14 x 4 3/4 x 2" (35.6 x 12 x 5 cm). Collection of Juan Logan, Chapel Hill, N.C.

Figure 5.12. Selma Burke. *Temptation*, c. 1938? 1/2, limestone, 14 x 10 1/4 x 4 3/4" (35.5 x 26 x 12 cm). Howard University Gallery of Art.

Figure 5.13. Selma Burke. *Franklin Delano Roosevelt*, 1945, bronze plaque, 3' 6" x 2' 6" (106.7 x 76.2 cm), Recorder of Deeds Building, Washington, D.C. Photograph © Lisa Farrington.

Figure 5.14. Nancy Elizabeth Prophet sculpting, undated photograph courtesy of National Archives, photo no. NWDNS-200-H-HS-6-27 (Harmon Foundation Collection).

Figure 5.15. Nancy Elizabeth Prophet. *Negro Head*, before 1930, wood, 20 1/2" high (52 cm). Museum of Art, Rhode Island School of Design. Gift of Eleanor B. Green. 35.780.

Figure 5.16. Nancy Elizabeth Prophet. *Congolaise*, 1931, wood, 17 1/8 x 6 3/4 x 8 1/16" (43.5 x 17.15 x 20.48 cm). Whitney Museum of American Art, New York. Purchase 32.83. Photograph by Geoffrey Clements, New York.

Figure 5.17. Nancy Elizabeth Prophet. *Silence*, before 1930, marble, 12" high (30.5 cm). Museum of Art, Rhode Island School of Design. Gift of Miss Ellen D. Sharpe. 30.092.

Figure 5.18. Nancy Elizabeth Prophet. *Discontent*, before 1930, polychromed wood, 14" high (35.6 cm). Museum of Art, Rhode Island School of Design. Gift of Miss Eleanor Green and Ellen D. Sharpe. 30.019.

CHAPTER SIX

Figure 6.1. Elizabeth Catlett. *Negro Mother and Child*, 1940, limestone, 35" high (69 cm). Location unknown. © Elizabeth Catlett/Licensed by VAGA, New York. Photograph courtesy of the University of Iowa.

Figure 6.2. Elizabeth Catlett. *I Am the Negro Woman*, from *The Negro Woman* series, 1946–1947, linocut, 5 1/4 x 4" (13.3 x 10.1 cm). Collection of the artist, Cuernavaca, Mexico. © Elizabeth Catlett/Licensed by VAGA, New York. Photograph courtesy of Melanie Herzog.

Figure 6.3. Michelangelo (1475–1564). *David* (detail, frontal view of head), 1501–1504, marble, full height of sculpture approx. 14' (4.26 m). Galleria dell'Accademia, Florence, Italy. © Scala/Art Resource, New York.

Figure 6.4. Elizabeth Catlett. *In Harriet Tubman I Helped Hundreds to Freedom*, from *The Negro Woman* series, 1946–1947, linocut, 9 x 6 7/8" (22.86 x 17.5 cm). Collec-

tion of Elizabeth Catlett. Photograph by Melanie Herzog. © Elizabeth Catlett/Licensed by VAGA, New York.

Figure 6.5. Sylvia Abernathy, Barbara Jones-Hogu, Carolyn Lawrence, Myrna Weaver, Jeff Donaldson, Eliot Hunter, Wadsworth Jarrell, Norman Parish, William Walker, and others. *The Wall of Respect*, 1967 (destroyed 1971), 43rd and Langley streets, Chicago, Ill. Photograph © 1989 Robert A. Sengstacke.

Figure 6.6. Barbara Jones-Hogu on scaffolding painting *The Wall of Respect*, 1967 (destroyed 1971), 43rd and Langley streets, Chicago, Ill. Photograph © 1989 Robert A. Sengstacke.

Figure 6.7. Betty Blayton. *Untitled*, 1971, with the assistance of Sulvin Goldbourne and the Children's Art Carnival, Lenox Avenue and 140th Street, Harlem, N.Y.

Figure 6.8. Elizabeth Catlett. *Political Prisoner*, 1971, polychromed cedar, 71 1/4 x 36 x 15" (181 x 91.4 x 38.1 cm). Art and Artifacts Division, Schomburg Center for Research in Black Culture, The New York Public Library, Astor, Lenox and Tilden Foundations. Gift of Peter Putnam. © Elizabeth Catlett/Licensed by VAGA, New York.

Figure 6.9. Elizabeth Catlett. *Malcolm X Speaks for Us*, 1969, color linocut, serigraph, and monoprint, 37 1/2 x 27 1/2" (95.25 x 69.85 cm). Collection of the artist, Cuernavaca, Mexico. © Elizabeth Catlett/Licensed by VAGA, New York. Photograph courtesy of Melanie Herzog.

Figure 6.10. Faith Ringgold. *Between Friends*, from *American People* series, 1963, oil on canvas, 40 x 24" (101.6 x 61 cm). Collection of the artist, Englewood, N.J. © Faith Ringgold, Inc., 1963.

Figure 6.11. Faith Ringgold. *Die*, from *American People* series, 1967, oil on canvas, 72 x 144" (183 x 365.7 cm). Collection of the artist, Englewood, N.J. © Faith Ringgold, Inc., 1967.

Figure 6.12. Faith Ringgold. *U.S. Postage Stamp Commemorating the Advent of Black Power*, from *American People* series, 1967, oil on canvas, 72 x 96" (183 x 243.8 cm). Collection of the artist, Englewood, N.J. © Faith Ringgold, Inc., 1967.

Figure 6.13. Faith Ringgold. *The Flag Is Bleeding,* from *American People* series, 1967, oil on canvas, 72 x 96" (183 x 243.8 cm). Collection of the artist, Englewood, N.J. © Faith Ringgold, Inc., 1967.

Figure 6.14. Marie Johnson Calloway. *Silver Circle,* 1972, construction, 36" diameter x 6"deep. Collection of the artist, Oakland, Calif.

Figure 6.15. Samella Lewis. *Field,* 1969, linocut, 22 x 18" (56 x 45.7 cm). Samella Lewis Collection of the Hampton University Museum. © Samella Lewis/Licensed by VAGA, New York.

Figure 6.16. Yvonne Parks Catchings. *Detroit Riot,* 1967–1968, oil and mixed-media assemblage on canvas, 36 x 24" (91.4 x 61 cm). Collection of the artist, Detroit, Mich.

Figure 6.17. Kay Brown. *The Black Soldier,* 1969, collage, 50 x 37" (127 x 94 cm). Collection of the artist, Washington, D.C.

CHAPTER SEVEN

Figure 7.1. Sharon Dunn. *Maternity,* Yarmouth and Columbus avenues, South Boston, Mass., 1970. Sponsored by Summerthing. Photograph © James Prigoff and Robin J. Dunitz from *Walls of Heritage, Walls of Pride: African American Murals* (San Francisco: Pomegranate, 2000).

Figure 7.2. Faith Ringgold. *Women's Liberation Talking Mask, Witch* series #1, 1973, mixed media, beads, raffia, cloth, gourds, 42" high (106.7 cm). Collection of the artist, Englewood, N.J. © Faith Ringgold, Inc., 1973.

Figure 7.3. Faith Ringgold. *Woman Freedom Now,* from *Political Posters,* 1971, collage, 30 x 20" (76.2 x 50.8 cm). Collection of the artist, Englewood, N.J. © Faith Ringgold, Inc., 1972.

Figure 7.4. Faith Ringgold. *For the Women's House,* 1971, oil on canvas, 96 x 96" (244 x 244 cm). Women's House of Detention, Riker's Island, N.Y. © Faith Ringgold, Inc., 1971.

Figure 7.5. Faith Ringgold. *Of My Two Handicaps,* from *Feminist* series #10, 1972, acrylic on canvas *tanka,* 51 x 26" (130 x 66

cm). Collection of the artist, Englewood, N.J. © Faith Ringgold, Inc., 1972.

Figure 7.6. Faith Ringgold. *The French Collection Part I: #3, Picnic at Giverny,* 1991, acrylic on canvas with pieced fabric border, 73 1/2 x 90 1/2" (186.7 x 230 cm). Collection of Eric Dobkin. © Faith Ringgold, Inc., 1991.

Figure 7.7. Emma Amos. *Tightrope,* 1994, acrylic on linen canvas, African fabric collage, laser-transfer photographs, 82 x 58" (208.3 x 147.3 cm). Collection of the artist, New York. Photo by Becket Logan.

Figure 7.8. Emma Amos. *Worksuit,* 1994, acrylic on linen canvas, African fabric border, photo transfer, 74 1/2 x 54 1/2" (190 x 138.4 cm). Collection of the artist, New York.

Figure 7.9. Emma Amos. *Measuring Measuring,* 1995, acrylic on linen canvas, African fabric collage, woven border, laser-transfer photographs, 84 x 70" (213.3 x 177.8 cm). Collection of the Birmingham Museum of Art, Birmingham, Alabama. Photo by Becket Logan.

Figure 7.10. Betye Saar. *The Liberation of Aunt Jemima,* 1972, mixed media, 11 3/4 x 8 x 2 3/4" (29.9 x 20.3 x 7 cm). University of California, Berkeley Art Museum. Purchased with the aid of funds from the National Endowment for the Arts (selected by the Committee for the Acquisition of African-American Art). 1972.84. Photographed for the Berkeley Art Museum by Benjamin Blackwell. Courtesy of the artist.

Figure 7.11. Betye Saar. *Black Girl's Window,* 1969, mixed-media assemblage, 35 3/4 x 18 x 1 1/2" (91 x 45.72 x 3.81 cm). Collection of the artist, Los Angeles. Courtesy of Michael Rosenfeld Gallery, New York.

Figure 7.12. Betye Saar. *Africa,* 1968, mixed-media construction, 10 x 6 x 3" (25.4 x 15.24 x 7.62 cm). Collection of the Des Moines Art Center, Louise Nown Collection of Women Artists.

Figure 7.13. Betye Saar. *Diaspora,* from the exhibition "With the Breath of Our Ancestors," 1992, mixed-media installation, 12 x 18 x 14 1/2' (3.6 x 5.5 x 4.4 m). Barnsdall Municipal Art Gallery, Los Angeles. Photo by William Nettles, Los Angeles, Calif.

Figure 7.14. Kay Brown. *Sister Alone in a Rented Room*, 1974, etching 30/35, 20 x 16 1/2" (50.8 x 42 cm). Art and Artifacts Division, Schomburg Center for Research in Black Culture, The New York Public Library, Astor, Lenox and Tilden Foundations. PR.98.009. Gift of the artist.

Figure 7.15. Dindga McCannon. *Morning After*, 1972, linocut, 18 x 24" (45.72 x 61 cm). Collection of the artist, New York.

Figure 7.16. Dindga McCannon. *A Day in the Life of a Black Woman Artist*, 1978, collage and mixed media on canvas, 51 x 36" (130 x 91.4 cm). Art and Artifacts Division, Schomburg Center for Research in Black Culture, The New York Public Library, Astor, Lenox and Tilden Foundations. Gift of the artist.

Figure 7.17. Dindga McCannon. *Revolutionary Sister*, 1974, assemblage, 60 x 30" (152.4 x 76.2 cm). Collection of Harry Smith, New York. Photograph © Lisa Farrington.

CHAPTER EIGHT

Figure 8.1. Barbara Chase-Riboud. *The Last Supper*, 1958, bronze, 8 x 24 x 6" (20.32 x 61 x 15.24 cm). © Barbara Chase-Riboud. Reproduced with the permission of the artist. Collection of the Estate of Ben Shahn.

Figure 8.2. Barbara Chase-Riboud. *Malcolm X #3*, 1970, polished bronze and silk, 9' 10" x 3' 11 1/4" x 9 7/8" (300 x 115 x 24 cm). © Barbara Chase-Riboud. Philadelphia Art Museum. Reproduced with the permission of the artist.

Figure 8.3. Barbara Chase-Riboud. *Cleopatra's Bed*, 1997, multicolored cast bronze plaques over steel armature and silk mattress, 39 3/8 x 51 1/8 x 23 5/8" (100.3 x 130 x 59.7 cm). © Barbara Chase-Riboud. Reproduced with the permission of the artist. Private collection, Rome.

Figure 8.4. Barbara Chase-Riboud. *Africa Rising*, 1998, bronze with silver patina, 19' 7" x 9' 2" x 4' 3" (597 x 279.4 x 129.54 cm). © Barbara Chase-Riboud. Reproduced with the permission of the artist. Collection of the U.S. General Services Administration, New York.

Figure 8.5. *Victory of Samothrace (Nike of Samothrace)* (3/4 view with galley), marble, Greek Hellenistic, c.190 B.C.E., marble, approx. 8' high (2.44 m). Louvre Museum, Paris. © Réunion des Musées Nationaux/Art Resource, New York. Photo by Gérard Blot/C. Jean.

Figure 8.6. Barbara Chase-Riboud. *Africa Rising* (side view), 1998, bronze with silver patina, 19' 7" x 9' 2" x 4' 3" (597 x 279.4 x 129.54 cm). © Barbara Chase-Riboud. Reproduced with the permission of the artist. Collection of the U.S. General Services Administration, New York.

Figure 8.7. Anonymous. Headrest, Shona culture, Zimbabwe. © Werner Forman/Art Resource, New York.

Figure 8.8. Alma Woodsey Thomas (1891–1978). *Wind and Crepe Myrtle Concerto*, 1973, acrylic on canvas, 35 x 52" (88.9 x 132.1 cm). © Smithsonian American Art Museum, Washington, D.C./Art Resource, New York.

Figure 8.9. Alma Woodsey Thomas. *Still Life with Chrysanthemums*, 1954, oil on masonite, 24 x 32" (60.96 x 81.28 cm). American University, Watkins Collection.

Figure 8.10. Alma Woodsey Thomas. *Lunar Surface*, 1970, acrylic on canvas, 34 x 39" (86.36 x 99.06 cm). American University, Watkins Collection. Gift of the artist. 1975.5.

Figure 8.11. Alma Woodsey Thomas (1891–1978). *The Eclipse*, 1970, acrylic on canvas, 62 x 49 3/4" (157.48 x 126.36 cm). Gift of the artist. © Smithsonian American Art Museum, Washington, D.C./Art Resource, New York.

Figure 8.12. Alma Woodsey Thomas. *Red Azaleas Singing and Dancing Rock and Roll Music*, 1976, acrylic on canvas, 72 1/4 x 156 3/4" (183.5 x 398.2 cm). © Smithsonian American Art Museum, Washington, D.C./Art Resource, New York. Bequest of the artist.

Figure 8.13. Alma Woodsey Thomas. *Wind Tossing Late Autumn Leaves*, 1976, acrylic on canvas, 72 x 52" (183 x 132 cm). New Jersey State Museum Collection, Trenton. Museum Purchase FA 1987.26. Photograph by Dan Dragan.

Figure 8.14. Howardena Pindell. *Untitled #73*, 1975, watercolor, gouache, crayon, ink, punched paper, spray adhesive, and thread on board, 7 1/2 x 9 1/2" (19 x 24.13 cm). Collection of Mr. and Mrs. Howard Pindell, Philadelphia, Pa.

Figure 8.15. Howardena Pindell (United States). *Autobiography: Water/Ancestors/Middle Passage/Family Ghosts*, 1988, acrylic, tempera, cattle markers, oil stick, paper, polymer photo-transfer, vinyl tape on sewn canvas, 118 x 71" (299.7 x 180.3 cm). Wadsworth Atheneum, Hartford, Conn. The Ella Gallup Sumner and Mary Catlin Sumner Collection Fund. Courtesy of the artist. Accession #1989.17.

Figure 8.16. Adell Westbrook. *Solar, No. 4*, 1985, acrylic on canvas, 50 x 36" (127 x 91.44 cm). Collection of the artist, Silver Spring, Md.

Figure 8.17. Gaye Ellington. *The Blues Ain't*, 1989, acrylic on canvas, 24 x 36" (61 x 91.44 cm). Collection of the artist, New York.

Figure 8.18. Gaye Ellington. *Oclupaca*, 1983, acrylic on canvas, 28 x 22" (71.1 x 55.9 cm). Collection of the artist, New York.

Figure 8.19. Vivian Browne. *Sempervirens*, 1989, oil on canvas, 60 x 160" (152.4 x 406.4 cm). Estate of the artist, Studio City, Calif.

Figure 8.20. Betty Blayton. *Reaching for Center*, c. 1970, oil collage, 60" diameter (152.4 cm). Collection of the artist, New York.

Figure 8.21. Mary Lovelace O'Neal. *Racism Is Like Rain, Either It's Raining or It's Gathering Somewhere*, 1993, lithograph, 13 1/4 x 22" (33.65 x 55.88 cm). Collection of Professor and Mrs. David C. Driskell, Hyattsville, Md. Photograph by Gregory Staley.

Figure 8.22. Sylvia Snowden. *13*, 1993, acrylic and oil pastel on canvas. 72 x 132" (183 x 335.3 cm). Collection of the artist, Washington, D.C.

Figure 8.23. Sylvia Snowden. *Age 13*, from *Malik, 'Til We Meet Again*, 1994–1998, mixed media on canvas and enlarged jet-ink photo, 6 x 9' (1.82 x 2.74 m). Collection of the artist, Washington, D.C.

Figure 8.24. Stephanie Pogue. *India Pattern/Pattern of India*, from the *Fan* series, 1986, mixed media on paper, 15 x 22 1/2" (38.1 x 57.15 cm). Collection of Professor and Mrs. David C. Driskell, Hyattsville, Md. Photograph by Gregory Staley.

Figure 8.25. Joyce Wellman. *Under Sea Life*, 1985, acrylic on paper, 22 x 30" (55.88 x 76.2 cm). Collection of Terry Lee, Washington, D.C. © Joyce Wellman.

Figure 8.26. Geraldine McCullough. *Ancestral Parade*, 1994, bronze, 46 x 37" (116.84 x 94 cm). Courtesy of the artist, River Forest, Ill.

Figure 8.27. Geraldine McCullough. *Echo 5*, 1993, brass, brazed copper, brass rods, 61 1/2 x 37 x 57 1/2" (156.2 x 94 x 146 cm). Courtesy of Jonathan Green and Richard D. Weedman.

Figure 8.28. Helen Evans Ramsaran. *Prehistoric Giraffe*, 1991, bronze, 12 x 13 x 5" (30.5 x 33 x 12.7 cm). Collection of the artist, New York.

Figure 8.29. Nanette Carter. *Point-Counterpoint #12*, 1996, oil on canvas with collage, 77 x 73 1/2" (195.6 x 185.7 cm). Collection of Ferguson Development, L.L.C., Lansing, Mich. Courtesy of June Kelly Gallery, New York. Photograph by Manu Sassoonian.

Figure 8.30. Nanette Carter. *Detour Left #2*, 2001, oil on mylar with collaged and painted canvas, 24 x 24" (61 x 61 cm). Courtesy of the Sande Webster Gallery, Philadelphia, Pa. Photograph by Manu Sassoonian.

Figure 8.31. Ruth Lampkins. *Untitled*, 1990, paper, oil paint, metallic powder, 6 x 10' (1.82 x 3 m). Collection of the artist, Detroit, Mich.

CHAPTER NINE

Figure 9.1. Adrian Piper. *I Embody Everything You Most Hate and Fear*, from *Mythic Being* performance, 1975, oil crayon on black-and-white photograph, 7 x 10" (17.78 x 25.4 cm). Private collection, New York. Courtesy Thomas Erben Gallery, New York.

Figure 9.2. Adrian Piper. Interior view of *Four Intruders Plus Alarm System*, 1980, installation of circular wood environment,

four photographs, silk-screened lightboxes with attached headphones, and sound (five cassette units), 72 x 60" diameter (183 x 152.4 cm). Collection of the Wexner Center for the Arts, The Ohio State University. Gift of the artist, 1983. 015.001.

Figure 9.3. Adrian Piper. *Cornered*, 1988, installation with video (produced by Bob Boilen), table, lighting, and birth certificates. Photo courtesy of John Weber Gallery, New York.

Figure 9.4. Adrian Piper. *Cornered*, detail of birth certificates, 1988. Installation with video (produced by Bob Boilen), table, lighting, and birth certificates. Photo courtesy of John Weber Gallery, New York.

Figure 9.5. Deborah Willis. *Tribute to the Hottentot Venus: Bustle*, 1995, fabric and photo linen, 23 x 28" (58.42 x 71.12 cm). Courtesy of the artist, New York, and Bernice Steinbaum Gallery, Miami, Fla.

Figure 9.6. Deborah Willis. *Daddy's Ties: Tie Quilt II*, 1992, photo linen, button, tie clips, and pins, 27 x 34" (68.58 x 86.36 cm). Courtesy of the artist, New York, and Bernice Steinbaum Gallery, Miami, Fla.

Figure 9.7. Vicki Meek. *A Man in Touch with His Origins Is a Man Who Never Dies*, 1989, installation, mixed media, 18 x 25' (5.48 x 7.62 m). Photo courtesy of the artist, Dallas, Tex.

Figure 9.8. Vicki Meek. *In Homage to Lady Day, Part III*, 1990, mixed media with audio installation. Photo courtesy of the artist, Dallas, Tex.

Figure 9.9. Carrie Mae Weems. *The Hampton Project*, installation view detail, mixed media with sound recordings, 2000. Courtesy of the artist and P.P.O.W. Gallery, New York.

Figure 9.10. Frances B. Johnston. *Students at Work on a House Built Largely by Them (Stairway of the Treasurer's Residence: Students at Work)*, c. 1899–1900, gelatin silver print. Frances Benjamin Johnston Collection, Prints and Photographs Division, Library of Congress, Washington, D.C.

Figure 9.11. Lorna Simpson. *Sometimes Sam Stands Like His Mother*, from *Gestures/ Reenactments* series, 1985, 6 gelatin silver prints, 7 panels of text, each photo 42 x 38" (106.68 x 96.52 cm). Courtesy of Sean Kelly Gallery, New York.

Figure 9.12. Lorna Simpson. *The Waterbearer*, 1986, gelatin silver print, 45 x 77 x 1 1/2" (114.3 x 195.58 x 3.81 cm). Courtesy of Sean Kelly Gallery, New York.

Figure 9.13. Lorna Simpson. *Screen No. 1* (front and back views), 1986, wooden accordion screen, 3 gelatin silver prints, 62 x 66 x 2" (157.5 x 167.9 cm). New School University. Photo courtesy of Sean Kelly Gallery.

Figure 9.14. Lorraine O'Grady. *Mlle Bourgeoise Noire*, performance at the New Museum of Contemporary Art during the opening of *Personae*, September 1981. Photograph courtesy of the artist.

Figure 9.15. Lorraine O'Grady. *Sisters IV*, from *The Miscegenated Family Album*, installation of images taken from the *Nefertiti/Devonia Evangeline* performance, 1984/1990, cibachrome diptych, 27 x 38.5" (68.6 x 97.8 cm), edition of 9. Courtesy of Thomas Erben Gallery, New York.

Figure 9.16. Renée Cox. *The Liberation of Lady J and U.B.*, 1998, cibachrome, 48 x 60" (122 x 152.4 cm). Courtesy of Robert Miller Gallery, New York. Collection of the artist, New York.

Figure 9.17. Renée Cox. *Hott-En-Tot Venus*, 1998, cibachrome, 60 x 48" (152.4 x 122 cm). Courtesy of Robert Miller Gallery, New York. Collection of the artist, New York.

Figure 9.18. Renée Cox. *41 Bullets at Green River*, 2001, archival digital c-print mounted on aluminum, 40 x 32" (101.6 x 81.3 cm). Courtesy of Robert Miller Gallery, New York. Collection of the artist, New York.

Figure 9.19. Renée Cox. *Untitled #9*, from *The People's Project*, 2000, black-and-white photograph. Courtesy of Robert Miller Gallery, New York. Collection of the artist, New York.

Figures 9.20, 9.21. Kara Walker. *Slavery! Slavery! Presenting a Grand and Lifelike Panodramic Journey into Picturesque Southern Slavery; or, "Life at Ole Virginny's Hole (Sketches from Plantation Life)." See the Peculiar Institution as Never Before! All Cut*

from *Black Paper by the Able Hand of Kara E. Walker, an Emancipated Negress and Leader in Her Cause*, 1997, cut black paper installation, 11 x 85' (366 x 2584 cm) in the round. Eileen and Peter Norton, Santa Monica, Calif. Courtesy of Brent Sikkema Gallery, New York.

Figure 9.22. Kara Walker. Detail of *Slavery! Slavery! Presenting a Grand and Lifelike Panodramic Journey into Picturesque Southern Slavery; or, "Life at Ole Virginny's Hole (Sketches from Plantation Life)." See the Peculiar Institution as Never Before! All Cut from Black Paper by the Able Hand of Kara E. Walker, an Emancipated Negress and Leader in Her Cause*, 1997, cut black paper installation, 11 x 85' (366 x 2584 cm) in the round. Eileen and Peter Norton, Santa Monica, Calif. Courtesy of Brent Sikkema Gallery, New York.

CHAPTER TEN

Figure 10.1. Carole Byard. *Praisesong for Charles*, 1988, outdoor installation, mixed media. Courtesy of the artist, Baltimore, Md.

Figure 10.2. Alyne Harris. *Untitled*, c. 1986, acrylic on canvas, 20 x 24" (51 x 61 cm). Arnette Collection, Atlanta, Ga.

Figure 10.3. Mary Tillman Smith. *Untitled (6 Heads)*, c. 1987, enamel on tin, 26.5 x 39" (67.3 x 99.1 cm). Courtesy Shari Cavin, Cavin-Morris Gallery, New York.

Figure 10.4. Nellie Mae Rowe's Yard, 1971. Photo courtesy of Judith A. Augustine.

Figure 10.5. African House, c. 1798–1800, Melrose Plantation, Natchitoches, La. Photograph courtesy of Shelby Gilley, Gilley's Gallery, Baton Rouge, La.

Figure 10.6. Clementine Hunter. *Quilt*, c. 1940, cotton fabric and thread on paper, 45 x 39 1/2" (114.3 x 100.33 cm). Frederick R. Weisman Art Museum, University of Minnesota, Minneapolis. Gift of the Hugh Schoephoerster Family.

Figure 10.7. Clementine Hunter. *Saturday Night at the Honky Tonk*, c. 1976, oil on canvas board, 17 x 23 1/4" (43.18 x 59 cm). Frederick R. Weisman Art Museum, University of Minnesota, Minneapolis. Gift of the Hugh Schoephoerster Family.

Figure 10.8. Clementine Hunter. *Paw Paw*, c. 1960, oil on masonite, 24 x 16" (61 x 40.6 cm). Courtesy of Shelby Gilley, Gilley's Gallery, Baton Rouge, La.

Figure 10.9. Clementine Hunter. *Big Sky (Clouds)*, c. 1950, oil on artist's board, 29 1/2 x 29 1/2" (75 x 75 cm). Michael S. and Piper Wyatt Collection. Photograph courtesy of Shelby Gilley, Gilley's Gallery, Baton Rouge, La.

Figure 10.10. Clementine Hunter. *African House Mural Panel (St. Augustine Church on Cane River)*, Melrose Plantation, 1956, oil on plywood. Association for the Preservation of Historic Natchitoches, Cane River, La.

Figure 10.11. Clementine Hunter. *Crucifixion*, c. 1960, oil on canvas board, 24 x 8 1/2" (60.96 x 21.6 cm). Courtesy of Shelby Gilley, Gilley's Gallery, Baton Rouge, La.

Figure 10.12. Minnie Evans. *My Very First (top)*, 1935, ink on paper, 5 1/2 x 7 7/8" (13.97 x 20 cm); *My Second (bottom)*, 1935, 5 3/4 x 5 7/8" (14.61 x 19.37 cm). Whitney Museum of American Art, New York. Gift of Dorothea M. and Isadore Silverman. 75.8.1/2. Courtesy of Luise Ross, Luise Ross Gallery, New York.

Figure 10.13. Minnie Evans. *Untitled (Abstract Shape), G #156*, 1944–1945, graphite and wax crayon on paper, 12 x 9" (30.5 x 22.9 cm). Collection of the Family of Minnie Evans. Courtesy of Luise Ross, Luise Ross Gallery, New York.

Figure 10.14. Minnie Evans. *Design Made at Arlie Gardens*, 1967, oil and mixed media on canvas mounted on paper board, 19 7/8 x 23 7/8" (50 x 60 cm). National Museum of American Art, Smithsonian Institution. Gift of the artist. Courtesy of Luise Ross, Luise Ross Gallery, New York, and the Family of Minnie Evans.

Figure 10.15. Nellie Mae Rowe (1900–1982, Vinings Cobb County, Georgia). *Cow Jump over the Mone*, 1978, colored pencil, crayon, and pencil on paper, 19 1/2 x 25 1/4" (50 x 64 cm). Collection of American Folk Art Museum, New York. Gift of Judith Alexander, 1997.10.I. Photo by Gavin Ashworth, New York.

Figure 10.16. Nellie Mae Rowe. *Two-Faced Head (back)*, 1980, chewing gum, bottle cap, costume jewelry, ceramic tile, ribbon, artificial hair, marbles, acrylic paint, 5 1/4 x 4 3/4 x 5 1/2" (13.3 x 12 x 14 cm). Arnette Collection, Atlanta, Ga.

Figure 10.17. Nellie Mae Rowe. *Untitled (Brown Mule)*, c. 1979, crayon and graphite on paper, 18 x 23 1/2" (46 x 60 cm). Courtesy Barbara Archer Gallery, Atlanta, Ga.

Figure 10.18. Sister Gertrude Morgan. *New Jerusalem*, c. 1971, acrylic on cardboard, 10 x 12" (25 x 30 cm). Courtesy Fleisher/Ollman Gallery, Philadelphia, Pa.

Figure 10.19. Bessie Harvey. *Voodoo Queen*, c. 1980s, found wood, paint, beads, feathers, metal earrings, 14"h (35.5 cm). Courtesy Shelby Gilley, Gilley's Gallery, Baton Rouge, La.

Figure 10.20. Bessie Harvey. *Black Horse of Revelations*, c. 1985, polychromed wood, mixed media, 57 x 44 x 9" (144.8 x 111.8 x 22.9 cm). Courtesy Shari Cavin, Cavin-Morris Gallery, New York.

Figure 10.21. Bessie Harvey (1929–1994, Alcoa, Tennessee). *The World*, c. 1980s–1990s, polychromed wood, glass and plaster beads, hair, fabric, glitter, sequins, shell, duct tape, 53 x 38 x 28" (134.6 x 96.5 x 71.1 cm). Collection of American Folk Art Museum, New York. Blanchard-Hill Collection, gift of M. Anne Hill and Edward V. Blanchard, Jr. 1998.10.26.

CHAPTER 11

Figure 11.1. Xenobia Bailey. *Mojo Medicine Hat (Wind)*, 1999, 23" circumference at rim, 4-ply acrylic and cotton yarn, hand-crocheted, single stitch, hand-sculpted, shaped, and sized with lacquer. Collection of the artist, New York.

Figure 11.2. Xenobia Bailey. *Trilogy*, 2000, 4-ply acrylic and cotton yarn, plastic pony beads, hand-crocheted, single stitch, attached with embroidery stitches and cotton canvas backing, 8 x 7' (2.43 x 2.13 m). Collection of the artist, New York.

Figure 11.3. Carol Ann Carter. *Living Room: Garment Apron on Her Chair* (detail of installation with shelf by Lisa Olson),

1994, mixed-media installation. Collection of the artist, Lawrence, Kans.

Figure 11.4. Winifred Owens-Hart. *Life Is a Beach . . . Howard Beach*, 1988, ceramic, 12 x 9 3/4" (30.5 x 24.76 cm). Collection of the artist, Washington, D.C.

Figure 11.5. Winifred Owens-Hart. *Trimesters*, 1990, clay, 63 x 18 x 24" (160 x 45.72 x 61 cm). Collection of the artist, Washington, D.C.

Figure 11.6. René Magritte. *Delusions of Grandeur II (La Folie des Grandeurs II)*, 1948, oil on canvas, 39 1/8 x 32 1/8" (99 x 81.3 cm). Hirshhorn Museum and Sculpture Garden, Smithsonian Institution, Washington, D.C. Gift of Joseph H. Hirshhorn, 1966. © 2003 C. Herscovici, Brussels/Artists Rights Society (ARS), New York. (66.3199)

Figure 11.7. Joyce J. Scott. *Buddha Supports Shiva Awakening the Races*, 1993, sculpture with fabric, beads, thread, wire, and mixed media, 15 x 14 x 6" (38.1 x 35.56 x 15.24 cm). Collection of the artist, Baltimore, Md. Photograph by Kanji Takeno.

Figure 11.8. Joyce J. Scott. *P-Melon #1*, 1995, glass beads and blown glass, 11 x 14 x 8" (28 x 35.56 x 20.32 cm). Collection of the artist, Baltimore, Md. Photograph by Kanji Takeno.

Figure 11.9. Renée Stout. *Trinity*, 1992, wood and mixed media, open: 45 x 22" (114.3 x 56 cm), closed: 45 x 11" (114.3 x 28 cm). Courtesy of the artist, Washington, D.C.

Figure 11.10. Renée Stout. *Fetish #2*, 1988, mixed media and plaster body cast, 64" high (162.56 cm). Dallas Museum of Art, Metropolitan Life Foundation Purchase Grant, 1989.27.

Figure 11.11. Alison Saar. *Mamba Mambo*, 1985, mixed media, 5' 4" x 2' 10" x 1' 5" (162.56 x 86.35 x 43.18 cm). Courtesy of the artist.

Figure 11.12. Alison Saar. *Diva*, 1988, wood, tin, paint, and shell, 32 x 30 x 10" (81.28 x 76.2 x 25.4 cm). Private collection, Los Angeles. Courtesy of the artist. Photograph courtesy of Jan Baum Gallery, Los Angeles.

Figure 11.13. Alison Saar. *Dying Slave*, 1989, wood, tin, Plexiglas, and nails, 9' high

(2.74 m). Private collection, Los Angeles. Courtesy of the artist. Photograph courtesy of Jan Baum Gallery, Los Angeles.

Figure 11.14. Freida High W. Tesfagiorgis. *Aunt Jemima's Matrilineage*, 1982, pastel, 32 x 45" (81.28 x 114.3 cm). Collection of the artist, Madison, Wis.

Figure 11.15. Freida High W. Tesfagiorgis. *Hidden Memories: Mary Turner*, 1985, pastel, 40 x 30" (101.6 x 76.2 cm). Collection of the artist.

Figure 11.16. Margo Humphrey. *The Last Bar-B-Que*, 1988–1989, lithograph with variegated red foil and gold metallic powder, 22 x 48" (56 x 122 cm). Hampton University Art Museum, Hampton, Va. Gift of Dr. Samella Lewis. Courtesy of the artist.

Figure 11.17. Valerie Maynard. *Get Me Another Heart, This One's Been Broken Many Times*, from *No Apartheid* series, 1995, acrylic paint on oaktag, 56 x 36" (142.24 x 91.44 cm). Collection of the artist, Baltimore, Md.

Figure 11.18. Camille Billops. *The Story of Mom*, 1981, ceramic, 47 x 11 x 7" (119.4 x 28 x 17.8 cm). Collection of the artist, New York.

Figure 11.19. Camille Billops. *From the Story of Mom*, 1986, colored pencil on paper, 15 x 22" (55.88 x 88.1 cm). Collection of the artist, New York.

Figure 11.20. Martha Jackson-Jarvis. *The Gathering*, 1988, ceramic shard installation at the University of Delaware Gallery.

Figure 11.21. Martha Jackson-Jarvis. *Sarcophagus I*, from *Last Rites*, 1992–1993, clay, glass, pigmented cement, and wood, 36 x 72 x 30" (91.44 x 182.9 x 76.2 cm). Collection of the artist, Washington, D.C.

Figure 11.22. Jean Lacy. *Twins in the City*, 1987, mixed media on museum board, 11 1/2 x 8 3/4" (29.21 x 22.22 cm). Collection of Michelle and Barry Barnes, Houston, Tex.

Figure 11.23. Jean Lacy. *Prayer for the Resurrection of a Row House in Baltimore*, 1995, mixed-media construction with carved wooden doll, 8 1/2 x 6 1/2" (21.6 x 16.51 cm), doll: 4" high (10.16 cm). Collection of the artist, Dallas, Tex. Photograph by Tom Jenkins.

Figure 11.24. Beverly Buchanan. *Home of Reverend Beulah Robinson*, 1995, tin, wood, plastic, collage, 17 1/4 x 15 x 11" (43.8 x 38 x 28 cm). Courtesy of Bernice Steinbaum Gallery, Miami, Fla.

Figure 11.25. Robin Holder. *Show Me How III*, 1990, stencil monotype, 32 x 25" (81.3 x 63.5 cm). Collection of the artist, Brooklyn, N.Y.

CHAPTER 12

Figure 12.1. Ellen Gallagher. *Dance You Monster*, 2000, right side of diptych, enamel, rubber, and paper on canvas, 120 x 96" (304.8 x 243.8 cm). Courtesy of the Anthony d'Offay Gallery, London.

Figure 12.2. Ellen Gallagher. *Untitled*, 2000, oil, pencil, plasticine, and paper on canvas, 72 x 84" (182.88 x 213.36 cm). Courtesy of Anthony d'Offay Gallery, London.

Figure 12.3. Ellen Gallagher. *Untitled*, detail, 2000, oil, pencil, plasticine, and paper on canvas, 72 x 84" (182.88 x 213.36 cm). Courtesy of Anthony d'Offay Gallery, London.

Figure 12.4. Paul Colin. Word-drawing from *Le Tumulte Noir* lithograph series, 1927. Estate of Paul Colin/© 2003 Artists Rights Society (ARS), New York/ADAGP, Paris.

Figure 12.5. Pamela Jennings. *Solitaire Game Board*, 1996, the main game engine interface for the CD-ROM project *Solitaire Dream Journal*. Courtesy of the artist, Wilkinsburg, Pa.

Figure 12.6. Pamela Jennings. *The Bridge*, 1996, from the CD-ROM project *Solitaire Dream Journal* (an image from one of the interactive screens in the *Book of Melancholy*). Courtesy of the artist, Wilkinsburg, Pa.

Figure 12.7. Laylah Ali. *Untitled*, 2000, gouache on paper, 7 x 6" (17.8 x 15.24 cm). Courtesy of 303 Gallery, New York.

Figure 12.8. Laylah Ali. *Untitled*, 2000, gouache on paper, 13 x 19" (33 x 48.26 cm). Courtesy of 303 Gallery, New York.

Figure 12.9. Deborah Grant. *Cryptic Stages*, 2000, acrylic, enamel, oil, and markers on linen, 38 x 38" (96.52 x 96.52 cm). Collection of Nancy Lane, New York.

Figure 12.10. Deborah Grant. *Verdicts*, 2000, acrylic, enamel, oil, and markers on linen, 38 x 38" (96.52 x 96.52 cm). Collection of the Norton Family.

Figure 12.11. Philemona Williamson. *Curiosity's Path*, 1995, oil on linen, 48 x 60" (122 x 152.4 cm). Courtesy of June Kelly Gallery, New York.

Figure 12.12. Philemona Williamson. *Prickly Pear*, 2002, oil on linen, 48 x 60" (122 x 152.4 cm). Courtesy of June Kelly Gallery, New York. Photo by Peter Jacobs.

Figure 12.13. Gail Shaw-Clemons. *In Flight*, from *Indigo* series, 2001, colored pencil and graphite, 22 x 30" (55.88 x 76.2 cm). Collection of the artist, New York.

Figure 12.14. Chakaia Booker. *Vertical Flight*, 2003, rubber tires and wood, 46 x 39 x 28" (116.84 x 99.06 x 71.12 cm). Private collection. Courtesy of Marlborough Gallery, New York. Photograph by Nelson Tejada.

Figure 12.15. Debra Priestly. *Patoka #10: Dried Apples*, 1994, mixed media on birch, 32 x 48 x 4" (81.3 x 122 x 10.16 cm). Courtesy of the artist, New York. © Debra Priestly. Photo by Manu Sassoonian.

Figure 12.16. Debra Priestly, *Strange Fruit #18*, 2001, mixed media on wood, 36 x 24" (91.44 x 60.96 cm). Courtesy of the artist, New York. © Debra Priestly. Photo by Becket Logan.

Italicized numbers refer to illustrations.

Index

Hines, Felrath, 127
Holder, Robin, *278, 279*
Hollingsworth, Alvin, 127
Hope, John, 113, 114
Hosmer, Harriet, 55, 56
Hottentot Venus, 16, *17*, 182, 210, 223, 224
Howard University, 54, 74, 79, 86, 88, 118, 119, 121, 168, 184, 185, 191, 194–197, 256, 272
HUAC (House Un-American Activities Committee), 116, 117, 124, 132
Hughes, Langston, 77, 86, 88, 108
Humprey, Margo, *269, 270*
Hunt, Richard, 141
Hunter, Clementine, 235, *236, 237, 238, 239, 240,* 243, 249
Hurston, Zora Neale, 77, 86, 212

impressionism, 45, 52, 72, 82, 90, 91, 127, 194
Indigenists, 91
Ingram, Zell, *104*
installation art, 166, 167, 204, 207, 208, 210, 212, 214–217, 219, 220, 227, 232, 234, 253, 255, 274, 288

Jackson, May Howard, 4, 64, 65, 71, *72, 73, 74, 75,* 79
Jackson-Jarvis, Martha, *274, 275, 276*
JAM Gallery (Just Above Midtown Gallery), 129
Jarrell, Wadsworth, *128, 129*
jazz, 76, 80–82, 85, 129, 134, 192, 272, 274, 294
Jazz Age. *See* Harlem Renaissance
Jefferson, Louise, *104*
Jefferson, Thomas, 178
Jennings, Pamela, 283, *284*
Jezebel, 4, 8, 16, 20, 22, 25
Jim Crow, 21, 64, 78, 162, 164, 165, 228, 281
Johnson, James Weldon, 70, 73, 77, 82
Johnson, Sargent Claude, 9, 22, 263
Johnston, Frances B., 214, *215*, 216, 217
Jones, Grace, 20
Jones, Jennie C., 288
Jones, Lois Mailou, 71, 87, *88, 89, 90, 91, 93,* 99, 100, 107, 118, 184
Jones-Hogu, Barbara, *128, 129*

Kandinsky, Wassily, 18, 190, 198, 275
Karamu House, 97
Kauffman, Angelica, 147
Keckley, Elizabeth, 4, *43,* 44

Kenkeleba Gallery, 129
King, Martin Luther, Jr., 125–127
Knight, Gwendolyn, 97
Kongo *pakèts. See pakèts* Kongo
Kongo power figure. *See nkondi* figure
Kosuth, Joseph, 204
Ku Klux Klan, 76, 126, 130, 285

LACWA (Los Angeles Council of Women Artists), 148
Lacy, Jean, *276, 277, 279*
Lampkins, Ruth, *203*
landscape design, 26, 45–49. *See also* yard art
Lange, Dorothea, 97
Langston, John Mercer, 54
La Revue Nègre, 9, 80, 283
Lawrence, Carolyn, *128, 129*
Lawrence, Jacob, 105, 279
Lee, Canada, 117
Lewis, Mary Edmonia, 4, 53, *54, 55, 56, 57, 58, 59, 60, 61, 62, 63,* 64, 65, 72, 75, 174
Lewis, Norman, *104*, 105, 127
Lewis, Samella, 142, *143,* 144, 264
Lewis, Sinclair, 108
LeWitt, Sol, 204
Liebes, Dorothy, 161
Lightfoot, Elba, 97
Li'l Kim, 20
Lincoln, Abraham, 44, 57
Lincoln, Mary Todd, 4, *43,* 44
Lloyd, Tom, 141
Locke, Alain, 73, 76, 79, 85, 86, 88, 92, 102, 118, 120, 122, 126
log cabin quilt, *34*
Longfellow, Henry Wadsworth, 61
Lopez, Jennifer, 223, 161
Lord, Francisco, *104*
los tres grandes. See Mexican muralists
L'Ouverture, Toussaint, 182

MacArthur Foundation fellowship, 210, 227
Magritte, René, *258, 259*
Maillol, Aristide, 108
Malcolm X, 126, *128,* 129, *133,* 176, 177, 179, 182
Mammy, 4, 8, 20–22, 25, 79, 164, 165, 227
Manet, Edouard, *18,* 19, 20, 155, 223
Marshall, Thurgood, 125
Maryland Institute College of Art, 197, 253, 260
Mason, Charlotte Osgood, 85, 86